HOKUSA
GREAT WAVE

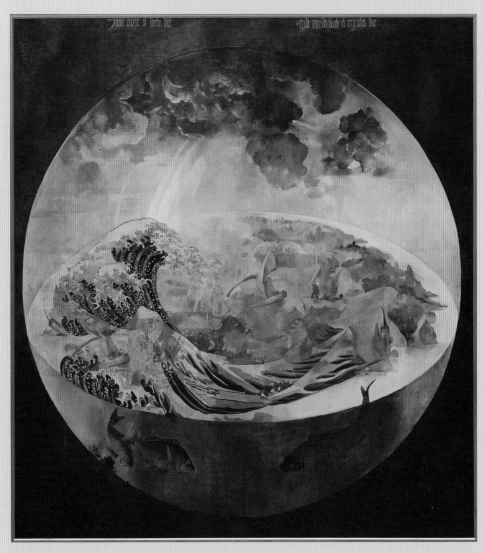

Wolfe von Lenkiewitcz, *Creation*, 2012. (Courtesy of the artist)

HOKUSAI'S GREAT WAVE

Biography of a Global Icon

CHRISTINE M. E. GUTH

University of Hawai'i Press

HONOLULU

Subvention of the research and publication of this volume was generously supplied by a Martha Sutton Weeks Fellowship, Stanford Humanities Center, and by the Sainsbury Institute for the Study of Japanese Arts and Cultures and the Toshiba International Foundation.

20 19 18 17 16 15 6 5 4 3 2 1

Library of Congress Cataloging-in-Publication Data

Guth, Christine, author.
 Hokusai's Great wave : biography of a global icon / Christine M. E. Guth.
 pages cm
 Includes bibliographical references and index.
 ISBN 978-0-8248-3959-8 (cloth : alk. paper)
 — ISBN 978-0-8248-3960-4 (pbk. : alk. paper)
 1. Katsushika, Hokusai, 1760–1849. Great wave. 2. Popular culture and globalization. I. Title.
 NE1325.K3A65 2015
 769.92—dc23
 2014030643

Designed by Mardee Melton
Printed by Regent Publishing Services

In memory of Jay
(1949–2007)

Contents

Illustrations

Acknowledgments

THIS BOOK DEALS WITH THE FORMATION OF A global icon, but its own formation began so long ago that I am no longer sure exactly what prompted the idea to write it. I may have first considered the possibility when I saw a re-creation of Hokusai's print, alongside Andy Warhol's *Marilyn Monroe* and Van Gogh's *Starry Night*, as part of a colorful mural painted as a student project on the walls of the Community Art Center in Princeton, New Jersey. However, it wasn't until I moved to California, where I encountered the astonishing variety of reinterpretations of this design as logos on tattoo parlor windows, as part of the décor of Japanese restaurants, on clothing and surfing gear, and even at a bicycle shop, that I determined to make its migrations the subject of a book. By the time I moved to London in 2007 under difficult but ultimately fortunate circumstances, I was deep into research. What I didn't yet realize was the scope and complexity of the topic or the way that my introduction to the history of design would change my approach.

When intellectual adventures span such temporal and geographic distances, one accrues many debts of gratitude. At the Stanford Humanities Center, where I was a Martha Weeks Fellow from 2006 to 2007, I was inspired and encouraged by conversations with many scholars but especially cultural geographers Karen Wigen and Hilda de Weert. Since then, many friends and colleagues, including Ken Brown, Ellen Conant, Greg Levine, Joshua Mostow, Noriko Murai, Chris Reed, and Miriam Wattles, have offered invaluable criticism on drafts of various chapters. Allen Hockley has been a good friend and critic sensitive to both the specifics and the larger issues I have sought to address throughout the time I have been engaged in this research. In London I have benefited greatly from many conversations with Tim Clark, who shares a special interest in this topic. Tim Screech generously offered a close, insightfully critical reading of the entire manuscript.

As this book is the product of research carried out over more than five years, parts of it were published in earlier versions. Chapter 1 is based on "Hokusai's Great Waves in Nineteenth-Century Japanese Visual Culture," which appeared in *The Art Bulletin,* and Chapter 4 on "Mediating between the Local and the Global: The Great Wave in Contemporary Product Design," published in *Design Issues.* Comments from reviewers of these articles were instrumental in the development of my thinking about the early history of the print and its adaptation for commercial use.

For the past six years I have been privileged to teach in the Royal College of Art and Victoria and Albert Museum's Postgraduate History of Design Program, where students and colleagues introduced me to some of the methodologies that inform this research. Among the many whose casual conversations and observations helped me shape my arguments, I owe special thanks to Sarah Teasley. Discussions with Angela McShane helped in framing the introduction and conclusion. I also appreciate the intellectual generosity of David Robins, whose own passion for Debussy led to productive exchanges about the composer's relationship to Hokusai's print. I would also like to acknowledge the assistance of Taka Oshikiri and three former students, Kimberley Chandler, Zoya Street, and, especially, Liz Stanford, in helping to carry out web research and to secure images for this publication.

There are also a number of colleagues and friends to whom I am grateful for help at different stages along the way. Malene Wagner assisted with research and translation from Danish sources. Radu Leca and Paul Steier drew my attention to the value of stamps as a vital form of graphic communication in the global circulation of "The Great Wave." More friends and acquaintances than I can acknowledge here have sent me examples of the use of this image from around the world—only a handful of which I was ultimately able to include—but special thanks are due Ken Brown, Greg Irvine, Julia Hutt, Angus Lockyer, Katherine Martin, Nicole Rousmaniere, and Peter Smith. I am also grateful for the unfailing encouragement of Suchitra Balasubrahmanyan, with whom I shared an office in the final stages of preparing the manuscript for publication. Lastly, I would like to thank

the artists and collectors who kindly permitted me to reproduce their works.

The initial research for this book was carried out with the financial assistance of a Martha Sutton Weeks Fellowship at the Stanford Humanities Center. Picture research was partially funded by the Royal College of Art / Victoria and Albert Museum History of Design Program. Publication has been supported by the Sainsbury Institute for the Study of Japanese Arts and Cultures, UK, and the Toshiba International Foundation. To them all I extend my deepest gratitude.

Final thanks to Patricia Crosby for agreeing to take on this manuscript and for expediting its publication.

Introduction

Very often afterwards, in the midst of their talk, he would break off, to try to understand what it was that the waves were always saying; and would rise up in his couch to look towards that invisible region, far away.

—CHARLES DICKENS, *Dombey and Son*

Creating a new culture does not only mean one's own individual "original" discoveries. It also, and most particularly, means the diffusion in a critical form of truths already discovered, their "socialization" as it were. . . . For a mass of people to be led to think coherently . . . about the real present world, is a "philosophical" event far more important and "original" than the discovery by some philosophical "genius" of a truth which remains the property of a small group of intellectuals.

—ANTONIO GRAMSCI, *Selections from the Prison Notebooks*

NO NON-WESTERN ARTWORK HAS BEEN REPRODUCED SO WIDELY or undergone so many reconfigurations in so many parts of the world as Hokusai's "Under the Wave off Kanagawa," commonly known as "The Great Wave." Not only is it instantly recognizable, but familiarity with it has contributed to the way many people visualize waves today. Despite its iconic stature, however, historians have not explored its temporal and spatial migrations from Japan to distant parts of the world. What is it about this image that so galvanizes viewers? Why has it generated such a plurality of responses in so many media? What do its reworkings and reconfigurations say about the processes of global cultural socialization?

The wave possesses easily recognizable visual and highly adaptable symbolic attributes that have given it a capacity to connect people across time and space, but there is no simple explanation for its global iconicity. Its celebrity is the result of the many, often contradictory, meanings that have coalesced around it. The cresting wave is bound up with elemental, often erotic, mythologies of natural destruction and renewal. Its trajectory evokes the oceans over which Europe, America, and Japan have struggled for power. It draws attention to the border-crossing movement of ideas, people, technologies, capital, and commodities as well as to the creative cultural exchanges that may accompany them. But above all it connotes hybridity.

This study examines the woodblock print originally titled *Kanagawa oki no namiura* through its many articulations, arguing that since its publication in 1831 as part of Hokusai's *Thirty-Six Views of Mount Fuji,* it has been a site where the tensions, contradictions, and, especially, the productive creativities of the local and the global have been negotiated and expressed. Through its iteration and reiteration across a multisited network, this arresting color print has participated, as both product and producer, in the still ongoing process of globalization. This is what makes "The Great Wave" a subject of more than art historical or even academic interest.

One of the most spectacular of Hokusai's serial views of Mount Fuji from different vantage points—in different seasons, times of day, and atmospheric conditions—Hokusai's "Under the Wave off Kanagawa" stands out for its startling juxtaposition of a towering cresting wave in the foreground and a tiny Mount Fuji in the deep distance. Monumental in size and frozen in space, the wave looms improbably over Mount Fuji, its fluid historicity challenging the timelessness of the immortal mountain. At first glance, the colossal wave with its clawlike crests seems to form an impenetrable wall, but closer inspection reveals three elongated boats rowed by columns of men defiantly cutting through this watery expanse. Will they succeed? Hokusai's narrative lacks a clear conclusion: like the frozen wave itself, the viewer is held in suspense, the deferred pleasure heightening the appeal of the drama.

To feel the emotional power of this image, whatever its medium

or scale, does not require knowledge of the artist who created it or its country of origin. It exemplifies, to borrow Stephen Greenblatt's observations on resonance and wonder, "the power of the displayed object to reach out beyond its formal boundaries to a larger world, to evoke in the viewer the complex, dynamic cultural forces from which it has emerged and for it may be taken by a viewer to stand." This sense of wonder also includes "the power of the displayed object to stop the viewer in his or her tracks, to convey an arresting sense of uniqueness, to evoke an exalted attention."[1] Precisely what "The Great Wave" was meant to stand for and what its beholders think it stands for, however, are not necessarily the same across continents, cultures, and generations. In tracing this image's global peregrinations, it is essential to distinguish between intended, constructed, and received or reconstructed meanings in each locale.

Unlike many forms of early modern Japanese visual culture, "Under the Wave off Kanagawa" has exceptional communicative power as a graphic design because it combines a set of easily recognizable almost geometrically defined features: mountain and sea (also the components of the term *sansui,* the literal meaning of the Japanese word for landscape), figures in boats, and a dramatic narrative open to individual interpretation but often understood to imply the contest or uneasy balance between nature and humanity. Adding to its visual appeal, its flat pictorial idiom, predominantly blue palette, and adoption of elements of spatial illusionism make this marine view at once abstract and realistic, familiar and unfamiliar, to Japanese and non-Japanese viewers alike.

With the publication of "Under the Wave off Kanagawa," Hokusai created a way of seeing the power and mutability of the sea that has had an enduring impact around the world. Although he was not the first Japanese artist to create a landscape dominated by a giant wave, this subject nonetheless has come to be inextricably identified with him. Today, this woodcut is widely known as "The Great Wave," the "the" in its title succinctly expressing both its transcendent power and its iconic stature. So evocative is this phrase that a Japanese transliteration has even been adopted in the print's country of origin. As scholar Timothy Clark observed, "Since the 2005 blockbuster exhibition at

Tokyo National Museum, even ordinary Japanese people have begun to refer to it, affectionately and in recognition of its ever-growing global iconic status, as *gureto uebu* ('Great Wave')"—rather than by the title "Kanagawa oki no namiura."[2]

Acceptance of this Anglophone characterization serves as a reminder that Hokusai's wave was first designated a masterpiece of world art outside of Japan. The image still enjoys far higher stature abroad than at home because its canonization is bound up with the role that Japanese woodblock prints are ascribed in the development of European modernism. As a popular art form mass-produced by and for commoners, in Japan it has occupied a relatively lowly place in the artistic canon vis-à-vis painting, calligraphy, and the decorative arts. The global success of anime and manga, many of whose young enthusiasts admire Hokusai, has contributed significantly to the reevaluation of Hokusai's great wave.[3]

The dramatic contours of the cresting great wave are so familiar that the woodcut itself hardly needs any introduction, but characterizing it as a "global icon" requires some explanation. "Global" is not used here to imply that the motif is familiar in every country in the world but rather to suggest the networked relationship of its multisited appearances. The term "global" summons up a historically complex and contentious process of connectivity for which there is no singular definition or causal interpretation, one inextricably bound up with access to technology, military might, capital, and communications media. In the past two decades, the convergence of old and new media—print, television, film, and the Internet—have played a particularly important role in global cultural flows through their challenge to local, regional, and nation-based notions of identity. Anthropologist Arjun Appadurai has usefully characterized these global flows as "ethnoscapes"—the moving landscapes of tourists and migrants—"technoscapes"—the movement of technologies across national boundaries—"financescapes"—the movement of capital—"mediascapes"—the electronic capabilities to produce and disseminate images—and "ideoscapes"—the network of images with state or oppositional ideological implications.[4] All these forms of globalization are implicated in the diffusion of "The Great Wave."

Globalization is often represented in a dialectical manner as a form of Western imperialism, an unequal and unevenly distributed market-driven phenomenon that contributes to homogenization to the detriment of less powerful, usually non-Western, cultures.[5] Yet the case has been made, equally convincingly, that globalization has also produced remarkable diversity. Countervailing forces of local consumption preferences may arouse opposition, resistance, or stimulate the creation of adaptations through which new differences are produced. Increasingly, more nuanced critical analyses of globalization have underscored the tactics individuals and groups have mobilized to reimagine such cultural impositions, in so doing criticizing or subverting its force. Hybridity is a critical product of globalization. Although locally customized hybrids are seen by some to represent a dilution of a pure and authentic culture, this assumption is highly problematic since what is perceived to be authenticity may itself be a product of earlier, possibly even global interactions. To label "The Great Wave" as global, then, implies that it should not be understood as an entity solely framed by Japan but, from its inception, as a hybrid whose entangled history has been strongly influenced by other cultures even as it may influence them.[6]

When viewed in a global context, the wave suggests fluidity, an in-betweenness and resistance to fixed boundaries. Mikhael Bahktin's notion of hybridity as "two social languages within the limits of a single utterance" is a useful way of thinking about the communicative power of this image.

> What we are calling a hybrid construction is an utterance that belongs, by its grammatical [syntactic] and compositional markers, to a single speaker, but that actually contains mixed within it two utterances, two speech manners, two styles, two "languages," two semantic and axiological belief systems. . . . It frequently happens that even one and the same word will belong simultaneously to two languages, two belief systems that intersect in a hybrid construction—and consequently, the word has two contradictory meanings, two accents.[7]

Such dialogic tensions, expressed in both the subject and the idiom of Hokusai's design, have facilitated a plurality of creative reinterpretations.

As defined by art historian Martin Kemp in his book *From Christ to Coke: How Image Becomes Icon,* an iconic image is one that "has achieved wholly exceptional levels of widespread recognisability and has come to carry a rich series of varied associations for very large numbers of people across time and cultures, such that it has to a greater or lesser degree transgressed the parameters of its initial making, function, context and meaning."[8] Iconic images, he suggests, are not necessarily artistic masterpieces but may include the Coke bottle, the heart, or DNA's double helix. What these disparate visual formations have in common is a schematic shape that makes them easily recognizable in whatever medium they appear, elastic connotations, and visual ubiquity.[9] Hokusai's cresting wave has all these features as well as particular topicality in a world where global encounters and environmental disasters are the stuff of daily news. In addition, the appearance of the wave itself—its monumental scale, singularity, and the distinctive manner in which its cresting is captured and frozen in time and space—is well suited to a postmodern visual culture that demands the spectacular.

Other factors that have contributed to its iconicity follow from its verbal connotations and may be best interpreted with reference to figures of speech. The wave's functional versatility might be likened to that of a literary trope, a mechanism that helps to organize and give expression to diverse and often contradictory concepts and associations. The wave has an infinitely expandable range of denotative and connotative meanings, many of them specific to a particular historical moment or cultural context. Although most everyone would recognize the primary denotative meaning of a wave as the oscillating movement of water, to a Japanese courtier of the ninth century, through poetic conventions, the wave, *nami,* connoted lost love and exile, a meaning lost to modern viewers. Similarly, the word "wave" or its representation today might bring to mind hair waves, light waves, sound waves, and brain waves, associations that would have provoked puzzlement and even disbelief in earlier times. Although Hokusai's woodcut represents a wind-driven rather than a tidal wave, it also has been read as a tsunami

and thus a metaphor for environmental disaster. The wave has a further metaphoric relationship to the global flow of people, ideas, and goods. Because waves are in a perpetual state of flux, related to but not part of the shores on which they break, they are resonant signifiers of both the deterritorializing effects of globalization and the hybridity resulting from the mixing of their waters. In the past decade, the cresting wave's connotative versatility has even made it a stand-in for the risks of global economics and trade.[10]

Martin Kemp omitted this "non-Western artwork" from his book "because its fame resided largely within the world of art."[11] The print has indeed had an impact on the arts—from painting, sculpture, and architecture to music. Since the nineteenth century it has opened up new ways of articulating a natural phenomenon that has a place in the visual arts in most parts of the world. Today many artists, such as Wolfe von Lenkeiweitz, whose reinvention of Hieronymus Bosch's *Creation of the World* figures as frontispiece to this book, continue to conjure it up in their work. Contrary to Kemp's assertion, however, this study argues that the iconicity of Hokusai's wave follows from its representations in many forms outside the art world and, often, without explicit reference to Hokusai or to Japan. Waves are semiotically rich carriers of meaning in many cultures, whose encounters with Hokusai's design have overlaid their representation with an ever-widening range of historical, scientific, and cultural references. Who could have imagined that Hokusai's wave might serve as model for analysis of the recursive patterns of fractals?[12]

No one who looks at the image today does so innocently. This makes it all the more surprising that no scholar has yet critically examined why or how, in the century and a half since its appearance, it has captured the global imagination to a degree unmatched by any other work of Japanese art. Collectors and art historians have typically explained its stature with reference to Hokusai's artistic genius, but neither artistic intentionality nor intrinsic meanings can account for its success outside of its country of origin. Analysis of its formal properties may be a first step in understanding how the artist intended his image to work and how it was received in the context of the time and

place where it was produced but cannot adequately explain its impact among those who do not share the same cultural assumptions or viewing practices.

Why were beholders equally receptive to this image in late-nineteenth-century Paris, Prague, and St. Petersburg? Why has it become so ubiquitous in twentieth and twenty-first century Europe, North America, and Australia but not regions in East and South Asia or in South America? To address such questions requires locating the source of its reputation in a multiplicity of historically and geographically specific responses. Hokusai's print must be understood as an active producer of meaning, not a reflection or reproduction of some prior reality, and the interpretive engagements with it as contributing to the emergence of locally contingent meanings. Its dissemination across vast geographic spaces implies that it participates in fields of cultural production whose interactions articulate and disseminate new meanings that constantly naturalize, revise, or reinforce existing ones.

The study of a work that finds expressions in so many times and places demands a cross-disciplinary approach, and this book draws promiscuously on art and design history, anthropology, sociology, and media studies. Art history has tended to inscribe the objects of its study within a closed system defined by national borders. This nation-centered approach is particularly strong in art historical scholarship on Japan, partly because of the ongoing power of the myth that Japan was "closed" to the world during the Tokugawa period (1615–1868).[13] It has been further fostered by popular and scholarly literature that explicitly or implicitly posits Japanese culture as fundamentally inalienable, that is, having an identity that cannot be transferred to another country. Furthermore, the Fuji-centric perspective that dominates study of this woodblock print and the series of which it is a part has produced interpretations that do not adequately take into account the wider significance of the wave with which it is juxtaposed. One of the premises of this study is that Hokusai's heroic waves captured the imagination of their nineteenth-century Japanese viewers because of a growing preoccupation with and unease about relations with the world beyond Japan's watery periphery.[14]

This study explicitly rejects the "influence" approach to the interpretation of the iconity of Hokusai's "Under the Wave off Kanagawa." Although I am mindful of the important foundational work carried out under the general rubric of Japonisme, conventional studies of the relationship between Japanese prints and European art and design are for the most part premised on an interpretive model against which art historian Michael Baxandall long ago railed in his book *Patterns of Intention,* going so far as to describe influence as a "stumbling block," a "scandal," and a *"curse of art criticism."* As he explains, "if one says that X influenced Y it does seem that one is saying that X did something to Y rather than Y did something to X. But in consideration of good pictures and painters, the second is always the more lively reality."[15] I concur with his view that influence is a problematic model, but its application in the context of cultural exchange between Japan and Europe is made more problematic still because the ascription of agency often depends on the direction in which the "influence" is thought to flow. If it is West to East, then the source is privileged rather than the agent carrying out the adaptation, and the process is often seen as one of dilution and diminishment. However, if the movement is East to West, attention is directed to the European artists who acted radically and innovatively on what they saw in Japanese prints with little or no recognition of the agency of their Japanese origins. Rather than thinking about artistic relationships in a linear trajectory, Baxandall proposes that we think about them as a field like a billiard table in which, every time one ball hits another, there is a rearrangement that creates a new network of relations among all the constituent parts. This concept of distributive agency is particularly useful for the study of the global circulation of Hokusai's wave.

In rethinking the trajectories of Hokusai's "Under the Wave off Kanagawa" beyond Japan, I have found particularly helpful the art historical framework modeled in Thomas da Costa Kaufmann's *Toward a Geography of Art.*[16] Kaufman interrogates national style, demonstrating its limitations as a historically meaningful interpretive category. By the same token, he problematizes center-periphery and colonizer-colonized models of study that marginalize as provincial or derivative

significant bodies of work produced outside the metropolitan arena. His approach underscores the degree to which the creative interplay and permutations of cultural forms found in geographically distant regions may be mutually constitutive and in so doing offers a more nuanced and nonhierarchical framework for the interpretation of multisited art. His approach makes a strong argument for seeing the continuous and still ongoing cultural flows in which "The Great Wave" participates as multidirectional rather than bidirectional and as intricately bound up with and overlapping one another.

The "biography" of my title was inspired by anthropologist Igor Kopytoff's essay "The Cultural Biography of Things: Commoditization as Process," but my approach extends his argument beyond the economic exchange of physical objects and the permutations in form, function, and meaning that these may assume over time and space.[17] This study shares Kopytoff's blurring of the boundaries between people and things through commoditization, but it also recognizes the importance of the technologies and agency of spatial flows, the specificities of geography in this process, and both the material and the immaterial forms that commodities may assume. The social life of "The Great Wave" was set in motion by the production, circulation, and consumption of thousands of impressions of the woodblock print, many of which, over time, were lost, so that surviving examples accrued in exchange value. However, the commoditization of Hokusai's design independent of this woodblock print and with an exchange value often only marginally dependent on it is also a significant and ongoing part of its biography. In other words, the iconicity of "The Great Wave" involves its evolution from a material thing to a brand that can add value to other things.

This evolving citational value has been used in other print media, as in a scene from the Tintin series *Les cigares du Pharaon* (Cigars of the Pharoah) and on the cover of Iris Murdoch's 1978 Booker-prize-winning novel about obsessive love, *The Sea, the Sea,* to give only two of many examples.[18] As discussed in Chapter 4, fashionable goods including watches, clothing, home furnishings, and stationery feature the motif. It also has been used in ways that are historically and culturally

inaccurate, as in the print's representation, mirror reversed, as the backdrop for the refrain of "I'm on My Way," sung in Chinese, in the opening credits of the 1969 film *Paint Your Wagon* about the California Gold Rush.[19] The Internet offers a plethora of imaginative engagements with the wave in unexpected forms, such as artist Phil Hansen's wacky demonstration of how to paint "The Great Wave" with Coca-Cola.[20] All manifestations, however ephemeral and regardless of artistic merit, should be regarded as constituents of the wave's biography.[21]

In recent decades the Internet has accelerated and expanded recognition of "The Great Wave." Consideration of the old and new media and technologies that have shaped and reflected its iconicity is therefore an important thematic thread in this study. Sociologist Bruno Latour's essays on how technological agency may authorize, influence, and even prevent other human or nonhuman actors from carrying out intended activities have been helpful in this respect.[22] Henry Jenkins' insightful writings about the promises and perils of the convergence of old and media have also productively informed my thinking about the global flow of "The Great Wave."[23] The trajectories of Hokusai's wave support his view that technology and media, rather than producing cultural homogeneity, have fostered diversity by providing a global platform for individual and collective intervention.

Although the larger questions of global iconicity have been informed by scholarship in various disciplines, this study could not have been written without the large and still growing international body of art historical literature on Hokusai and his *Thirty-Six Views of Mount Fuji*. In Japanese it ranges from monographic treatments, the first of which was Iijima Kyoshin's 1893 *Katsushika Hokusai den,* and close readings of individual prints, such as Kano Hiroyuki's *Katsushika Hokusai Gaifū kaisei: Aka Fuji no fōkuroa* (Katsushika Hokusai's "South Wind, Clear Dawn": the folklore of the Red Fuji), to the multitude of essays by scholars including Suzuki Jūzō and Kobayashi Tadashi.[24] The first book-length treatments of Hokusai in Western languages were Frederick Dickins' 1880 study of Hokusai's *One Hundred Views of Fuji* followed by Edmond de Goncourt's more ambitious 1896 monograph on the artist. These early publications have been enriched by a wealth

of literature only a handful of which can be acknowledged here.[25] Deserving of special note, however, are the many pioneering publications of Jack Hillier.[26] The volumes of multiauthored essays edited by Gian Carlo Calza and John Carpenter also have expanded the literature in significant ways. Especially valuable for this study is Henry Smith's "Hokusai and the Blue Revolution in Edo Prints," which appeared in *Hokusai and His Age.*[27] Mention is also due the writings of Timothy Clark, Matthi Forrer, Roger Keyes, Richard Lane, and Timon Screech, all prolific specialists in ukiyo-e.[28]

Because no single artist or work has done more to shape modern Euro-American conceptions of Japanese art or to make the woodblock print one of the nationally distinctive artistic traditions of Japanese art than Hokusai and his "Under the Wave off Kanagawa," both have figured prominently in studies of "Japonisme." This French term was coined in the 1870s to characterize the wave of enthusiasm for all things Japanese, but especially woodcuts, that engulfed Europe and America in the last decades of the nineteenth and the first decades of the twentieth centuries. In a field that is dominated by European and American scholars, the scholarship of Inaga Shigemi stands out for its acute and well-nuanced interpretations of the mutually constitutive nature of the relationship between Japan and France at the fin de siècle.[29] For the most part, however, studies of the reception of Hokusai and his influence on Japanese prints are descriptive rather than analytical, driven primarily by the quest for new images and objects for display in exhibitions. Works such as Genevieve Lacambre's magisterial *Japonisme* and Seigfried Wichmann's book of the same name have been extremely helpful in uncovering the range of European incarnations of Hokusai's designs.[30] However, they have not adequately examined the particular conditions in which these were created and interpreted. Gabriel Weisberg has also contributed to this field through his ongoing, richly contextualized studies of Siegfried Bing, a particularly influential figure in the promotion of Japanese art across Europe and America, but these publications similarly endorse a Eurocentric perspective.[31]

Exhibitions of Hokusai have been legion, and these and the legacy they leave in the form of catalogues both shape and reflect the

canonization of "Under the Wave off Kanagawa" as "an almost perfect piece of art [that] has also been enjoyed by people of all lands," to quote James Michener, one of its influential American popularizers.[32] Many shows have been based on collections of Hokusai's work formed outside of Japan since the late nineteenth century. These collections have made France, Britain, and the United States greater repositories of impressions of the print than Hokusai's homeland, fueling a level of Euro-American popular and scholarly enthusiasm for ukiyo-e unequaled by any other genre of non-Western art. This has led as well to documentary films such as *The Private Life of a Masterpiece* and a feature in the BBC Radio's *The History of the World in One Hundred Objects*.[33]

Record-breaking exhibitions held in 2005 in Tokyo and 2006 at the Freer Gallery of Art and Arthur M. Sackler Museum in Washington, D.C., testify to the special place "The Great Wave" occupies today in this artist's vast oeuvre. The exhibition held at the Tokyo National Museum produced a voluminous catalogue of 494 works by Hokusai, with the Japanese text accompanied by brief summaries and an annotated list of illustrations in English. To underscore the organizer's international outlook, the Japanese-language cover (opened from right to left) featured a detail of painted fans from a larger hanging scroll composition on silk, with the characters for "Hokusai Exhibition," whereas the English-language cover (opened from left to right) showed a detail of "The Great Wave" with Hokusai inscribed over it in red.[34] The Freer show, the first comprehensive presentation of the vast collection of paintings by Hokusai amassed by the American collector Charles Freer, was accompanied by a massive two-volume scholarly catalogue.[35] Although Hokusai's woodcuts were not its main thrust, an impression of "Under the Wave off Kanagawa" borrowed from a private collection (since the Freer did not own one), was prominently featured in the publicity and the enthusiastic reviews of the show.[36] Other major exhibitions devoted to Hokusai held in Paris, Milan, London, and Berlin also have similarly featured "The Great Wave" in their publicity.[37]

All this has made it difficult to see this print today as Hokusai's contemporaries did. Whereas its modern-day beholders, both in Japan and in Europe, may view it through the lens of its impact on

modernism, in Hokusai's day it was seen in relation to European illusionism. Looking at it today, Western viewers, however, are likely to be drawn first to the spectacular wave and only afterwards to Mount Fuji, the reverse of the way it was framed as part of the *Thirty-Six Views of Mount Fuji*. Consequently, it is impossible to conceive of the global history of this image as a single epic narrative guided by Hokusai's artistic genius. To understand its reception in different locales requires adjusting our vision and critical faculties, divorcing ourselves from later mythic accretions, and examining both Hokusai's woodcut and its many avatars in the very specific local conditions in which they were produced, circulated, and consumed. Consequently, its "biography" is presented here as an incremental process involving thousands of often highly particular events that, in concert, have constituted a network, or web, of interconnectedness.

This book takes a microhistorical approach to the globalization of "The Great Wave." It is organized roughly chronologically, with each chapter mapping thematic clusters that help to understand the simultaneity of its local and global meanings within specific geographic and temporal contexts. There is no doubt that Hokusai's "Under the Wave off Kanagawa" was popular during the artist's lifetime, but was it in fact a best seller, as is commonly assumed today, and if so, what factors contributed to its being singled out from the series of which it was a part? Chapter 1 situates the image in the conditions of its cultural production and reception in Japan, devoting particular attention to the importance of the woodblock print medium for the dissemination of Hokusai's wave both in Japan and beyond. As book historian Roger Chartier reminds us, repetition is "one of the most powerful instruments of acculturation."[38]

Although historically specific and highly varied, the discursive uses of the great wave in Europe and America are bound up with larger sociopolitical and cultural transformations. The socialization of Hokusai's woodcut in the nineteenth and early twentieth centuries took place against the backdrop of nation-state consolidation and competition for colonial and imperial power through trade and conquest. The second chapter examines the reception and reinterpretations of

"The Great Wave" during this period in Europe and America with particular attention to the culture of artistic citation made possible through new forms of mechanical reproduction. The implications of the fact that Japanese prints, with their logic of serialization, multiples, and replication, first took hold of the world imagination at the same time as the explosion of other technologies of mechanical reproduction is a theme running through this chapter.

"The Great Wave" has long served as a conspicuous means of negotiating ethnic and cultural difference in the United States. In examining its ubiquity there, Chapter 3 takes into account the special relationship between Japan and the United States resulting from Matthew Perry's so-called opening of the country in 1853, the formation of vast collections of prints during the Gilded Age, the impact of World War II and the American Occupation of Japan, and the two nations' subsequent close, and often competitive, economic ties. Cutting back and forth between American and Japanese engagements with the wave in forms ranging from children's books to Kabuki theater posters, it underscores the mutually constitutive nature of perceptions of this image.

"The Great Wave" is a star performer in the commercial realm. How it instantiates globalization as a phenomenon that simultaneously produces homogeneity and heterogeneity is dramatically illustrated by its use in product design and promotion over the past two decades. How does this image serve to persuade people that what is on offer—from shower curtains and skateboards to soy sauce—is worth buying? Chapter 4 suggests that, in the world of commerce, the wave does not simply carry national and historical culture from one place to another, but capitalizes on alterity to brand products associated with aspirational lifestyles. In a world of homogeneity, generic difference and the sense of authenticity it conveys have become valuable commercial assets. The association of the wave with "natural" cultural and spiritual authority lacking in the industrialized West also contributes to its invocation in site-specific installations in countries spanning the globe.

Because a majority of its articulations are on paper, "The Great Wave" is thought of primarily in visual terms, but it has also gained

public visibility in three-dimensional forms at airports, city streets, rice paddies, and beaches. Chapter 5 considers the enduring significance of place by examining how, paradoxically, an image denoting a very particular locale in Japan has been redeployed to construct a sense of local identity in parts of the world with which it has no obvious connection. In so doing, it suggests that place matters more than ever in a globalized world.

Chapter 5 was originally intended as the final chapter in this study, but in the aftermath of the 2011 tsunami a brief, historically grounded discussion of the impact of this event on the creation and interpretation of "The Great Wave" has been added. These concluding reflections, however, by no means exhaust the interpretive possibilities of the multisited "The Great Wave." This global icon has figured in more times and places than can be adequately discussed in any one book.

CHAPTER 1

"Under the Wave off Kanagawa"

Thirty-Six Views of Mt. Fuji by Zen Hokusai Iitsu; single sheet *aizuri*. One view to each sheet, to be published one after another. These pictures show how the form of Fuji differs depending on the place, such as the shape seen from Shichirigahama, or the view observed from Tsukudajima: he has drawn them all so that none are the same. These should be useful for those who are learning the art of landscape. If the blocks continue to be cut in this way, one after another, the total should come to more than one hundred, without being limited to thirty-six.

—Advertisement for *Thirty-Six Views of Mount Fuji*, 1830

IN 1830 THE PUBLICATION OF A SERIES OF *Thirty-Six Views of Mount Fuji* by the artist Hokusai was announced in the back of a collection of stories by Ryūtei Tanehiko, a writer of popular fiction whose public recognition at the time matched that of his artist friend Hokusai. This advertisement, quoted above, was not unique but accompanied others on the same page for woodblock printed pictures and books forthcoming from Eijudō, the publishing house of Nishimura Yōhachi (also known as Nishimuraya), a leader in this highly competitive field.[1] Repeated in other books in 1832 and again in 1833, and 1834, the ad provides valuable clues to the selling points that the publisher hoped would make *Thirty-Six Views of Mount Fuji* a hit series (figure 1.1).[2]

Nishimuraya's strategies followed from decades in business in Edo's downtown Nihonbashi district and a keen understanding of his customers' tastes. Seventy-year-old Hokusai was already a celebrated book illustrator, painter, and designer of prints, so Nishimuraya knew

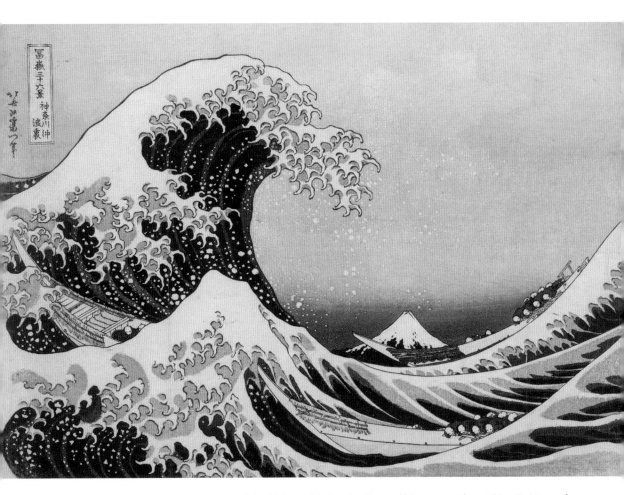

FIGURE 1.1. Katsushika Hokusai, "Under the Wave off Kanagawa," from *Thirty-Six Views of Mount Fuji*, ca. 1830–1833, color woodblock print, 10 × 14 ½ in. (25.9 x 37.2 cm.). (British Museum, London, 2008,3008.1. © Trustees of the British Museum.)

that this name would attract the reader's attention. He also knew that Mount Fuji was a subject with wide appeal since the sacred peak was the object of devotional cults that enjoyed significant following among residents of Edo and the surrounding region. Yet by claiming that "these pictures show how the form of Fuji differs depending on the place, such as the shape seen from Shichirigahama or the view observed

from Tsukudajima," and that Hokusai "has drawn them all so that none are the same," the series promised a welcome change from the conventionalized views in circulation at the time (figure 1.2). Few artists in the print medium before Hokusai took note of different angles of vision or the atmospheric and seasonal changes that could inform the appearance of the sacred mountain, nor had they incorporated these features into an implicit narrative of travel.[3] With its suggestion of empirical accuracy, the announcement further tapped into public interest in the depiction of local topographies of the kind known as "true views."[4] By asserting that Hokusai's pictures "should be useful to those who are learning the art of landscape," Nishimuraya was specifically, although not exclusively, also targeting a niche audience of aspiring amateur artists who were already familiar with Hokusai's many innovative and often entertaining painting manuals, the most successful of which was

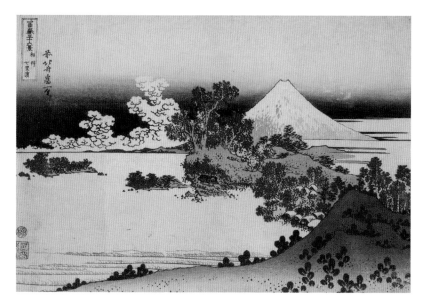

FIGURE 1.2. Katsushika Hokusai, "Shichirigahama Beach in Suruga Province," from *Thirty-six Views of Mount Fuji,* ca. 1830–1833, color woodblock print, 9 ½ × 14 ¼ in. (24.4 × 36.4 cm.). (British Museum, London, 1907,0531,0.144. © Trustees of the British Museum.)

his *Manga* (Random sketches), an informative, multivolume compendium of pictorial subjects and styles.

Adding to their allure, Hokusai's views, like his *Manga*, promised to be encyclopedic in scope. "If the blocks continue to be cut in this way, one after another, the total should come to more than a hundred, without being limited to thirty-six." Few had dared to create such an ambitious series of prints, much less one that gave these innovative views larger cultural resonance through the iconic number thirty-six that readers would have identified with the immortals of poetry and, by extension, as a verbal pun on Fuji's popular etymology as *fu-ji,* immortal. Like one hundred, thirty-six was an auspicious number and thus an ingenious way of packaging and marketing a serial production, prints that would "continue to be cut . . . one after another" over a period of approximately four years. At the same time, by this seriality, the publisher was astutely catering to the desire for completion among collectors.[5]

The pictures' greatest novelty, however, was that they promised to be *aizurie,* a term that identified them as being printed with a newly imported aniline dye known in Japan as *bero,* Berlin blue, that produced a more intense, saturated hue than domestically produced indigo. Although this pigment had been imported in small quantities at least since the 1780s, its use for woodblock prints was still unusual.[6] By this material strategy, Nishimuraya introduced an element of the exotic to representations of a peak that was visible daily to every resident of Edo and familiar, at least in word and image, to most inhabitants of the Japanese archipelago.

From the perspective of a consumer today, price is the only information missing from the enumeration of the qualities of the projected *Thirty-Six Views of Mount Fuji.* Although publishing in nineteenth-century Japan included marketing strategies associated with modern industry, there is very little precise data about matters such as print run, number of editions, distribution, prices, or consumption. "Publishing," as historian of Japanese books Peter Kornicki has observed, "of course, implies a public, and that public expanded and changed in the course of the [Edo] period."[7] Yet precisely who bought

Hokusai's *Thirty-Six Views of Mount Fuji* and what they saw in them remains elusive.

This chapter examines the popularity of Hokusai's *Thirty-Six Views of Mount Fuji* and the life that his great wave came to lead beyond the series, from the time of its publication until the decline of the Tokugawa regime in the 1860s. These prints now command such an unquestioned place in the canon of Japanese woodblock prints that it is easy to forget that not all in fact are equally memorable, and, as Nishimuraya's ambiguity about the number in the series hints, their publication was a commercial enterprise entailing a certain amount of risk. Although Hokusai was a renowned artist, not all of his prints were equally successful. Had the Fuji series not found public favor, the publisher would likely have discontinued it—as was the fate of Hokusai's projected series *One Hundred Poems as Told by the Nurse,* of which only ninety-one of a promised hundred appeared.[8]

In the absence of written testimony from consumers of the time, the series's printing history and reception by other artists offer useful gauges of the circulation of "Under the Wave off Kanagawa." There were many complex phenomena at work in the great wave's ascendency, but its global recognition today is indisputably bound up with the print medium in which it first appeared. Nineteenth-century Japan had a highly articulated culture of visual display in which many memorable paintings were created but were subsequently lost to fire, earthquakes, and other natural or human-made disasters. Multiplicity and replication enhanced chances of an image's survival long after its creation, while at the same time underwriting its dissemination. Therefore, it is important to consider the totality of the print's experience, not simply the visual information it communicates.

This study follows the premise that "Under the Wave off Kanagawa" exists and participates in a discursive space that frames it artistically, conceptually, and physically. The implications of the technology that created the print and its materiality are as important in assessing its reception as the identity of the artist, his or her subject, and style. This chapter begins by examining how meaning unfolds within economies of printing and then turns to a discussion of Mount Fuji

and the wave as powerful collective sites of national representation. In so doing, it aims to advance understanding of the mechanisms that produced and structured this print's reception in the context of Japan's globalizing nineteenth-century.

Eijudō's Enterprise: Technologies and Economies of Color Printing

When Eijudō's advertisements appeared, polychrome woodblock prints were already well established and relatively inexpensive popular commodities throughout Japan and even beyond. Under the banner of *nishiki-e*, "brocade pictures," they were purchased both by local residents and by travelers desiring distinctive touristic souvenirs of the capital. Edo's numerous publishers staked out their territorial claims accordingly, with some positioning their shops in downtown Nihonbashi and others at the bridges leading in and out of the city. First-time visitors to the shogunal capital seeking Eijudō's Nihonbashi bookshop could learn its location from one of the many shopping guides detailing the consumer pleasures available in this city of more than a million inhabitants. Those provincials unable to afford the luxury of travel could buy prints from itinerant peddlers or other collectors, although in the case of a famous actor or beauty these might be out-of-date. For instance, the courtesan prints purchased by the American Captain Devereux during his illegal stay in Nagasaki in 1799—among the earliest surviving examples of Japanese woodblock prints outside of Japan— were already several years old when he bought them.[9] Longer shelf life was an important consideration in the rise of landscape as a print genre for both publishers and consumers.

Nishiki-e were not reproductions of canonical paintings but original compositions designed expressly for the small format on which they were printed. They commanded a wide viewership across region, class, gender, and age, communicating on many different levels that blur the lines between the commercial and the artistic.[10] While they may not have been intended for formal display in the *tokonoma,* the ceremonial space reserved for painted scrolls or calligraphy, they satisfied claims of ownership, status, and social identity. Since prints could

be accumulated, transported, and traded, they constituted a form of economic as well as cultural currency. A print, no less than a painting, was a physical entity that collectors could share with friends by display on the wall or by being held in the hands. Some had iconography that concealed culturally complex meanings whose decoding was part of their individual and collective aesthetic pleasure. Together with illustrated books, they were important constituents of early modern Japan's "networks of sociality."[11] Many a successful print's meaning was constructed as much by its buyer's imagination as by the artist's intent.[12]

In the world history of art, the Japanese print medium tends to be thought of as mere ground rather than as figure, a backdrop to more dramatic thematic, compositional, and stylistic developments; it is a subject whose significance has also been largely ignored in the world history of technology. Yet, when Hokusai's *Thirty-Six Views of Mount Fuji* began appearing in 1830, Japanese woodblock prints arguably represented the most efficient, cost effective, and artistically sophisticated form of color printing in the world. Japanese began mass-producing polychrome prints in the 1760s using a system premised on separate woodblocks for each color several decades before lithography, a method for printing images on stone plates, was successfully developed in Germany. To ensure that each color was properly aligned, Japanese craftsmen perfected a simple device of carving notches along the lower right and left margin of each block with which each state of the print needed to be matched. Chromolithography only became commercially viable in the late 1830s, after the problem of registration had been resolved.[13]

The commercial adoption in Japan of the woodblock rather than the press, which had been tried briefly in the early seventeenth century for printing both text and color images, was a pragmatic solution based on available materials, technology, cheap labor, and the complexity of the Japanese written language.[14] Since little capital was required, the barriers to entry into the market were low compared to investment in a printing press, and, once publishers had grasped the potential of color printing, there was no holding back. Both private and commercial publishing of books and single sheet prints took off, with calendars, greeting cards, and poetry compilations appearing alongside pictures

of actors, geisha, fashion plates, and, eventually, city scenes and landscapes. Like Eijudō, most publishers handled both books and single sheet prints.

In the Edo print world, artistic talent alone was no guarantee of success: an artist needed the financial backing of a publisher. As Julie Nelson Davis has shown in her study of Utamaro, publishers could play a central role in constructing a public persona for artists in much the same way that managers do for screen stars today.[15] The idea for Hokusai's public painting performances in Edo and Nagoya, discussed below, are likely to have come from his publishers, eager to draw attention to him and his work.[16] The degree to which the subject matter of prints was determined by publishers is uncertain, but there is no doubt that they only commissioned works they believed would find favor with their public. Whether the concept for the *Thirty-Six Views* originated with Hokusai or with Nishimuraya, or both, is uncertain. In any event, the artist received payment only for the completed designs, with no royalties.

Publishers guided production at every step of the way, hiring engravers and printers, buying the raw materials (cherry-wood blocks, pigments, and paper), and, upon completion, promoting and selling the finished works in their shops. Craftsmen adapted to this technology, turning out ever more technically complex and richly decorative prints in prodigious numbers. Woodblock prints were not only amenable to the addition of as many as twenty-five colors, but they also could take on shading, embossing, and the application of mica, lacquer, and other materials. In human terms it may seem an expensive way to produce prints, but as long as cheap and skilled labor was available they were economically viable.

A report on Japanese printmaking techniques commissioned in 1889 by the Smithsonian Institution from a Mr. T. Tokuno, chief of the Bureau of Engraving and Printing, gives a sense of the cost of the design, engraving, and printing of a triptych illustrating *Nise Murasaki Inaka Genji* (Rustic Genji), a best-selling work of popular fiction by Ryūtei Tanehiko, pictorialized by Utagawa Kuniteru. The artist was paid 10 yen for the design; engraving, requiring seven days, cost 10 yen;

the printer printed 3,000 sheets per day from the key block and 700 to 800 sheets from the color blocks, for which he was paid 70 sen per day and, having worked for twenty days, completed 14,800 "impressions." (In this context, "impression" refers to the number of times the printing surface is covered with a different pigment.) In the case of this triptych, the first print required 25 impressions, the second 26, and the third 23 colors. As translated by Peter Morse into 1982 dollars with inflation taken into account, the publisher's total capital outlay for an edition of two hundred would have been $307, an investment sufficiently low to keep the retail price of each print modest enough for the mass market.[17]

The xylographic mode of print production incorporated many elements of a modern industrial model, although with heavy reliance on artisanal talent. It had in common with lithography an emphasis on consistency, predictability, interchangeability, and economies of scale through standardization. Every step was broken into its component parts and carried out over and over again. Repetition in turn produced efficiency. Yet printing done well also depended on a wealth of nuanced specialist knowledge, such as the direction in which to rub the disk used to transfer the pigment to the paper.[18] Craftsmen continuously juggled the various components of printing, bringing to the process their powers of organization, observation, and skill of hand.

As the individual who put up the capital for the project and assumed the greatest financial risk, the publisher was also the one who, at the completion of a publication project, retained ownership of the blocks. Eijudō limited his capital outlay by issuing the Fuji series over a period of four years. Yet by controlling the means of production he could, if there was a demand, continue to print until the blocks wore out. Although blocks became the physical property of the publisher to do with what he wanted, neither he nor the artist who created the design had the degree of intellectual control over its content assured by modern copyright law.[19] Publishers often modified and reissued successful prints by recutting the blocks; rivals could issue similar ones; and, over time, the artist himself could produce a succession of similar designs. Most collectors today would rather not be reminded that

their Hokusai print is not unique, but this modern-day identification of authenticity with uniqueness was not part of cultural thinking in Edo period Japan. In woodblock prints recycling, repetition, imitation, and outright plagiarism were accepted practice. Copying was a measure of popularity and indeed essential in understanding the diffusion of Hokusai's great wave.

Changed color schemes are the most striking features of different print editions, but *Thirty-Six Views of Mount Fuji* is unusual because, after announcing designs entirely in shades of Berlin blue (*aizuri*), the publisher revised his plans and combined this color with others. When the advertisement for the series appeared at the end of 1830, according to Henry Smith, five monochrome blue prints, including views of Mount Fuji from Shichirigahama and Tsukudajima, an island at the mouth of the Sumida River at the mouth of Edo Bay, had already been issued. The symbolic and expressive qualities of this first "pure" *aizuri* group, he suggests, were intimately bound up with the watery locales and activities depicted.[20] The next group of five, still featuring blue outlines but with a more varied palette, appeared at the New Year of 1831, including "Under the Wave off Kanagawa," "South Wind, Clear Dawn" (Gaifū kaisei, popularly known as "Red Fuji"), and "Rainstorm beneath the Summit" (Sanka haku'u), continuing until 1833 (figures 1.3 and 1.4). Cost and availability were likely factors in the decision to print the additional ten (making the set total forty-six) with black rather than the blue outlines that had distinguished the preceding prints.[21]

Berlin or Prussian blue is a synthetic pigment developed in Germany in the early eighteenth century that has a significant advantage over blue made from indigo in that it is not water soluble. First available to European artists in the 1720s, it seems to have been imported into Japan, either directly by the Dutch or via China, beginning in the 1760s, where its exorbitant cost at first led to its rare and only sparing use. Smith's study of the "blue revolution" in prints has shown that it was only in the Bunsei era (1818–1830) that large quantities made available by Dutch and Chinese traders brought prices down sufficiently for its widespread use in all-blue prints featuring a wide range

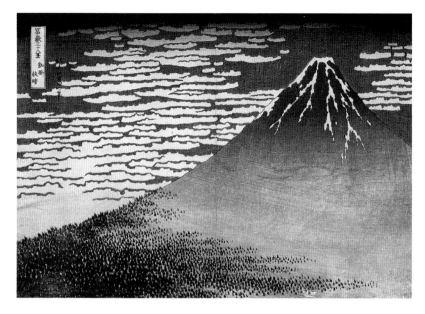

FIGURE 1.3. Katsushika Hokusai, "South Wind, Clear Dawn," from *Thirty-Six Views of Mount Fuji*, ca. 1830–1833, color woodblock print, 10 ¼ × 14 ⅞ in. (26.1 × 38.2 cm.). (British Museum, London, 1906,1220,0.525. © Trustees of the British Museum.)

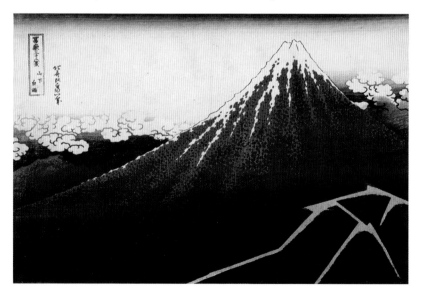

FIGURE 1.4. Katsushika Hokusai, "Rainstorm beneath the Summit," from *Thirty-Six Views of Mount Fuji*, ca. 1830–1833, color woodblock print, 9 ¼ × 14 ¼ in. (24.1 × 36.5 cm.). (British Museum, London, 1906,1220,0.526. © Trustees of the British Museum.)

of subject matter.[22] More recent research by conservator Kate Bailey has further revealed that the period when the vogue for Prussian blue was strongest in Japan coincided with Chinese production at a factory in Canton, roughly between 1827 and 1842, a development that increased availability and lowered the cost. It is thought that the manufacturing process was acquired covertly from a London manufacturer by an enterprising Chinese to shut the British out of the market. In China, this pigment seems to have served primarily as an additive to enhance the color of tea.[23] The Japanese fashion for woodblock prints in an all blue palette no doubt reflected exotic novelty, while also drawing on the luxury connotations and popularity of blue and white porcelains, originally imported from China. The subtle tonalities of blue achieved in such pictures, as seen in an example by Hiroshige reproduced in figure 1.5, may have been further appreciated for their approximation of the effects of monochrome ink landscape paintings, works of higher cultural standing than woodblock prints.

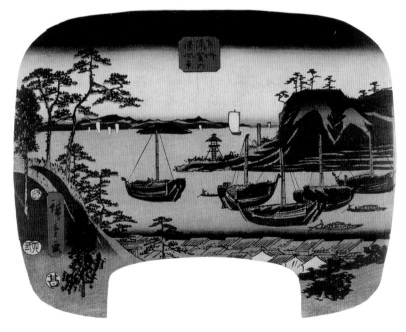

FIGURE 1.5. Utagawa Hiroshige, "View of Uraga Bay in Sagami Province," 1855, fan shaped *aizuri-e*, color woodblock print (E.12071–1886. © Victoria and Albert Museum, London.)

By employing Berlin blue as a signifier of the exotic to represent familiar sights, the promised series of *Thirty-Six Views of Mount Fuji* reinforced the indexical and artistic operations of the great wave. *Bero* profoundly altered the meaning of the views of Japan in which it was used, because it materialized the relationship between Japan and the world beyond its shores, making the medium part of the message. Hokusai's "Under the Wave off Kanagawa" thus participated in a discourse in which the beholder did not simply imagine China and Europe but experienced them bodily. Berlin blue intimated an experience of the outside world not as separate and remote from Japan but as vitally connected through desirable imported commodities.

A Best Seller?

The term "best seller," an American coinage that originated in 1889, has come to refer to publications that achieve a popular commercial success often deemed to be out of proportion to their literary merit.[24] Scholars of Japanese books and prints have adopted this term, along with its modern cultural baggage, to refer to the "light fiction" (*gesaku*) and prints that enthralled nineteenth-century Edo audiences.[25] Ryūtei Tanehiko's *Rustic Genji* is commonly characterized in this way. This spoof of the eleventh-century court literary classic *The Tale of Genji* sold more than 10,000 copies. Takizawa Bakin, whose first literary success was illustrated by Hokusai, was also a best-selling author: by his own account, when his *Moroshigure momiji no aigusa* (Under an umbrella of maple leaves in the rain shower) appeared in 1823, it sold 13,000 copies within three months.[26]

Sales of 10,000 also seem to have been the mark of a best seller in the realm of *nishiki-e*. Exact figures are hard to come by, but individual views of Hiroshige's *Fifty-Three Stages of the Tōkaidō Road,* published by Hōeidō between 1832 and 1834, reputedly had sales of 20,000. A decade later, an Edo bookseller recorded in his journal his pleasure at sales of 8,000 for prints in two series and disappointment about the response to a triptych by the well-regarded artist Kuniyoshi, of which only 50 of an initial print run of 1,000 were sold at 60 mon.[27]

This price for a triptych is in line with the estimated cost of 20 mon per print cited by modern scholars. In the context of the early nineteenth century, this was about 20 percent more than a bowl of soba noodles.[28]

This evidence combined with Tokuno's, cited above, suggests that the size of an edition varied widely depending on the publisher's estimate of the market. Costs are also likely to have differed depending on the amount of labor and materials. Embossing (blind printing), with the addition of gold, silver dust, or mica, likely increased the price of a print as did the use of Berlin blue in the first edition of Hokusai's *Thirty-Six Views of Mount Fuji*.

Modern estimates of the sales of "Under the Wave off Kanagawa" range from 5,000 to 10,000, but it is impossible to know precisely how many copies were in fact printed, in how many editions, or over how long a period.[29] Nor is it known if all the Fuji designs were equally successful. A reconstruction of the series's publishing history and of the recycling of its distinctive wave motif by Hokusai himself as well as other artists, however, offers some clues to its popular reception. That ten more than the announced number of thirty-six views were published is one indication that Nishimuraya's gamble on an untested new artistic formula for single sheet prints was at least a qualified success. Had it been a bigger hit, he might have continued to print new designs to reach the magical number of one hundred. Another piece of evidence is the publication of these additional ten prints coincidentally with a second edition of the first thirty-six prints with black rather than Berlin blue outlines and a variety of new color schemes.[30] Like the first printing, this one is thought to have resulted in 200 to 500 impressions of each design, considerably fewer than the huge editions referred to above by the bookseller. There were further printings, although the number is unknown. The most obvious identifying features of these editions are the changing color schemes and signs of wear and damage to the blocks visible on individual prints. Late editions of "Under the Wave off Kanagawa" can be identified by the crack in the cartouche bearing the title (figure 1.6).

A third sign of the series's success, which might also account for its cessation at forty-six designs, is that in 1834, even as demand for the

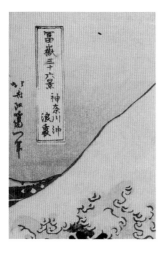

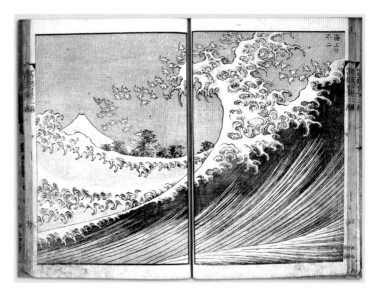

FIGURE 1.6. Detail of cracked cartouche from "Under the Wave off Kanagawa," from *Thirty-Six Views of Mount Fuji*, ca. 1830–1833, color woodblock print, 9 ½ × 14 ¼ in. (24.4 × 36.4 cm.). (British Museum, London, 1906,1220,0.533. © Trustees of the British Museum.)

FIGURE 1.7. Katsushika Hokusai, "Mount Fuji Viewed from the Sea," from *One Hundred Views of Mount Fuji*, ca. 1834, woodblock-printed book, 9 × 6 ½ in. (22.7 × 15.8 cm.). (British Museum, London, 1979,3-5.0454. © Trustees of the British Museum.)

single sheet series of *Thirty-Six Views* continued, Hokusai began to prepare his three-volume album *One Hundred Views of Mount Fuji*. In volume 2 Hokusai reiterated the view of Mount Fuji with a wave in the foreground but with its movement from right to left, in keeping with the direction a Japanese reader would view a book, and the addition of a flock of plovers, seemingly emerging from the spume (figure 1.7). Although printed to exceptionally high production standards in black with subtle tones of gray produced through the use of two additional blocks, this small, roughly 6 × 9 inch (15 × 22 cm.) book could be sold at a more modest cost than polychrome single sheet prints. Like a print series, its publication could also be staggered over a long period. Although the first and the second volumes were published in 1834, the third volume did not appear until the 1840s.[31] At that time, a second

edition of the first volumes was also published. The series continued to be published using the badly worn original blocks in 1875, 1876, and even as late as 1943.[32]

An anonymous broadside, *kawaraban,* issued in 1834 showing a colossal wave at the foot of Mount Fuji with humans, animals, and goods caught up in its watery maelstrom testifies to the rapidity with which the album version of the great wave became independently taken up for completely new purposes. Anonymous, free-floating and potentially subversive, inexpensive and often crudely printed *kawaraban* were an important unofficial medium of mass communication about topical issues (figure 1.8).[33] The caption analogizes Hokusai's great wave to the destructive mudslides that followed volcanic tremors and a rainstorm that poured down from the mountain. This was one of many disasters that occurred during the Tenpō era, which saw crop failure and famine across the country. Although this print is ostensibly informational, unlike a sea wave, this wave was an unnatural phenomenon, whose destructive consequences could be understood as a divine sign of bad governance.

Variations of Hokusai's great wave were also issued both as parts of new series focused on Mount Fuji and in independent form. Hiroshige's 1852 reinterpretations in "The Embankment at Koganei in Musashi Province" (1852) and his "The Sea off Satta in Suruga Province" (1858), each published within series titled *Thirty-Six Views of Mount Fuji,* speak to the ongoing enthusiasm for serial views of the mountain, while also testifying to the redistribution of Hokusai's cultural capital by quotation (figure 1.9). Hiroshige also created *One Hundred*

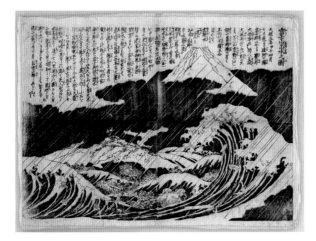

FIGURE 1.8. Anonymous broadside with Mount Fuji, 1834, woodblock print, 14 ¼ × 19 in. (36.5 × 48.5 cm.). (Tokyo University, Ono Collection. Photograph courtesy Tokyo University.)

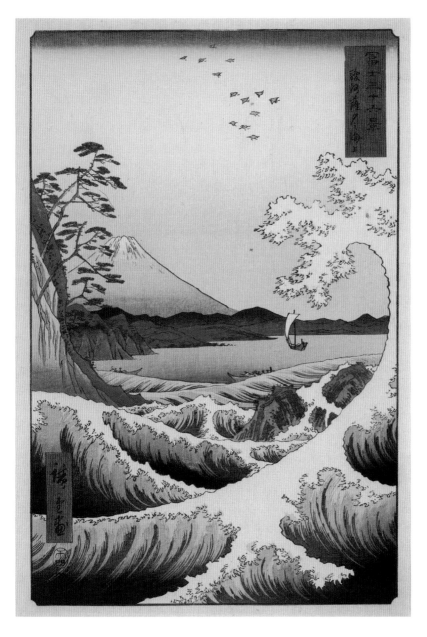

FIGURE 1.9. Utagawa Hiroshige, "The Sea at Satta in Suruga Province," from *Thirty-Six Views of Mount Fuji*, ca. 1858, color woodblock print, 14 × 9 ½ in. (35.4 × 24.3 cm.). (British Museum, London, 1902,0212,0.396. © Trustees of the British Museum.)

Pictures of Fuji (*Fujimi hyakuzu*), a book published posthumously in 1859.[34] As will be discussed in Chapter 2, the mediation of Hokusai's book and Hiroshige's versions of the great wave were crucial to the dissemination of this motif beyond Japan. They became more readily available abroad and in greater numbers than Hokusai's series because they were issued closer to the time that the treaty ports of Shimoda and Hakodate (1854) and Yokohama, Kobe, Nagasaki, and Osaka (1858) were opened to international trade. Variations of the wave figuring in Hokusai's *Thirty-Six Views of Mount Fuji, One Hundred Views of Mount Fuji,* and other prints and book illustrations were also adapted by this artist's disciples as well as his chief rival Kuniyoshi, as discussed below. Although there is no way to verify how widely within Japan this image circulated during or after Hokusai's lifetime, its reiterations and reconfigurations kept the motif in the public eye, helping to transform it into an image with a high level of popular recognition.

Mount Fuji as a Site of National Integration

Hokusai's series appeared at a time of booming popular domestic travel, often under the guise of pilgrimage, and enthusiasm for modern, commodified scenic spots.[35] Hiroshige's hugely popular *Fifty-Three Views of the Tōkaidō Road,* issued by the publisher Hōeidō between 1832 and 1833, for instance, visualized the stations and name brand goods (*meibutsu*) that could be purchased along the most traveled route between Edo and Kyoto. The multivolume *Edo meisho zue* (Guide to Edo's famous sites) was a richly illustrated travel guide to the city with information about temples, shrines for devotion, or simply sightseeing, as well as a wealth of tantalizing images of shops and their goods.[36] Earlier, Hokusai had himself contributed to this burgeoning interest in both city and country by illustrating a book titled *Azuma asobi* (The Eastern Capital at play), first published in 1799, and one called *Shokoku taki-meguri* (A tour of waterfalls around the provinces). The publication of the latter was announced in a publication in which *Thirty-Six Views of Mount Fuji* was also advertised for a third time.[37] Like *Shokoku*

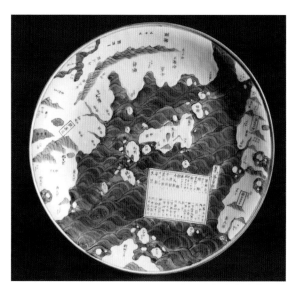

FIGURE 1.10. Large platter decorated with a map of the world, late Edo period, 1830–1850 (Tenpō era), Arita blue and white ware, Imari type, porcelain with decoration in underglaze, diameter 51 cm. (2 ½ x 20 ¹/₁₆ in.). (Harvard Art Museums/Arthur M. Sackler Museum, Gift of the Hofer Collection of the Arts of Asia, 1984.494. Photograph © President and Fellows of Harvard College.)

taki-meguri the *Thirty-Six Views* constituted a creatively imagined tour underpinned by the time-honored scenic beauties of nature.

Through travel, maps increasingly became part of the way people understood their place within Japan and, despite the ban on leaving the country, the world beyond. Telescopic vision further contributed to this new sense of visuality. As Henry Smith has observed: "The study of a distant landscape through a telescope, enabling identification of places not visible to the naked eye, could with the proper sense of manipulative viewpoint and spatial breadth . . . lead to the idea of looking at the entire country of Japan from a great distance and identifying its separate places."[38] The creation during the 1830s and 1840s of large blue and white porcelain plates decorated with maps of Japan at their center and alien regions both real and imaginary at the periphery speaks to this new form of visual literacy (figure 1.10). Although these plates vary somewhat, most show the Japanese archipelago with Mount Fuji prominently indicated, surrounded by huge rolling waves rendered in intense cobalt blue and beyond them much larger undifferentiated land masses. A chart showing the distances between Japan and China, Korea, India, as well as fear-inspiring imaginary places such as the land of women gives these map plates an aura of veracity.

Mount Fuji had long been regarded with awe. It was celebrated in the *Man'yōshū* of 720, the first compendium of Japanese poetry:

> Rising between the lands of Kai and Suruga
> Where the waves draw near,
> Is Fuji's lofty peak.
> It thwarts the very clouds
> From their path.
> Even the birds cannot reach its summit on their wings.
> There, the snow drowns the flame
> And the flame melts the snow.
> I cannot speak of it.
> I cannot name it.
> This occultly dwelling god![39]

By Hokusai's day, the 12,385-foot-high volcano, sixty-two miles southwest of Edo, had been routinized as part of the shared visual experience of the city's residents and was familiar at least in word and image to most of the archipelago's inhabitants. As an active volcano that had erupted as recently as 1707, its sight combined both pleasure and fear. Indeed, Hokusai included an imaginative interpretation of the force of this explosion, hurling homes, their contents, and the surrounding populace into the air (figure 1.11). Although representations of fire were common in the Japanese pictorial tradition, this iconography was novel at the time, and, as Tsuji Nobuo has proposed, may have been inspired by Dutch book illustrations of explosive naval battles.[40]

Paradoxically, despite its volcanic nature, Mount Fuji was deemed immortal, *fu-ji* (literally "no death"), as noted above, suggesting that, even as the world around it changes, Mount Fuji reassuringly does not. Another popular etymology held the mountain to be *fu-ni* (not two)—unequaled or peerless—and these are the two Chinese characters Hokusai used to identify Fuji in the captions in his *One Hundred Views*. These ideas along with that of its divine status underpinned the growing national significance that Fuji began to assume during the late Edo period.[41]

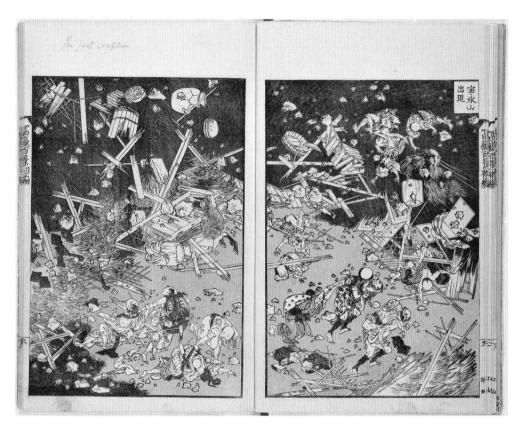

FIGURE 1.11. Katsushika Hokusai, "The Hōei Era Eruption," from *One Hundred Views of Mount Fuji*, ca. 1834, woodblock-printed book, 9 x 6 ½ in. (22.7 x. 15.8 cm). (British Museum, London, 1979,3-5.0454. © Trustees of the British Museum.)

National pride in Fuji is reflected in claims that it was unequaled not only within Japan but beyond its borders as well. This notion is encoded in its characterization as *sangoku ichi no yama*, the tallest peak among the three countries of India, China, and Japan. So famous was Fuji that an eponymous Noh drama has a traveler from China coming to admire it.[42] Fuji was also celebrated by those rare European visitors who had an opportunity to travel to Edo, as did the German physician

Engelbert Kaempfer during his sojourn in Japan between 1690 and 1692. "The famous Mount Fuji in the province of Suruga," he wrote, "in height can be compared only to Mount Tenerife in the Canaries and in shape and beauty compares to no other in the world."[43]

The belief that Fuji's veneration could confer immortality on its devotees had contributed to its becoming the focus of devotional cults with a wide regional following, and, in the summer months, many pilgrims climbed the sacred peak in the hopes of achieving this goal. There is no evidence that Hokusai himself did so, but frequent allusions to his desire to reach the age of one hundred suggest that he was drawn to Mount Fuji's promise of immortality.[44] The importance of this devotional aspect is made explicit in what is believed to be the final print in the series, showing pilgrims, staffs in hand, struggling to reach the cave where others are already crowded together (figure 1.12). It is possible that this was intended to represent the cave where Jikigyō, a vital figure in the development of the cult, entered nirvana in 1733 after fasting for thirty-one days. Although Fuji worship had earlier roots, Jikigyō was instrumental in fostering the growing numbers of all-male religious confraternities who annually made pilgrimages to the peak.[45] Hokusai did not belong to this 70,000 member strong Fuji-kō, but his publisher Nishimuraya is thought to have been among them.[46]

As noted above, the publisher promoted Hokusai's series by stressing the variety of perspectives from which the sacred mountain would be shown, implying that the artist was bringing to its representation a fashionable new empiricism. Although modern scholarship has devoted considerable effort to pinpointing the different locales that formed the basis of these vistas, there is no consensus that Hokusai in fact created the series on the basis of firsthand observation.[47] Indeed, in the preface to his own *One Hundred Pictures of Fuji,* Hiroshige explicitly distinguished his work from that of Hokusai, whose "Fuji was often subservient to his overriding concern for compositional interest [*e-gumi no omoshiroki*]." "My pictures here," he wrote, "are different. All I have done is to tidy up the large number of sketches I made of what I saw before my eyes."[48] What is significant is that Hokusai gave the illusion of having firsthand experience of them. To do this he drew on the

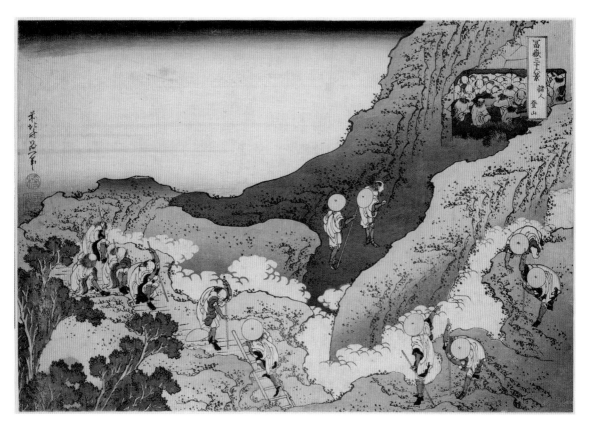

FIGURE 1.12. Katsushika Hokusai, "Groups of Mountain Climbers," from *Thirty-Six Views of Mount Fuji*, ca. 1830–1833, color woodblock print, 10 x 14 ⅞ in. (25.8 x 37.7 cm.). (British Museum, London, 1937,0710,0.167. © Trustees of the British Museum.)

growing cultural authority of European perspective to create pictures that incorporate a theatricalized sense of volume and deep perspective.

By defamiliarizing Mount Fuji through techniques of illusionistic perspective, Hokusai was following a practice first adopted in the 1740s in prints known as *uki-e*, "floating pictures," featuring views of the theater or the Yoshiwara brothel district. These opened up the world in a new way by extending the viewer's own space into the fictive space

of the picture, making accessible the pleasures offered therein. As the scholar Kishi Fumikazu observed of a broadside of 1739 in which the first appearance of *uki-e* is listed between the sighting of a foreign ship and the return of shipwrecked Japanese sailors, illusionistic perspective represented a window on the world that was also understood metaphorically as a larger "opening," *kaikoku,* of the country.[49] Although the angle of vision in each representation of Fuji differed, by regulating the totality of its experience through the use of European pictorial conventions, individual experience of it was encompassed within a uniform visual framework that in effect revised and reshaped the lived space of Japan. The sense that viewers of the prints were participating in a shared experience is reinforced by the inclusion of people looking at Fuji within many of the pictures.

Hokusai brought further novelty to the experience of Mount Fuji through a creative manipulation of geometric forms prompted by his study of European painting manuals. In "Under the Wave off Kanagawa" the conical form of Mount Fuji is viewed through the circular sweep of the wave, an approach that has a visual correlative in "View of Fuji from the Rice Fields in Owari Province," where the distant peak is seen through a cooper's barrel (figure 1.13). Similarly, in the "Mitsui Store in Suruga District," the mountain is framed by a triangular space formed beneath a flying kite, which is echoed in the pitched roofs of the adjacent buildings—the same approach that distinguishes "The Honganji Temple in Asakusa." Many of the designs play the cone of Mount Fuji off of a variety of rectangular forms: piles of lumber, as in "Tatekawa in Honjo," or the viewing platform of a temple, as in the "Sazai Hall of the Temple of the Five Hundred Rakan."[50] Even as these visual strategies serve to create pictorial depth, their interplay draws the composition together more tightly in an allover surface pattern. Furthermore, through their repetition each individual view is rhythmically connected to others in the series.

The telescope is another viewing context that may have informed the artist's objectification of the Japanese landscape, although his viewers may not have been aware of it. This instrument, introduced to Japan by the Dutch and closely associated with "Dutch studies" (Rangaku),

FIGURE 1.13. Katsushika Hokusai, "View of Fuji from the Rice Fields in Owari Province," from *Thirty-Six Views of Mount Fuji*, ca. 1830–1833, color woodblock print, 10 ¼ × 14 in. (26 × 36 cm.). (British Museum, London, 1937,0710,0.166. © Trustees of the British Museum.)

implies a withdrawal and distance between the viewer and the object of his or her gaze. By transforming and circumscribing the landscape, its use produces a sense of detachment from the actual physical experience that is related both to theater and to the tourist's gaze.[51]

If Hokusai brought to popular prints visual techniques that other artists saw as part of Dutch studies, he did so more for their entertainment than their didactic value.[52] As the foregoing examples suggest, he used Western pictorial techniques playfully, for their spectacular effects. In so doing his work calls attention to the role of cultural practices such as theater and public performances in nineteenth-century viewing habits. Hokusai was a master showman who, long before he created this series, had captured the attention of a novelty-loving public by staging sensational displays of artistic virtuosity. To promote the publication of a new volume of his *Manga* in 1817, for instance, he painted

before a huge crowd in Nagoya a 250-square-foot image of the Buddhist deity Daruma, an artistic feat commemorated in a souvenir print that carefully provides the impressive dimensions of the face, eyes, ears, and nose.[53]

This same defiance of the norms of scale also underlies Hokusai's Fuji series, where the artist seduces the viewer by theatricalizing the wave. Just as Hokusai in his performance in Nagoya extended the fictional space of artistic creation to include the viewer, so too the vantage point adopted in "Under the Wave off Kanagawa" erases the boundaries between subject and object, transforming the viewer into a participant in this watery drama. In effect, the wave sets in motion a creative process that the beholder completes.

What is striking about the visual rhetoric in "Under the Wave off Kanagawa" is that the wave's authority depends not simply on its scale but on its singularity. In his design Hokusai has tailored the visual tools that woodblock print artists customarily deployed to celebrate glamorous courtesans and Kabuki actors to create a superstar wave. The great wave performs much as does an actor when he strikes a dramatic pose, or *mie*, at the high point of a Kabuki play. Recognition of this commonality is evident from a clever print issued in Osaka, where the frozen form of Hokusai's great wave serves as a dramatic double for the stop-action pose of a Kabuki actor on stage in a new play (figure 1.14).[54] Like the Kabuki theater with its stage extending into the audience, Hokusai's woodcut also depends on a mode of theatricality that intrudes into the beholder's physical space. Holding a print engages the hands as well as the eyes; the multisensorial impact of its feel, its weight, and the intensity of its color all contribute to the embodied experience of its dramatic visual design.

Just as viewers of Hokusai's day would have made the connection between the "pose" of the wave and that of a Kabuki actor, so too they would have brought to their appreciation of this image a host of other connections. As a conspicuous sacred landmark, Mount Fuji had long figured in poetry and painting, where it became invested with religious and cultural meanings.[55] Despite their nominally secular status, these images of Fuji were not emptied of sacred content: the devotional

cult that had formed around the peak was an important constituent of their popularity. In previous prints, however, a rather fixed type was developed. By contrast, the most memorable views in Hokusai's series, "Under the Wave off Kanagawa" among them, introduced novel ways of visualizing Fuji. Through his views of the mountain from various points both within the city and in the surrounding provinces, Hokusai produced a kind of vicarious tourism in which all viewers could share, regardless of where they lived, reinforcing both the ancient sanctity and the newer sense of national identity that was coalescing around the sacred mountain. By creating an "imagined community" among those who viewed them, Hokusai's prints helped to carry out the cultural work of defining Mount Fuji as pillar of the nation. By its juxtaposition, Hokusai's wave shared in both the national significance and the reassuring presence of Mount Fuji.

The Great Wave

Just as the visuality of Mount Fuji was embedded in prior experience and knowledge of the mountain through poetry, painting, prints, and personal observation, so too was that of the wave.

FIGURE 1.14. Kitagawa Toyohide, "Kabuki Actor Kataoka Gadō II as Chishima Kanja Yoshihiro," ca. 1841, color woodblock print, 15 × 10 ¼ in. (38 × 26 cm.). (Dr. Martin Levitz Collection. Photograph courtesy Dr. Levitz.)

This motif, however, lent itself more readily to communicating a multiplicity of messages beyond those originally intended by its creator. Hokusai's wave's power derived in good part from the fact that, when its viewers looked at it, they recalled other similar ones, often linked to poetic tropes. Hokusai added mightily to this visual archive. Over the course of a career spanning six decades from the 1790s until his death in 1849, Hokusai produced image after image of waves. No other artist before him engaged so obsessively or creatively with this subject. There are scenic views of waves breaking on the beach at Enoshima; book illustrations of waves identified with legendary feats of heroism and self-sacrifice; designs of waves for the decoration of personal accessories and architectural interiors; artists' instructional manuals with incoming and outgoing waves; depictions of waves in the formal, semiformal, and cursive brush styles; a boat fighting waves to enter the famous Cave of the Three Deities; rabbits running over waves; views of boats caught between mountainlike waves (figure 1.15); a great wave seemingly morphing into plovers; male and female waves; "one thousand images of the sea," a series (never completed) whose title, *Chie no umi,* can be understood acoustically to mean "sea of wisdom"; and even a Taoist magician conjuring up waves from the palm of his hand.

Although many of these enjoyed wide circulation, it was his iterations of a single great cresting or tumescent wave that especially captured public imagination by bringing into an integrated and magnified aesthetic focus the sociocultural and political anxieties of the times. Hokusai's novel isolation of a single giant wave linked to Mount Fuji gave it a heroic persona imbued with a sense of both strength and menace. As Susan Stewart has written in another context, "the gigantic presents us with an analogic mode of thought . . . [involving] the selection of elements that will be transformed and displayed in an exaggerated relation to the social construction of reality." "Aesthetic size," she continues, "cannot be divorced from social function and social values."[56] The giant wave was especially resonant at a time of growing preoccupation with the country's shifting geopolitical circumstances and vulnerability to foreign incursions.[57]

FIGURE 1.15. Katsushika Hokusai, "Rowing Boats in Waves at Oshiokuri," ca. 1810, color wood-block print, ca. 7 ⁵⁄₁₆ × 9 ⅝ in. (18.5 × 24.5 cm.). (Museum of Fine Arts, Boston, William and John Spaulding Collection, 21.6678. Photograph © Museum of Fine Arts, Boston.)

Early literary and visual sources testify that the sea fostered contradictory images of attraction and revulsion. On the one hand, the idea that the waves encircling the Japanese islands sheltered them from outside intruders was deeply rooted in Japanese thinking. In a poem in the eighth-century *Man'yōshū*, Japan is described as a beauteous island "hidden by a thousand lapping waves."[58] On the other hand, rough seas, *araumi*, filled with saw-toothed monsters were visual tropes associated with the dangers of travel to China.[59] Such images express geographer Marcia Yonemoto's observation that "the construction of ocean fears and fantasies allowed the Japanese to engage the idea of an overseas 'elsewhere' while maintaining only limited contact with (and evading threats from) non-Japanese peoples and cultures."[60]

Indeed, the relative paucity of Japanese images of the open sea attests to a strong emotional attachment to the familiar coastlines, inland waters, and nearby islands of the Japanese archipelago. Yet even those that do feature the sea as viewed from the coast are less concerned with topographic particularity than with the metaphorical meanings evoked through their association with poetic tropes. Such patterns of visual and verbal correspondence were essential to the appeal of Matsushima, literally "pine island(s)," one of the most enduringly popular seascapes, whose representations from the seventeenth century on incorporated profile views of cresting waves similar to Hokusai's. Images of rocks and waves loosely identified with Matsushima circulated widely in eighteenth- and nineteenth-century Japan in the form of screen paintings, fans, ceramics, lacquer boxes, and especially as illustrated in the *Kōrin hyakuzu,* one hundred pictures by Kōrin, published in homage to this

FIGURE 1.16. Sakai Hoitsu, illustration from *One Hundred Designs by Kōrin,* 1826, woodblock-printed book, 10 × 6 ⅞ in. (25.5 × 17.5 cm.). (British Museum, London, 1915,0823,0.185. © Trustees of the British Museum.)

artist in 1815.[61] This publication also features a more unusual, fanciful design of two waves with tentacle-like arms reaching out to one another, lacking any reference to a geographic setting like the decorative motifs common around the rim of Chinese blue and white porcelains, an iconographic association that viewers may have brought to Hokusai's design (figures 1.16 and 1.17). The ubiquity of the wave

FIGURE 1.17. Blue and white porcelain dish with galloping horses and waves, Qing dynasty. (© Victoria and Albert Museum, London)

motif on ceramics in turn reflected its iteration in Chinese ink painting. It is likely that Kōrin, Hokusai, and their audiences were familiar with these interrelated traditions.[62]

The wave also absorbed into its larger meaning the affective and associative power of the Buddhist notion of impermanence that underlies the term *ukiyo*, or "floating world," used to characterize the popular culture of the theater and pleasure quarters in the Edo period and the pictures, ukiyo-e, associated with them. The term *uki-e* (floating pictures), designating pictures employing illusionistic perspective that first appeared in the second quarter of the eighteenth century—primarily interior views of the theater and fashionable teahouses—also reflects this Buddhist habit of mind. In these usages, however, transience, rather than being a source of sadness as it had been in the medieval era, sanctioned a new hedonistic enjoyment of novelty and sensuality. Asai Ryōi, the seventeenth-century author of *Tales of the Floating World,* advocated living for the moment, grasping pleasure where it could be taken, and drifting with the current of life "like a gourd floating downstream."[63] Like a wave, the floating world was a source of pleasure precisely because it was constantly changing, exciting, and fashionable. Yet the exhilaration it provided could not altogether overshadow the underlying uncertainties of life.

Outside the context of diplomatic, religious, and cultural exchange with China, the sea was not a place for imaginative escape or the testing of character. Although distant imaginary islands such as Hōrai and Fudaraku were identified as Taoist and Buddhist paradises, real islands such as Sado and Oshima, off the west and east coasts of Honshu respectively, were sites of exile, as was the periphery of the island of Honshu itself. Suma and Akashi, the seaside sites of the unhappy exile of the hero of the eleventh-century *Tale of Genji,* for instance, were well-known literary and visual tropes for the uncouth world of the hinterland and longing and nostalgia for life in the capital. These associations could be evoked through Prince Genji's simple declaration: "I envy the waves," itself an allusion to an earlier poem in *The Tales of Ise,* "Ever more do I long, for the

place that recedes behind me: Enviable indeed are those returning waves!"[64]

In the Edo period, the classical wave poems that would have been most familiar to a wide public were popularized through the anthology *Hyakunin isshu* (One hundred poets, one poem each), which had inspired a card game played by both men and women at the New Year. Among them are the following twelfth-century verses, the first by a Lady Kii and the second by Fujiwara no Toshitada:

> Known far and wide,
> the unpredictable waves
> of Takeshi beach
> I will not let them catch me
> For I'd be sorry should my sleeves
> get wet.

The poem was presented at a poetry competition in response to the following:

> Unknown to any
> I long—and how I long to say
> that I come to you in the night
> like the waves blown by
> the bay-wind of Ariso.[65]

Both are love poems, with allusions to surreptitious coastal approaches in the night toward a beach with wind-tossed waves. Both were also illustrated in forms ranging from printed poetry compendia to kimono pattern books in images featuring a prominent wave.[66]

In the Edo period reliance on classical allusive poetic tropes to express serious contemporary concerns was not uncommon among the educated elite. When Tokugawa Harumori, the feudal lord of Mito, for instance, composed the following verse about Hakodate Barrier, the port on the southern tip of the island of Hokkaido, he may have had in mind poems about lovers slipping ashore secretly like those cited above.

Hakodate Barrier
Guardsmen
Be Alert
This is not a time when only waves come to shore.[67]

The poem is thought to have been composed around 1800, a time when that northern island had become, as Timon Screech has put it, Japan's "new outside."[68]

Concerns about the periphery were also reflected in the numerous pictorializations and reinterpretations of accounts of the abortive Mongol Invasions of 1274 and 1281.[69] These events had produced an early thematics of national unity, with prayers for protection addressed in temples and shrines throughout the country. In response to these prayers, it is held that a divine wind, *kamikaze,* caused great waves to arise, destroying the invading fleet. This richly symbolic moment of divine intervention became closely bound up with a visual rhetoric in which wind-driven great waves signified moments of heightened national danger. The confluence of Hokusai's vision of Mount Fuji, the wave, and the monk Nichiren, to whose prayers much credit for the country's salvation from the Mongols was later attributed, is made explicit in a print by Kuniyoshi dating from 1835–1836. It recounts an episode in the life of this thirteenth-century monk, the founder of a religious sect whose many adherents included both this artist and Hokusai (figure 1.18). Nichiren stands precariously but fearlessly on a small boat facing a great wave as he invokes the name of the *Lotus Sutra.* As he does so, the very words he utters, *namu myōhō rengekyō* (honor to the wonderful *Lotus Sutra*), appear on the calm surface of the water beneath the threatening wave.[70] For Nichiren's followers, this image demonstrated the saint's superhuman power to calm the stormy seas through faith in the *Lotus Sutra,* a scripture central to the sect he founded. The mountain in the distance represents Sado Island, where Nichiren had been exiled, but evokes the shape of Mount Fuji, a connection that viewers of the time are likely to have made.

Although representations of the perils of sea travel were not uncommon in the context of Buddhist narratives, there was no tradition

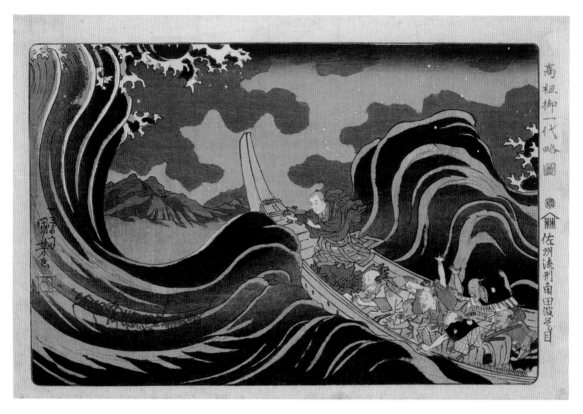

FIGURE 1.18. Utagawa Kuniyoshi, "On the Waves at Kakuda on the Way to Sado Island," from *Concise Illustrated Biography of the Monk Nichiren*, ca. 1835, color woodblock print, 10 × 14 ⅞ in. (25.4 × 37.8 cm.). (British Museum, London, 2008,3037.12109. © Trustees of the British Museum.)

of paintings of shipwrecks as developed in Europe. Sailing out of sight of land was rare in the Edo period since Japanese ships were not seaworthy, and foreign travel was banned by the shogunal authorities. Furthermore, harrowing accounts of boats swept off course by typhoons or the currents were all too common, making ships in stormy seas an inauspicious pictorial subject.[71] The decorative blue and white map plates discussed above rely on fanciful visual tropes, such as images of

female demons or dog-headed people, to mark the boundaries of the known world, but these imaginary aliens also spoke to very real concerns. Since the turn of the century, British, Russian, and American ships had been increasingly pressing the shogunal authorities for access to Japanese ports such as Hakodate, sometimes under the pretext of returning shipwrecked sailors to Japan. The year 1816, for instance, saw the return to Hokkaido of the captain and surviving crew of the *Tokujōmaru,* a Japanese junk that three years earlier had gone off course during its journey from Toba to Edo to deliver rice to the shogunate. It drifted to California, bringing the first known Japanese to the United States. The Japanese captain, Jūkichi, and his crew were rescued by the *Forester,* a ship owned by the American John Jacob Astor but flying under the British flag, on its way to sell its cargo in Sitka, Russia.[72] This global narrative of repatriation is one of many that challenged time-honored spatial understandings of Japan as protectively sheltered by the sea.

These various visual and verbal contexts throw light on how Hokusai's "Under the Wave off Kanagawa" began to assume its iconic status. There was no one way in which it was interpreted; in Hokusai's day as today, viewers brought disparate and sometimes unpredictable values and aspirations to its reading. Whatever meaning was ascribed to it, however, one of the mechanisms at work in its success was the sheer number of other similar images of cresting waves. The woodblock print medium was key to this visual proliferation. Hokusai's version had an impact because it was filtered, simultaneously, through many versions by other artists before and after him. Christopher Pinney's observations about the recursivity of popular chromolithographic and photographic pictures of Hindu gods in modern India is equally relevant to nineteenth-century Japan: "The visual possibilities stored in these archives lack any clear sedimentation. . . . No images ever die, they all remain alive, on stand-by. Images migrate endlessly back and forth across new times and contexts."[73] The authority of Hokusai's wave, like those images Pinney discusses, followed from sedimentation and cross-referentiality, resulting in the viewer's always having a sense of an image "half seen." The wave was not validated by an external power or

institution, such as the officially sponsored Kano painting academy, but by its very discursive ubiquity.

Even as Hokusai's wave was familiar and easily recognizable in other contexts, it was also novel and highly topical. His achievement was to isolate and make the cresting wave memorable by giving it a spectacular new scale, pigments, and visual identity by association with Mount Fuji. Even as it amused, the witty inversion of scale, with the towering wave challenging the authority of Mount Fuji, encouraged reflection and speculation about the dangers to the country from without. The imported pigment employed in the print's realization reinforced this powerful metaphor while at the same time materializing the desire for exotic goods. This dialectic of bringing the outside in and the inside out may help to explain why "Under the Wave off Kanagawa," though popular, does not enjoy the stature in the Japanese estimation of the "Red Fuji," with its unalloyed celebration of the beauty, majesty, and sacred power of Mount Fuji.[74]

International Nationalism

Thirty-six times and a hundred times
the artist portrayed the mountain.
Now pulled away, now compelled
(thirty-six times and a hundred times)

— RAINER MARIA RILKE, "Der Berg,"
trans. Barrows and Macy

ILLUSTRATED BOOKS AND SINGLE SHEET PRINTS OF HOKUSAI'S great waves began circulating in Europe and America in the 1860s. The speed with which they were disseminated, reproduced, and reinterpreted speaks to the new modes of transportation, communication, and technology that were simultaneously constructing and dismantling existing understandings of center and periphery.[1] Individual agents, exhibitions, reproductions, and adaptations in visual and material forms, as well as literary references all played a role in their circulation. Although iterations of the wave were extremely diverse, and sometimes only loosely related to Hokusai's designs, his interpretations helped to make this motif a metaphor for both the optimism and the anxieties of the times.

The wave integrated and made visible the manifold experiences that were transforming culture and society around the world. For some, it denoted the action and change of travel; for others, the new therapeutic pastime of sea bathing; for still others it was a metaphor for time, memory, the human condition, and even consciousness itself. In Charles Baudelaire's famous words, "the sea is your mirror: you contemplate your soul in the infinite billowing of its waves."[2] As a recurrent theme in the visual and decorative arts, in literature and music,

as well as in the sciences, the fluid, energized wave also evoked escape from the confines of tradition and the celebration of change in the name of social and aesthetic progress. This idea underlies the term *la nouvelle vague* (the new wave), with which the flow of fashionable exotic goods from Japan was associated, and the recurrence of the wave's sinuous form as a motif emblematic of the decorative and design reforms of *l'art nouveau* (figure 2.1).

Waves were also part of the new vocabulary deployed to describe the visual and auditory experiences revealed through technology that made it possible to measure the vibrations of light and sound. Yet even as these discoveries signalled growing understanding of and mastery over the environment, Hokusai's towering wave also seemed to offer a countervailing image of the disruptive powers of nature. In 1896 a tidal wave that caused massive destruction in northern Japan was quickly reported via telegraph and photographs that brought home

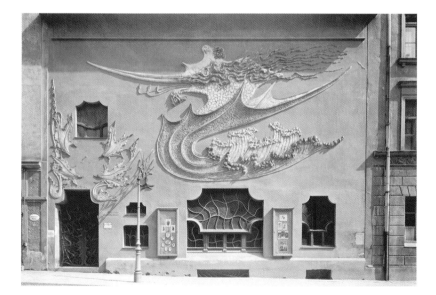

FIGURE 2.1. August Endell, façade of Elvira Studio, Munich, 1896. (622.026. © Bildarchiv Foto Marburg.)

to Euro-Americans the dangers of a natural disaster previously known only at a historical distance. This event marked the introduction of the term "tsunami" to the anglophone lexicon.[3] Scientific research on seismology had earlier brought to public attention the fact that an earthquake on one continent could produce a tidal wave on the coast of another, by analogy hinting at the potentially disruptive effects of the flow of people, goods, and ideas across national borders.[4]

What happened when Hokusai's waves were taken out of their original contexts of production and consumption and introduced into the new, dynamically evolving environments of Europe and America? Where and in what forms did they travel? Who were the agents in their transmission? How and why did they become worthy of such pervasive attention? This chapter seeks to bring a critical framework to the interpretation of the first stages in the incremental and cumulative process that led to the canonization of "Under the Wave off Kanagawa" as one of Hokusai's most representative works. A full history of "Japonisme," the term commonly used to refer to the Japanese influence that swept Europe in the second half of the nineteenth century, is beyond the scope of this study, but reconstructing the global cultural networks in which waves participated helps to historicize the larger forces that informed this transnational phenomenon.[5] Focusing on the period between the 1860s and the first decades of the twentieth century, this chapter follows the movement of Hokusai's waves and their multisited cultural mediations across spaces widely separated in physical geography yet linked by networks of artistic travel, commercial trade, and technology exchange. In so doing, it discloses how waves became idioms of intercultural communication through which particular national expressions of modernity and modernism were negotiated and made visible.[6]

Book Illustration

The early reception of three of Hokusai's illustrated books throws light on the varied contexts and incremental valuation processes Hokusai's waves underwent on their arrival in Europe and America. With its more than four thousand plates, the fifteen-volume *Manga* was central to the

construction of the symbolic world of which this artist and his creations became a part. Inexpensive, easily portable, and visually entertaining, this woodblock printed series helped to awaken and cultivate a taste for all things Japanese.[7] Enthusiasm for the *Manga* generated a loose network of artistic subcultures spanning the globe that contributed to the internationalization of Hokusai's aesthetic vocabulary and, by the same token, to the building of a consensus that his art was worthy of sustained critical attention. The *Manga*'s reception, by transforming Hokusai into an artist assigned the task of representing Japanese art and character, also modeled expectations that were extended to other works.

The *Manga*'s wide-ranging subject matter and pictorial styles as well as its serial publication were guided by the original function of the books as popular instructional manuals for aspiring amateur artists. Although cresting waves are recurring motifs, there is no single interpretation that could be characterized as a "great wave."[8] Instead, the books presented students with a variety of forms this natural phenomenon could assume. This didactic objective is made explicit in the careful delineation of incoming and outgoing waves, each accompanied by a caption, presented in volume 3 (figure 2.2). Euro-American viewers, however, were for the most part unaware of this larger purpose, and, unable to read the explanatory texts, often misinterpreted the individual images as well. Indeed, in his 1899 study of Hokusai, Charles Holmes saw the pair of images in figure 2.2 as a representation of "crawling foam that creeps over the sand fold upon fold, and, below, the dark hollow of a great wave just about to break."[9]

The *Manga* was first introduced to Europe in the 1830s through a small selection of line drawing illustrations in Philippe von Seibold's *Nippon*, the enormously influential source of information on Japan published following the author's seven-year residence there between 1823–1829.[10] By the mid-1850s, familiarity with Hokusai's series had led its European and American enthusiasts to declare that such picture books reflected an art that was distinctly Japanese and that their creator was an artistic genius. By such critical stances, rival collectors sought to claim their "discovery" of Japanese art. The British art critic William Rossetti, writing in 1863 of the "Hoxai Manga," declared: "It assuredly

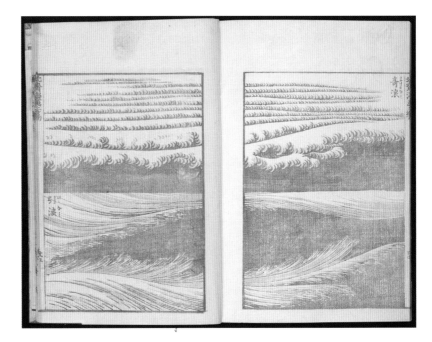

belongs in various respects to the greatest order of art practiced in our day in any country in the world. It has a daringness of conception, an almost fiercely tenacious grasp of its subject, a majesty of designing power and sweep of line, and clenching hold upon the imagination."[11] The French collector Philippe Burty claimed that the sketches rivaled "Watteau in their grace, Daumier in their energy, the fantastic terror of Goya and the spirited animation of Delacroix."[12] Overwhelmed by their scope and variety, the writer and collector Edmond de Goncourt proclaimed them a "kind of delirium on paper from a man *mad about drawing.*"[13] Thus was Hokusai inscribed into European discourses on connoisseurship, graphic art, French painting, and artistic genius while at the same time helping to promote the writers' own critical authority.

Despite such enthusiasm, Euro-American viewers, with their own expectations of linear logic, experienced considerable difficulty in discerning the principles underlying in the *Manga*'s array of nearly four thousand different plates.[14] Although it was often characterized as encyclopedic in terms of its sheer volume and variety, the *Manga*'s apparent lack of taxonomy belied the configuration of such familiar compendia. This gave rise to commentaries that emphasized its randomness and the illustrations' sketchiness, in the sense of both unfinished and spontaneous, and, eventually, to the title *Random Sketches,* by which the publication is still commonly known in the anglophone world today.[15] Such assessments confirmed expectations of the Japanese artist as one whose work expressed "natural" reactions to the environment rather than being premised on rational thought and action. The racialized ascription to Hokusai of an intuitive, unmediated apprehension of nature could not accommodate the reality that this artist was working from memory and tradition as much as from observed experience. Nor did it take into account the fact that his book illustrations were mediated by the craftsmanship of the cutter and the printer. The label *Random Sketches* in effect instantiated the view that Hokusai and his countrymen were endowed with a nature whose moral, emotional, and intellectual development was immature, even childlike.

Yet, paradoxically, Hokusai's *Manga* also found a receptive audience among avant-garde Euro-American artists and designers because it seemed to address the transformations of their own modern experience of time and space. It gave expression to the atomized and disorienting sensory overload of modern urban life, its disjunctive, improvisational quality evoking the fragmented "impressions" that they were seeking to express in their own work. In capturing the visual experiences of his own teeming urban environment, Hokusai offered the equivalent of the flâneur's stroll, where the eye seizes random sights and stores them away without any particular order. His attentiveness to the details of life in the countryside also echoed a growing idealization of rural life in Europe and America. In effect, his work aroused the shock of recognition at seeing what was already recognized.

This reflexivity, in which European modernity was constructed through representations of Japan, is clear from a passage in the influential critic and collector of Japanese art Théodore Duret's biography of Manet, where Hokusai serves simultaneously to model and to validate the direct apprehension of the environment: "The drawings by Manet generally remain in the state of a sketch or a *croquis.* These drawings were done in order to grasp a fleeting aspect, a movement, or an eminent detail. . . . To compare with Manet in this respect, I can find nobody else but Hokusai, who knew how to combine simplification with a perfect determination of character in his drawings, made upon first attack, in the *Manga.*"[16]

Whereas the *Manga* attracted attention because of its disorienting visual scope, the three-volume *One Hundred Views of Mount Fuji* did so for its obsessive focus on a single subject. Hokusai's startling ability to illuminate the many different ways this majestic mountain could be experienced conformed to the familiar aesthetic categories of the sublime and the picturesque but in a startlingly unfamiliar nonmimetic idiom. Like the *Manga,* this publication was extremely popular in Japan and reissued several times, also making it more readily available to Western collectors.[17] Small numbers of enthusiasts were likely studying its pages already in the 1850s and 1860s, with reproduction of selected views further contributing to its familiarity among a wider audience. During this period, the popular American journal *Harper's Monthly* often featured articles and book reviews treating Japan that included illustrations based on Japanese prints and books, including this one.[18]

Although the *One Hundred Views* was widely understood to be a picture book, it includes prefaces, postscripts, and captions that explain how it came into being and what each image was intended to represent. In 1880 the text was translated by Frederick Dickins in a British publication that marked the first monographic treatment of a Japanese work of art.[19] "Fuji Viewed from the Sea" was not among its selected illustrations, suggesting that the "great wave" had not yet achieved visual authority as a canonical image.

The responses of two American illustrators in the 1860s, John La Farge and Winslow Homer, testify to the special importance of

One Hundred Views of Mount Fuji in Hokusai's reception in the United States. As Christine Laidlaw has proposed, its study was the likely catalyst for the breakthrough pictorial style Homer developed in his 1862 wood engraving of a civil war sharpshooter perched awkwardly in the branches of a tree.[20] His radical, nonillusionistic approach was a response to the growing availability of realistic photographic records of the Civil War that, together with the development of chromolithography, threatened to render woodcut book illustrations obsolete. A pioneer collector of things Japanese, La Farge is best known today for his decorative stained glass designs for Tiffany, but early in his career he too made a living as an illustrator.[21] La Farge had acquired Hokusai's *Manga* in 1856 and by 1864 had amassed a substantial number of Japanese illustrated books and prints that included volume 2 of the *One Hundred Views of Mount Fuji*.[22] He used "Mount Fuji Viewed from the Sea" (see figure 1.7) as raw material for an illustration in the first American edition of Alfred Lord Tennyson's epic poem *Enoch Arden,* a best seller in England (figure 2.3). The illustrations its Boston publisher, Ticknor and Fields, commissioned from La Farge and other artists were intended to distinguish this American edition from its British counterpart.

The dramatic black and white values of Hokusai's views were well suited to the illustration of this tale of a sailor whose "China-bound" ship is washed ashore on a "beauteous hateful isle," an exotic, lush tropical paradise where "the mountain wooded the peak, the lawns, the winding glades [were] high up like ways to heaven."[23] In his illustration of the shipwrecked hero with a towering wave behind him, La Farge successfully harnessed the new Japanese aesthetic to the graphic needs of a melodramatic Victorian narrative by paying less attention to the intricacies of Hokusai's image than to its underlying visual structure. As a result, the wave's monumentality thwarts the small size of the illustration.

La Farge's embrace of Japanese styles and motifs, like Homer's, was a strategy closely bound up with changes that were transforming the small-scale, individual, craft-based woodcarving and engraving profession into a modern, specialized publishing industry that could reach a mass audience. Japanese picture books modeled novel artistic alternatives to existing styles, and identification with the culture that

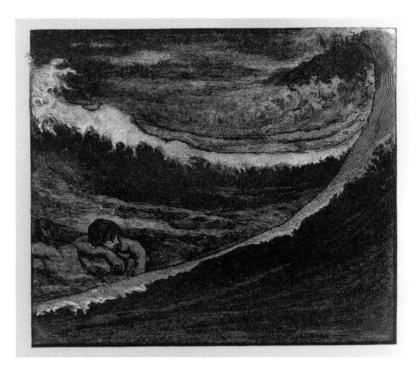

FIGURE 2.3. John La Farge, illustration in Alfred Lord Tennyson's *Enoch Arden*. (Boston: Ticknor and Fields, 1865. Courtesy Department of Special Collections, Stanford University Libraries.)

had produced them—one where woodblock prints were understood to be a high art—promised to enhance the professional status of those involved in commercial illustration and design. This helps to explain why La Farge would become one of Hokusai's American champions. As he wrote in a 1903 collection of essays titled *Great Masters,* in which he ranked Hokusai together with Michelangelo, Raphael, Rembrandt, Rubens, Velasquez, and Durer:

> I am fully aware of the classical Japanese views regarding the art-
> ist of the "vulgar school." They are, in the main, right. . . . But
> the enormous amount of Hokusai's productions, his unflagging

power, the spirit of his vision of life, and his being, like the others I write about, an untiring workman, make him touch at least the limits of the greatest art. And then he has been given the special mark which lifts the designer out of the lower categories—a gift of fresh perception of any subject, the sight of the result before it is undertaken—so that not to have seen his manner of seeing would be to miss an absolutely different part of the whole field of representation.[24]

An agenda of artistic reform also underlay the British architect Thomas Cutler's reworking of the depictions of waves Hokusai had created as models for designers in his *Models of Modern Combs and Pipes* (*Imayo sekkin hinagata,* 1822–1823) (figure 2.4). The Crystal Palace exhibition of 1851 had aroused in Britain an enormous appetite for material goods from the Orient. Initially this taste was directed toward the Middle East and India, regions whose exotic textiles, carpets, and ceramics were already familiar to British consumers through travel and empire. China and Japan became the new focus of attention after the display of Rutherford Alcock's collection of Japanese ornamental and industrial arts at the 1862 exhibition and the flood of Chinese ceramics, textiles, and cloisonné that reached Britain following the sack of the Imperial Summer Palace in 1864. This inaugurated a period during which individuals from many backgrounds, most of them possessing only a superficial knowledge of the culture and language, sought to explore and explain Japan through its visual and material culture from a British frame of reference: the union of good design and economic progress. As Stacey Sloboda has observed, this "brand of design reform was concerned with [the] performative aspect of decoration and saw in flat, decorative forms abstracted from nature an enactment of imperial and industrial, or in their words, 'scientific' modernity."[25]

When Owen Jones published his *Grammar of Ornament* in 1856, it barely touched on China, a country whose design he believed had little to offer.[26] Jones' contact with the collector Arthur Morrison the following year, however, led him to revise this view and publish a sequel, *Grammar of Chinese Ornament.*[27] Jones never pursued the subject

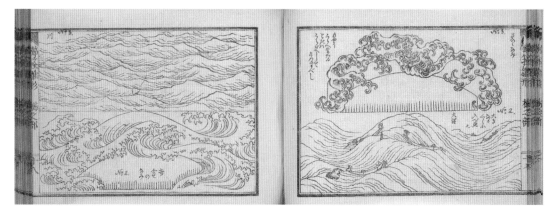

of Japanese design, but Cutler's 1880 *Grammar of Japanese Ornament and Design* unabashedly borrowed his title to help bolster its author's own modest claims to authority. [28] Like Jones, Cutler was an architect with no experience of Asia, although he was in contact with British Japanophiles including Frederick Dickins, who, as noted above, also published in 1880, with Batsford, a translation and commentary of Hokusai's *One Hundred Views of Mount Fuji,* on which Cutler drew for a number of his illustrations.

What prompted the *Grammar of Japanese Ornament and Design* is unclear. Indeed, little is known of Cutler, possibly because, despite its beautiful color chromolithographic illustrations, his book was quickly overshadowed by *Japan, Its Architecture, Art and Art Manufactures,* the product of Christopher Dresser's three-month trip to Japan in 1876.[29] Dresser had been invited by the Japanese government to travel there to advise on the modernization of its crafts industries and upon his return became Britain's leading expert on Japanese arts and crafts. Like Cutler, he viewed Japanese art primarily in terms of a domestic agenda. As he declared: "I cannot too strongly recommend our young ornamentalists to consider these drawings and to try and acquire the Japanese power of

delineating natural forms with simplicity. . . . But I must not be misunderstood: I do not wish to destroy our national art, and substitute it for the Japanese style. . . . Art, to be of value[,] must be national."[30]

Flat patterning was what recommended Japanese ornament and design to Cutler. This outlook guides his choice of illustrations, which include nine different wave treatments extracted from Hokusai's *Models of Modern Combs and Pipes*. Of these he wrote: "In the drawing of water the Japanese show all their wonted originality and power, and portray with marvellous freedom, always in thoroughly conventional spirit, the gently ripping stream or the restless ocean in its ever-varying moods."[31] The designs, regrouped in two columns on a single page of Cutler's book, span four pages in Hokusai's, where, as the book's title indicates, they were intended as models for the decoration of combs. For this reason, most designs are curved at the bottom to allow for the teeth of the wooden comb. Some also include information identifying them as a river or as distant windblown waves. Cutler, however, has shown one pair of designs in the upper righthand corner upside down and has omitted the descriptive labels (figure 2.5).

Cutler's classification of Hokusai's waves as part of a language of ornamental design exemplifies the British taxonomic approach to the making and distribution of knowledge about Japan.[32] Grammars codify and prescribe the rules of usage of a particular language, aiding the learning process by transforming its complex workings into simple rules and eliminating contradictions in favor of essentializing clarity. In removing the denseness and variability of language, they also take away its historical contingency. Such a process of standardization was essential in translating Hokusai's waves into an idiom that would be widely understood and mobilized outside their country of origin.

Royal Copenhagen Porcelains

A blue and white porcelain plate with a cresting wave in a seascape evocative of Denmark designed by Arnold Krog for the Royal Copenhagen Manufactury embodies the complex and multidirectional commercial exchanges of which Hokusai's wave became a part beginning

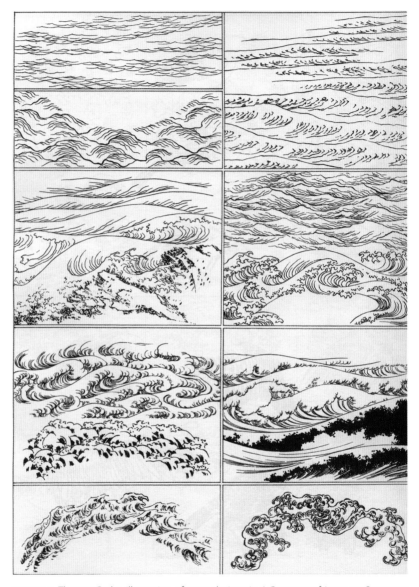

FIGURE 2.5. Thomas Cutler, illustration of wave designs in *A Grammar of Japanese Ornament and Design,* 1880. (Dover Editions reprint, 2003)

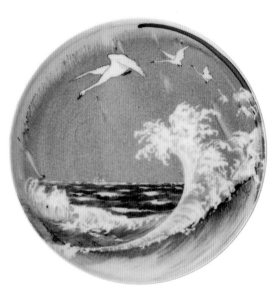

FIGURE 2.6. Arnold Krog, Royal Copenhagen plate with wave and swan, 1885, porcelain painted with underglaze blue, diameter 11 13/16 in. (30 cm.). (© Design Museum, Denmark. Photograph Pernille Klemp.)

in the 1880s (figure 2.6). The encounters that led to and followed its creation disclose the network of personal connections and material movements linking Copenhagen, Paris, Tokyo, and Hirado, an important site of porcelain production on Japan's southern island of Kyushu. At the same time these throw into relief the degree to which the dissemination of Hokusai's wave was mediated by the illustration in *One Hundred Views of Mount Fuji* and Hiroshige's woodcut "View of Mount Fuji from Satta" (see figures 1.7 and 1.9).

There is no conclusive evidence that "Under the Wave off Kanagawa" was in circulation in Europe or America before 1883, when Louis Gonse declared in *L'Art japonais,* the first comprehensive representation of Japanese art written in Europe or America, that he owned a complete set of the *Thirty-Six Views of Mount Fuji.*[33] It is likely that the exhibition he organized in Paris that same year was also the first time this print was displayed abroad.[34] Although there may have been a few impressions already in private hands, the wave was becoming familiar during the 1870s and 1880s primarily through its recurrence in other forms and media—illustrated books, single sheet prints by Hokusai and other artists. An early-eighteenth-century design of waves and rocks for screen paintings by Ogata Kōrin, for instance, was reproduced in Dresser's 1882 *Japan: Its Architecture, Art, and Art Manufactures.*[35] Iterations of the wave in the decorative arts were especially influential in

its growing recognition. A nineteenth-century bronze vase with an encircling design of crested waves bought by the Victoria and Albert Museum in 1876 from the influential dealer Siegfried Bing and a seventeenth-century blue and white Arita dish with a huge cresting wave about to break on the beach near a fisherman's hut, acquired after its display at the 1878 Paris Exposition, underscore the range of media and contexts that helped to establish this motif as part of a distinctly Japanese idiom (figures 2.7 and 2.8).

The Arita dish, made as part of a set of food-serving utensils, was part of a long tradition of pictorialized blue and white porcelains that informed the production and consumption of Krog's Royal Copenhagen porcelain plate. China and Japan had held a monopoly over the commercial production of porcelain exported to Europe until the chemist Johann Friedrich Bottger, working under the patronage of Augustus the Strong, unlocked the secrets of its manufacture, leading

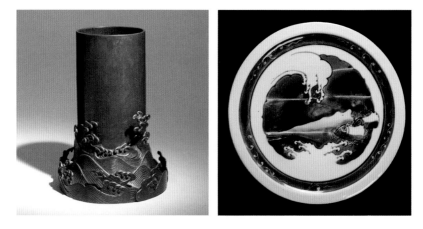

FIGURE 2.7. Vase with encircling waves, 1800–1850, bronze, 11 ½ x 8 ½ in. (29.5 x 22 cm.). (85:1,2-1876. © Victoria and Albert Museum, London.)

FIGURE 2.8. Anonymous dish with design of wave breaking on beach, seventeenth century, porcelain painted in underglaze blue, Arita, diameter 8 ¾ in. (21.6 cm.). (Given by the Japanese Commissioners to the Paris Exposition of 1878, 720-1878. © Victoria and Albert Museum, London.)

to the founding of the Meissen kilns in 1710. Royal Copenhagen's establishment in 1775 to provide high-fired porcelain dinner services for the Danish monarchs followed from comparable experimentation carried out by the chemist Frantz Heinrich Muller under the patronage of Queen Juliann Marie. The earliest services made for the royal family featured blue and white floral décor and bore as their trademark three wavy lines standing for Denmark's three straits, Oresund, Great Belt, and Little Belt. One of Krog's first projects after being hired by the firm in 1885 was to modernize this floral décor. When he began work, Royal Copenhagen had lost its exclusive royal charter and become a private firm, its fortunes uncertain as enterprising businessmen opened competing companies to produce porcelain for growing middle-class consumption. Krog helped to maintain and revive the firm's reputation by updating existing designs as well as expanding its offerings to include a new range of decorative ceramics.[36]

Like designers across Europe, he saw Japan as a rich repository of motifs that could be mobilized to bring a new cosmopolitan look to local productions. Hiroshige had translated Hokusai's design from the horizontal to a vertical print format and reversed the direction of the wave; Krog took the motif two steps further by adapting it to suit the circular form of a three dimensional plate and relocating the setting from Japan to Denmark. He did this by eliminating Mount Fuji and adding swans to the foreground. This dramatic ennobling of Denmark through the romanticization of the sea around it effectively capitalized on the Japanese tendency to distort perspective by enlarging the foreground and leaving the background almost empty to create a dramatic contrast between movement and stillness. Figures and landscapes had long been common on blue and white wares, but these tended to be fragmented and framed by border decoration. What gave Krog's design a sleek modern appearance was the integration of a coherent pictorial décor into a single borderless composition, all rendered in a light blue palette created by blowing pigment onto the slip. The plate (of which two versions were made) was displayed at the 1888 Copenhagen Industrial Exhibition, and the following year a vase with an adaptation of the same motif was among the works that helped Royal Copenhagen win

a *grand prix* for porcelain with pictorial underglaze décor at the Exposition Internationale in Paris.[37]

Krog's interest in Japan was likely aroused by Karl Madsen, whose *Japansk Malerkunst* (Japanese painting, 1885) became an important source of discovery for many Nordic artists.[38] Like Louis Gonse's *L'art japonais,* published in Paris two years earlier, this work was based largely on illustrated books, single sheet prints, lacquer, ceramics, metalwork, and other decorative arts in Madsen's own and friends' collections. Works by Hokusai likely figured prominently among them since Madsen devoted an entire chapter to Hokusai, singling out for special praise the view of Fuji "looking over the great waves of the ocean whose fluttering foam turns into storm birds."[39] Whether or not Madsen or Krog also owned an impression of Hiroshige's "View of Fuji from Satta" is unknown, but it is possible that they or another member of the Copenhagen circle of Japanophiles had acquired one from the Paris art dealer Siegfried Bing, whose fashionable Paris shop was a mecca for collectors across Europe. Krog himself is known to have visited Bing in Paris to buy Japanese art to inspire work at Royal Copenhagen, and in 1888 Bing himself exhibited Japanese ceramics, lacquer, and metalwork as well as works by French designers at the Nordic Exhibition of Industry, Agriculture, and Art in Copenhagen. Among these was a vase with the wave motif made by Bing's protégé Ernest Chaplet that underscores this art dealer's pan-European role in promoting the wave as emblematic of *l'art nouveau.* [40]

Although the precise route of its transmission is not clear, by the end of the century, Krog's design for the blue and white Royal Copenhagen plate had made its way back to Japan, where a small number of dishes modeled after it were fired in Hirado's Mikawachi kilns (figure 2.9). Blue and white underglaze porcelain had been a speciality of the Hirado kilns since the beginning of the nineteenth century. These wares were first made under the patronage of the Matsuura, the local feudal lords, for domestic use and gift giving. By the end of the century, however, production in Hirado, as in many other Japanese kilns, was largely destined for the international market.[41] Some ceramics producers even began sending representatives to the world's fairs in Europe to

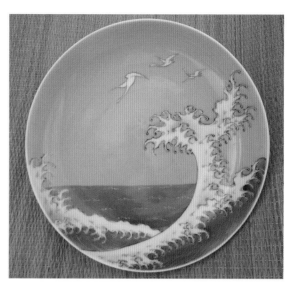

FIGURE 2.9. Plate with wave and birds, 1900–1910, porcelain painted in under-glaze blue, Hirado (Mikawachi kiln), diameter 8 in. (20.7 cm.). (Anne and David Hyatt King Collection. Photograph courtesy David Hyatt King.)

carry out industrial research that would help them develop products in keeping with fashionable trends there. There is no evidence that the Hirado kilns sent merchants or potters abroad, but in 1889 Miyagawa Kōzan, the head of a successful Yokohama firm, sent his adoptive son Hanzan (Kōzan II) to the Paris International Exposition, where Royal Copenhagen was awarded prizes. Soon thereafter, Danish styles and motifs featured in Kōzan's Yokohama productions.[42] It is likely that Krog's design was reimported to Japan in a similar manner.

The Hirado dish is an early instance of the way European art nouveau revitalized decorative design in Japan, in effect, giving that country an aestheticized relationship to its own history. Like its Danish model, the Hirado dish seems to have been a limited edition.[43] Although it is likely that the Japanese designer who took note of Krog's creation recognized its source to be Hokusai or Hiroshige despite the erasure of Mount Fuji, the motif's reappropriation was dependent on its European translation into porcelain, a form that disassociated it from the lowly medium of the woodblock print and invested it with the cachet of modernity. As one of the most dynamic and high-end media in Japan's export trade, this new material support thus helped to legitimate its reproduction in Japan.

This circular movement, in which Krog appropriated the authority of the Japanese design to elevate his own, and Japanese ceramicists in

Hirado, in turn, reappropriated the Danish adaptation to lend a European imprimatur to theirs, is symptomatic of the mutually constitutive (and competitive) relationships of the modern global marketplace in which Hokusai's great waves participated. These hybrid designs all carried out a process that made what had been exotic and different part of the local. In both Europe and Japan, the wave was disassociated from the external reality of its local topography and absorbed into other imaginary topographies to produce new modern conceptions of Japan, and of Japanese and European art.

L'Estampe Originale

New technologies of mass communication available at the end of the nineteenth century were instrumental in the assimilation of Japanese art and design into Euro-American visual and material culture. Half-tone reproduction, for instance, led to the first photographic illustration of "Under the Wave off Kanagawa" in Siegfried Bing's 1898 article on Hokusai's *Thirty-Six Views of Mount Fuji*.[44] Before that time, however, color illustrations, original graphic art, and poster design combined to make Hokusai's great waves familiar to a public beyond the small circle of Japanophiles that had initially celebrated their creator.

From the start, Japanese woodblock prints attracted admiration for the high quality of their registration and, especially, their polychromy. In so doing they drew attention to both the artistic and the commercial potential of color printing. Whereas the first reproductions of Japanese books and prints were in the form of simple line drawings and black and white illustrations, the advent of chromolithography made it possible to mass reproduce them inexpensively in color. These were representations rather than exact reproductions of Japanese prints, however, since they had to be re-created by other artists on the lithographic stone in order to be printed. Recognition of the commercial potential of this technology led the U.S. government to include a lurid fold-out facsimile of a woodcut by Hiroshige in Hawks' 1856 *Narrative of the Expedition of an American Squadron to the China Seas and Japan, Performed in the Years 1852, 1853, and 1854*.[45] In 1875 a French

publication featured color facsimiles of prints by Hokusai and Hiroshige to accompany an article on Japonisme by the collector and connoisseur Philippe Burty.[46] Not until the appearance of Siegfried Bing's luxurious *Le Japon artistique,* however, did a wider public begin to gain an accurate appreciation of the striking palette of Japanese woodblock prints. The title "Red Fuji" by which Hokusai's "South Wind, Clear Dawn" is now commonly known (see figure 1.3), for instance, would have been meaningless to all but a handful of collectors before Bing reproduced it on the April 1889 cover of this publication.[47] Published between 1888 and 1891 in French, English, and German editions, and sold below its production cost, Bing used this journal to promote the sale of all forms of Japanese art and design, which he identified as *l'art nouveau.*

The diffusion of European technologies of color printing had a significant, if unintended, impact in Japan by making even those Japanese government officials who decried the vulgarity of their own print culture recognize the historical, cultural, and technical value of this medium. When *Kokka* (National flowers), the first Japanese art journal aimed at both a domestic and an international audience, began publication in 1889, articles about ancient painting and other fine arts were accompanied by tipped-in color woodblock-printed illustrations. *Kokka* also pioneered the use of collotype, a form of mechanical reproduction that produces very high quality images.[48]

Japanese prints dazzled viewers in Europe and America by their brilliant colors but also because the manner in which these were applied challenged traditional European practices and assumptions. Their simplification and juxtaposition of large flat areas of color without naturalistic grounding thus helped to open up radical new approaches to painting and printmaking. As Andre Mellerio, the editor of the Parisian art journal *L'estampe et l'affiche,* wrote in 1898:

> It seems in particular that the original colored lithograph, since it had not existed previously in the conditions in which we recently saw it flower, is the special production of art in our era. . . . Two influences appeared to have determined again the

movement toward color. On the one hand, the school called Impressionism. . . . Add to that Japanese art. . . . There, in a very definitive form with varied and seductive aspects in its curious printings triumphed the color print.[49]

Monet was among the "Impressionists" captivated by this "new system" and, especially, by the use of Berlin blue that was a distinctive feature of many of Hokusai's views of Mount Fuji. He owned several designs in the series distinguished by their predominantly blue color scheme, including "Under the Wave at Kanagawa."[50] Admirers and critics alike identified Japanese prints as the source of the luminous, unmodulated blue that became a feature of Monet's treatment of water.[51]

A color long identified with China and Japan through the blue and white ceramics exported to Europe, blue was given new connotations through its use in woodblock prints. So pervasive was it that one critic decried it as an obsession, even a sign of color blindness he dubbed "indigo-mania," and Duret, an avid collector of Japanese illustrated books and prints who visited Japan in 1872, felt it necessary to proclaim that its truthfulness to nature conformed to his own experience of the Japanese landscape![52] These conflicting responses were inflected by pseudoscientific explanations holding the perception of color to be historically and racially determined. At the time, the Darwinian theory of evolution was used to argue that the ancient Greeks saw in black and white, color blindness was an atavistic trait, and a preference for a strong palette was common among less civilized nations.[53] Monet's adoption of what he believed to be experientially authentic Japanese hues, the classification of the enthusiasm for indigo blue as a disease, and Duret's efforts to counter such critiques on the basis of his personal experience of Japan underscore the multilayered and ideologically loaded discourses in which Japanese prints became implicated.

As these racialized views suggest, even as Japanese prints helped to release European artists from the constraints of realism, their influence also aroused anxieties. These fears were clearly articulated by

Jules Champfleury in 1868, when he criticized the "bizarre use of color" associated with the "Japanese invasion in painting."[54] Still ongoing in the 1890s, this uneasiness about Japanese influence was given artistic expression in an oversize lithograph by Henri Jossot created as part of *L'estampe originale* (figure 2.10). Its subject, a man tumbling backwards as his boat is hit by a great wave, refers unmistakably to Hokusai's "Under the Wave off Kanagawa." Jossot's design is more than a satirical commentary on Hokusai's print. By clothing the oarsman in exotic costume, cropping the composition, sharply tilting the picture plane to produce a "fish-eye" view, and showing an easel catapulted out of the boat, the artist draws attention to all the features

FIGURE 2.10. Henri-Gustave Jossot (French, 1866–1951), "La vague," 1894, lithograph in olive green ink, sheet: 24 3/16 × 16 15/16 in. (61.4 × 43 cm.), image: 20 11/16 × 13 7/8 in. (52.5 × 35.2 cm.). (Collection of Zimmerli Art Museum at Rutgers University. Museum purchase, acquired in the name of Laventhol & Horwath, 74.018.001. Photograph by Jack Abraham.)

associated with Japonisme as a "new wave" that irrevocably altered French pictorial traditions. If art is understood as making or revealing power, the anarchic challenge of Jossot's wave emblematically evoked the revolution in the graphic arts that Japan helped to bring about.

Even as the stylized great wave was understood to be a sign of modernism, paradoxically, it could also suggest the stultifying forces of the past. These contradictory connotations are illustrated in a poster advertising an exhibition of the Manes group of avant-garde artists in Prague (figure 2.11). Here, a figure aboard a schooner with a sail emblazoned with the name of Prague's leading modern art gallery throws a life preserver to a man about to drown beneath a huge wave. The implication seems to be that the artists of the Manes group hold out the promise of saving the public from the "old wave" that threatens to sink them.[55] In other words, even as the artist seems to celebrate a Japanese design as art nouveau, he simultaneously uses it as a historical foil for his own modernism. In this sense, this poster designed by Arnost Hofbauer, a Czech Japanophile, shares with Jossot's lithograph a vision of the wave as productive, energetic, and, above all, dangerous. It is worth recalling in this respect, the language of the remarks of a reviewer of the 1878 Paris Exposition: "Japonisme! Attraction of the age, a disorganized rage in our art, our fashions, our tastes, even our reason."[56]

Like their Prague counterparts, the French artists who participated in the production of *L'estampe originale* were invoking Japan as part of their efforts to bring about artistic change. Their objective in this portfolio of ninety-five lithographs, woodcuts, and etchings created between 1893 and 1895 was to make "original prints" accessible to the middle class.[57] Each of the designs was issued in a limited edition of one hundred and signed by the artist who had created it. Study and promotion of the techniques and expressive idioms of Japanese woodblock prints were integral to this program since these modeled the combination of "originality," aesthetic quality, and modest cost to which proponents of "original prints" aspired.

Henri Rivière, another contributor to *L'estampe originale* and an especially dedicated student of Japanese woodblock printing, adopted

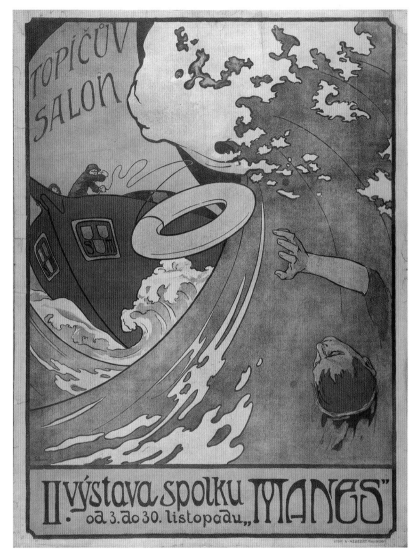

FIGURE 2.11. Arnost Hofbauer, poster for the second exhibition of the Manes Association, 1898, color lithograph, 43 5/16 × 33 5/64 in. (110 × 84 cm.). (The Museum of Decorative Arts, Prague)

this technique for a series of seven wave studies, which follow Hokusai's views in their exploration of nature under different atmospheric conditions. However, as French print scholar Dennis Cate has observed, the French and Japanese approaches to engraving were fundamentally different since the former relied on a burin to produce a linear style analogous to engraving and etching, whereas the latter cut out the wood to create designs in relief complemented by planar areas of color.[58] The difficulty and time required to adapt to Japanese woodblock carving techniques may have led Rivière to abandon his original intention of creating his signature *Thirty-Six Views of the Eiffel Tower* in this manner. Instead, the series was printed using lithography, with many of the designs based on photographs that Rivière took himself.[59] This technique, in which the artist worked directly on the stone, could produce images that shared the sense of immediacy that was admired in Japanese woodblock prints.

Illustrating once again the simultaneously traditional and modern values Japan could serve to invoke, in this series Rivière analogized the natural sublimity of Mount Fuji to the technological sublimity of the Eiffel Tower. At three hundred meters, this structure built for the 1889 International Exposition was not only a new eruption on the Parisian landscape, but one that was highly controversial, since many saw its modern, engineered form as a threat to time-honored landmarks such as Notre Dame. The writer Guy de Maupassant, among others, declared it "an unavoidable and tormenting nightmare."[60] Indeed, so despised was this wonder of engineering that it was scheduled to be torn down in 1909. Public voices rose in its support, however, and it remained, later achieving the same synecdochical status vis-à-vis Paris that Mount Fuji had for Tokyo. Rivière's series was part of this process of validation.

Apart from their iconic number, Rivière's *Thirty-Six Views of the Eiffel Tower* makes no obvious iconographic reference to Hokusai's series. Instead, the artist adapted Japanese compositional approaches and cropping techniques to offer strikingly new perspectives on this Paris landmark. A sense of motion is achieved by the quick succession of different times and moods invoked. In one striking aerial view, he

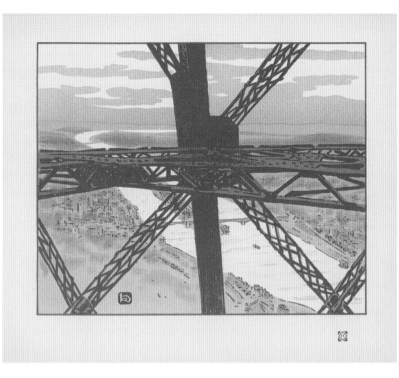

FIGURE 2.12. Henri Rivière, "In the Tower," from the series *Thirty-Six Views of the Eiffel Tower*, 1888–1902, color lithograph, 6 ⅝ × 8 ⅜ in. (16.8 × 21.3 cm.). (Print Collection, Miriam and Ira D. Wallach Division of Art, Prints and Photographs, New York Public Library, Astor, Lenox and Tilden Foundations. © ADAGP, Paris, and DACS, London, 2013.)

takes viewers into the upper reaches of the tower, where the Seine can be made out far below through crisscrossing iron trusses (figure 2.12). Taken in their totality, Rivière's lithographs do not form a teleological narrative but instead a heterogeneity of sharply observed "fragments" of the urban experience, artfully juxtaposed with bits of nature or of human activity in the manner of Hokusai's *Thirty-Six Views*. Although appreciation of this series did not depend on familiarity with its Japanese referent, its title suggests that the artist expected his audience to make that connection.

La Vague

Even as replication and adaptation in pictorial form of part or all of Hokusai's series were key to the canonization of "Under the Wave off Kanagawa," written descriptions also contributed to this process. Of the many paeans to Hokusai, none was more influential than Edmond de Goncourt's monograph, published in 1896 based on a biography of the artist by Iijima Hanjūrō (also known as Kyoshin) published three years earlier in Tokyo. This Japanese publication was the first to distill Hokusai's life and career into a form that modern readers would recognize as an artistic biography.[61] Iijima's study did not come about because of local Japanese interest in Hokusai but rather because the growing market for Hokusai's prints in Europe had created a need for reliable information about their maker. In 1893 the art dealer Siegfried Bing had charged Iijima, who was his Japanese research assistant, to gather materials for a projected biography of Hokusai to be published in Europe. Instead, after interviewing individuals who reminisced about the artist and collecting anecdotes, correspondence, and records about Hokusai's book and print series, Iijima wrote his own biography, which was published in Japan by Kobayashi Bunshichi, a major international dealer in prints. By establishing himself as the author of the first biography of Hokusai at a time when print collecting and scholarship was dominated by Europeans and Americans, Iijima sought to rekindle admiration at home for an artist who had garnered unparalleled acclaim abroad. By the same token, he was arguably also opening up a space for himself and others in Japan to participate in modern discourses on Japanese print culture if not on their own terms, at least in their own language.

Iijima's biography was translated and adapted into French for Goncourt by the art dealer Hayashi Tadamasa, who was in Tokyo the year the book appeared to promote an exhibition of French Impressionism he had organized, the first ever in Japan.[62] Angry at both Iijima's duplicity and Goncourt having upstaged him, Bing wrote an article on Hokusai in *La revue blanche* accusing Goncourt of plagiarism.[63] This cultural struggle pitting a Jewish art dealer against a distinguished

French author, both claiming to have "discovered" Japanese art, broke just as Bing was preparing to open his newly renovated Paris shop, Art Nouveau, as a center for innovative styles associated with the international decorative arts movement.

Goncourt's literary prominence as well as his status as a well-known collector of things Japanese helped to establish his monograph as the authoritative source of information on and validation of Hokusai as a world-ranked artist. In so doing he followed the same "template" that, as Sarah Burns has shown, was also being developed for the "invention" of the modern artist—one whose constituents included the expression of a "pure" national vision, genius, individuality, authenticity, and progress.[64] Also central to this construct was the notion of the creative artist as an oppositional figure whose talent is unrecognized by his contemporaries.

In writing *Hokousai,* Goncourt did not aim simply to celebrate the heroism of the Japanese artist, but also to comment on his own culture.[65] This double agenda is clear from the opening lines of the book: "In both East and West it seems that the same injustices await the artist who breaks with the past! Here we have a painter who successfully banished Persian and Chinese influences from the painting of his country, transforming and rejuvenating it, with a religious devotion to the study of nature, into an art that was truly Japanese."[66]

That the French litterateur's biography was as much about the writer as the artist is also evident from the fact that, despite the explosion of technologies available for reproducing Hokusai's prints, apart from a frontispiece portrait of the artist, it does not contain a single illustration. Readers of *Hokousai* had to visualize the works through the author's words alone.

Goncourt's description of "Under the Wave off Kanagawa," for which he proposed the title "La vague," exposes this process of translation:

> The interior of a wave opposite Kanagawa (at Tokaido). Print which should have been called "The Wave" and which is, like the sketch, somewhat deified by a painter with a religious fear

of the formidable sea completely encircling his country; a sketch which gives you the full fury of the wave's ascent in the sky, the deep blue of the transparent interior of its curl, the rending of its crest as it disperses in a rain of droplets formed as animal claws.[67]

By renaming Hokusai's print "La vague," Goncourt gave it a new identity, one that was Japanese but also French. Naming is one of the most powerful tools of cultural imperialism. The physical and lexical appropriation of Hokusai's masterpiece had many French precedents, most notably in the identification of Leonardo da Vinci's celebrated *Mona Lisa,* which was in the Louvre, as *La Joconde.* Goncourt's verbal relocation of Hokusai's image similarly gave it local resonance as well as a new immediacy. "Sous la vague de Kanagawa" begged the question, where or what is Kanagawa? The title "La vague" transformed its Japanese particularity into a universalized modern defined by France.

When Goncourt's book appeared, Gustave Courbet had been canonized as one of France's greatest artists. Courbet was the most prolific and admired nineteenth-century French painter of waves, most also known simply by the title *La vague,* and these are likely to have helped to constitute the visual and verbal climate within which Hokusai's print was received, experienced, and understood by Goncourt and his readers.[68] Between 1867 and 1872, Courbet painted some thirty versions of this subject, bringing to their representation both a new sensibility that privileged the direct experience of nature and a new mode of expressing it (figure 2.13). In a departure from earlier traditions of European marine painting, which included ships or figures walking along the shore, Courbet's large breaking waves are devoid of such extraneous details. They plunge the viewer into their action, giving an unprecedented sense of immediacy in a manner much like Hokusai's "Under the Wave off Kanagawa," with which Courbet was likely familiar. Courbet's experience of the sea, however, was not mediated solely by such exotic pictorial conventions. He was also a keen swimmer. Sea bathing was a therapeutic activity promoted at the time by several French doctors, who even went so far as to prescribe "the

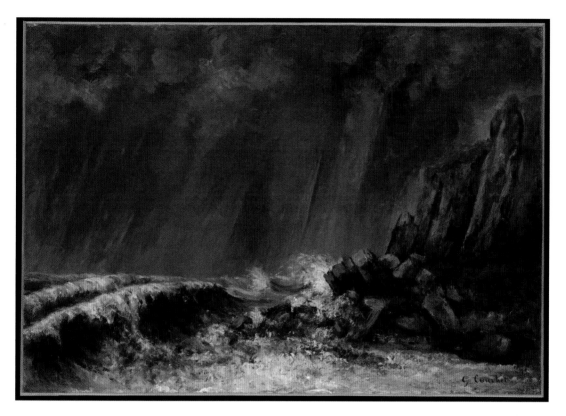

FIGURE 2.13. Gustave Courbet, *Marine: The Waterspout*, 1870, oil on canvas, 27 ⅛ × 39 ¼ in. (68.9 × 99.7 cm.). (H. O. Havemeyer Collection, gift of Horace Havemeyer, 1929. Acc. No. 29.160.35. © 2013. Image copyright The Metropolitan Museum of Art/Art Resource/ Scala, Florence.)

manner in which the wave must be received on the body." As Alain Corbin has written of the transformation in attitudes toward the sea between 1750 and 1840, "bathing among the waves was part of the aesthetics of the sublime: it involved facing the violent water, but without risk, enjoying the pretence that one could be swept under, and being struck by the full force of the waves, but without losing one's footing."[69] Courbet successfully translated this sensation into paint.

Goncourt's reference to "La vague" in terms of "religious terror," a concept intrinsic to the aesthetic of the sublime, was also key to the process of its translation for European viewers. Based on ideas developed by Edmund Burke, the sublime consisted of that which was vast, terrible, and suggestive of pain and danger. For nineteenth-century viewers, conditioned by habit to seeing nature in terms of the sublime, it took little to conceive of Hokusai's print within this framework. Goncourt thus carried out a double act of translation, not only from pictures to words, but also from the language of pictorial experience of one culture into the language of another.

Not all viewers shared Goncourt's reading, however. Whereas he saw sublime terror, in Siegfried Bing's view, "it is precisely this admirably balanced harmony in the forces brought together—the revelation of the mysterious law which co-ordinates every atom of Nature in a common action—that inspires us with a feeling of peace and security even in the midst of the wildest chaos and warring of the elements."[70] For Bing, it would seem, the sequestered, monumental form of the wave transfixed movement into an almost lapidary stasis that he found reassuring. Where others saw the potential for disaggregation, he saw aggregation. Bing's observations—first presented in a lecture to the members of the Japan Society in London—underscore the polyvalence of the wave's configuration, depending on whether the beholder is attuned to its stability or its disruptive dynamism.

Bing's and Goncourt's contrasting interpretations of "Under the Wave off Kanagawa" speak to the contest for interpretive control and "ownership" of Hokusai that was being fought out in the pages of newspapers, magazines, and books among collectors, dealers, and aspiring scholars in Japan, France, Britain, and America. Goncourt wanted to be in control of the process of defining cultural values in France and resented the new commercial culture of which Bing was a part. A conservative who identified Japanese art with the values of the ancien régime, he was among those who, in the words of Gabriel Weisberg, "saw the [art nouveau] movement's alliance of social and artistic reformers, as well as the influx of foreign influences with each

succeeding international art show, as a pernicious threat to the status quo, aided and abetted by such other 'unacceptable' elements as Jews, liberals, and *nouveaux riches*."[71] Bing's own prophetic pronouncements in 1897 did little to help him in this chauvinistic climate: "The influence of France will never again dominate the world so completely as in former times. As communication between the different nations becomes easy and constant, as frontiers grow nearer, and the exchange of ideas multiplies, one may imagine each separate people as fearing lest the formidable leveling wind that is now passing over the world overtakes them."[72]

The Tale of Tsar Saltan

The adaptations of "The Great Wave" in Russia underscore the interpretation of its diffusion in terms of intersecting centers rather than center and periphery relations. The international arts and crafts movement, which had its origins in the writings of John Ruskin and William Morris in Britain, was one such node. Although it encompassed an extremely disparate range of artistic activities in the various locales where it took hold, all had in common a utopian vision of bringing about social, political, and cultural change through art and design. Unlike the progressive industrial reform movement in which Cutler and Dresser participated, however, the Arts and Crafts Movement had a strong moral and antimodern dimension that led to the romanticization of local handcrafted techniques and styles of the preindustrial past.

Defining a new Russian vernacular art and design was a central objective of artists associated with the World of Art, an eclectic group that espoused the ideology of the British Arts and Crafts Movement.[73] The reform of art and design across America and Europe depended on differentiating between those who were modern and those who were not yet modern. In the Russian context, this impulse took many forms, among them, the valorization of indigenous folk traditions to revitalize contemporary graphic design. Some artists sought inspiration in the "primitive" authenticity of their own Russian "folk art," while

also turning to what they understood to be analogous manifestations in other cultures, Japan's among them. The perception that Japanese art was culturally pure and uncontaminated by outside influence made it particularly suitable for national narratives, even those of another country.

The visual articulation of this homology is particularly pronounced in Ivan Bilibin's book illustrations for Pushkin's *The Tale of Tsar Saltan* published between 1904 and 1905 by the Department of State Documents as part of a series of national fairy tales.[74] Japan became part of the constructed authenticity of Bilibin's vision of Russian national identity through what anthropologist Johannes Fabian has called "chronopolitics," a temporospatial mode of thinking in which people living at a geographic distance are understood also to be living in an earlier stage of development.[75] Japanese "picture" books confirmed these expectations simply because they privileged image over text. Despite Japan's rapid modernization, many artists continued to promote the fiction that the description of the natural world was an innate talent of all Japanese, who had, as John La Farge put it, "the simplicity of attitude in which we were once children."[76] That this vision was shared in Russia is clear from "The Genius of Children," the title of an 1896 article about an exhibition of Japanese art.[77] This cultural infantilization recommended Japanese art as a source of inspiration for children's book illustration in Britain, the United States, as well as Russia.

Exhibitions of the art collections formed by Sergey Kitayev (or Kitaev) and others, first in St. Petersburg and later in Moscow, beginning in 1896 and continuing even into the 1904–1905 Russo-Japanese War, were instrumental in stimulating Russian Japonisme.[78] Enthusiasm was further fostered by British and French publications with admiring accounts of Hokusai's work disseminated within Russia through the journal the World of Art group published. Hokusai's books and prints apparently made a particularly strong impression on Ivan Bilibin. A student at the art school where he taught recalled that Bilibin often brought prints and books to class, among them impressions from the *Thirty-Six Views* and the *One Hundred Views of Mount Fuji*.

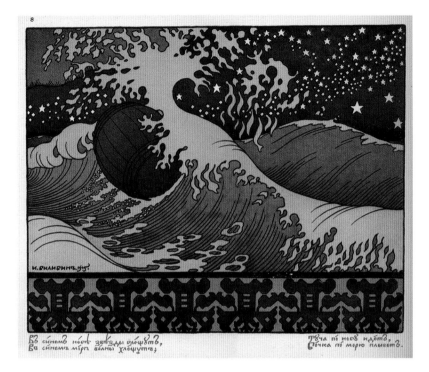

FIGURE 2.14. Ivan Bilibin, illustration from Pushkin's *The Tale of Tsar Saltan*, 1905. (Photograph courtesy David Crowley)

"As a result, that volcanic mountain became as familiar to us as Aiu-Dag and Ai-Petri in the Crimea."[79]

Bilibin's personal style speaks to a creative fusion of elements of Russian folk art, art nouveau, as well as Japanese prints, all of which had in common a nonillusionistic approach to the representation of pictorial space.[80] Scholars have drawn attention to a number of illustrations in *The Tale of Tsar Saltan* that, though redeployed in local contexts that camouflage their sources, suggest inspiration from Hokusai's waves.[81] This relationship is most apparent in a picture of a giant crested wave buffeting a wooden cask beneath a starry sky (figure 2.14). In this dramatic episode, palace plotters have entombed the

Tsarina and her baby son in a large cask and then cast them adrift into the sea. In Pushkin's poetic narrative, they are saved when the anthropomorphized wave responds to their pleas:

> Wave, my wave, I beg of thee,
> Ever ranging, ever free,
> Foaming far in feckless motion
> Rolling rocks beneath the ocean,
> Coursing up the coastal crest,
> Heaving hulks upon thy breast
> Up onto the mainland wave us![82]

In his work, Bilibin used the energies of the wave in different ways as part of a vocabulary of what might be termed international nationalism. If his Japanese models lost something of their recognizability after being reworked into illustrations for a Russian fairy tale, their relocation did not diminish Japan's weight as a source of artistic validation. By the same token, his recodings contributed to the incremental expansion of the motif's field of visual referents. Ironically, this publication appropriating the visual language of a "childlike" Japan to build Russian cultural identity appeared in the midst of the Russo-Japanese War. From a retrospective vantage point, Bilibin's vision of the Tsarina and her baby—the future of Russia—buffeted by Hokusai's wave, might be read as an articulation of the previously unrecognized operations of Japanese imperialism.

La Mer

In the opening decades of the twentieth century, Hokusai's "Under the Wave off Kanagawa" became part of an ever-widening and diversified representational network through its association with Claude Debussy's *La mer*. The composer had a strongly visual imagination, declaring, "I like pictures almost as much as music," and surrounded himself with objets d'art, many of them from Japan.[83] That the wave occupied a special place in his imagination is suggested by his ownership of an

impression of Hokusai's work and a photograph of himself and Igor Stravinsky standing before it (figure 2.15). In addition, Debussy, who was exceptionally attentive to the design of his sheet music, seems to have requested that an image based on the print appear on the cover of the musical score of *La mer*. The stylized design figuring on the first edition was rendered in shades of green, blue, and beige with black contours, and in a letter to his publisher Debussy commented on the pleasing lacquered effect of the wave's outline (figure 2.16).[84]

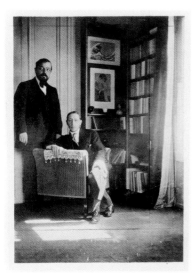

FIGURE 2.15. Photograph of Claude Debussy and Igor Stravinsky standing in front of Japanese prints, 1911. (Bibliothèque national de France, Paris)

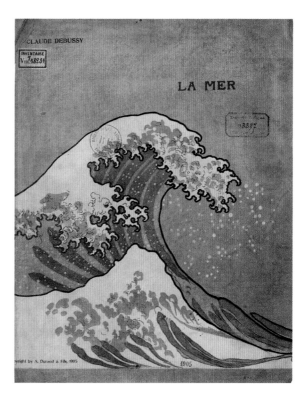

FIGURE 2.16. Cover design of the musical score of Debussy's *La mer*, published 1906 by A. Durand, Paris. (Bibliothèque national de France, Paris)

Color, or orchestral timbre, is widely thought to be one of Debussy's most distinctive contributions to music. It is difficult to determine, however, whether the allusion to "Under the Wave off Kanagawa" was merely emblematic of a perceived fashionable affinity between the language of Japanese prints and his music, or whether it was intended to suggest more active agency. Art historical literature often takes for granted the print's influence, but Debussy's own silence on the subject leaves open to interpretation the question of whether it helped him transcend traditional musical language to achieve a deeper, more authentic perception of ambient sound in the same way that the release of form and color from their traditional role of representing objects was said to free painters from conventional modes of expression.[85]

The voice of the sea was hardly new in music in 1905, when Debussy completed *La mer, trois esquisses symphoniques pour orchestre* (The sea, three symphonic sketches for orchestra). Wind and waves are the theme of "Soave sia el vento," an aria in the first act of Mozart's *Così fan tutte*; the mutability of the sea is the subject of Mendelssohn's *Hebrides* overture; and the sea is a key motif in Wagner's operas. Various French orchestral works of the 1890s also take the sea as their subject.[86] The originality of Debussy's *La mer*, however, has long, and controversially, been linked to the composer's interest in the visual and literary arts.[87] While the imagistic title of *La mer* as *esquisses* (sketches) as well as the titles of its three movements, "De l'aube à midi sur la mer," "Jeux de vagues," and "Dialogue du vent et de la mer" (From dawn to midday on the sea; Play of waves; and Dialogue of wind and sea), lend themselves to such interpretation, the composer himself was resistant to it and particularly hostile to those who labeled his work "musical impressionism." Nonetheless, this characterization, which got its start among critics who drew unflattering analogies between the "vagueness" of impressionist painting and that of his compositions, has persisted.[88] As conductor Leon Botstein has pointed out, when the composer denied that he was doing "what imbeciles call 'impressionism,' " he was objecting to its popular (mis)understanding as a form of expression that was vague and indistinct. "Debussy," argues Botstein, "understood, as many did not, impressionism's recasting of realism."[89] Following from this line

of thought, it might be argued that Hokusai's print was emblematic of the discovery, in Debussy's own words, of "something else—*realities,* in a manner of speaking."[90]

Although the relationship between the visual and musical arts had a long tradition in Europe, in the nineteenth century contact with and idealization of non-Western societies, where, it was held, people lived sensorially richer lives, enhanced awareness of the value of all the senses, while also contributing to growing interest in the correspondences among them. Paradoxically, developments in the sciences were further catalysts for this trend. The popularization of the wave theory of light, by undermining the classical system of perspective based on geometric principles and revising understanding of human perception, revolutionized both artistic and musical cultures. As Andreas Bluhm and Louise Lippincott have written in their study of light, art, science, technology, and culture in the industrial age, many scientists emphasized the

> analogies between the light waves that produced sensations of color and the sound waves that produced sensations of musical tone. It is a very short mental jump to the notion that just as musical harmonies result from complementary patterns of sound waves, so visual harmonies would result from complementary patterns of light waves, that is color. . . . If light waves acted directly on the senses, and therefore on the emotions (as did sound waves), narrative content simply interfered with the direct communication of feeling from work of art to viewer.[91]

The use of color independent of descriptive function was recognized in Europe and America as a distinguishing feature of Japanese prints, as discussed above, and the Japanese palette provoked visceral reactions among some French viewers. Japanophile painters including Monet, Van Gogh, and Whistler mobilized this alternative language of color in order to lend emotional authenticity to their painting. Whistler also underscored the synesthetic relationship between the visual and musical arts by giving his paintings titles such as *Harmony in Blue*

and Silver. Comments on Hokusai's *Thirty-Six Views of Mount Fuji* by Siegfried Bing and the American collector-dealer Ernest Fenollosa suggest that, in the 1890s, such synesthetic correspondences were also part of wider critical reception of Japanese prints. Whereas Seigfried Bing referred to the "tender vibrations" of Hokusai's colors in his lecture on this series, Ernest Fenollosa declared, with specific reference to "Under the Wave off Kanagawa": "It is, possibly, not too odd to say of its color, that it actually affects the nerves with a pleasure so keen and strange that its vibrations almost pass into pain, as in hearing some of Chopin's music."[92]

Avant-garde composers active during the first decade of the twentieth century were also translating their experiences of color into musical language. Rimsky-Korsakov and Alexsandr Scriabin, for instance, freely associated colors with music and even matched them with specific keys, such as E major with blue.[93] Debussy himself used the language of color and light in the titles of works such as *En blanc et noir* (In white and black) or *Caprices en blanc and noir.*[94] Although these might appear to be little more than fashionable titles, the composer's comparison of the orchestration of his own "Jeux de vagues," the second movement of *La mer,* to Wagner's *Parsifal,* as if "lit from behind," suggests a much deeper relationship between the visual and musical arts.[95]

Debussy's close friendship with the symbolist poet Stéphane Mallarmé and other members of his "Salon japonais" may have contributed to his critical sensitivity to such synesthetic correspondences as well as to the desire to experience Japan through its art.[96] Debussy was an avid collector for whom the touch, as much as the sight, of objects mediated access to the "authentic" cultures he admired. His friends recalled that he owned a wooden toad from Japan that he called his fetish and carried with him during his travels, claiming not to be able to work without it.[97] When asked about the sources of his music, Debussy underscored the importance of physical intimacy with such objets d'art: "I live in a world of imagination, which is set in motion by something suggested by my intimate surroundings rather than by outside influences, which distract me and give me nothing. I find an exquisite joy where I search deeply in the recesses of myself and if anything original

is to come from me, it can only come that way."[98] It is noteworthy in this respect that, in addition to *La mer*, two further compositions, *Estampes* and *Poissons d'or*, refer to Japanese works in his collection.[99] The former title alludes to Japanese prints, and the latter evokes the golden carp under a willow figuring on a *maki-e* lacquer plaque he owned.

Debussy and his friends may have shared a taste for Japanese art, but their reception and interpretation of it was highly individualistic. Friends recall that the sculptress Camille Claudel and Debussy enjoyed looking together at Hokusai's *Manga*, but like him she was especially drawn to the terrifying yet seductive forces of nature evoked in "Under the Wave off Kanagawa."[100] When she creatively translated it to sculptural form, with the title *La vague*, she seems to have self-consciously located herself in relation both to Hokusai's print and to a Western cultural identification of the sea in terms of the female body (figure 2.17). Her three-dimensional composition, dominated by a towering, gravity-defying wave beneath which stand three female bathers, appears to present an image of primitive, sensual jouissance, but one figure's upward gaze at the threatening avalanche of water might also be read as an expression of vulnerability. The tension between the literal and the metaphoric—water as nature and woman as nature—points to darker, gendered readings that distinguish these *baigneuses* from the works of Claudel's

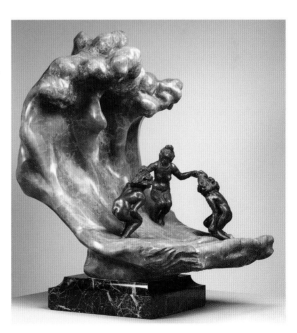

FIGURE 2.17. Camille Claudel, "The Wave," 1897–1903, onyx, marble, and bronze, height 24 ¹³⁄₃₂ in. (62 cm.), width 22 ³⁄₆₄ in. (56 cm.), depth 19 ¹¹⁄₁₆ in. (50 cm.). (S.6659. Photo: Musée Rodin. © ADAGP, Paris, and DACS, London, 2013.)

male counterparts.[101] Claudel made three versions of *La vague:* the first (1897) in plaster; a second in bronze, commissioned in 1903 by the art dealer Hayashi Tadamasa but presumably lost; and a third in bronze and green onyx with a marble base begun in 1898 and first exhibited in 1905, the same year that Debussy completed *La mer.*[102]

Paul Claudel, brother of Camille, was another member of the "Salon japonais." His identification of the wave (although not specifically Hokusai's) with the creative process of writing offers a further instance of the expanded and multivocal readings of this resonant motif.

> The hand of a writer covers the paper from beginning to end in a uniform motion. A million different words, lending strength and color to each other, owe their life to this uniform motion, so that the entire mass . . . feels each contribution of the moving pen. . . . The essential creative act is the emission of a wave. The wave can be tentatively defined as a movement which originates in a center and reaches all the points of an area circumscribed by the bounds it draws when completed. . . . The effect of the wave is an *internal formation* or extension of a certain form within the area it determines. Form is nothing but a variation of the circle. By form, I mean not only the outline of a certain figure, but, owing to its being closed, the constitution of a certain medium, in as much as all its parts obey the rhythm which regulates them.[103]

Written only a few years after Claudel's first journey to China and Japan, it is likely that this passage from his *Art poétique* (1903) followed from his newfound acquaintance with calligraphy, an art form that would play an increasingly important role in his literary activity.[104] Regarded as the highest form of artistic expression in East Asia, calligraphy–especially in its cursive form—produces with the rising and falling motion of the brush an endlessly varied, flowing line like the rhythms of waves. Claudel's affinity for this art was not surprising given its synthesis of writing, poetry, and painting, and—more important—the

success with which calligraphic strokes externalize thoughts in a way that seems to transcend the mind/body dichotomy. Paul Claudel, like Debussy, it would seem, understood the wave as gesturing beyond external reality to the very essence of creativity.

Waves are highly fugitive, as is sound. Just as waves do not exist except through movement, music only exists when it is played. When *La mer* was first performed in Paris in 1905, it received mixed reviews. Uncomprehending reviews of its performances in the United States and elsewhere continued for some time before it was finally recognized as a milestone in French musical modernism. Until then, awareness of the special relationship between this symphony and Hokusai's print probably went no further than Debussy's circle of avant-garde friends and a few musicians with access to the first edition of the score, issued in a print run of only one-hundred.[105]

The activities and writings of Kuki Shūzō, a scholar philosopher active between Japan and Europe in the 1920s, help to document the spread of the association between Debussy's composition and Hokusai's print. Although the enthusiasm for Japanese prints had waned somewhat in Europe by the 1920s, this decade saw a revival of interest in them among Japanese artists and intellectuals. The philosopher Kuki Shūzō contributed to this trend through his essay *Iki no kōzō* (On the structure of *iki*), a forceful validation of the aesthetic sensibility of Edo townspeople in which ukiyo-e, the art of the floating world, figured so prominently. The draft of this work was written while Kuki was in France.[106] The son of an influential diplomat who became a prominent figure in the Japanese cultural world in the early Meiji era, young Kuki had traveled to Europe in the 1920s to study philosophy first in Germany and then in Paris. In 1928, coincidentally the year of *La mer's* first recording, he was invited to present two lectures on the theme of time that were subsequently published in French. The second of these, "Expression of the Infinite in Japanese Art," drew analogies between the music of Japan and that of Debussy, and the relationship between *La mer* and Hokusai's print in particular. Kuki asserted that "thus the wave of Hokusai is as much an example of expressionism as it is of impressionism, it is just as much *mundi intelligibilis forma* as *mundi*

sensibilis forma. In the same way, what has in music been called, sometimes abusively, impressionist, what was thought to be only a fleeting, 'momentary impression' is very often the expression of an eternal and mystic voice coming from the depths of the soul."[107]

Kuki's comments are noteworthy for their adoption of terms such as "impressionist" and "expressionist" to characterize "Under the Wave off Kanagawa." This language lifted the work from the realm of Japanese popular art to that of a high modernism while at the same time attributing to the woodblock print, through its association with *La mer,* a mystical profundity. Kuki's recalibration of the meaning of prints founded on their reception in Europe arose as a reaction to the social and historical circumstances that had led them to be dismissed in Japan. Edo prints and the discourses around them were central to Kuki's vision of Japanese national history, heritage, and race and the unique aesthetic these had produced. Yet his objectification of his own culture and the methodology he brought to its analysis proceeded from assumptions, expectations, and interpretations formed in Europe.

Hokusai's "Under the Wave off Kanagawa" did not have a fixed and singular voice in the nineteenth and early twentieth centuries but rather multiple ones that mutually reinforced one another. The aesthetic pleasure that its beholders derived from it followed from the associated ideas and images it stimulated. The power of Hokusai's design was its ability to enlist around it a huge range of mutable and often contradictory beliefs, aspirations, and symbolic meanings: the promise of a better world through artistic reform, the democratization of art through technologies of replication, the simultaneous allure and danger of tradition and modernity, the recovery of multisensory authenticity, and the rediscovery of a national past. Although these meanings were highly contingent and variable even within the same cultural contexts, all speak to the nationalistically motivated, modern, and modernist investment in the reception and interpretation of Hokusai's "Under the Wave off Kanagawa."

America's Japan

In the middle of the world we float,
In the middle of the sea.
The realities remain remote
In the middle of the sea.

— STEPHEN SONDHEIM, *Pacific Overtures*, 1976

IN THE OPENING DECADE OF THE TWENTY-FIRST CENTURY, two very different evocations of "The Great Wave" appeared in the United States. Published in 2003 on the 150th anniversary of Perry's arrival in Japan, a book, *The Great Wave: Gilded Age Misfits, Eccentrics, and the Opening of Old Japan,* featured on its opening page a detail of Hokusai's print.[1] The title of Christopher Benfey's engaging narrative affirmed the perception that the United States has a special relationship with Japan because of Matthew Perry's role in ending its "self-imposed isolation from the outside world." Three years later, a quarter-page advertisement for the Japanese newspaper *Yomiuri Shimbun* in the *New York Times* showed two rows of Hokusai's signature waves, one facing East and the other facing West, with a bridge of Japanese language newspapers between them extending the viewer's gaze from New York to the silhouetted skyscrapers of modern Tokyo and Mount Fuji beyond (figure 3.1).[2] Claiming to have "the largest circulation of any newspaper in the world, with over 10 million copies sold daily," and "26 million readers who trust us to keep them informed and in touch with what's happening in their world," *Yomiuri Shimbun*'s ad signaled the global flow of capital that has bound the two countries together economically as well as culturally.

That these very different publications could take for granted their readers' familiarity with the phrase "The Great Wave" and Hokusai's distinctive cresting silhouette is a measure of the iconic role of the motif in expressing America's long-standing relationship with Japan. Chapter 2 showed how, in the nineteenth and early twentieth centuries, the wave figured in multidirectional cultural flows that were geographically expansive but relatively shallow, not extending much beyond artists, designers, and collectors. The wave's trajectory in the United States deepened as it became enmeshed in narratives of Japanese immigration, World War II, the American Occupation, and the political blocs created by the Cold War. These factors along with the two countries' close and often competitive economic relationship since the 1970s form the discursive framework for many disparate reinventions of this image.

The level of public recognition "The Great Wave" now enjoys follows from the extraordinary proliferation of its reproductions and adaptations since World War II, when Japan reemerged on the world stage as an ally in the fight against communism and rose rapidly to the status of the most powerful economy in the world after the United States. During this period Hokusai's design served to evoke Japan's exceptionality as an Asian nation and also a global bilateralism often disguised as multiculturalism. Familiarity with Hokusai's signature image grew in Europe as well, but the wave took on particular significance as an index of the ups and downs of America's ties with Japan.

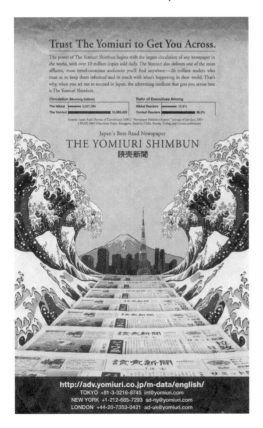

FIGURE 3.1. *Yomiuri Shimbun* advertisement (*New York Times,* September 27, 2006)

Hokusai's "Under the Wave off Kanagawa" infiltrated postwar American consciousness in many ways. Museums contributed to its dissemination through exhibitions and related publications, but commerce and the mass media were also instrumental in this dynamic and ongoing process. In 1953, on the one hundredth anniversary of Commodore Perry's trade negotiations with Japan, a commemorative stamp was issued, and the first day of issue cover featured an adaption of Hokusai's design (figure 3.2). As Japan was "rehabilitated," humor began to figure in reinventions of the wave, as illustrated by a 1959 cartoon in the *New Yorker* magazine (figure 3.3). In the United States, as earlier in France, multiple acts of translation were crucial to this process of domestication. The anglophone word "wave" brought the image into a fundamentally different metaphorical realm from that which it occupied in nineteenth-century Japan or France, one associated with human gestures (hand waves), neurological activity (brain waves), hair (hair waves), and surfing's "perfect" wave. Although it is impossible to pinpoint the exact moment when the print's long, unpronounceable

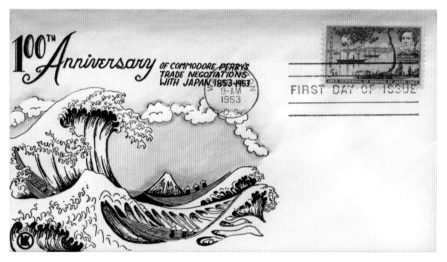

FIGURE 3.2. U.S. stamp commemorating Commodore Perry's 1853 trade mission to Japan. (Author's collection.)

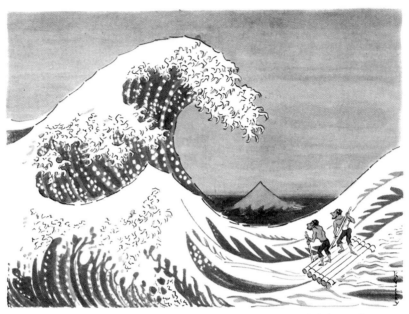

"We're in Japanese waters, that's for sure."

name was replaced with the "The Great Wave," this catchy, brandlike identity played a crucial role in its cultural assimilation, asserting the image as the definitive wave, just as China's Great Wall is the world's definitive wall.[3] If the greatness of the wave has something to do with its sheer scale, it is also a quality that speaks to its metonymic relationship to the visual idiom of ukiyo-e within the international language of "great" art. A photomontage of the Venus de Milo, the Mona Lisa, Andy Warhol's Marilyn Monroe, and a Rembrandt self-portrait all under threat of being swamped by Hokusai's great wave, accompanying a 1997 article in the *New York Times* about the National Endowment for the Arts, underscored this dual sense of its greatness.[4]

This chapter explores the shifting forms and meanings of "Under the Wave off Kanagawa" as Japan came to be recognized as a part of the developed world, an honorary Western power, but one at some cultural distance from and threatening to other rich and powerful Western

nations. References to Hokusai's wave are ambivalent and uneven, often surfacing in times and in places that intensify the dialectics between the United States and Japan even as they seem to give rise to pluralism. Beginning with the formation of private and public collections of Japanese prints in the 1890s, when American prosperity created a flourishing culture of collecting, and concluding more than a century later, this chapter selectively considers both the wave's incarnations in the United States and those Japanese artists created in response to American constructs of Japan, tracing the image's movements in and out of the spaces of collecting and exhibitions, children's books, graphic design, and new artworks.

Collectors and Collections

Today the United States is a repository of woodblock prints and illustrated books without equal anywhere in the world, even Japan, and these include more than twenty impressions of "Under the Wave off Kanagawa" in public and private collections. The image's reception history in the United States was constituted by both Gilded Age collectors who amassed the vast numbers of Japanese prints now in museums across the country and by collectors of more modest means who acquired a few of these colorful, exotic, and relatively inexpensive forms of graphic art. The narratives of possession that cumulatively formed around these collections fostered the paternalistic view that Americans were instrumental in protecting and preserving an invaluable part of Japan's heritage ignored in the country of its origin. As Louis Ledoux, whose collection was widely exhibited in the 1920s, declared in an essay on Japanese art: Prints were "scorned until recently in Japan, because they were made by and for the people of the middle classes and represented merely the joys and sorrows of this fleeting world."[5]

Recognition of their aesthetic quality and accessibility to the "common man" in Japan led some American proponents to rationalize their collecting by arguing that Japanese woodblock prints were singularly well suited to American taste. Commenting on an exhibition of "specimens of [woodblock prints] that have influenced Western art"

on view in Pasadena in 1929, Arthur Miller of the *Los Angeles Times* observed: "The Chinese painters may have touched loftier heights of pure art than the printmakers of eighteenth-century Japan, but because the latter were a democratic, unpretentious set of artists, they find an immediate response among us, kindle a warmth sometimes left cold by the more rarified beauties of aristocratic Chinese painting."[6] Earlier, Frank Lloyd Wright had used the print's purported democratic value as a selling point in his own prodigious, if controversial, activities as a dealer. For him, the art of Hiroshige was "that of the artisan class, the common people, in the strict sense of the term, and attests to the infinite delight and the inherent poetic grace not of the Japanese nobleman but of the hard-worked, humble son of Nippon of seventy-five years ago."[7] Woodblock prints needed such propagandists to mediate their migration across the Pacific. Although Wright was using the authority of Japanese culture not to legitimate the value of prints for mass consumption, but instead to make them accessible to the chosen few, demonizing the feudal elite who looked down on prints as vulgar was effective propaganda in the "democratic" United States.

The acquisition in 1911 of 40,000 prints that in the words of their donor, William Sturgis Bigelow, "illustrate pretty much all that is worth illustration in the history of block printing in Japan . . . from beginning to end" made the Boston Museum of Fine Arts America's premiere collection.[8] In 1921, 6,495 prints from the collection of the Spaulding brothers, also philanthropists with deep roots in Boston, whose bequest came with the stipulation that they never be shown so as to ensure their pristine condition, were added to this initial gift (see figure 1.15).[9] Today this museum possesses seven impressions of Hokusai's "Under the Wave off Kanagawa": one from Bigelow, two from Spaulding, three gifts of Denman Ross, also an early benefactor of the museum, and still another from Nellie Carter.[10] The Metropolitan Museum is another treasure house of ukiyo-e with multiple impressions of this print, one acquired from Louisine Havemeyer, a collector as enthusiastic about French Impressionist painting as she was about Japanese art, and another from the connoisseur Howard Mansfield, acquired in 1936.[11]

Museums and collectors on the Eastern seaboard were not alone in their enthusiasm: the bequest of several thousand prints from the collections formed by Clarence Buckingham and his sister Kate Sturgis Buckingham helped to make the Chicago Art Institute another major repository. When the prints were first exhibited to the public in 1915, curator Frederick Gookin told the *Chicago Daily Tribune* that "no such an exhibit of Japanese color prints has ever been made in Chicago or anywhere else in the world, except in Paris."[12] Three impressions of the print entered the museum through Buckingham bequests.[13] In 1965 and 1969 San Francisco's Achenbach Collection, with the most extensive holdings in the graphic arts west of the Mississippi, also added to its original 1948 bequest two impressions of the print. One is identified as an original print and the other, as a "reproduction."[14]

The Honolulu Academy of Arts acquired an impression of "Under the Wave off Kanagawa" through novelist James Michener's bequest, predominantly landscapes by Hiroshige and Hokusai. Michener and his Japanese-American wife, Mari, had developed a strong affection for the institution while living in Hawai'i during the research and writing of his novel *Hawaii,* published in 1959, the year the island gained statehood.[15] Michener purchased the majority of his 5,400 prints en masse at an auction of Charles Chandler's collection, which had been formed at the turn of the century. These prints served as the basis of Michener's *The Floating World* (1954), arguably the single most influential American publication on Japanese prints.[16] Woodblock prints do not figure prominently in the Los Angeles County Museum's extensive Japanese collection: it only acquired an impression of "Under the Wave off Kanagawa" in 1981 as a gift.[17] This acquisition suggests that, in the same way a museum of modern art has to have a Picasso, so too a world-class collection of Japanese art must include Hokusai's signature print.

Specific references to Hokusai's waves in the popular press were infrequent before 1900, but mention of the artist speaks to his growing public recognition when the first major U.S. collections were being formed. The journalist Lafcadio Hearn's report on the World's Industrial and Cotton Centennial Exposition of 1884 for the New

Orleans *Times-Democrat,* alluding to the ubiquity of images of Mount Fuji, "of which the great artist Houkousai [*sic*] alone drew one hundred different views," underscores the role of the artist's book illustrations in the dissemination of this motif.[18] Most references to Hokusai and his art, however, were woven into local articulations of larger questions of American relations with Japan. A fictional conversation that appeared in a Boston newspaper in 1883, for instance, has Nora, a housewife, speaking with a "Mr. Hokusai" about the cultural gap between the two countries.[19] In an 1894 article in the *Atlanta Constitution,* "the immortal painter" Hokusai is discussed in the context of "rates of remuneration for artists and writers" in Japan that cause them to lead "from first to last a hand to mouth existence."[20] Similarly, in an allusion to Japanese immigration in California, a *New York Times* correspondent visiting San Francisco in the wake of the 1906 earthquake reports seeing among the hundreds of refugees and ruined buildings "at one corner . . . a Japanese mother with her child, pretty as a picture by Hokusai."[21]

Economic value is a theme running through many newsprint references to Hokusai. The December 1907 issue of *Harper's Bazaar* advises that "Japanese prints when well done, are gifts appreciated by the lovers of something a little unusual" and asserts that "it is possible to get the Hokusai prints—some of them—at reasonable rates."[22] The following year the *Washington Post* reported on the theft of a Japanese album that a certain J. Ross had just purchased for $290. Although it was described as consisting of thirty-seven plates in color done around 835 [*sic*], it is likely that the works in question were a set of Hokusai's *Thirty-Six Views of Mount Fuji.*[23]

The American scholar, collector, and art dealer Ernest Fenollosa argued that prints were unworthy of representing Japan to the world, singling out Hokusai's work for particular criticism, yet he organized the first American exhibition of Hokusai's paintings in Boston in 1893 and, in New York in 1896, the first recorded American showing of "Under the Wave off Kanagawa."[24] Calling it "Fujiyama and a boat," he praised it as "most original and striking" but, as noted in Chapter 2, qualified this by adding that it was almost painful to look at.

Despite such negative assessments, public enthusiasm for Japanese prints grew and along with it international sales and auctions. An annotated copy of the 1909 London auction catalogue of prints belonging to John Stewart Happer of New York provides clues to the relative valuation of "Under the Wave off Kanagawa" at the time. It also illuminates the aesthetic criteria by which discerning collectors were encouraged to select one impression of "Under the Wave off Kanagawa" over another. Two impressions were on offer as part of a complete set of the *Thirty-Six Views.* Whereas the first, described as "an exceptionally fine sharp copy," fetched only £9.10, the second, "an exceptionally brilliant impression," fetched £23.10, roughly the equivalent of £542 and £1340 (approximately $876 and $2167) respectively in 2005.[25] The growing importance among connoisseurs of discerning fine distinctions among early and late editions is clear from the commentary on the second print: "It will be noted that in the background there are some slightly tinted clouds in the upper part, which in late impressions, even from the original blocks, are scarcely observable, and in reprints are left out altogether, or if put in have harsh outlines. Here the softness of that cloud effect is just what should be desired. Out of many copies under observation this is the finest ever seen."[26]

Alongside auctions, impressions of "Under the Wave off Kanagawa" are likely to have changed hands through a cadre of sophisticated Japanese art dealers, including Hayashi Tadamasa, Matsuki Bunkyō, and Yamanaka Sadajirō. Moving easily from one continent to another, these men brought reassuring authority and authenticity to their commercial transactions with American collectors.[27] Announcements of their sales exhibitions often featured in local newspapers: the *Independent* reported on a "magnificent impression" of Hokusai's "Wave" on sale at Yamanaka's New York Gallery in 1916.[28] Prices were also publicized, as was the Metropolitan Museum of Art's purchase in 1925 of impressions of "The Great Wave off Kanazawa [*sic*]" and "Red Fuji in Storm" for $375 and $300 respectively.[29] The publicity surrounding the impressive prices this print commands in the global art market today continues to fuel public awareness of its iconic status. The steady appreciation in value of this work is reflected in the $220,000 an

impression of "Under the Wave off Kanagawa" brought at auction in 1991. In 1948, the same work was sold for $500.[30]

Although World War II dampened enthusiasm (and prices) for ukiyo-e, it was rekindled after the war among a new generation of collectors, many of whom, unlike their predecessors, had firsthand experience of Japan. The American Occupation of Japan between 1945 and 1951, when more than 500,000 American members of military and civilian forces passed through that country, dramatically expanded opportunities for Americans to acquire woodblock prints. The dealer Watanabe Shōzaburō helped to fuel a mutually reinforcing enthusiasm for ukiyo-e and new-style woodblock prints produced since the turn of the century (*shin-hanga*) by putting both on display at Post Exchange (PX) stores, where they could be readily purchased by individuals who might never have thought to enter a shop specializing in prints or art. He also made the designs of Hokusai and Hiroshige affordable by reissuing their landscape prints made from newly carved blocks, a practice he and others had inaugurated before the war, when international demand was at its peak.[31] These were printed on Japanese papers, giving them the feel and look of authentic Japanese prints, thus satisfying a craving for ownership of beautiful images.

In Japan, many Americans found themselves empowered by relative wealth in terms of the local economy, a condition that fostered the acquisition of Japanese prints, whether as artistic souvenirs or as the start of a serious collection. Some postwar collectors may also have felt, as did H. E. Robison, an American enthusiast of *shin-hanga,* that by buying prints they were helping to build a bridge across cultures that had been divided.[32] Robison's conviction exemplifies the way Japanese prints of all kinds became implicated in the sentimentalized "global imaginary of integration" that scholar Christina Klein argues is central to the "middlebrow aesthetic." Those who shared this American ideal not only helped to produce knowledge, but asserted a special relationship with Japan whose aim was to contrast America to European imperialist nations and to posit America as the "benefactor and protector, as well as the nurturer of democracy and modernizing reforms."[33]

By focusing on the natural beauties of Japan and avoiding the contradictory, and potentially politically sensitive, representations of the real conditions of the country, Japanese landscape prints, those of Hokusai and Hiroshige in particular, helped to blunt the horrific consequences of the bombing, which had rendered Japan, in the words of one American, "like the face of a still-beautiful woman pockmarked by ugly scars."[34] In suppressing the realities of modern Japan, picturesque views of Mount Fuji or the Tōkaidō Road also may have helped to assuage guilt at the devastation Americans themselves had wrought, a response that would have intensified after the appearance in 1946 of John Hersey's shocking best seller about the atomic bomb, *Hiroshima*.[35] More than stable and reassuring descriptions of specific locales within Japan, landscapes were comforting spatial metaphors for the resistance to change taking place all around—in Japan as well as in cities and towns at home. The image of Japan as a scenic country of nature-loving, artistic people has had an enduring hold on the American popular imagination, but, in the aftermath of World War II, promotion of this image became part of an active agenda on the part of government officials in Japan and the United States, and one in which popular writers like Pearl Buck, James Michener, and Oliver Statler participated as well.[36] Oliver Statler's *Japanese Inn,* a historical novel set against the backdrop of the Minaguchi Inn on the Tōkaidō Road, satisfied the popular hunger to rediscover the "old" Japan. When it appeared in 1961, it was on the *New York Times* best-seller list for twenty-three weeks, only slightly longer than *Sayonara,* James Michener's 1954 pioneering novel about interracial marriage in postwar Japan.[37] Ukiyo-e lent itself to helping Americans reimagine Japan and its people in a positive light because private and public collections across the country had already made it familiar. Ownership also made Americans stakeholders in its interpretation.

Destruction and Renewal

Children's literature has been a significant but overlooked platform for the popularization of Hokusai's wave in the United States. Deborah

Kogan Ray's *Hokusai: The Man Who Painted a Mountain* (2001) features an adaptation of "The Great Wave" on its cover, and in the author profile Kogan Ray declares that her encounter with this powerful image in a museum at age sixteen led her to become an artist.[38] *The Great Wave* (2010), also inspired by Hokusai, tells the story of the baby Naoki who fell into the arms of his adoptive father when a great wave swept over his boat.[39] It is nonetheless surprising that one of the most resonant early postwar statements of "The Great Wave's" evolving place in the American imagination appeared in the form of a children's book. Published in 1948, Pearl Buck's award-winning *The Big Wave* tells the story of Kino and Jiya, the sons of a Japanese farmer and fisherman who bravely confront danger and death when a tsunami obliterates their seaside village. With this story Buck became the first American author since Lafcadio Hearn's fictionalized account of his own experiences in Japan to give literary expression to the environmental consequences of a tsunami.[40]

Pearl Buck is best known as the Nobel-prize-winning author of novels based on her childhood in China, but in her autobiography she declared Japan to be her "third country" since it had provided a welcome haven for her and her missionary family on several occasions when they had to escape the political and social turmoil on the continent.[41] While in Japan, she experienced firsthand the kind of natural disaster she would later write about.[42] Although her views accommodated considerable ambiguity and contradiction, these personal experiences made her more engaged and empathetic toward both Chinese and Japanese people than most Americans of her generation. Even as she decried the Japanese military leaders who misled their countrymen, she did not accept the widely held view that Japanese Americans should be identified as enemy aliens, and during the war she responded to a call from the American Civil Liberties Union to testify on behalf of those whose property was being confiscated.[43]

Unusually for the time, *The Big Wave* does not feature the simple happy ending characteristic of most children's fare. Instead, it suggests that war, like volcanic eruptions and tidal waves, is an unpredictable and natural occurrence that is likely to happen again and again.

Buck's introduction to the original edition declares that she wanted the pictures for the book to be "more than mere illustrations," saying: "They should express the spirit of Japan and her people. It's a beautiful country, this Japan, and so they must be beautiful pictures.[44] "Under the Wave off Kanagawa" was among the eleven prints by Hokusai and Hiroshige that Buck selected to illustrate her story. It appears on the page facing the introduction, which concludes: "If you look long and deeply into the pictures while you read the story, you will know how it seems to be in Japan, and you will understand Kino and Jiya and when you understand them, you will like them."[45] Buck's allegory has been reprinted many times and is still used in the classroom to teach eight-to twelve-year-olds the "positive outcomes of tragedy," but the politically fraught postwar environment in which it was originally written and the prints that inspired it have been forgotten because the author's introduction and the prints crucial to the book's original interpretive context were omitted from later printings.[46]

The Big Wave appeared at a turning point in American attitudes toward Japan—the beginning of efforts to rehabilitate the country, directly through an occupation that sought to inculcate American values but also indirectly by encouraging Americans to see Japan in a more favorable light. Ukiyo-e played an important, though largely unanalyzed, role in this process, with Hokusai's "Under the Wave off Kanagawa" often singled out for special attention.

The contrast between an article that appeared in *Life* magazine in 1943 and another in *Reader's Digest* in 1959 speaks to the cultural work the woodblock print and especially Hokusai helped to carry out. In the wartime article, *Chushingura,* also known as *The Revenge of the Forty-Seven Rōnin,* illustrated with "eleven prints by Hokusai in the Boston Museum," served to illuminate "the bloodthirsty character of our enemy." This well-known Kabuki play based on an actual event celebrated the samurai code of loyalty and honor as embodied by forty-seven men reduced to masterless, or *rōnin*, status who avenged their lord's unjust death. "Their military behavior in this war," the article continued, applying the values of this time-honored story to contemporary Japan, "has revealed a cold-blooded ruthlessness,

not only towards their enemy but also toward themselves, that has shocked us."[47]

In sharp contrast, the *Reader's Digest* article "The Magic Hand of Hokusai," condensed from James Michener's *The Floating World,* celebrated the artist as a hero who "became one of the most famous and popular artists in Japan and one of the last and most gifted practitioners of the art called ukiyo-e."[48] Among the handful of prints mentioned in the article, the "Breaking Wave off Kanagawa" is singled out as "an almost perfect piece of art [that] has also been enjoyed by people of all lands."[49]

Although the print's striking visual qualities alone might account for Michener's singling it out, it is difficult to ignore the possibility that both he and Buck saw this subject as a Christian metaphor for Japan. Read against the political backdrop of postwar America, Pearl Buck's *The Big Wave* becomes an allegory of that country's destruction and rebirth through a return to pristine, natural beginnings. Hokusai's single towering wave with Mount Fuji in the background lent itself to such a reading since it acknowledged the stereotype of Japanese violence, while translating it into a sublimely aesthetic form isolated from all the causal and moral ambiguities of the war. This was arguably a visual shorthand that only parents and teachers were likely to understand and needed to explain to children.

The status of a book changes on every reading, and readers today—parents, teachers, and children—bring to it different sets of expectations. Pearl Buck wrote *The Big Wave* in the context of postwar adult fears associated with the beginning of the Atomic Age. It offered a secular understanding of the relationship between humans and nature that helped children deal with a world filled with moral uncertainty and incomprehensibility. When it appeared, Buck's refusal to cater to ideals of childhood innocence was extremely unusual. Today, in the wake of the 2004 and 2011 tsunamis, teacher's guides available on the Internet suggest that it serves instead as a catalyst for classroom discussion of environmental disaster.[50]

The ongoing pedagogical interest in both Buck's *The Big Wave* and Hokusai's "The Great Wave" reflect the way these address the needs of both environmental awareness and multiculturalism in the American

school curriculum. The use of the print for the latter purpose is under-scored by its appearance in a book of sample questions intended for high school students preparing for the SAT exams, whose results deter-mine college admission. One test question featured a line drawing of Hokusai's print followed by the question: "The nineteenth-century woodblock printed above (in detail) is associated with the culture of a. Japan b. India c. Iran d. Myanmar (Burma) e. Thailand."[51] One of the problems with this kind of multiculturalism is that it frames Japan through art in such a way that its people and culture are experienced as part of an imaginary museum. Multiculturalism constitutes a form of distancing and containment that, as Homi Bhahba has argued, is much easier to accommodate within liberal viewpoints than the idea of cul-tural difference, which may be more conflictual and require constant negotiation.[52]

Whose Japan?

The perpetuation of Western stereotypes of Japan through wood-block prints of geisha, samurai, and pristine landscapes has long aroused resentment among Japanese with other aspirations for the nation's iden-tity. As early as 1900, Okakura Kakuzō (Tenshin), author of the first comprehensive history of Japanese art, published in Japanese and in French on the occasion of the 1900 Paris International Exposition, asserted that this popular commercial idiom was not representative of his nation.[53] His claim that "Japanese art cannot be written through ukiyo-e" underscored both his demand that Japanese scholars like him-self gain control of the critical act of artistic interpretation and the way the troubled relationship between ukiyo-e and social class was brought to bear on Japan's international self-representation.

Okakura's views were shared to the extent that until very recently the Japanese government and corporations, while eager to participate in international exhibitions, rarely sponsored those featuring ukiyo-e.[54] Outside of the museum world, however, commercial interests have often prevailed over class and aesthetic sensitivities. The design of Japa-nese postal stamps is an instance of the way this idiom and "Under

the Wave off Kanagawa" in particular were mobilized in the service of international cultural understanding and tourism. Despite their small size, stamps, as anthropologist Douglas Frewer has observed, are powerful social agents that may both shape and reflect the changing social and political environment. [55] Their design gives governments considerable scope to send messages to the public both at home and abroad. This recognition led American Occupation authorities, as part of their oversight of the Japanese postal system, to develop guidelines, still in force today, emphasizing the importance of recording important people and events, deepening international friendship and understanding, enhancing tourism, and supporting letter writing to improve interest and understanding of stamps. Religion, politics and industry, living people, or controversial issues were to be avoided.[56]

One of the first stamps issued under the Occupation was a two-tone view of "Rainstorm beneath the Summit," adapted from Hokusai's *Thirty-Six Views of Mount Fuji* (see figure 1.4). Although nothing is known of either the designer or the decision-making process, this choice is likely to have reflected the desires of American authorities.[57] Other ancient forms of art and architecture that Japanese officials of the Ministry of Posts and Telecommunication deemed to be more significant—most notably the eighth-century wall paintings of Hōryūji—featured in later stamps issued for domestic mail, but woodblock prints continued to be the idiom of choice in commemorative stamps such as those issued for International Letter Writing Week, first celebrated in Japan in 1958. The first five of the annual stamps were based on Hiroshige's views of the Tōkaidō Road. These were followed, in 1963, by Hokusai's "Under the Wave off Kanagawa."[58] Like the previous stamps in this series, this 40-yen issue featured a high-quality full-color engraved reproduction of the woodcut, accompanied by the inscription "International Letter Writing Week" in English. Many such stamps survive in fine condition because they became collectibles and were kept out of circulation, one of the economic benefits of using such readily recognizable and visually appealing designs.

Although not writing specifically of Occupation restrictions on stamps, the comments of designer Hiroshi Onchi speak to the

perception that the use of subjects and styles from ukiyo-e transformed Japanese into tourists in their own country. Writing in the 1953–1954 issue of *International Poster Annual,* he complained that foreigners merely wanted to see "but a remnant of old tradition . . . in no way representative of modern commercial art so closely linked with modern industry."[59] Graphic designers of the 1950s still faced the dilemma of conforming to foreign expectations of traditional Japan or adopting modernist styles. Their decisions were further complicated by the demands of Japanese industry and, even after the end of the Occupation, by the paternalistic authority often commanded by American designers such as Walter Landor, who was given prominent commissions in Japan.[60] By the 1960s, a decade of innovation and experimentation in all the creative arts, however, most designers saw themselves as belonging to the era of international modernism. For this new generation, the World Design Conference (Wo-de-co) held in Tokyo in 1960, with designers from twenty-seven countries in attendance, was an important turning point.[61]

Posters were not a well-established medium of creative or commercial expression as they had been in Europe, but in the 1960s they became the medium of choice for many ambitious graphic designers, in large part thanks to the efforts of the Japan Advertising Artists' Club (JAAC). Until it was disbanded in 1970, it held yearly competitions for which many young designers were invited to submit posters. As these were not formal corporate commissions, they fostered creativity and experimentation. Winners of the competition were given a "leg up in the profession," and, because of the costs of producing posters were relatively low compared to television, newspapers, and magazines, many companies began to commission them.[62]

Adaptations of Hokusai's wave were rare during this period because most designers self-consciously rejected the vocabulary of ukiyo-e as passé and compromised by its role in constructing stereotypes of Japan. A silk-screened poster designed by Yamashiro Ryūichi for the second International Prints Biennale held at Tokyo Museum of Modern Art on the occasion of the Wo-De-Co is an exception. He may have chosen this subject because of his awareness that it

would appeal to the international audience in Japan for the conference (figure 3.4).[63] Such is the wave's iconic power that, at first glance, the design appears to be dominated by a silvery incarnation with Mount Fuji in the distance. On closer examination, however, it becomes clear that the composition is constructed around a geometric form in cool tones of blue, green, and lavender that both frames and establishes the dynamic sweeping movement echoed in the more naturalistic wave superimposed over it. This streamlined, abstract form suppresses any overt historicizing reading of this familiar cultural signifier of Japan. The angularity of Yamashiro's interpretation is informed by international modernism, which he clearly accepted as a universal language of design.

One of the first generation of postwar graphic designers to enjoy international success, Yamashiro had worked for the Mitsukoshi and Hankyū department stores before becoming a founding member of Nippon Design Center, the country's leading advertising company.[64] For him, modernist values were guarantors of an international idiom that his younger counterpart Yokoo Tadanori rejected. Yokoo's posters, created to promote concerts and subcultural theatrical performances, self-consciously adopted a visual strategy of layering, photomontage, readymade pictorial vocabulary, often garish palette, and sense of ironic play. Yokoo likewise began his career working for department stores, later joining Yamashiro and others in the professional associations that aimed to gain greater industry and

FIGURE 3.4. Yamashiro Ryūichi, poster for the Museum of Modern Art, Tokyo, 1960, silkscreen, 40 ½ × 28 ¹¹/₁₆ in. (103 × 72.8 cm.). (Courtesy of the Musashino Art University, Museum, and Library, Tokyo)

international recognition for commercial designers. His social activism and especially his support of student protests, however, brought him into conflict with many of his peers.

Like many young artists, Yokoo was deeply opposed to the continued American presence in Japan after the formal end of Occupation in 1951. The U.S. Japan Security Treaty, or Anpo, gave the United States the right to maintain 100,000 troops there, ostensibly to defend Japan against communism, and this right was renewed in 1960 in the wake of widespread protests, strikes, and demonstrations in which many artists participated. Yokoo became a pioneer in transforming the poster from a medium of commercial communication into a flamboyant vehicle for political dissent and social critique. Nationalism and anti-Americanism were powerful themes in Yokoo's work during the 1960s, but these were not clearly recognized as such at the time because they were articulated in the form of a double discourse using the language of Japanese popular, commercial culture to deconstruct the effects of consumerism in a manner analogous to that of Pop artists in Britain and America. Motifs disseminated through ukiyo-e, especially by Hokusai, also figure conspicuously in his work.

Yokoo's visual strategies are exemplified in a 1964 poster he created for a music conference featuring the Japanese crooner Kasuga Hachirō. Kasuga was a popular singer who rose to fame during the Occupation by developing a sentimental ballad style, later called *enka*, that represented a nativist reaction to the massive influx of American jazz and rock and roll. A photograph of his smiling face is collaged above a stylized star-studded jacket set against a splashy ground in the red, white, and blue colors of the American flag (figure 3.5). The large cresting wave with a plover (*chidori*) in the background is a traditional motif with nativist overtones because of the homophony of the plover's piercing *chi-yo chi-yo* cry and the auspicious word *chiyo,* meaning "for thousands of generations." This disorienting mixture of typefaces, photography, stylized motifs, and colors speaks to the chaotic cultural landscape of the 1960s. As Mishima Yukio later wrote in *Popcorn Spiritualism* (*Popucon shinreigi*): Yokoo "linked commonplace Japanese sorrow with the idiotic, blatant nihilism of America's pop art."[65]

Yokoo Tadanori's refusal to conform to the cool, balanced modernism dominant at the time in favor of the flamboyant countercultural language of Pop relied on his appropriation of widely recognized "readymades" in the form of popular motifs and symbols detached from their original context and recombined in unexpected, often unsettling ways to provoke questions about patriotism, sexual identity, and burgeoning mass consumer culture. His signature motifs—the Japanese flag, Mount Fuji, and waves—as well as his aggressive exposure of his emotional vicissitudes, however, gave his work a highly idiosyncratic existential angst that sets it apart from that of other exponents of Pop art.[66] In a study of the artist's posters, Tanikawa Koi-

chi has suggested that Yokoo's repeated use of face-to-face cresting waves (like those used in the Yomiuri advertisement in figure 3.1) in combination with the Japanese flag may have been inspired by the logo of Asahi Breweries, where Yokoo was responsible for advertising copy in 1963.[67] Yet the bright red sun with rays also resembles the war flag used by the Japanese imperial army and navy from 1870 until 1945. This deliberate and ironic conflation of consumerism and patriotism to comment on the predicament of Japan's postwar conditions is asserted repeatedly in his work.

FIGURE 3.5. Yokoo Tadanori, poster for Kyōto Ro-on, 1964. (Photograph courtesy of Yokoo Tadanori Museum of Contemporary Art, Tokyo. © Yokoo Tadanori.)

Exactly how the artist intended these references is complicated by his close association with Mishima Yukio, a nationalist novelist obsessed with themes of warfare and samurai honor. This relationship led to the commissioning of a poster designed, in close consultation with Mishima, for the latter's Kabuki play *The Moon like a Drawn Bow* (figure 3.6).[68] The four-act play, performed in November 1969 at the Japanese National Theater, a year before Mishima's suicide, was based on *Chinsetsu yumiharizuki,* a best-selling novel by Takizawa Bakin updating the adventures of the twelfth-century military hero Mina-moto no Tametomo. Hokusai's illustrations for the novel had creatively linked great waves with epics about Chinese and Japanese warriors, most notably in the scene in which Tametomo's loyal retainer Takama Isohagi commits suicide following the presumed death of his master (figure 3.7). In this illustration, Isosagi stands on a rocky promontory with his dead wife and plunges a sword into his gut, the erotic violence of his gesture redoubled by the tumescent wave that is about to break over him. This drama of destruction and renewal is reit-erated in the spindrift, which seems to spray like blood from his arched body.

FIGURE 3.6. Yokoo Tadanori, poster for Kabuki play *The Moon like a Drawn Bow*, 1969. (Photograph courtesy of Yokoo Tada-nori Museum of Contemporary Art, Tokyo. © Yokoo Tadanori.)

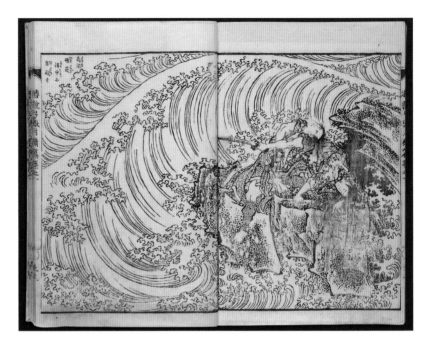

FIGURE 3.7. Katsushika Hokusai, Takama Isohagi from *The Moon like a Drawn Bow*, 1807–1811, woodblock-printed book, 8 ¾ × 6 in. (22 × 15 cm.). (British Museum, London, 1979,0305,0.488. © Trustees of the British Museum.)

Yokoo's poster is a pastiche that combines this dramatic illustration with two other fantastic scenes, also by Hokusai: one of Tametomo's loyal retainer Kiheiji riding a *wanizame* (crocodile dolphin), also from *Chinsetsu yumiharizuki,* and the other a wave morphing into a white horse from Hokusai's illustration for *Ehon Kanso gundan* (The wars of Han and Chu illustrated) (figure 3.8). These vignettes are augmented by a variety of other visual, textual, and numerical insets all rendered in psychedelic colors that, according to Mishima biographer John Nathan, many Japanese viewers deemed to be in bad taste. But, as Nathan also observed, these "pinks and oranges [are] a good indication of the kind of Kabuki Mishima was after. He wanted rococo Kabuki, vulgar, grotesque, and perhaps, above all, gory Kabuki. On November 3,

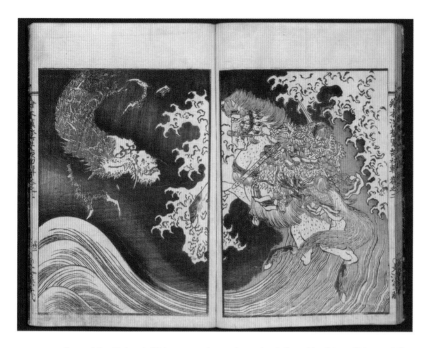

he stopped the dress rehearsal in the middle of the *seppuku* scene to insist that more blood must be used and that the blood must 'glisten.' "[69]

A loyal retainer's suicide following the death of his master was the warrior's ultimate sacrifice, but what gave Hokusai's illustration for *Chinsetsu yumiharizuki* its unusual imaginative power is the way he pitted the lone warrior against the far greater force of the wave, and by extension the sea and world beyond. With this symbiosis, Hokusai introduced a new image of masculinity linked to great waves that could be mobilized symbolically in many contexts and against many enemies. Although both Mishima and Yokoo may have been attracted to the erotics of Hokusai's wave, it is hard not to imagine their seeing in this heroic confrontation with the forces of nature an ennobling

metaphoric expression of personal resistance to a very different contemporary power.

Yokoo Tadanori understood ukiyo-e as part of a repository of populist images that were consumed in both Japan and the West. He self-consciously paraded Hokusai's great waves as clichéd commodities, comparable to and interchangeable with the advertising logos he also absorbed into his graphic designs. His crude montages and lurid palette both signaled his repudiation of European modernism as a source of external validation for Japanese art and parodied the purported refinement of Japanese aesthetics. While Yokoo seemingly stripped Hokusai's waves of the cultural cachet they had previously enjoyed, he also overlaid them with new meanings, in so doing giving them new subversive currency.

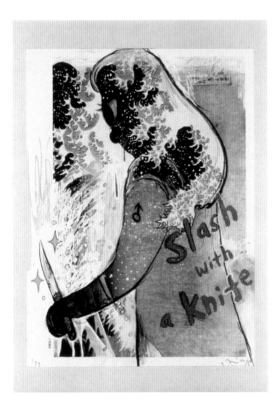

By trading on the motif's recognizability, multivocality, and commodity status, he arguably opened the way for other artists, such as Nara Yoshitomo and Murakami Takashi, to carry out their own critiques of American-style capitalism two decades later. Yokoo Tadanori's passive-aggressive stance also characterizes Murakami's *Little Boy*, a double reference to the code name of the bomb the United States dropped on Japan and to the infantilization of the country and the angry, lost children who populate Nara's visual world (figure 3.9).[70]

FIGURE 3.9. Nara Yoshitomo, *Slash with a Knife*, 1999, color Xerox print, 16 ½ × 11 ¾ in. (42 × 29.8 cm.). (Photograph courtesy of the artist and Pace Gallery. © Nara Yoshitomo, courtesy Pace Gallery.)

Japonisme Redux

The consumption of ukiyo-e in the United States tells as much about the receiving culture as about the one that produced it. Japanese prints were inscribed into self-reflexive narratives about American connoisseurship, protection of Japanese cultural heritage, democratic values, and cross-cultural understanding that to a large extent deny agency to Japan. The revival of Japonisme in the 1970s fits this larger interpretive pattern, as further inflected by a rekindling of interest in French Impressionism and Post-Impressionism motivated in part by highly charged American cultural debates of what constituted art. Like other frames of reference brought to ukiyo-e, it had strong sociopolitical and economic underpinnings.

Two paired exhibitions, *Impressionism: A Centenary Exhibition* and *The Great Wave: The Influence of Japanese Woodcuts on French Prints,* held at the Metropolitan Museum in 1974–1975, throw light on how Hokusai's design became a visual and verbal shorthand for this Japonisme revival. At a time when the modernist tradition was being displaced by new artistic idioms, Impressionism, Post-Impressionism, and Japanese prints were safe cultural forms that satisfied both elite and popular tastes. With attendance figures in the hundreds of thousands, the shows built around them were harbingers of the trend for crowd-pleasing international blockbusters celebrating individual artists such as Monet and Van Gogh.[71] As Thomas Hoving, the controversial populist director of the Metropolitan Museum at the time, later wrote in his memoir *Making the Mummies Dance,* this era saw "the most sweeping revolution in the history of art museums." His motto, "Teach about quality, what's great, what's spine tingling. Don't be ivory tower," sums up the provocative vision he brought to this elitist institution.[72]

The relationship between Japanese prints and Impressionism was well known to scholars before the 1970s, but the Met's *Impressionism* and *The Great Wave* were the first major shows in the United States to bring these two traditions together in a way explicitly designed to appeal to the broader American public. The massive illustrated catalogue for the former drew attention to Monet's ownership of prints

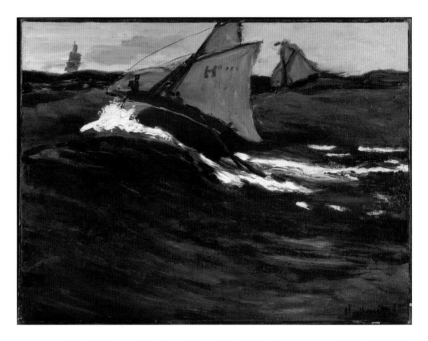

FIGURE 3.10. Claude Monet, *The Green Wave*, after 1865, oil on canvas, 19 ⅛ × 25 ½ in. (48.6 × 64.8 cm.). (H. O. Havemeyer Collection, Bequest of Mrs. H. O. Havemeyer, 1929. Acc. No. 29.100.111. © 2013. Image copyright The Metropolitan Museum of Art/Art Resource/ Scala, Florence.)

from Hokusai's *Thirty-Six Views of Mount Fuji* and their influence on his work, most notably including *The Green Wave*, painted in 1867 and said to have been inspired by "Under the Wave off Kanagawa" (figure 3.10).[73] It also foregrounded the role of Louisine Havemeyer, whose collection—this painting included—figured conspicuously among the works in *Impressionism: A Centenary Exhibition*.

Hokusai's print was occasionally referred to as "The Great Wave" before the 1970s, but the publicity surrounding these shows arguably helped to fix this moniker in the public imagination. The catalogue for *The Great Wave: The Influence of Japanese Woodcuts on French Prints* featured on its sunshine yellow dust jacket Toulouse Lautrec's vision of

the dancer Jean Avril, her skirt a series of billowing curves edged with ruffles, and on its title page a full-color reproduction of the best of the museum's three impressions of Hokusai's "Great Wave."[74] Like this evocation of the correspondence between the sweeping curve of the wave and that of the dancer's dress, the entire show was devoted to juxtapositions of Japanese prints and the Western works they "influenced." *The Seaweed Gatherer*, an allusive variation of one of Hokusai's great waves in the form of a fan-shaped color woodcut by Utagawa Sadahide, for instance, was identified as the pictorial source for Paul Gauguin's 1889 zinc lithograph *Dramas of the Sea: Descent into the Maelstrom*, which illustrates a story by the American writer Edgar Allen Poe (figures 3.11 and 3.12).[75] The catalogue says nothing, however, that might help to situate either Hokusai's or Sadahide's work within the material conditions of its production. Displayed in glass frames in a museum, this and other ukiyo-e prints were presented as artifacts to be appreciated within a Euro-American frame of art historical development.

With the exception of Mary Cassatt, *The Great Wave* featured only French artists whose work was influenced by ukiyo-e, but together with the larger exhibition *Impressionism: A Centenary Exhibition*, with which it was paired, it clearly conveyed the triumph of American aesthetic foresight and munificence in gathering these works together. With the New York collector Louisine Havemeyer, who had donated to the Metropolitan major collections of both, leading this cast of American cultural visionaries, these shows told the public that Japan and France may have produced great art, but America led the world in recognizing and collecting it.

"Japonisme" is a term that has been evoked for many different ends since it was first coined in the 1870s to refer to the French enthusiasm for all things Japanese. The Met's shows and accompanying catalogues speak to the way, a century later, it came to refer more specifically to the study of the relationship between Japanese and European art, especially as mediated through prints. This discourse locates Japan as a source of aesthetic and spiritual authority, without denying the skill or creativity of Japanese artists, but its focus is on the European artists who valorized prints by translating them into the

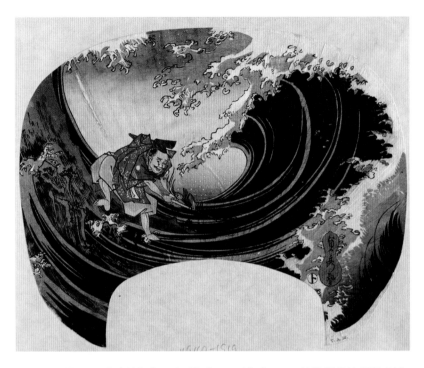

<figure>**FIGURE 3.11.** Utagawa Sadahide, fan print *The Seaweed Gatherer*, ca. 1850. (E.4940-1919. © Victoria and Albert Museum, London.)</figure>

idiom of modernism. While this form of Japonisme is driven by and privileges Euro-American preoccupations, it also has a dialectical force within Japan, where celebrating the role of Japanese prints as a source of European modernism confirms the roots of Japan's own modernity. As anthropologist Brian Moeran has pointed out, this self-reflexive celebration of Japonisme both to set Japan apart from other Asian nations and to "gain authority over 'the West'" can be seen as one of many manifestations of the nationalistic discourse known as *nihonjinron*.[76] The economic implications of this Japonisme became apparent in the 1980s, when the appreciation of the yen against other currencies led many Japanese corporations to embark on very conspicuous but ultimately

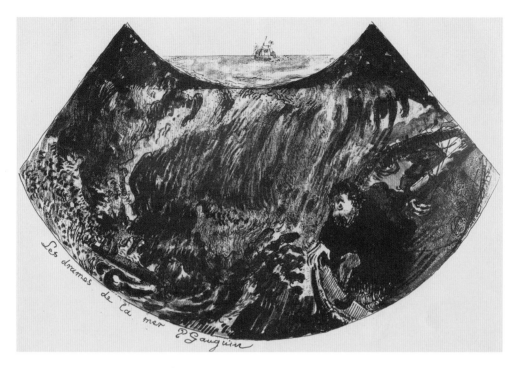

FIGURE 3.12. Paul Gauguin, *Dramas of the Sea: A Descent into the Maelstrom*, 1889, zincograph, 12 × 17 7/16 in. (30.5 × 44.3 cm.). (1950.16.64. Washington, National Gallery of Art, Rosenwald Collection.)

risky investments in Impressionist and Post-Impressionist paintings. In 1987 the Yasuda Fire and Marine Insurance Company bought a version of Van Gogh's *Sunflowers* at auction for a record-breaking $39,900,000. Three years later, industrialist Ryoei Saito topped this by purchasing the *Portrait of Dr. Gachet* for $82,500,000.[77] These paintings, which were central to the canon of Western modernism, inserted Japan into that history because of Van Gogh's close study of prints by Hiroshige and Hokusai, including the latter's great waves. "When I look at Hokusai," Van Gogh had declared in a letter to his brother Theo, "it feels like that wave is a claw and the boat is being seized by that claw."[78] For Japanese collectors, who for so long had been marginal players in the

international art world, acquisition of such works was a triumphant demonstration of their nation's global economic clout. This was, to borrow the title of John Nathan's 2004 book, whose jacket tellingly features a dramatically cropped, close-up view of Hokusai's giant wave, the era of *Japan Unbound*. [79]

Like other shows exhibiting Japanese prints in conjunction with French graphic arts and Impressionist and Post-Impressionist painting, *The Great Wave* popularized a view that emphasized Western canons and Western agency in determining what was valuable in other places and in creating a "universal" modernism on Western terms. *Impressionism* and *The Great Wave* also led the way in making Impressionist painting and ukiyo-e key constituents of the late-twentieth- and early-twenty-first-century culture industry, with its emphasis on crowd-pleasing international blockbuster exhibitions, dependence on corporate sponsorship, and museum shops selling masterpiece merchandise, a topic further explored in Chapter 4.

The Pacific Rim

"The Great Wave" has figured conspicuously in the cultural imaginations of Americans across the country, but, just as its interpretations have changed over time, so too they vary considerably over the vast distances between the Atlantic and Pacific coasts, where awareness of the print historically has been strongest. Whereas East Coast perceptions of Hokusai's wave are positively bound up with New England cultural heroes, as evoked in Christopher Benfey's *The Great Wave: Gilded Age Misfits, Eccentrics, and the Opening of Old Japan,* on the West Coast and Hawai'i its representational uses have been informed by the long and fraught history of immigration from China, Japan, and other parts of Asia. In 2000 California alone had an Asian population of nearly 5 million, constituting over 12 percent of the state's total.[80] The pluralistic responses to the wave among Japanese Americans and other ethnic groups on the Pacific Rim include allusions to painful personal experiences of ethnic and racial prejudice as well as to dynamic transnational connections.

Immigrants from China and Japan who made the United States their adoptive home often found their imagined cultures more welcome than they. This was especially true of Japanese, whose right to settle in California was being challenged at the very moment that collections of Japanese prints were being eagerly amassed around the country. In 1907, the year following the San Francisco earthquake, Japan and the United States signed a "Gentleman's Agreement," ending the immigration of male Japanese workers but, owing to fears of miscegenation, still allowing their spouses entry. A total ban on immigration was put in place in 1924. The Japanese attack on Pearl Harbor led to further discrimination. In 1942, a year after the attack on Pearl Harbor, the government relocated most families of Japanese ancestry to internment camps, but especially those living in Hawai'i and on the Pacific Coast, despite the fact that many were United States citizens. It was not until 1988 that the U.S. government issued a formal apology and financial reparations were made. Four years later, in 1992, the Japanese American National Museum, located in the Little Tokyo area of Los Angeles, opened its doors to record this shameful history. Its logo, with stylized mirror images of cresting waves contained within a diamond, suggests the role of the Pacific in mediating the identities of Japanese Americans.[81]

Struggles with racial discrimination and stereotypes played a catalytic role in the career of the prolific writer Yone Noguchi—father of the sculptor Isamu Noguchi—who arrived in the San Francisco Bay Area in 1893 and remained there until the end of the century, when he moved to New York to pursue a career as an English-language poet and writer on Japanese cultural issues. His pseudo-autobiographic book *The American Letters of a Japanese Parlour-Maid* (1905) evokes the double experience of displacement of a young Japanese man in America through a self-orientalizing narrative in which he represents himself as a young woman.[82] By hiding his masculine identity and masquerading as a young woman, he was conforming to American ideas of Japan. Noguchi's need to take on such a fictional identity makes explicit the kinds of personal and cultural negotiations he and other artists and writers of Japanese ancestry felt compelled to carry out in order to establish themselves professionally.

Noguchi's ongoing struggles with his identity are evident in the monographs on Hiroshige, Utamaro, and Hokusai and other print artists he published in the 1920s and 1930s. Much of his commentary on Hokusai's art is framed as a personal dialogue with the artist, with effusive phrases of praise recurring like a refrain throughout. By painting a picture of patriotic pride in his Japanese identity that could not be created in reality, Noguchi's reading of "The Great Wave" is arguably as much a reaction to the actualities of his own reception in the United States as his first book. The characterization of the multisensorial communicative power of the wave is the longest passage in the book on any of Hokusai's works and vividly conveys both his personal engagement with this print and his conflation of the wave with its creator's greatness:

> Oh, what a fierce action of nature in the picture! What a dreadful feeling we receive from the billows, one glance of which makes us feel drenched or drowned. Where is a picture which we can compare with this piece and gives us an equally unforgettable sensation? Where is a western artist like Hokusai who gives us such a fearful representation of realism as in this work? But to see the action only in it, to hear the wild voice alone, in it, is not all what Hokusai attempts to express here. You must see how the Lilliputian Fuji Mountain peers from behind the mad billows. Oh, what silence creeps around the mountain! Again what a silence against the wonderful voice in the billows! Am I wrong to say that Hokusai means this piece to be a duet of silence and voice? . . . I know that any artist, when he is splendid, spins his web of art with these two feelings, silence and voice. Let me hail Hokusai again, "You are great!"[83]

Waves are bodies that move freely with little regard to geographic boundaries, seemingly erasing borders and transforming the world into an interconnected whole, in the process submerging individual identity within collective identity. That Noguchi willfully ignores any reference to this work's cultural hybridity—most notably the conscious

interpolation of European perspective that makes it so visually distinctive—is very much in keeping with an era when the value of Japanese art was premised on its being not merely exotic but separate and, above all, possessing purity of form and content. This resistance to the blurring of genres and genes was as prevalent in the United States as it was in Japan.

Roger Shimomura is a third-generation Japanese born in Seattle whose earliest memories are of the camp in Hunt, Idaho, where he and other Pacific coast families were relocated during the war. He recalls that, after their internment, "the family house was purged of everything even remotely Japanese" so as to assimilate into mainstream American culture.[84] Yet the cultural adjustments made by him and many of those of Japanese ancestry in America continued to have consequences many years later. Shimomura's ironic ukiyo-e *Masterworks*, a series of silkscreen prints, highlights how even as the great wave motif created opportunities for sharing aspects of his ancestral culture (with which he was, in fact, unfamiliar), it also underscored the sharp divide separating him from his fellow Americans. "Oriental Masterprint #5" (1974) combines an actor in a female role dressed in a garment with a pattern of smiley faces with the great wave in the background (figure 3.13).

The catalyst for this series was Shimomura's encounter in the early 1970s with a man who asked him "where he was from and why he spoke English so well. After discovering that Shimomura was not a foreigner and in fact taught painting at the University [of Kansas], the man persisted by asking 'Do you do pictures of them gee-shee girls wearing them ko-monas?' "[85] Although ukiyo-e prints were not then part of his visual vocabulary, he was so incensed by this event that he adopted their style and motifs to create Pop pastiches that critiqued American clichés of Japanese Americans.

Los Angeles' location on the Pacific Rim, its film and media driven economy, and its concentration of people of Japanese, Chinese, Korean, and Vietnamese background have made it a congenial setting for many forms of creative expression with Asian inflections. Masami Teraoka, who moved there in 1961 to study art, created a name for himself with Pop-style compositions that addressed with biting humor

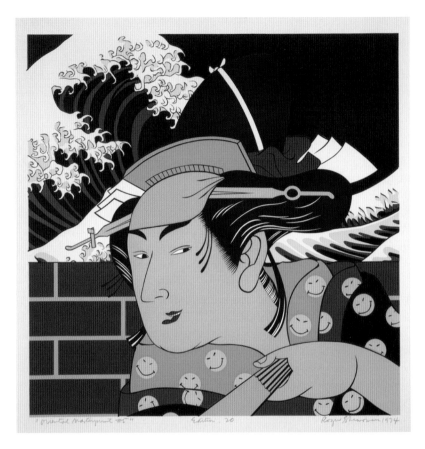

FIGURE 3.13. Roger Shimomura, "Oriental Masterprint #5," 1974, color screen print on woven paper, 27 × 27 in. (60.9 × 60.9 cm.). (Courtesy of Spencer Art Museum, University of Kansas, Lawrence, 1999.0050)

topics including AIDS, global consumerism, and the tourist industry, especially as it affected the pristine environment of Hawai'i, where he eventually moved in 1980. His rise to national fame paradoxically coincided with the era of virulent hostility toward Japan fueled by the corporate shopping spree that included acquisition of iconic American properties such as Rockefeller Center and Pebble Beach Golf Course.

Unusual among artists who mobilized the idiom of ukiyo-e and the wave, his work reverses the process of mass-production: rather than working in the print medium, each one of his compositions is painstakingly painted in vibrant watercolor.

Hokusai-inspired waves feature throughout Teraoka's paintings, many of which also comment on the artist's own identity. He evoked the balancing act required of Japanese immigrants like himself in his 1979 self-representation on a tightrope stretched across Los Angeles' La Brea Tar Pits (transported to Japan as an amusement park) carrying boxes labeled East and West, with great waves threatening him in both directions.[86] Waves are particularly conspicuous motifs in his 1975–1979 *New Views of Mount Fuji,* a series of narratives painted on the long and narrow format associated with Japanese picture scrolls, with explanatory texts in cartouches dotting the composition. These, however, are in Japanese and are consequently unintelligible to the artist's primarily American audience without bilingual mediation. "Sinking Pleasure Boat," with its passengers assaulted on all sides by clawlike waves, is the most direct allusion to Hokusai's signature work, but the sense of doom is alleviated by Teraoka's earthy humor: one of the men in the foundering boat has bared his bottom and is breaking wind.[87]

Following his move to Hawai'i, Teraoka brought his acute creative and critical faculties to narratives about America's fiftieth state in his *Hanauma Bay* series. In "Wikiwiki Tour" he juxtaposes the craggy rocks of the bay with mountainlike waves in the background that echo the many allusions to sexual arousal among the Japanese tourists who populate the beach in the foreground (figure 3.14). In this composition Teraoka skewers Japanese tourists, highlighting stereotypes both visually and verbally. A cartouche in the style of a Kabuki playbill on the dos and don'ts for the tourist lists "Things to bring: golf clubs, digital watch, calculator, and of course the ubiquitous camera," concluding with the additional advice "Be sure to lock the door of your rent-a-car."[88] In later works, Teraoka eschewed such narrative devices and created an elegiac *Wave* series celebrating the islands' natural but ephemeral beauty, whose visual referents extend beyond Hokusai to Japanese ink painters who engaged with this resonant motif.[89]

FIGURE 3.14. Masami Teraoka, "Wikiwiki Tour," from *Hanauma Bay* series, 1982, watercolor on paper, 21 ⅜ × 77 in. (54.29 × 195.58 cm.). (Private collection. Courtesy of Catharine Clark Gallery, San Francisco, California.)

Like Yokoo Tadanori, Teraoka self-consciously positioned himself as an artist by his critically reflexive use of the legitimating functions of accepted, stereotypical forms of Japanese culture in transgressive ways. Although his first solo show was in Los Angeles, his breakthrough 1979 exhibition at the Whitney Museum of American Art in New York signaled his adoptive country's embrace of him as one of its own, but his success has not been carried back to Japan. Many private and public American collectors and museums have bought his work, but,

owing perhaps to its often sexually explicit nature as well as its open critique of Japan, until quite recently few in Japan have done so.[90]

Unlike Teraoka's work, with its roots deep in traditional Japan, enthusiasts of manga and anime embrace that country's technologically progressive and commodified culture. The activities of second-generation Japanese and Chinese Americans Eric Nakamura and Martin Wong, who founded the magazine *Giant Robot* in 1994, offer a window into this world. Their magazine's success in promoting cutting-edge Asian popular culture led the young entrepreneurs to open shops in Los Angeles, San Francisco, and New York offering manga- and anime-related products, including those branded by Takashi Murakami

and Yoshitomo Nara, who also designed covers for their magazine. The publication of the fiftieth issue of *Giant Robot* was celebrated in 2007 with an exhibition at the Japanese American National Museum.[91]

The careers of Kozyndan, a Japanese-American graphic designer team formed by Kosue and Dan Kitchens and based in Los Angeles, got a huge boost after they were invited to design a cover for *Giant Robot* that was later issued as a poster titled "Uprisings" and made available for sale globally through their website http://shop.kozyndan.com (figure 3.15). Their humorous take on Hokusai's wave, with its white spume morphing into hundreds of rabbits, is quite different from Brian Chan's verbally punning use of it in his "A Great Eva off Kanagawa," inspired by the epic battles in the apocalyptic anime series *Neon Genesis Evangelion* (figure 3.16). In his visualization, the cyborg Eva, piloted by young Shinji, strides into the giant wave to confront the grotesque Angel that threatens the planet. Chan is an artist whose work ranges from Japanese swords and replicas of sword furniture to complex award-winning origami.[92] Originally from the San Francisco Bay Area, he "just grew up knowing about it [the wave] . . . and always liked its combination of chaos and order."[93]

When the *Evangelion* television series first aired in Japan in 1995–1996, it became a nationwide social phenomenon. Its narrative about a vulnerable teenager coopted by his distant father into becoming a pilot for a robotic weapon named Evangelion (Eva) created to combat dangerous creatures from outer space, struck a chord both for its emotionally complex evocation of its alienated youthful protagonist and for its problematization of human interaction with technology. Its success led to a film, which along with the multipart television series was dubbed into English and made available online. Chan's hand-painted reinterpretation of Hokusai's wave and *Evangelion*'s protagonists featured on the cover of Ian Condry's *The Soul of Anime* (2013), an exploration of the global success of this genre, and until recently a digital print based on it could be purchased online as well.[94] This flow of Hokusai's wave across the Pacific and around the world mediated by fans of manga and anime speaks to what Henry Jenkins calls "media convergence," a space where "old and new media collide, where grassroots and corporate

FIGURE 3.15. Kozyndan, "Uprisings," 2007, digital print, 22 ¼ × 16 ½ in. (57 × 42.5 cm.). (Photograph courtesy Kozyndan)

FIGURE 3.16. Brian Chan, "The Great Eva off Kanagawa," ca. 2013. (Photograph courtesy Brian Chan)

media intersect, where the power of the media producer and the power of the media consumer intersect in unpredictable ways."[95]

The reception history of "The Great Wave" in the United States and responses to it in Japan speak both to its multivocality and to its role as a vehicle for the negotiation of the often-fraught balance of power between the two nations. Politics, economics, and demographics loom large in this ongoing process of interpretation and reinterpretation even as the wave's hybrid iterations are bound up with the tensions of particular regional, generational, and subjective concerns. The discourses of which it is a part underscore the potential of "The Great Wave" to both express and contest essentializing narratives of race and nation. But to see this potential solely in terms of the politics of representation is to miss the increasingly transnational dimensions of its visual appeal in the popular participatory culture of manga and anime.

Lifestyle Branding

For Guy, love was the message. Love the brand and stay ahead of the curve and the crucial importance of adopting a forward position in relation to it. Even so, the document's 800 bullet-pointed words and Hokusai wave intro-graphic left much unsaid about Guy Swift's personal relationship with the future.

—Hari Kunzru, *Transmission*

Recursivity over a long period of time in strikingly varied contexts has given "The Great Wave" considerable value as global commercial currency. Many other works of art, including Michelangelo's *David,* Leonardo's *Mona Lisa,* and, especially, Van Gogh's *Sunflowers,* enjoy comparable recognition. The wave's nonfigural subject, its adaptability, and, above all, its twinned connotations of alterity and authenticity, however, make it far more conducive to multiethnic and multicultural product design and promotion. The elimination of Mount Fuji, a feature of many of its commodified articulations, has helped the image migrate by unmooring it from Japan and transforming it into a nonspecific trope of non-Western otherness that may be useful in positioning products at a variety of social levels. At the same time, its evocation of the powerful forces of the natural world also makes it suitable for niche branding in ways that suggest sports and environmental sensitivity. Added to this, the wave, as a phenomenon that exists outside the borders of any one country yet linking many, can convey integrity in a way that is not located in global capitalism.

This interpretive fluidity has prompted the wave's adoption to add value to mass-produced merchandise, including home furnishings,

clothing and accessories, beauty products, stationery, and food and wine, as well as to promote tourism. What these disparate usages have in common is their potential to brand the product, through sympathetic resonance, with aspirational characteristics of the consumer's personal lifestyle. An advertisement under the banner of "Dorm must-haves," circulated in the Sunday newspapers in Northern California just before the start of the 2007 academic year by the North American department store Target, throws light on how publicity persuades by modeling the potential for self-transformation.[1] The advertisement featured a collection of low-cost furniture arranged as if in a small room, with a young woman in jeans and T-shirt looking up mischievously at a very large framed print of "The Great Wave" hanging conspicuously in the center of the wall. Target's aim was to sell furniture to college-bound students, and "The Great Wave" was understood to serve this objective by its evocation of the experience of an exciting cosmopolitan lifestyle free from parental control. The print was not on sale in the store but was a prop that served to enhance the youthful allure of the merchandise that was on offer and, by association, the distinction that follows from their acquisition.

Advertisements like this mobilize the principle of mass customization promoted by Pine and Gilmore in their best-selling book *The Experience Economy: Work Is Theater and Every Business a Stage.* "Mass customization," they write, "requires an environmental architecture . . . comprised of two elements: a design tool that matches buyer need with company capabilities, and a designed interaction within which the company stages a design experience that helps the visitor decide exactly what he or she wants."[2] Pine and Gilmore identify four different, but overlapping, realms within which experiences can be produced and sold: educational, escapist, aesthetic, and entertainment realms.[3] The wave is unusual in that it can serve within all four.

Branding is a self-conscious process that aligns a product with a carefully orchestrated image that conveys the qualities that make it desirable. It may do so in an abstract manner, as does the Nike Swoosh, or in a more figural one, as does Hello Kitty. Whereas the former effectively conveys the speed and mobility of Nike's trainers, the round-eyed,

mouthless anthropomorphized kitten conveys the cuteness of Sanrio's products. Like these famous brands, the allure of the wave in ads today is that it is always "half seen," through its citation in so many contexts. To capitalize on its already ongoing iconicity is to transfer something of this quality to the product being promoted, a process that simultaneously markets sameness and difference.

The mobilization of the wave to sell goods and services speaks to a world saturated with images that no longer direct back to what they represent but primarily to other images, as citations of citations. Like celebrity, the recognition value of the great wave feeds on itself. Architectural historian Terry Smith's discussion of what he calls an "iconotype" is also helpful in thinking about the branding function of the wave. An iconotype, he writes, is "an image that, usually through repetition, stands out in the image flow, halts the incessant circulation, and draws fixity to itself. It maintains its iconicity, not by being different from the nature of other images in the flow, but by being more excessively like them. While singular in its configuration it is also, and primarily, a precipitator of mobility—its own reproducibility, and that of its viewers."[4]

An iconotype has much in common with an advertising logo, like Ralph Lauren's polo pony or the Nike Swoosh. The authors of *Nike: The Sign of the Swoosh* have observed that "Nike signs its ads with only its icon, so confident are they that the *swoosh* can be interpreted minus the accompanying text."[5] Like these, the great wave also has such a distinctive silhouette that, even if altered or rendered in simplified linear form, it can be recognized at a glance. Its use may direct the beholder back to the original artwork as a source of auratic value, but it may point to other, often commercially mediated, representations of itself as well. These multiple sources of elite and popular authority may simultaneously reinforce and be in tension with one another. Unlike a trademark that must be replicated exactly in every usage, thus becoming degraded through overexposure, copyright-free permutations of the great wave can be adapted and conjoined to trendy new products.[6] Awareness that the wave may be creatively manipulated without legal implications could be a factor in its appeal to professional graphic designers. Playful bricolage, with its implications of audience

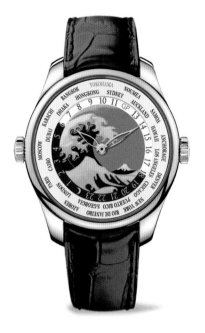

FIGURE 4.1. Girard-Perregaux WW.TC Kanagawa watch, 2009. (Photograph courtesy Girard-Perregaux)

participation, and "knowingness" are thus important constituents of the wave's lifestyle branding.

This chapter looks at the diffusion of "The Great Wave" in a range of goods, beginning with museum merchandise, where its ties to the authority of Hokusai's woodcut are most important, through food, drink, and dress to sporting and leisure goods, where its representational value as a mark of authenticity of the other has been molded chiefly in opposition to local mainstream cultures, even by multinational corporations. This design has been used to sell a variety of high-end products, such as the £39,000 ($63,000) Girard-Perregaux WW.TC Kanagawa watch with gold case and cloisonné enamel dial produced in 2009 to celebrate the 150th anniversary of this Swiss watchmaker's founding of a shop in Yokohama (figure 4.1).[7] The focus of this chapter, however, is on everyday, mass-produced goods in the late twentieth century and the first decade of the twenty-first.

Masterpiece Merchandise

"The Great Wave's" intrinsic spectacularity gives it agency to transform even the most commonplace article into something that communicates the cultural authority of the museum. Not surprisingly, museums with impressions of the woodcut in their collections or on loan for special exhibitions are leading purveyors of mass-produced merchandise that acknowledges Hokusai's wave as a masterpiece of world art. The British Museum has a particularly large range, including T-shirts, tea towels, plates and mugs, watches, and clocks. The Victoria and Albert

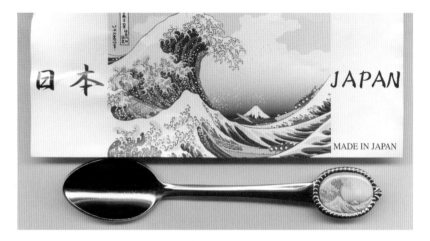

FIGURE 4.2. Great wave enameled spoon. (Author's photograph)

Museum sells in its museum shop a witty print of the great wave mor-
phing into white rabbits by the Japanese-American artist team Kozyn-
dan (see figure 3.15). The Metropolitan Museum of Art has a product
line that over the years has expanded from framed reproductions and
paper goods to scarves, refrigerator magnets, and luggage tags. Enam-
eled teaspoons made in Japan are available at the Musée Guimet in
Paris and paper stereoscopes manufactured in the Netherlands, at the
Fitzwilliam Museum, Cambridge (figures 4.2 and 4.3).

Igor Kopytoff observed that, when objects enter the museum,
they undergo a process of "singularization" and "terminal decommod-
itization," that is, they are effectively deactivated as freely circulating
commodities.[8] Objects in the museum nonetheless continue to partic-
ipate in the market in other ways. Museumization, by creating unique
object value, also increases the value of comparable works still in cir-
culation. This phenomenon helps to explain the £130,000 ($210,000)
purchase price of an unusually fine impression of Hokusai's "Under the
Wave off Kanagawa" acquired by the British Museum in 2008.[9] The
potential of museum masterpieces to be adapted for use in the design
of commercial goods further complicates this narrative. Impressions of

Hokusai's "Under the Wave off Kanagawa" may be "formally decommoditized" in museums, but, by their replication and adaptation in secondary forms, they "remain potential commodities."[10]

Masterpiece branding makes good commercial sense because it gives mundane mass-produced goods a cachet that distinguishes them from those available on the street. Yet this perception of status may also inform the desirability of street goods. The great wave has been exceptionally successful as a museum brand because it is so striking—whether reproduced in its entirety, in detail, large or small—but also because for some it has a sleek minimalist look associated with "good" taste and design. A further attraction may be the product's connotations of intrinsic quality. Yet, unlike other comparable articles, the quality of the museum-branded product is not guaranteed primarily by the manufacturing process, but rather by the internationally recognized masterpiece in the museum's collection. A pendant that advertises itself as "inspired by the V&A collection," on sale both in the Fitzwilliam Museum's shop in 2010 and online on Amazon.com, is an example of the way that commercial enterprises, by paying a licensing fee, may capitalize on the aura of the museum.[11] Visitors also may be moved to pay more for a museum purchase because it reconciles consumerist impulses with good work: as announced on the Metropolitan Museum's packaging, "proceeds from the sales of all publications and reproductions are used to support the museum." Despite its close relationship to the physical form of the product on which it appears, however, the wave remains an externally applied decoration that affects its perceived but not its actual performance. In other words, its intent is to influence consumer behavior rather than to improve functionality. By maintaining its separateness from the product, unlike an official brand or logo, the wave also retains a kind of autonomy that allows it to float freely among multiple commercial contexts.

When purchased in the museum, merchandise featuring "The Great Wave" may project a variety of aspirational lifestyles. As noted above, museum goods have connotations of good taste, so small size, practicality, and modest cost may make them ideal impulse purchases as souvenirs or gifts to mark a visit to the museum. The motif may also

strike a chord among those with a special interest in or ties to Japan and its culture. Museums often function as displaced sites for touristic experiences, and a memento localized by a striking image of the wave and Fuji may hold appeal as a surrogate for the actual experience of the country and of the museum itself when the print is not on display. Waves have connotations of travel and leisure that come into play explicitly when featured on merchandise such as luggage tags, note pads, or calendars available in international airport shops. In 2008 the Metropolitan Museum was operating twenty-three satellite stores in major cities and airports across the United States, all selling the same merchandise.[12]

"The Great Wave" is a valuable piece of cultural property whose circulation the Metropolitan Museum tries to contain and restrict by selling in its own retail stores and websites only products featuring exact reproductions, sometimes skillfully cropped for dramatic effect. The number of parodic adaptations available from other museums, however, has undermined the elitist aura that once surrounded such merchandise.[13] Today the production, sale, and consumption of "masterpiece brands" are no less bound up with the global flow of capital than any other consumer goods. Just as museums have extended their footprint by opening new outposts in faraway locations and blockbuster exhibitions travel from one continent to another, so too museum merchandising has become part of a vast network of material and symbolic exchange. "The Great Wave" is a brand that gives expression to the postmodern museum as a multisited and multifunctional part of the global culture industry.

Wave merchandise is much less conspicuous in Japan than in Europe and America except in national museums or at special exhibitions where it can be pitched to international visitors. The shops in the Tokyo National Museum as well as numerous European museums sell a paper diorama (*tatebanko*) of "Under the Wave off Kanagawa" to be constructed by cutting, pasting, and setting the waves in the foreground, middle, and background in a paper box to create a three-dimensional effect (figure 4.3). Although a modern design, it can claim a kind of authenticity since paper constructions of this kind were popular during the Edo period, and Hokusai himself designed some representing vernacular architecture.[14] This kind of 3-D illusionism is a

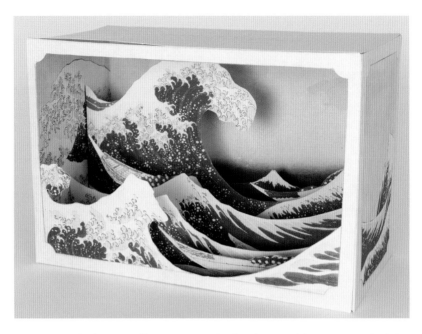

FIGURE 4.3. *"Under the Wave off Kanagawa," tatebanko.* (Photograph by Dominic Tschudin)

legacy of the European optical devices and floating pictures (*uki-e*) introduced to Japan in the 1740s refashioned as modern spectacles for global touristic consumption.

A postcard mythologizing Fuji, the wave, Astro Boy, and other signifiers of Japan also speaks to the way the wave has expanded and evolved, colonizing new products and museums in Japan, though not necessarily aimed at foreign visitors (figure 4.4). It is an example of the inexpensive merchandise available at the Osamu Tezuka Manga Museum, honoring the man revered as the founding father of modern Japanese manga. The graphic design, rendered in pastel blues and pinks, subsumes Mount Fuji and the cresting wave into the familiar iconography of Astro Boy swooshing through the sky. The caption beneath asks: "There is ??? in Japan?" The response, written in both Japanese and roman letters, is a long list of Japanese words (sushi, bonsai, futon,

karate, and so on) that have become part of the international lexicon. The final entries—anime, manga, and Tetsuwan/Astro Boy—represent the most recent entries in the international symbology of Japan.

Tetsuwan Atomu (as he is known in Japanese), the boy robot built by a scientist as a surrogate for his dead son, is one of Tezuka's most familiar and beloved creations. When he first appeared in 1952, he offered young Japanese a compensatory alternative to the still war-damaged world in which they lived. Episodes of the manga version of *Tetsuwan Atomu* were first issued in book form, but in 1963 these also became Japan's first animated television series, also televised abroad.[15] Consequently, today the boy hero exercises a powerful nostalgic hold on the imagination of older Japanese as well as appealing to a new generation of children and international manga fans. The Manga Museum and traveling exhibitions of the artist's works speak to the institutionalization of this medium both as distinctive to Japan and as a part of global popular culture. In asserting that Astro Boy, Mount Fuji, and the cresting wave are all equally noteworthy icons of national culture, this mass-market product speaks to the fusion of historical styles, popular culture, and national identity that have become a significant trend in Japanese advertising since the late 1990s.

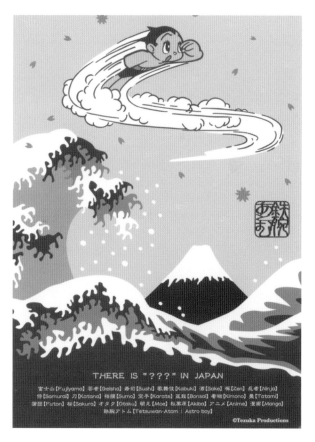

FIGURE 4.4. Postcard with Tetsuwan Atomu/Astro Boy, Mount Fuji, and great wave. (© Tezuka Productions)

Food and Drink

When Japanese wave merchandise became a fixture in museum retail shops in the 1990s, sushi was also becoming so popular that it could be purchased in supermarkets and takeout stores across the United States. The first wave of internationalization that began in California as part of the countercultural movement of the 1970s was dependent on the Japanese-American population there as well as on local farmers to supply the varieties of short-grained rice necessary for sushi.[16] The second wave, of the 1990s, was made possible by changing economics as well as growing preoccupation with healthy eating. A significant factor in the popularization of sushi was the lower cost of operating restaurants with Chinese, Korean, Vietnamese, Burmese, or Mexican rather than Japanese chefs and staff.[17] This multicultural convergence went hand in hand with the introduction of a mélange of new local ingredients that resulted in sushi such as the avocado-filled California roll becoming part of menus even in Japan.

Businesses on the Pacific Rim, with its large Asian-American populations, have been particularly engaged in redistributing and remapping the creative capital of "The Great Wave." The business card of Nabiel Musleh, the proprietor of Sushi Grove, an upscale restaurant in San Francisco (now closed) that offered "raw talent on Russian hill," is emblematic of the local reinvention, repackaging, and repositioning of sushi (figure 4.5). His tongue-in-cheek use of the oversized cresting wave in a fishbowl complicates the more common deployment of the motif on restaurant façades or interior walls to establish a restaurant's ethnic credentials and the freshness of its seafood. Musleh's pastiche is one of many that underline how the wave represents the authority of Japanese authenticity as mediated by multicultural understandings of Japan. In these uses the wave constructs a separate non-Western but not necessarily Japanese identity to negotiate and structure one's personal or professional life.

Even as individuals engage in this process of symbolic exchange, corporations also create new local-global narratives to enhance the desirability of their products. A 2008 advertisement for Kikkoman

soy sauce offers an instance of the wave's use for promotional gesturing to create an affinity between Japan and a product that is not in fact intrinsically Japanese. Designed by the Swedish division of the advertising agency Scholz and Friends, which has offices across the European Union, it shows a dramatic photographic close-up of the rich amber-colored soy sauce splashing in the shape of Hokusai's cresting wave, with the company's distinctive hexagonal Japanese crest over it and, inscribed in small letters above, the tagline "Culinary art from Japan."[18] This advertisement displaces the stereotype of Japan as an artistic nation to food, a more recently recognized form of Japanese artistry.

Soy sauce is an indispensible ingredient in all East-Asian cuisines and one that, until the surge in popularity of sushi and other Japanese foods associated with healthy lifestyles, was more likely to be identified with China. Although many consumers outside of the region where it was historically consumed have long used a splash of it in cooking, brand awareness was unlikely to be a major consideration in its purchase until the 1970s, when Kikkoman became dependent on soybeans from the United States and opened a manufacturing plant there. Subsequently it also established plants in Europe.[19] The advertising strategy of Kikkoman's "Culinary art from Japan" followed from the globalization of its production and consumption.

FIGURE 4.5. Business card of Nabiel Musleh, proprietor Sushi Grove, San Francisco, California. (Author's photograph)

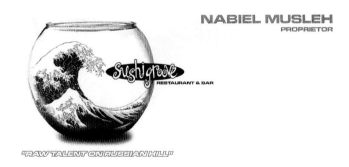

The global interconnection of cultural and economic processes is further underscored by the logo of Now and Zen, a brand of Alsacian white wine sold in the United States through the unconventional supermarket chain Trader Joe's.[20] Pitching parody instead of the obvious "buy me" approach, it uses language rich in visual and verbal citations that invite consumer complicity. The wine's logo is a figure in a rowboat perched precariously atop a playfully distorted cresting wave (figure 4.6). Now and Zen is produced in France, as suggested by the anglophone stereotype of the French mispronunciation of the word "then" that in turn links the wine to Japan, through identification with Zen Buddhism. The logic underlying its double-barreled branding is to convey the idea that this "wasabi white" wine is suitable for drinking with Asian fusion cuisine. This campy marketing attracts even as it distracts from the fact that the wine is a down-market product priced (in 2010) at $4.99. The label may further capitalize on the fact that *Now and Zen* is also the title of a hit record using exotic musical effects that Robert Plant issued in 1988, a connection not necessarily made, however, by all consumers. Such unconventional branding is effective, especially in the crowded marketplace of low-cost wines. Together, the brand name and logo create the image of a hip beverage that is fun to drink. Now and Zen doesn't claim to be Japanese but banks on an eclectic mix of qualities that some consumers associate with that country in order to impart transnational distinction to their product. This ironic cultural "mashup" is intended as a tool of persuasion for consumers distrustful of and resistant to high-power and often deceptive marketing techniques.

FIGURE 4.6. Now and Zen wine packaging (detail). (Photography by Dominic Tschudin)

Aggressive wit and marketing savvy are also at work in the branding of éclairs with quivering, creamy white filling produced by the distinguished Paris purveyor of gourmet foods Fauchon. Designated "La Vague" after the pictorial icing featuring the great wave, Mount Fuji, and a single lemon yellow boat, this gustatory delight also creates a visual pun by the elongated boatlike shape of the pastry itself. The visual and material qualities of ethnicity and geography brought into play here do not match the product, but it is precisely their unexpected conjunction that serves so effectively to distinguish this relatively commonplace pastry so that consumers are prepared to pay Fauchon's high prices.[21]

It is not clear when or where this éclair was first introduced, but its development was likely part of Fauchon's global marketing strategy to cater to Japanese consumers in both Paris and Tokyo. Fauchon has had a presence in Japan since the 1970s and still has independent outlets there as well as selling its confections through the up-scale Takashimaya Department Store (figure 4.7). References to the delicacy on

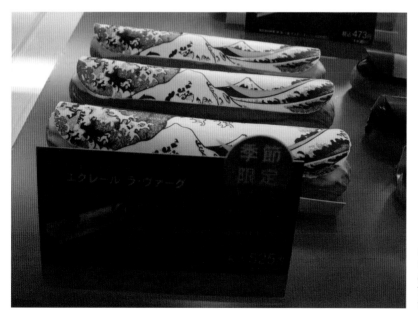

FIGURE 4.7. "La Vague," éclair made by Fauchon, purchased at Takashimaya, Tokyo. (Photograph courtesy Jonathan Harrison)

Japanese-language social networking sites, where it is referred to as a *dezain* (the Japanese pronunciation of design) éclair, suggest that it has a cosmopolitan cachet that makes it especially appealing to young women for gift giving.[22] Like many global corporations seeking to market their products in Japan, Fauchon has rightly calculated that flattering young consumers with displays of local culture that is admired abroad is an effective marketing tool.

Clothing

Consumption, as Veblen and Bourdieu have written, is a process of self-construction through differentiation, and marketing often capitalizes on the recognition that consumers who buy to satisfy their desires often do so with a concern with identity, but also with a need to authenticate their identity in very particular, and often idiosyncratic, ways that differentiate them from other people.[23] The goal can be accomplished through many forms of clothing, including scarves, ties, and even socks such as those sold in Kyoto's shopping arcades that cater to young tourists, both Japanese and foreign. These toed ankle socks suitable for wearing with thonged sandals are adapted from the socked shoes traditionally worn by farmers (figure 4.8). Although labeled with the character Wa, a designation for Japan, they are in fact made in China.

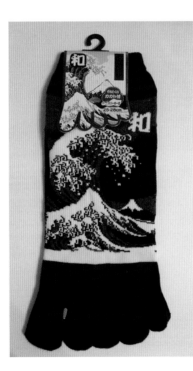

FIGURE 4.8. "Wa" socks with great wave motif. (Author's photograph)

T-shirts provide an especially popular means of asserting identity fashionably and inexpensively and, given their origins as countercultural apparel, lend themselves well to adoption by those who want to assert their independence from bourgeois value systems. The real and virtual marketplace is full of entrepreneurial designers who make and market T-shirts to commemorate special events, to cash in on the latest fashion, or to signal membership in a particular social community. Treasured as records of personal experience by those who buy them, they often take on social and cultural value beyond their modest cost.

Humor occupies an important place in the world of T-shirts because "getting" the joke creates a sense of complicity between the wearer and the viewer. The wave communicates with an economy of design and experience that lends itself well to playful manipulation. A design by Peggy Lindt, an artist based in coastal Santa Barbara, California, offers the playful spectacle of the heroic great wave face to face with a canary yellow rubber duck, almost its equal in size. The graphics were created in the 1990s, before the advent of Photoshop led to the explosion of cut and paste, enlarged and reduced, or layered versions of "The Great Wave." Her T-shirt has been available online since 2004 through Fliptomania.com and remains one of its most popular designs (figure 4.9).[24] Like other uses of humor discussed in this chapter, this visual joke works by creating a connection between images and things that are both vastly different in scale and normally found in different contexts, in this case the sea and the bathtub, an iconic artwork and a rubber duck. This convergence makes what is represented absurd, thus triggering laughter. The design's topical allusion to the global culture of cuteness further contributes to its appeal.[25]

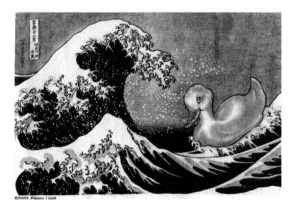

FIGURE 4.9. Peggy Lindt, "Hokusai Ducky" T-shirt design, 2004, printed by Fliptomania. (Photograph courtesy Peggy Lindt)

The wave can participate in this playful commentary on the fashion for cuteness without necessarily pointing back to Japan because it has been disassociated from Mount Fuji, a site that generates particular connotations with respect to both geography and politics. The absence of markers of national identity may seem to give the motif on a T-shirt a quality that sociologist Iwabuchi Koichi, in a discussion of the success of Japanese popular culture in China, Korea, and Southeast Asia despite the strong legacy of anti-Japanese sentiment, has characterized as "deterritorialization" (*mukokokuseki*).[26] However, deterritorialization is not necessarily fixed or predetermined, but rather a perception that may be highly subjective and contingent on local assumptions and customs. As well as the spatial location of the consumer, class, gender, and age may inform the degree to which the national characteristics of this motif orient it toward positive or negative lifestyle readings.

The highly contingent nature of what constitutes deterritorialization may help to explain why the wave does not seem to circulate together with the various forms of Japanese popular culture that enjoy success in China, Korea, and Southeast Asia. The wave's free-floating quality is not simply dependent on its being disassociated from its national origins by the elimination of Mount Fuji but results from the level of international recognition and connotations it has accrued. It is mobilized in Europe and America because advertisers believe it is a familiar icon that communicates desirable qualities. This follows from the long, rich, and overwhelmingly positive symbolic complex that has built up around it that is not likely to inform its apprehension in regions formerly under Japanese colonial rule. Graphic designers seeking a foothold in these relatively new and still unfamiliar commercial environments do not want to risk branding their products with a design that might well be perceived as having connotations of Japanese aggression.

Gendered commentary on the wave is relatively uncommon, but T-shirt and sweatshirt designs first created in the 1990s speak to the sense among some women that this is an image with decidedly masculine connotations. Rendered in stark black and white, these designs reveal a great wave emerging from a top-loading clothes washing machine

with the inscription "The laundry as perceived by Mrs. Hokusai" (figure 4.10). They take the muscular rhetoric of the great wave and subvert it by transforming it into a statement suggesting that behind every great artist there is a hard-working wife.[27] (And no woman wearing this would fail to note that it, too, requires washing.) Peggy Lindt's "Hokusai Ducky" design violates representational norms and thus can be readily appreciated even if the wave is understood as a generic visual symbol rather than a reference to a famous work of art. To "get" the joke here, in contrast, requires familiarity with the original work of art and with the tedious nature of household work, a message that is conveyed by a combination of word and image. Once understood, the image offers a momentary cathartic and pleasurable liberation from reality. Wearing a T-shirt or sweatshirt thus inscribed is a public act that invites reaction. In so doing it becomes a socializing experience that may bring together those who share the outlook it expresses.[28]

Most pastiches of Hokusai's design in the world of clothing and fashion do not point so explicitly back to the artist or his artwork. Many professional artists and graphic designers know "Under the Wave off Kanagawa" through their studies, but this is not necessarily true of the general public. Consequently, the former don't necessarily expect or want the latter to make the connection between their design and the work by Hokusai, but rather to other fashionable commercial uses of it. This is true, for instance, of an infants' clothing line available in 2011 through Baby Gap. The

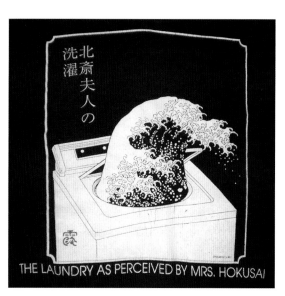

FIGURE 4.10. Designer unknown, "The Great Wave as Perceived by Mrs. Hokusai" sweatshirt design. (Photograph courtesy Anne Walthall)

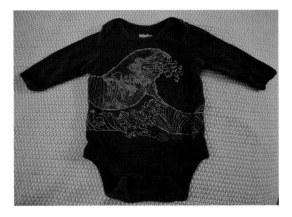

search for novelty in this competitive market led the company to develop diagonally zippered one-pieces with the sweeping curve of the wave imprinted over the front dramatizing this feature. This is a rare example of a product where the wave is not simply a decorative design intended to add visual appeal, but one that cleverly comments on the movement that is intrinsic to its functioning.[29] Its popularity led the design to be adapted for more conventional infant wear as well (figure 4.11).

The cresting wave is clearly a motif that conveys a fashionable global message of interconnectivity that is attractive to multinational corporations. In this sense it may function like the Coca-Cola musical campaign based on the song "I'd like to teach the world to sing in perfect harmony" or the analogous "United Colors of Benetton" slogan built around compelling color photographs of groups of people of disparate ethnic and racial backgrounds. Denim blue jeans also lend themselves to such marketing since they are worn around the world, and their production, design, and trade also span the globe. They are an immediately recognizable, indeed iconic, style of clothing worn by both sexes that can simultaneously make a fashion statement and signal a freedom from the fashion system and conspicuous consumption.[30]

In 2005 Levi's launched a limited edition of its "Love and Peace 501" jeans through a campaign involving a 22-by-12-foot collage by Levi's executive and surfer Caroline Calvino, formed from thirty-five pairs of jeans, each featuring a portion of the great wave. The collage, a commentary on the saturated "global blue" of the great wave, was introduced at Los Angeles fashion week before being shown in Japan. Thirty-two pairs of these exclusive jeans, each identified with

the words "Love and Peace" on the back were then sent to stores in New York, London, Los Angeles, Tokyo, and San Francisco for sale at $1,000 each.[31] By this clever ploy, Levi's disguised the commodity status of the jeans, while simultaneously carrying out an act of commercial seduction. As part of the globally circulated artwork, the jeans were unwearable, but, once dismantled locally, each pair was more valuable for its identification with the Calvino collage. Kikkoman, Fauchon and Levi's's branding strategies underline design historian Viviana Narotsky's argument that a "discourse of national identity, which generally draws on pre-established cultural stereotypes, can be arbitrarily constructed 'from the outside' around certain products, reflecting the global context in which they are created and consumed rather than their intrinsic formal or 'essential' qualities."[32] As discussed below, these constructs may also serve to reinforce national identity.

Sports and Leisure

The performativity of the wave—with its implications of personal transformation—as well as its obvious relationship to cleansing and sporting activities, underlies its ubiquity in branding goods for sports and leisure. Discursively created, its sometimes conflicting connections may be mediated by the producer, the consumer, or both. Consumers play a particularly conspicuous role in repositioning its currency by constantly disrupting and revising the meanings already ascribed to it. This is often achieved by recalibrations of the localizing and globalizing tendencies inherent in the motif. In the complex relationships thus formed, Japan may be the primary referent, as in a soap available at Pearl River, a well-known novelty store on the periphery of New York's Chinatown. Sold in 2007 for $3.00, more than double the price of an ordinary bar of soap, it featured the wave without Fuji on a box inscribed on the front with the Sino-Japanese character for "eternity" and the words "*The Perfect Spa*—water . . . aroma . . . the healing place, the unwinding place" and, on the back, the explanation that the image was based on Hokusai's woodcut ". . . a perfect representation of a moment frozen in time," adding that "the 'eternity' symbol suggests the

same idea: awareness of every moment." The label "Made in Australia" following the list of ingredients, like the toed socks sold as souvenirs of Japan, speaks to the logic of global production.

Gennifer Weisenfeld, in her study of the use of a modernist aesthetic in the packaging and marketing of Kao soap in 1930s Japan, noted that one message this conveyed implicitly was that, "even through a commodity as mundane as a bar of soap, every man or woman could tap into an international culture of modernism."[33] Similarly, the message in The Perfect Spa's clumsy effort to manufacture authenticity is the promise that, by using this exotic product to wash, the bather will discover the natural purity and serenity that is the essence of traditional Japan. In so doing, it relies on a time-honored trope of Japan as an island of tranquility in the modern Western world—an image strangely at odds with the disruptive potential of the wave.

Warm Planet Bicycles of San Francisco has remade "The Great Wave" by downplaying its Japaneseness in favor of references to the locale where the product or service is to be experienced. The shop's logo, until recently featured on the exterior wall and decorative grills protecting the windows of this bicycle parking facility and repair shop adjacent to San Francisco's Caltrain commuter train station, is an image of a cresting wave with Sutro Tower, a San Francisco landmark, replac-

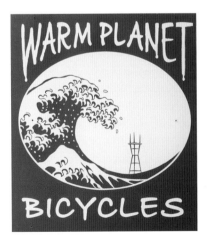

ing Mount Fuji in the background (figure 4.12). Although this image doesn't speak specifically to cycling, it evokes the Bay Area and the city where the shop is located. Some may see in the cresting wave an allusion to the big surfing waves at nearby Maverick. "Kash," the owner-operator of Warm Planet

FIGURE 4.12. View of Warm Planet Bicycles, San Francisco, California. (Photograph by Scott Tsuchitani)

Bicycles, acknowledged that he was inspired by Hokusai's print, proudly declaring, "I only rip off from the best," but it is unlikely that his customers recognize the allusion. Even if they do, they may be indifferent to its origins. Of his addition of Sutro Tower, he noted, "It's so overwhelming that most people block it from their minds, but, for me, it says 'that direction, that's where home is.' "[34] This logo is thus a cultural formation that insists on both the local meaning of "The Great Wave" and the interplay between its local and global connotations.

A shift from actual travel to virtual travel by electronic means has become a driving force behind the flood of new mutations of the wave marketing difference, yet is indifferent to the image's specific geographic origins. Many people prefer shopping online, believing they can discover products more distinctive than those available on Main Street. More important, they can customize their purchases to suit their personal needs. The medium has opened up do-it-yourself (DIY) opportunities that blur the lines between producer and consumer, artist and audience. Shower curtains with the cresting wave have been available for purchase in stores in the United States since the 1960s, but now glass and mosaic tile renditions are also advertised online for those wishing to remodel their bathrooms. There are even step-by-step guides to painting "The Great Wave" on the wall of any room.[35]

Global promotion and consumption of goods associated with skateboarding and surfing are significant contributors to the cresting wave's interactive online presence. The magazine *Giant Robot* has contributed to this phenomenon. "Uprisings," the poster sold at the Victoria and Albert Museum in London, for instance, was originally commissioned from Kosue and Dan Kitchens as the cover art for the magazine before being reproduced for public sale in a larger format (see figure 3.15). When interviewed for the magazine about the wide appeal of their work, Dan replied: "Our stuff crosses over to different places. I don't know why it's caught on with street, skate and urban crowds. . . . We don't skate and I couldn't use spray cans to save my life. We're not cool, but we'll show our art to whoever enjoys it."[36] Although *Giant Robot* ceased publication in 2011, it still maintains a sales website that includes the work of Kozyndan alongside that of

Japanese and Chinese American artists. As noted in Chapter 3, *Giant Robot* has also been instrumental in promoting the work of Murakami Takashi, Nara Yoshitomo, and other trendy Japanese artists who have developed flourishing international businesses by translating their high-end, "Superflat," and manga character paintings into product lines that include plastic figurines, picture books, and other inexpensive collectibles with multigenerational appeal both within and beyond Japan.[37]

The new creative landscape of the great wave is dominated by interactive marketing that exploits consumers' desire to personalize what they wear through visual "sampling." Zazzle, for instance, invites consumers to take an active role in the styling of their Keds sneakers by the addition of a wide range of striking motifs.[38] "The Great Wave" is one of the many artistic options this online company offers as part of an activity it describes as "remixing an icon." The fashionable self-customization of comfortable, once inexpensive canvas athletic shoes is achieved using computer-aided printing systems, which allow mass reproduction at competitive prices. Zazzle customers need only a JPEG, TIFF, or similar image file of reasonable resolution. Although the same wave image is used on every pair of shoes, there is considerable variety in the way customers can choose to scale, crop, and place it, with the result that these simultaneously embody mass-produced standardization and differentiation. Zazzle promotes its products by featuring images of the personalized footwear along with the names of their designers on its website, in so doing creating a sense of "imagined community" of consumers who share a taste and general knowledge of this special wave. In his study of nationalism, Benedict Anderson emphasized the importance of communities formed around print media; access to new media has similarly facilitated the emergence of transnational communities bound together by lifestyle affinity.[39]

Who are the members of these communities? Their identity is difficult to pinpoint, but some net surfers are no doubt also streetwise skateboarders and surfers. The wave has become especially popular as a code for the creative translation of cultural difference among inner city youths or ethnic groups who have lost a stable sense of their own past and who look to a perceived non-Western purity to reclaim it.

In addition to clothing, Zazzle and other online sites also promote skateboards and surfboards customized with permutations of "The Great Wave."[40] The logic of the wave's identification with skateboarding is suggested by artist Valerie Theberge's explanation for choosing this motif in her design of a mural for a skate park in the Washington, D.C., suburb of Anacostia that "riffed" on Hokusai's print. As she later explained, "I wanted an image that reflected the power and dynamism that skateboarders embody as they curve around ramps. I lived in East Asia for ten years, and I think this imagery is strongly embedded in my visual imagination." The local online newspaper has dubbed the mural "The Great Wave off Anacostia."[41]

Once marginal, and confined to Hawai'i and California, surfing has become a global sport whose enthusiasts expend much money on high performance gear. Since 2005 it has been possible to download a "dashboard widget" styled with the great wave for the Apple computer called *marée* (tide) that gives the tide charts for the current day, allowing the user to choose from several harbors in France or elsewhere.[42] However, as Marjorie Kelly has observed in a study of T-shirts in Hawai'i, where surfing originated, "the vast majority of surf-related merchandise is sold to those who only empathize with this passion by surfing recreationally and by emulating the hard-core surfer's look and lifestyle."[43]

Sports marketing may center on young and predominantly male consumers, but it can spill over into other demographics as well. Themed greeting cards are among the popular items that make it possible for people to participate in the surfing lifestyle without getting their toes wet. In 2004 and again in 2006, the Chicago Art Institute's annual holiday sales catalogues, which reach consumers across the United States, advertised an unconventional Christmas card of a surfing Santa, designed by illustrator Tom Herzberg (figure 4.13). Surfing enjoys a huge following in Japan, and, in an interesting variation of the "artistic remix," one enterprising maker of inexpensive paper summer fans capitalized both on the wave motif and the celebrated Japanese brand Hello Kitty. Even JETRO has taken up the theme. An advertisement in the *San Francisco Chronicle* depicting a man in a business suit trying to

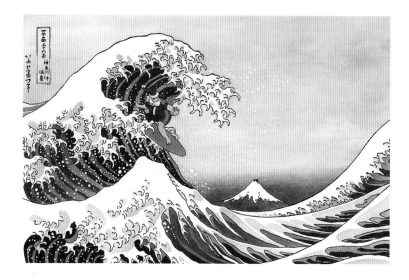

FIGURE 4.13. Tom Herzberg, Christmas card with Hokusai parody, 2000. (Photograph courtesy Tom Herzberg)

balance on a surfboard atop a cresting wave announces that "Japan has become the key to global competitive advantage for foreign businesses in many sectors" and that the Japan External Trade Organization can help with strategies for companies seeking to enter Japanese waters.[44]

Hokusai's design lends itself to these disparate usages because, by capturing the huge cresting wave in motion, it creates the illusion of overcoming gravity, nature, and time, even as it retains the threat of impending disaster. Its dynamic fluidity metaphorically expresses the freedom, grace, and agility required for any sport, while its heroic isolation is especially apt for those that are practiced individually, like skateboarding and surfing. The giant wave also has what might be characterized as street attitude, drawing public attention through its in-your-face spectacle, while also keeping the beholder at bay by its implications of danger. If identification with Japan is implicated in any of these

readings, it is more for the fantasy of anti-authoritarian alterity than for any intrinsic aesthetic or cultural traits.

Both skateboarding and surfing were once subcultural practices in American cities, especially on the West Coast, expressive of youthful rebellion, empowerment, and freedom from the bourgeois work ethic.[45] Today, while they retain something of this lifestyle image, they have been subsumed into multimillion dollar global businesses. The customization of Keds by kids speaks to the way marginal or subcultural groups may, through their do-it-yourself bricolage, have an impact on mainstream products.[46] Keds sneakers have been around since 1916, but they rose to fame in the 1940s and 1950s through their association with American basketball stars and again in the 1960s and 1970s when the boxer Sugar Ray Leonard wore them. During this period, they were de rigueur footwear for school athletics. Competition from new styles of footwear made by Nike, among others, forced the company to close down in 1986, but by 2002 Keds had made a comeback. Music, dance, and skateboarding were the main catalysts for this revitalization. As the authors of one of the numerous new publications devoted to the subject has written, sneakers "moved out from the sports arena and exploded into popular culture as a fashion style which simultaneously transcended race and class, yet defines who you are in today's urban tribes."[47] Keds took on connotations of back-to-basics retro chic with implications of resistance to the powerful forces of global branding. Viewed from this perspective, it might be argued that the image of irresistible momentum "The Great Wave" projects when applied to this footwear echoes the motion of Nike's Swoosh—providing commentary that is simultaneously a tribute and a parody.

Patagonia is a global corporation whose founder, Yvon Chouinard, successfully made the transition from counterculture to mainstream by imparting to his company values that reflect the outlook he shared with his early, primarily Californian consumer base. The title of his book, *Let My People Go Surfing: The Education of a Reluctant Businessman,* speaks for itself. A philosophy of sustainability and environmental awareness is deeply ingrained in the company's core production values, and a percentage of all sales are donated for the preservation and

restoration of the natural environment. Chouinard started out design-
ing, manufacturing, and distributing rock-climbing equipment and by
1964 had produced his first mail-order catalogue. In 1972 the company
moved into clothing, developing a variety of new lightweight, warm,
and absorbent materials "drenched in color" suitable for all rugged
outdoor sports. To distinguish the apparel from his earlier products, it
was marketed under the Patagonia label, adopted because "it brings to
mind Romantic visions of glaciers, tumbling into fjords, jagged wind-
swept peaks, gauchos and condors." [48] Since the opening in 1970 of
Patagonia's first retail outlet, the Great Pacific Ironworks in the beach
town of Ventura, California, Patagonia has used adaptations of Hoku-
sai's design as the store's logo and
on a wide range of apparel, but
especially T-shirts and the kinds
of long, baggy shorts favored by
surfers (figure 4.14).[49]

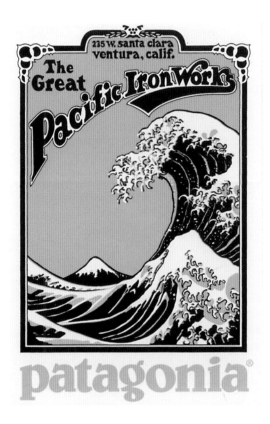

The market in Japan for
mountain-climbing gear, and,
later, for outdoor sports clothing
led the company to open shops
there as well, and today cloth-
ing branded with Patagonia's
distinctive logo has found spe-
cial appeal among young Japa-
nese surfers, who are likely to
recognize its source.[50] Among
those with leisure and the where-
withal to enjoy these goods, the
swaggering wave seems to have
become an expression of a gen-
uine, homegrown cool, but one
that emerges from a dynamic

FIGURE 4.14. Patagonia logo. (© Patagonia, Inc.)

FIGURE 4.15. Public service advertisement "Little by little, our waters are less like art." (*Gourmet*, August 1996)

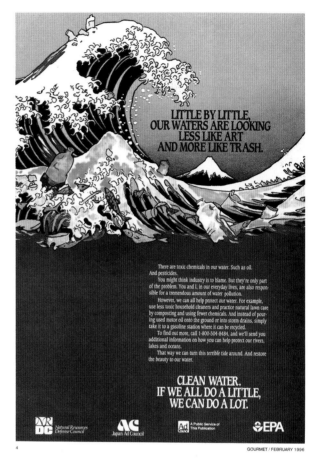

cross-cultural fertilization bound up with global consumerism. The predominantly female-gendered éclair and the masculine-gendered surfing ware speak to the importance of the context in determining readings of this motif.

It is easy to see the synergy between his logo design and Chouinard's love of mountain and surf, but this branding strategy has a larger significance as a dramatization of Patagonia's difference vis-à-vis other multinational corporate culture. By recoding the premodern space of nature into the postmodern space of commerce, Patagonia attracts socially conscious consumers. This is accomplished by appropriating the environmentalism that is also part of the complex symbolic network of "The Great Wave." A "public service" full-page advertisement that appeared in the August 1996 issue of the upscale magazine *Gourmet* throws light on the way the wave and global environmental awareness have intersected, the one arousing expectations of the other (figure 4.15).[51] The image of a garbage-strewn wave with Fuji in the background is conjoined with the caption "Little by little, our waters are looking less like art and more like trash." This is followed by a long explanatory text and concludes with another statement

in large bold type: "Clean water. If we all do a little, we can do a lot." For the sponsors of the ad—identified as the Natural Resources Defense Council, the Japan Ad Council, The Environmental Protection Agency (EPA), and the publication itself—connection with the issue of clean water asserts a kind of global environmental citizenship. Patagonia's use of "The Great Wave" is validated and accrues ethical stature through the discursive logic of such multiple and mutually reinforcing visual representations.

Cool Japan

In the prolonged recession that followed the collapse of Japan's bubble economy in the early 1990s, a new class of cultural brokers arose, flooding the global marketplace with new symbols and images of the country, many of them involving citations of traditional forms of art, including ukiyo-e. During this decade, computer games such as Pokemon, anime directed by Miyazaki Hayao, and manga of all kinds, as well as the Superflat art of Murakami Takashi and cartoonlike characters of Nara Yoshitomo all became hugely successful exports, a welcome trend when Japan's industrial market share was declining. Arguing that, "perversely, recession may have boosted Japanese national cool, discrediting Japan's rigid hierarchy and empowering young entrepreneurs," Douglas McGray asserted, in an influential 2002 article about globalization in *Foreign Policy* titled "Japan's Gross National Cool," that "Japan is reinventing superpower again. Instead of collapsing beneath its political and economic misfortunes, Japan's global influence has only grown. In fact, from pop music to consumer electronics, architecture to fashion, Japan has far greater cultural influence now than it did in the 1980s, when it was an economic superpower."[52]

Ukiyo-e is only one of many historical styles referenced in Japanese Pop, but for Western art critics it is the most familiar one. Consequently, these writers have frequently drawn analogies that have made "The Great Wave" part of its discourse, especially with respect to Murakami. In her best-selling *Seven Days in the Art World*, a commentary on the global market for art, *Economist* correspondent Sarah

Thornton describes "MR DOB, Murakami's postnuclear Mickey Mouse character, as a god riding on a wave, inspired by Hokusai's famous nineteenth-century woodblock print 'The Great Wave of Kanagawa.'"[53] (Japanese viewers might instead see it as an updated version of Tetsuwan Atomu.) Similarly, German curator Margrit Brehm, in the catalogue accompanying a 2002 exhibition at the Ursula Blickle Foundation, draws attention to the "flying fluid—unavoidably recalling Katsushika Hokusai's Great Wave—[that] recurs in a variety of forms in Murakami's paintings and figures."[54] This is an allusion to his iconic plastic sculpture *My Lonesome Cowboy*, a young manga-styled male ejaculating from his oversize penis a whiplash spray of semen. This cross-referencing was later reiterated in a Sotheby's catalogue, where the sale of the statue of the masturbating manga boy hero was promoted by juxtaposing its image with a reproduction of Hokusai's print. An illustrated commentary on the sale and catalogue in *The Art Newspaper* gave this promiscuous conjunction still further credibility and exposure.[55] These developments follow a time-honored pattern in which foreign cultural critics entertain assumptions that help to make Japanese art comprehensible and meaningful based on the identification of features that conform to their own expectations.

Initially officials in the Ministry of Economy, Trade and Industry (METI) ignored and even opposed recognition of these dynamic popular trends with roots in subversive subcultures. The *otaku* movement, comprising young men who refused integration into the adult workaday society of their parents, immersing themselves instead into the alternative worlds of autoeroticism, computer games, and manga, was especially antithetical to government objectives. Just as long-standing resistance to ukiyo-e was bound up with the way it paraded Edo period fantasies of sex and consumption, so too conservative officials were unprepared to negotiate critically with its contemporary counterparts. Nonetheless, the economic potential of the varied products of this cultural world led them to adopt its cuter and less threatening expressions as part of a strategic campaign to rebrand Japan.

The inauguration of what came to be known as the "Cool Japan" campaign was allegedly prompted by McGray's article, in which he

likened "Japan's National Cool" to a kind of soft power, a term used to refer to the ability to influence behavior through cultural means.[56] Although this was hardly news in Japan—a country that had considerable mastery in the fine art of soft power already by the turn of the twentieth century—this idea was eagerly taken up by government policy makers. To decide what was "cool" about Japan, a new television program that functioned like a focus group survey was launched on NHK television. According to Kazuhiko Tsutsumi, its executive producer, "the idea behind the show was to look at what aspects of Japan foreigners found most attractive."[57] Panelists made clear that Japanese pop culture was a key aspect of this.

The promotional graphics produced as part of this campaign suggests that, beyond hiring young female personalities who embodied a hip lifestyle and incorporating clichéd motifs from ukiyo-e, there was considerable uncertainty as to how to communicate the qualities of Japan's "gross national cool." "The Great Wave" came to figure most prominently in "Yōkoso Japan" (Welcome to Japan) literature aimed at tourists. Travelers passing through Narita Airport in 2005 could consult a Japanese-language guide to the services available there with a detail of Hokusai's design on the cover (figure 4.16). The Japan Rail Pass, valid only for foreign visitors, also featured it that year. The most unlikely publicity, however, was a Yōkoso Japan poster with J-Pop singers Puffy Ami Yumi standing before a giant collage of Mount Fuji and the Great Wave. Dressed in colorful short kimonos and high-heeled boots, one held aloft a phallic-looking eggplant and the other an eagle.[58] Although most Japanese viewers are likely to be familiar with the tradition that dreaming of Fuji, the eagle, and eggplant promises good luck, to those unfamiliar with this auspicious symbolism, these motifs no doubt added to the exotic mystique of the ad.

Ami and Yumi, teenage idols in Japan as well as successful in animated features on the Cartoon Network, were designated in 2006 the official Goodwill Ambassadors for the "Visit Japan Campaign in the United States." If this official recognition of their impact abroad signaled a fundamental shift in the government's relationship to contemporary vernacular culture, it also reinforced time-honored stereotypes

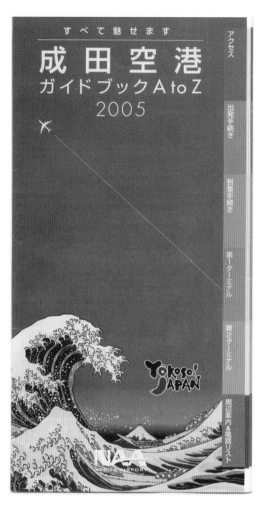

FIGURE 4.16. Yōkoso Japan (Welcome to Japan) brochure with guide to Narita Airport. (Author's photograph)

of Japan as weirdly wonderful and populated by childlike geisha. Bureaucratic mobilization of the unruly language of popular culture entails readings that the designers of this poster may not have foreseen.

Soft power recognizes the importance of cultural diplomacy through trade, tourism, and academic exchange. Murakami's, Nara's, and the Yōkoso campaign's selective reworkings of the past are expressions of it, arising from the bottom up or instituted from the top down, but they also conceal a hard political edge. All are predicated on a self-othering in which Japan mirrors itself back through the prism of Western stereotypes in commodified forms. The artists have interrogated and invoked Japanese art-historical themes and styles critically in order to reclaim for themselves agency to construct narratives about their own aesthetic tradition—agency that they believe has been usurped by the West, and especially America. The Yōkoso campaign is also an exercise of power but instead takes the value of Hokusai's design, as constructed in the West, as a given, linking it to a politics of national identity that seeks symbolically to reassert borders and boundaries in response to the

pressures of globalization. Such market-conscious and consumer-driven pastiches situate "The Great Wave" at the intersection between conflicting perspectives on the flow and counterflow of Japanese culture.

With its implications of constant movement to, from, and between boundaries, and its implications of spectacle at the expense of materiality, the wave is emblematic of the pluralistic, fragmented, and media-saturated landscape of the postmodern world made possible by media convergence. Reading it simply as a free-floating signifier fails to acknowledge the agency of both professional graphic designers and consumers to make new and often contradictory social meanings through its mobilization. The visual language and subject of the great wave invite creative manipulation of its deterritorializing qualities to refer to or reflect on local sociocultural structures. This process of displacement and reinvention has taken "The Great Wave" in and out of various niche lifestyles and subcultures, making the messages it communicates ever more pluralistic and ambiguous and, like the wave itself, constantly mutating. The proliferation of its manifestations have helped it occupy a hybrid "third" space apart from Japan even as it has been purposefully mobilized to both reinforce and critique Japanese national identity.

Throughout its historical and geographic trajectories, the media and circumstances in which the wave is consumed have been crucial to its apprehension. Viewers bring one kind of expectations to a Japanese woodblock print, another to articles they use in their daily lives, and still others to their experiences of it on the web. Web browsing and shopping are empowering local practices through which anyone anywhere can make the freely circulating image of the wave his or her own by downloading it and, further still, by modifying it to suit individual needs and tastes. The often playful retooling of individual and collective identity by claiming a cultural space and voice in the virtual world challenges views of globalization as a top-down form of capitalist imperialism against which there is no local recourse. The empowering appeal of the wave's online consumption and reinvention has contributed mightily to its already ongoing iconicity.

Placemaking

We study history as great waves that pass over the land and change how we use and think of it, but apart from an element of nostalgia, or longing, it tends to pass us by. It rarely seems to be our story. We forget that it goes right up to yesterday. The practical and grassroots process of living is the way most of us experience history and time.

—Lucy Lippard, *The Lure of the Local*

Relocations of "The Great Wave" as part of the natural and built environments bring home sociocultural awareness of both the challenges and the opportunities of global change. Their patterns of distribution, in forms that may be loosely characterized as site-specific art, are uneven and do not imply uniform understandings of the wave, but all share an emphasis on real-life responses to global interdependence.[1] Some involve permanent transformation of the lived environment, whereas others alter the way it is experienced only temporarily. Coupled with the recognition of the importance of particular places in constructing social identities, these adaptive reuses of the wave speak to a yearning for materiality in a globalizing world of mediated and virtual experiences. Whether fabricated from stone, brick, mortar, glass, or plant material, their scale and physical emplacement give them phenomenological implications different from a picture hung on a wall or an article held in the hand. Although they may be accessible virtually, their primary value is their very immanence.

"Placemaking" is a term that has been taken up by scholars in a number of disciplines, but it has been especially conspicuous in the writings of Ronald Lee Fleming on the way that city planners, builders,

users, and residents can collaborate in the production of meaningful spaces within the urban environment.[2] For Fleming, an advocate of community-engaged rather than top-down urban planning, placemaking fosters a sense of community by capitalizing on both past and present. "Place," he writes, is not merely what was there, but also the interaction of what is there and what happened there. . . . It may be a recollection of a distinctive physical setting that is the strongest sensation. . . . Certainly, those who have a design sensibility instantly grasp the tactile components that create the physical image of a place."[3] The varieties of placemaking discussed here differ from those examined by Fleming in that they introduce Hokusai's design to an environment with which it may have no obvious ties in order to create and sustain a sense of local distinction through connections with a larger world. These institutional and noninstitutional appropriations throw light on the rhetorical power of the wave as a tool of collective local empowerment.

"The Great Wave" has triggered a wide range of imaginary and often ironic placemaking. It has been paired, for instance, with the Eiffel Tower in Paris, the Golden Gate Bridge in San Francisco, and even the Federal Reserve Building in Washington, D.C.[4] Not surprisingly, such formulations are especially common in the form of postcards, banal expressions of modern tourism that provide evidence that a trip was made and that the traveler was "there." Today, photographs of these sights have become so clichéd that a view of them no longer evokes the aura of authenticity; as a result, only a parodic one will do. Contemporary artists have also adopted this visual strategy to comment on the global processes by which locally specific forms of hybridity emerge, as in Mohamed Kanoo's digital print *The Great Wave of Dubai*, remapping the wave next to the towering Burj Al Arab hotel in Dubai (figure 5.1).[5] Standing on an artificial island near Jumeirah Beach, the building's shape is intended to evoke a ship's sail. Although witty, this conflation comments on the transformation of the city through the intrusion of alien signs and forms that, even as they impart local distinction to Dubai, may also destabilize its authenticity and coherence.

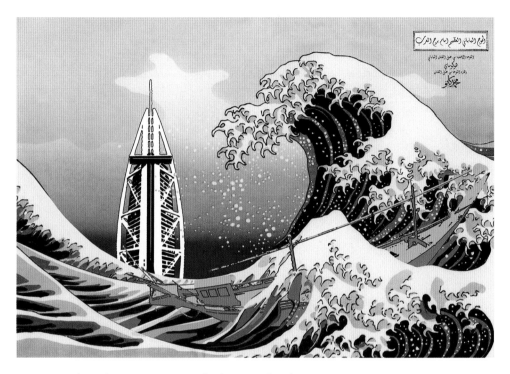

FIGURE 5.1. Mohamed Kanoo, *Great Wave of Dubai*, 2012, digital print, 51 × 31 ¼ in. (130 × 80 cm.). (Courtesy Meem Gallery, Dubai)

A stamp issued in 1997 to commemorate the one hundredth anniversary of Japanese diplomatic relations with Chile might easily be mistaken for another example of transcontinental relocation (figure 5.2).[6] This rendering of the wave in profile with a conical mountain in the distance features the red sun of the Japanese flag and the white star against a blue background of its Chilean counterpart. The design plays on the similarity between the Japanese volcano and Mount Osorno, a volcano 2,652 meters high in the Los Lagos region of western Chile that is often compared to Mount Fuji. Not all viewers will recognize the analogy, but it is not necessary to the appreciation of the visual drama of this design, cleverly framed in an unusually elongated stamp format.

Once again, we see here how the wave and Fuji have become part of a vocabulary of mass production and circulation, standardized units that may be reworked repeatedly in different media without instantiating a visual hierarchy that prioritizes the original.

These imagined geographies, however, do not explicitly address the way reinventions of "The Great Wave" are encountered as part of the physical landscape in forms larger than life yet subsumed within still larger structures. Nor do they engage with placemaking as an engaged, community-oriented practice resulting in a sense of ownership. This chapter focuses on a small, eclectic selection of site-specific projects from the past two decades whose realization is inextricably entwined with collective local histories and traditions. It highlights the multivocal and metaphorical thematics that help to account for the wave's appeal not only across geographies but across age, gender, and class. It particularly seeks to draw attention to the production of place as one of the

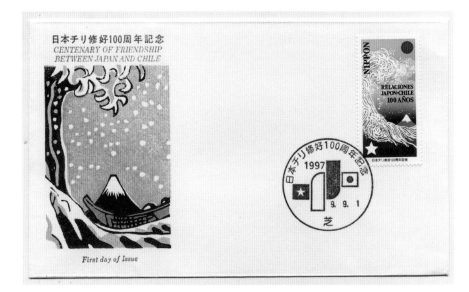

FIGURE 5.2. Japanese stamp commemorating one hundred years of diplomatic relations between Japan and Chile, 1997. (Author's photograph)

modes through which the forces of homogenization are resisted, but one that is nonetheless dependent on the availability of global communication technology.

"The Great Wave" Wall, Vancouver International Airport

There is no more telling metaphor of undifferentiated, postmodern space than the airport. As people travel in ever greater numbers to far-flung corners of the earth, they spend more and more time in airports with their national identity cards in hand, passing through security gates, riding moving walkways and escalators up and down long corridors, and waiting to board jets that will carry them to yet another airport, where they may repeat the same process before reaching, in airline idiom, "their final destination." As global travel writer Pico Iyer has trenchantly observed, "A modern airport is based on the assumption that everyone's from somewhere else, and so in need of something he can recognize to make him feel at home; it becomes, therefore, an anthology of generic spaces—the shopping mall, the food court, the hotel lobby—which bear the same relation to life, perhaps, that Muzak does to music."[7] Its embodiment of the postmodern experience of being in perpetual transit led sociologist Marc Augé to characterize the airport as a "non-place," a term that designates "two complementary but distinct realities: spaces formed in relation to certain ends (transport, transit, commerce, leisure), and the relations that individuals have with these spaces."[8]

As an urban, regional, or national gateway, the airport has long been symbolically defined by conspicuous investment in labor, capital, and awe-inspiring architecture. Minoru Yamasaki's 1956 design for St. Louis Airport and Eero Saarinen's 1962 design for New York's "Pan Am Terminal," for instance, impress through wavelike forms that evoke the soaring experience of flight. The interiors of airport terminals, however, were initially understood strictly in terms of safety and efficiency, the separation of the departure and arrival terminals being conspicuous developments in this respect.[9] Consequently, consideration of the design opportunities of their vast light-filled halls or the

long expanses of wall in corridors and jetways lagged behind that of the exterior aspects of the buildings. Since the 1980s, however, architects and designers and planners have devoted increasing attention to making them physically and psychologically comfortable. Transforming these impersonal, anxiety-inducing spaces into more welcoming places by investing them with the marks of local culture has been a conspicuous feature of these endeavors.

Although all interventions involve ritualization of departure and arrival, the material means used to achieve airport placemaking vary widely. Some are what Fleming has derisively labeled "plop art," in which artworks, chiefly sculptures or other three-dimensional works, are installed without particular regard to context, whereas others are conceived as part of the airport infrastructure.[10] The most successful, in his view, combine an awareness of local sociocultural particularities and of how experience is shaped through sight, touch, sound, and feeling. For Miami airport's award-winning design "A Walk on the Beach," for instance, artist Oka Doner handcrafted images of sea coral, shells, and other organisms evoking the living presence of the sea into a black terrazzo floor embedded with shimmering sprinkles of sand.[11] This design welcomes visitors through an immersive experience that captures the essence of the Florida beach in a way that can either provoke pleasurable anticipation or summon memories of past experience.

The redesign of the Vancouver International Airport, completed in 1996, builds on the idea of "Land, Sea, and Sky as the roadways of travel," themes intended to celebrate "the cultural heritage and spectacular natural beauty" of British Columbia.[12] Stretching from the Rocky Mountains to the Pacific, Canada's most westerly province is vast, and scale is an important consideration in the installations throughout the airport. Located in the Departure Hall of Vancouver International Airport, Lutz Haufschild's luminous "Great Wave Wall" is an awe-inspiring forty meters wide and ten meters high (130 by 32 ft.) (figure 5.3).[13] Made from thousands of horizontally arrayed one-inch strips of float glass in nine different hues of blue, green, and clear, it is a dynamic composition whose aspect changes according to the light flowing through the huge south-facing window behind it as well as to

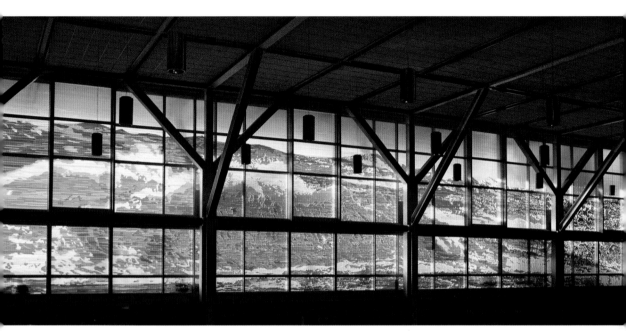

FIGURE 5.3. Lutz Haufschild, "The Great Wave," 1-inch strips of tinted float glass, stacked and laminated, set between layers of safety glass, International Arrival and Departure Lounge, Vancouver International Airport. (Fabricated by Kits Glass; photograph by John Moir)

the beholder's position. When viewed frontally, the great cresting wave appears to be headed toward the beholder; viewed from an angle, the image fragments suggest the experience of total immersion.

The decision to create "an ocean environment" in the International Departure Lounge followed from discussions with the airport authority, the architect, and an art consultant for the installation of Bill Reid's monumental "Jade Canoe." Lutz Haufschild recalled that "during those discussions Hokusai's Great Wave was first mentioned and we agreed this Great Wave had to be as memorable. . . . I initiated several experiments with materials, which were placed in situ before the building was complete. I collaged several photos I had taken of waves coming towards the shore and this gave us the design matrix for fabrication.

Fabrication took about 6 months in the facilities of Kits Glass, which was located conveniently close to the airport. Installation took 3 weeks. The project had to go through severe earthquake testing."[14]

Airports are places where people, for the most part, do not expect to reflect on art as they might in a museum. Whereas Bill Reid's "Jade Canoe" is surrounded by banquettes that invite travelers to stop and reflect, Haufschild's glass wall is not similarly framed as "art." Of the 15 million who reputedly passed through Vancouver airport last year, how many actually noticed or thought about Haufschild's and Reid's joint installation or made the connection to Hokusai's wave? Despite its conspicuous presence in a teeming public place, there is little evidence that travelers pay much attention to this impressive glass construction or are aware of its source of inspiration.[15] The scale and medium that make this creative interpretation of a great wave so very distinctive may work against the "half seen" effect produced by other pictorial versions. Although Haufschild may have sought to achieve a visual impact comparable to that he experienced when looking at Hokusai's wave, it does not matter if the beholder of his glass wall also makes this connection.

The "Great Wave Wall" derives its dramatic power from a magical two-way dialogue with the light passing through the huge windows behind it and the twenty-foot-long green-patinated bronze canoe filled to capacity with symbolic figures from the myths of the aboriginal Haida Gwaii people in front of it. The beholder standing at the stern of the "Jade Canoe" gets the impression that it is venturing out to sea, about to cut through the giant wave heading, perhaps, toward the island archipelago that was their home.

"The Great Wave Wall" and "Jade Canoe" provide more than an aesthetically appealing diversion from the congestion and impersonality of the airport. From their prominent and anchoring position in the International Departure Terminal, they greet the traveler passing through Canada with visually compelling reminders of other modes of travel in other times. Although they speak specifically to sea travel, they also metaphorically evoke the diasporic dislocations of local populations that began when Canada was part of Britain's colonial empire. Born to a Haida mother and a European father, Bill Reid, the creator

of the massive sculpture, devoted much of his life to the restitution of the archipelago and other lands to Canada's First Nations.[16] It was only in 2010 that the archipelago, named in 1787 the Queen Charlotte Islands after the wife of King George III, reclaimed its identity as Haida Gwaii.[17] While the millions of passengers who pass through the departure lounge are unlikely to know these historical specifics, even the most casual of them cannot fail to notice the importance now ascribed recognition of the heritage of Canada's First Nations peoples. As part of the planning of the new terminal, Vancouver Airport Authority also purchased a collection of seventy-five sculptures by contemporary Inuit artists that are exhibited in the domestic terminal. Welcome figures, totem poles, and other forms of ritual expression by other First Nations peoples are also displayed throughout the airport.[18]

The installation in the International Departure Terminal represents Canada not as a homogenous entity but rather as a constantly evolving multiethnic society. Even as it speaks explicitly of Canada's original inhabitants, so too its cultural hybridity can be understood to allude implicitly to its newest arrivals. Vancouver's mild climate and location on Canada's Pacific coast have long made it an attractive destination for immigrants from many parts of Asia, including Japan, but the human flow intensified in the run-up to the 1997 handover of Hong Kong to China, and today diasporic Chinese represent a significant proportion of the city's population. For these and many other people on the move, Vancouver International Airport is the gateway to Canada. This reading of "The Great Wave Wall" and the "Jade Canoe" is not necessarily one that all Canadians embrace, nor is it the message that either Haufschild (himself an immigrant of German background) or Bill Reid intended, but it is clearly one that acknowledges the demographic realities of Vancouver, a city of many identities and ethnicities.

Street Art

Street art plays a conspicuous role in restructuring the experience of everyday life in the urban environment by offering a platform for individuals and groups to leave their traces in forms ranging from tags and

scratches to stencils and freehand painting. Along with site-specific expressions such as happenings and environmental art, it is linked to critical resistance to the commodified system of artistic production by social activists' sensitivity to the physical and environmental qualities of their chosen sites.[19] Yet even though its meaning is inextricably bound up with emplacement, street art is not altogether removed from the logic of global capitalism.

Over the past two decades "The Great Wave" has entered into and commented on urban culture in public spaces in the form of fire hydrants painted by art students in Ann Arbor, Michigan;[20] a three-dimensional wave on a bridge in Dresden, Germany;[21] and murals in the catacombs of Paris and on the streets of the Sydney suburb of Newtown, Australia, to name only a few examples.[22] Because it has become part of a vocabulary of visual symbols familiar to a broad public, but especially to subcultural groups, it provides a readymade subject for irreverent quotation as well as political critique. While its iconicity gives it visual authority, as a vernacular motif that originated outside Western culture, it also holds special appeal among those who see themselves as united through difference. The mutually reinforcing status of "The Great Wave" both as a museum masterpiece and as a vernacular readymade, however, complicates this narrative: the earliest known example of its use in street art is a mural commissioned in the 1970s by "an art-loving" South American diplomat for the side wall of his brownstone residence in Washington, D.C.'s upscale Georgetown district (figure 5.4).[23] When the house changed hands in 1983, the buyer of the brownstone noted that the mural was "part of [its] appeal."[24] More recent online references in connection with the sale price of this residence and with "fresco tours of Georgetown" underscore that personal taste, local property value, and tourism also may be considerations in street art.[25]

Much has been written both condemning and celebrating the impact of street art on the urban environment, but there is no denying that it has helped to establish vibrant inner-city artistic communities with strong transnational links. Newtown, now recognized globally as a tourist destination, is typical in this respect. Established as a residential

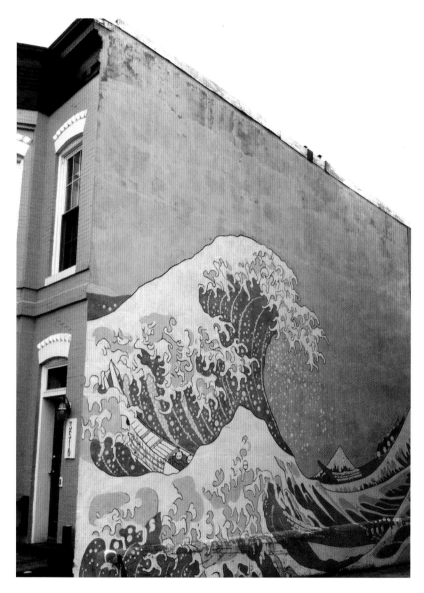

FIGURE 5.4. Great wave mural, Georgetown, Washington, D.C. (Photograph courtesy Alicia Volk Fishbein)

suburb of Sydney in the nineteenth century, Newtown became a prosperous commercial and industrial center with rail, brickworks, and potteries. The failure of these industries during the Depression, however, led to the city's gradual decline until the 1960s and 1970s, when the cheap housing in this rundown area attracted students from nearby Sydney University. A decade later Newtown developed a reputation as the center of a lively musical and art scene where gays and lesbians were welcome. It was during this period that local artists began to colonize the city streets with graffiti and murals reflecting their concerns, such as the multicultural vision embodied in the "I have a dream" mural with Martin Luther King speaking for Australian aboriginals. Their appropriation of buildings without their absentee owners' permission has served to revive this declining neighborhood, but city authorities often fail to distinguish between murals and graffiti, labeling both as threats to the quality of life in the city.

There is considerable local rivalry, with one group staking visual claims that are revised or even obliterated by others, but two groups have been especially active in challenging the uniformity and anonymity of Newtown: Unmitigated Audacity Productions (UAP), a collective whose members include Sydney and New Zealand born artists as well as a member of a hip-hop group, and Big City Freaks (BCF). UAP created a large number of the signed works in Newtown, including the Martin Luther King mural, many of them drawing on readymade icons such as the *Mona Lisa* or *The Last Supper*. The "great wave" mural was painted in 2000 by BCF (figure 5.5). Located on the side of an elongated house with a peaked roof that abuts the street rather than an alleyway, this complex rendition expands on the woodblock print by the addition of sweeping tile-roofed temples on the right and, most startlingly, in the center, a triad of snow-capped Mount Fujis with a full sun above them.[26]

The historical and cultural sampling Newtown's murals materialize is characteristic of contemporary popular musical and visual practices that draw promiscuously from around the world, often making use of readymade icons that feed on their own celebrity. Perceptions of Australia's own marginality may have led Newtown's street artists

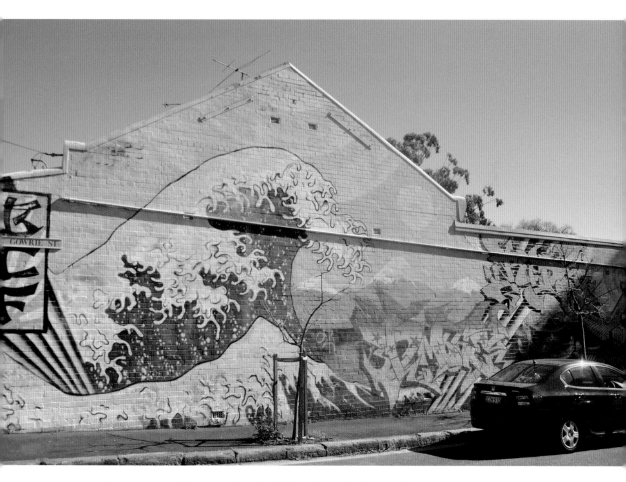

FIGURE 5.5. Great wave mural, Newtown, New South Wales, Australia. (Photograph courtesy John Clark)

to look to iconic motifs from North America, Europe, and Japan. As design historian Tony Fry has written, "a post-colonial nation like Australia is dependent, as is often the case, not just on the geospatially diffuse metropolitan capitalisms, which do not reduce to clear singular centers, but also on the local modalities of metropolitan modernity. . . .

The history to unfold here, then, is of the knowing and unknowing sign management of *bricolage.*"[27]

In Newtown, bricolage using the wave is a small part of a larger strategy for negotiating a relationship with outsiders to the neighborhood through a project that builds a sense of local identity. The newly invented locality has in turn served as a platform for the area's transformation into a tourist destination. The formal and thematic means and concerns of a landmark-making mural using mosaics and other found objects covering the exterior walls of artist Carrie Reichardt's own home in West London are more explicitly personal, aesthetic, and political. To its primary function as a shelter, her home adds a secondary function as a site of socially engaged transnational display.

Reichardt's explicit aim is to raise awareness of the detention conditions and treatment of blacks in American prisons. This objective is materialized in two complex narratives, one focused on the "Angola Three," black men who were for decades unjustly placed in solitary confinement in Louisiana's notorious Angola State Prison, and the other on Luis Ramirez, a Hispanic American, who, despite claims of innocence of the murder of his former wife's boyfriend, was convicted and executed in Texas. Until his death in 2005, Reichardt had been a pen pal of the death row inmate, and she continues to correspond with and visit other prisoners incarcerated in Texas.[28]

The wave is one of the motifs mobilized in the "Angola Three" narrative on the back of the house (figure 5.6). Explaining its significance, Reichardt writes:

> As a design feature we wanted something that would take your eye back into the center of the mural. We chose Hokusai's wave as Robert King (the only freed member of the Angola 3) has often spoken about how each individual can help to throw a pebble into the water, to bring about positive social change. He says that even though it might not seem much in itself, that if enough people throw pebbles into the water, eventually you will create a wave of change. Hokusai's wave is supposed to represent the wave of change we would like to see in bringing equality and

justice for everyone in the world. We thought it would be good to mosaic this wave and that as a universally recognized image it would be very well liked. We were proved right when the local Lib Dem Councilor, who lives around the corner, told us that it was his favorite part of the whole mosaic house.[29]

When a serendipitous sighting of Reichardt's house in 2012 prompted its inclusion in this study, the wave was not yet complete. Since that time colorful mosaic pieces representing landmark London buildings being swept up by the force of its movement have been added, giving it an ominous quality it did not initially have. Reichardt has also drawn new attention to this addition to her house through a video posted on YouTube that records the laborious process of creating

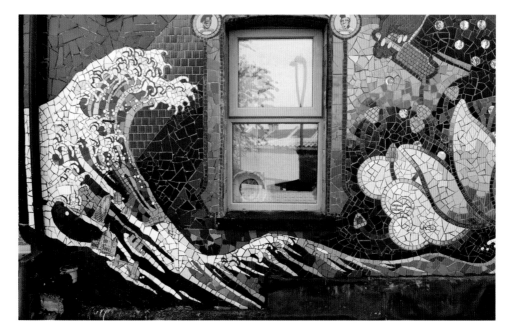

FIGURE 5.6. Carrie Reichardt, detail of great wave mosaic, The Treatment Rooms, London, 2013. (Photograph courtesy Elizabeth Beamer-Rimmer)

the wave mosaic, applying it to the outside wall of the house, and filling in the cracks with grout.[30] Viewing this creation process underscores the complex materiality of this rendition of Hokusai's wave.

It is difficult to reconstruct the nuances of thought and practice brought to the realization of the mostly anonymous forms of public art incorporating the wave, but interviews with Dominic Sword, creator of London's most celebrated version, offer further glimpses into the complex personal and social impulses that may give rise to such projects. Painted on the back of the second-story brick wall of a small house flanking Coldharbour Place, a pedestrian alley between two major thoroughfares, it animates an otherwise nondescript building, transforming the experience of the surrounding working-class neighborhood of warehouses, residences, and commercial establishments (figure 5.7). With its flow reversed from that of the print and Mount Fuji resited to the left foreground, the wave, dramatically elevated above the heads of passersby, appears about to deluge the alley below. The porthole-shaped window that can be made out in the middle of the wave suggests a boat caught up in its maelstrom or a haven from the storm raging outside. The mural's location on Coldharbour Place may provoke still further imaginative connections, "coldharbour" being an eighteenth-century term for a kind of wayside lodging, comprising a simple roof for shelter but no other amenities.[31] A place-name with counterparts elsewhere in Britain, it is likely that there was such a "harbour" somewhere along this route when this area was still a suburb of London.

Like Carrie Reichardt, Dominic Sword used his own home as an instrument of change, also performing in its transformation in a very personal way. The idea for a mural came to him in 1997, just after moving into the building, prompted by an assignment in a Landmark Education motivational course to undertake a project that would benefit the community. His undertaking was as much about the relationships forged in the process of creation as in the resulting mural. Concerned that his vision might come into conflict with conservation or other regulations, he first consulted local council authorities, who informed him that there were no restrictions in his neighborhood; no permission

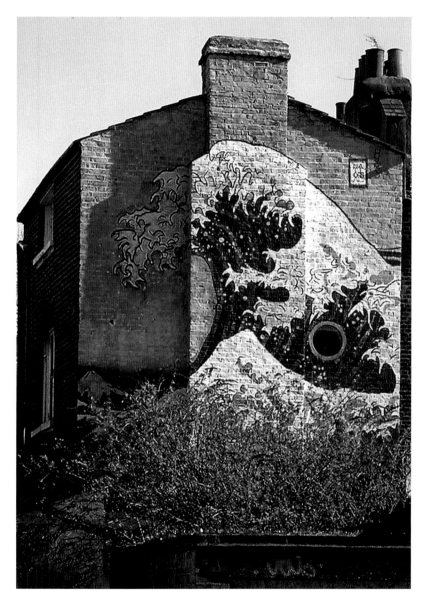

FIGURE 5.7. Great wave mural, Coldharbour Place, London, 2012. (Author's photograph)

was required, and he could paint his own house in any way he chose, as long as there were no complaints from neighbors.

Having decided that painting the drab bare wall at the back of his house would provide an opportunity to meet and engage his new neighbors in transforming their environment, he struggled to find a suitable subject that, as a poet rather than a painter, he might realize on this large and rather unpromising surface. He wanted a nonfigural motif that would evoke the wind as a force of nature, and Hokusai's "The Great Wave" came to mind. "It was there in my consciousness, and if I flipped it around, it was a perfect fit," he declared.[32]

This do-it-yourself project aroused enthusiasm and active participation from friends and neighbors far beyond his expectations. A local scaffolding company offered its services, and the National Paint Company offered supplies at a discount. (Both are acknowledged in the Japanesque cartouches on the right side of the mural featuring the initials H&S and a paint pot.) A local mechanic and artist friend, unexpectedly, not only was familiar with "The Great Wave," having himself etched it on glass, but provided advice on how to transfer the design to the newly repointed and primed wall using a projector, which he loaned. He even had at hand a slide of Hokusai's print, which was used as a guide in painting the black outlines of the composition at night, an event that participants documented on film. In the days that followed, the partylike atmosphere continued as friends and neighbors, adults and children alike, dropped by, climbed the scaffold, and brought the scene to life by the addition of colors. Further participation and public recognition followed from the project's embrace as part of the 1997 Camberwell Arts festival, an annual event that aims to instill in participants a sense of community.[33] "Today, people go by and still say, 'I did that corner.' No one has said it's an eyesore. Everyone loves it. It was one of the most positive experiences of my life," recalls Sword.[34]

Participation in mural making may bring people together in a way that produces a sense of collective ownership of their neighborhood, but its effects are often short-lived. The fact that "The Great Wave" on Coldharbour Place remained free of graffiti and otherwise undamaged for over a decade is a measure of recognition of its significance as

a local landmark. An interview with Sword, views of the mural, as well as clips of its realization filmed by participants included in the 2004 documentary "The Great Wave," part of the BBC television series *Private Life of a Masterpiece*, no doubt contributed to this local pride. On April 3, 2012, however, an accidental fire in the garage below damaged the lower left of the composition, effacing Mount Fuji and the smaller wave in the foreground. Such is the mural's reputation that the London Mural Preservation Society launched a successful campaign to recruit volunteers to restore it, using the same house paint with which it was originally created.[35] Even as news of the fire damage increased its print and Internet visibility, inclusion of a large photograph in an exhibition on Hokusai's "Under the Wave off Kanagawa" at the British Museum in late 2011 brought its history full circle, as part of both London's local history and the global history of this Japanese woodblock print.[36]

Inakadate, Aomori Prefecture, Japan

Approaches to placemaking may follow local topographies and materials, but this relationship is particularly conspicuous in Japanese variations of the global site-specific art form known as "crop art." The local press has dubbed these projects, undertaken since 1993 in Inakadate, a village of 8,700 in Aomori, Honshu's northernmost prefecture, *tanbo aato* (rice paddy art).[37] Taking their fields as template, villagers there have used different strains of rice to create giant compositions, ranging from Napoleon on his horse and the fictional heroes of popular television shows to interpretations of iconic works of European and Japanese art. In 2007 their twinned themes were "Under the Wave off Kanagawa" and "South Wind, Clear Dawn" (Red Fuji) from Hokusai's *Thirty-Six Views of Mount Fuji* (figure 5.8).

In undertaking these projects, the villagers of Inakadate have tapped into the spatial politics of *meisho*, or famous places. Locales of natural beauty, historical import, or sacred meaning celebrated in classical poetry and painting, *meisho* are part of a code of value-laden, geographically specific cultural markers through which space has been transformed into place since ancient times. Familiarity with this cultural

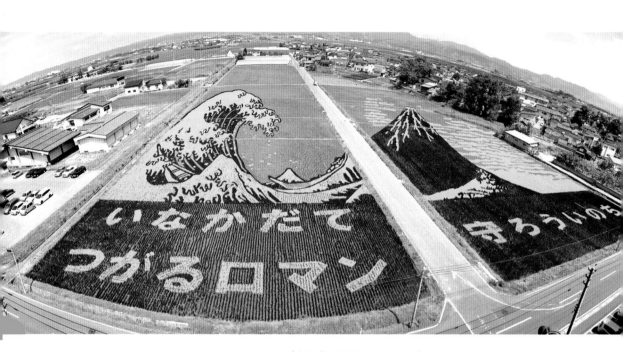

FIGURE 5.8. Great wave in rice fields of Inakadate, Aomori Prefecture, 2007. (© Jane Alden Stevens)

language is inextricably bound up with notions of Japanese identity. Since the nineteenth century, however, the representational force of this designation has been increasingly channeled away from culture toward commerce and tourism. Viewed from this perspective, rice paddy art arguably has transformed Inakadate into a modern *meisho*.

Inakadate's reinvention of the rural environment is at once modern and mythic, involving symbolic gestures that improbably link the hybridization of rice, computer-generated imaging, and theme park culture with recognition of the deep historic roots of rice cultivation in this community some six hundred miles north of Tokyo. How deep these roots extend was first revealed in 1981 by the discovery during highway improvements of traces of rice paddies dating to the Yayoi period (300 BC–300 AD), making this area one of the earliest documented sites of rice cultivation in northern Honshu. Japanese creation

myths involve transformation of the land through rice cultivation, and rice symbolism has always figured conspicuously in nativist rhetoric. Local authorities sought to capitalize on the evocative power of rice by gaining their local archeological excavation a designation as a national historic site in 1999.[38]

Meanwhile, Nakayama Akio, an official in the mayoral office, had also launched another more imaginative strategy to revitalize the local economy by honoring the history of rice. In 1993 farmers commandeered a field behind the town hall, planting there varieties of rice that, as they matured, created a 2,500-square-meter "living picture" of nearby Mount Iwaki, with below it the words "Inakadate, a village of rice culture." When the project expanded to 15,000 square meters in 2005 by incorporating other nearby paddies, more complex pictorializations were developed using computerized plotting and four different colored varieties of rice: heirloom yellow and purple rice and hybrid Red Miyako and pale green Tsugaru Roman. The latter variety, which gets its name from the county where Inakadate is located, is a source of special pride since it won the highest taste test awards from the Japan Grain Examination Association.[39]

"The Great Wave" and "South Wind, Clear Dawn" of 2007 were accompanied by the phrase "Inakadate: Let's protect Tsugaru Roman rice!" (*Inakadate, tsugaru roman o mamorou!*). By including the rhetorical marks of their preservationist concerns in their display, farmers drew attention to the precariousness of rice cultivation in a marginalized community subject to growing depopulation and aging. Local inhabitants have eagerly embraced compensatory creative means to draw attention to their plight, but these do not address the root problem that domestic Japanese rice production is economically unviable. Collective action through the expressive means of crop art merely affords them a measure of control over their self-representation and an impression of cultural continuity that is more imagined than real.

Inakadate's agricultural artistry has involved some controversy. It requires planning a year in advance, mobilizing hundreds of volunteers (both local and from outside Aomori Prefecture) for the backbreaking task of planting the rice in May and harvesting it in September,

and considerable funding. In 2008, when representations of Ebisu and Daikoku, the gods of wealth and good luck, were accompanied by an advertisement promoting Japan Airlines, the owner of one of the fields demanded that this be uprooted.[40] Although further commercial intrusions into the landscape have since been rejected, the reinvention of Inakadate through rice art is in fact all about the economic benefits of local tourism. And these are significant: the number of visitors varies from year to year, but estimates range from 130,000 to 300,000 between planting and harvesting. As a result, other nearby communities have started their own rice paddy art hoping to cash in on the tourist bonanza.[41]

Even though the Shinkansen bullet train now links Aomori Prefecture with the rest of Honshu, this prefecture remains one of Japan's most underdeveloped and one that appears exotic to those living in the metropolitan centers of Tokyo and Osaka. Aomori beckons for affective experiences that connect overworked city dwellers with Japan's vanishing past: many domestic tourists are lured there by traditional festivals and crafts or by ecotourism formed and framed by the local and national heritage industry.[42] Yet Inakadate's intervention into the politically fraught and nationalistic issue of domestic rice culture has transnational dimensions that are not acknowledged in press coverage.[43] The commercial disavowal in Inakadate echoes artistic discourses in other parts of the world where artists have turned away from museums and galleries to make site-specific art as part of a critique of the commodified conditions of artistic production.[44] Although produced by an anonymous rural collective rather than a celebrity artist, "tanbo art" is part of a global movement that appropriates and re-presents sites far removed from urban centers to ground art in the everyday and comment on the global environmental crisis. The programmatic development of the Kansas corn belt envisioned by Stan Herd, an early practitioner of crop art in the United States, has much in common with the practices developed in Inakadate. Working in a marginalized environment in Kansas almost entirely dependent on agriculture, Herd also sought to communicate "land and man's relationship to it spiritually, intellectually, historically," eventually winning the support of the Kansas

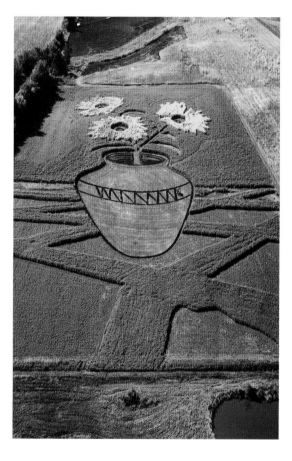

Farm Bureau for his ambitious projects.[45] Despite this, he too found it necessary to fund his work through commercial sponsorship, such as a giant advertisement for Absolut Vodka.[46] Herd's 1986 tableau of Van Gogh's *Sunflowers* earned him media coverage in Europe, South America, and, most notably, an hourlong television program produced by and for Japanese audiences (figure 5.9).[47]

Appreciating the reconstructed relationship to nature envisioned by Herd requires an aerial perspective that has provided welcome employment for local pilots. An elevated vantage point is also essential to take in the full scope of the aestheticized rice fields. By contacting the local industries office, visitors to Inakadate may book a place to participate in the rice harvest and receive in payment a small share of the crop, but most do not take up this work experience and content themselves with travel for the sake of seeing with their own eyes a fleeting, living picture of the floating world of rice paddies. To take in the scenic panorama that thematizes rice cultivation by revealing its previously unseen aesthetic qualities, visitors climb a 22-meter-high purpose-built castle tower next to the town hall. Media-based technologies of displacement and juxtaposition allow for the same aerial vista. Time-lapse photography of the great

wave available on the Internet even makes it possible for remote viewers to see the emergence of the wave in its predominantly green palate, month by month from May to September. So uncanny is its materialization in rice that a number of blog postings questioned whether it was a hoax perpetrated by "photoshopping."[48]

Rice paddy art is a creative intervention into rural space enabled by a convergence of technologies. It arguably embodies Fleming's vision of placemaking as a design practice that involves "locating images in those environments that stimulate our curiosity about where we are, inspire some reveries about how we can claim a future there, and, on occasion, encourage a whimsical smile about choices already taken."[49] Although Hokusai's wave was only one of many designs realized in Inakadate, its iconicity seems to have generated a global flow of media coverage far greater than any other.

TWA Flight 800 International Memorial, Smith Point County Park, New York

For many of its beholders outside Japan, Hokusai's "Under the Wave off Kanagawa" is "the portrayal of an incipient disaster."[50] In an interview for the BBC film "The Great Wave," art critic Raoul Cork observed that it is a "nightmarish vision of implacable nature about to visit death on man," adding that, "beautiful as it is, it's like a climax scene in a Hollywood movie."[51] Indeed, natural and human-made disasters are such a staple of the Hollywood entertainment industry that, when one actually strikes, it is often, consciously or unconsciously, perceived through the lens of film. The critic Anthony Lane, writing in the *New Yorker* magazine, reflected on this phenomenon in the aftermath of 9/11: "Of course, you could argue that last Tuesday was an instant dismissal of the fantastic—that people gazed up into the sky and immediately told themselves that this was the real thing. Yet all the evidence suggests the contrary; it was television commentators as well as those on the ground who resorted to a phrase book culled from the cinema. 'It was like a movie.' "[52] If nineteenth-century viewers were struck by the success with which Hokusai's print achieved a clarity of vision not available to

the eye before the advent of photography, their twenty-first-century counterparts are struck by its filmic qualities. With its towering performativity, "The Great Wave" inhabits the realm of the superlative and of the Hollywood blockbuster.

For Dominic Sword, the image summons up apocalyptic visions: " 'The Great Wave' means to me something very primordial, something very powerful in that it rises up from nature and wipes away everything here, yet it is simply made of water."[53] He is not alone in bringing this dark interpretation to the image. Hokusai's wave has been similarly invoked by many artists, most notably in a pictorial cycle of sweeping scale and scope, depicting *The Flood*, *The Creation*, and *The Last Judgment*, by American artist David Salle.[54] *The Flood*, formed from an assemblage of discordant art-historical, sources relocated to a contemporary setting, cites both Michelangelo and Hokusai. "The Great Wave" with a helicopter hovering nearby recalls televised scenes of the rescue of victims stranded on rooftops after Hurricane Katrina swept through New Orleans on August 28, 2005, while the whirling clouds on the far right of the composition are unmistakable as the eye of the hurricane (figure 5.10). The biblical reference explicitly dramatizes the artist's reading of this natural event as resulting from human causes, since the terrible loss of life followed chiefly from government mismanagement.

Although art, film, as well as computer games, have given disasters new imagined inflections, few are prepared when disaster actually strikes, and, in their aftermath, they are even less prepared to determine how the event should be remembered. "The Great Wave" 's emotional impact and potential to be shaped and reshaped by a multitude of contexts has led to its mobilization to allude to floods, hurricanes, and especially tsunamis, a topic discussed more fully in the epilogue. In a more unusual variation of this symbology, the version of the wave in Hokusai's *One Hundred Views of Mount Fuji* has been invoked in the design of the granite wall at the center of the memorial for those who lost their lives in the 1996 crash of TWA Flight 800 (figure 5.11). The victims' loss at sea meant that the grieving families were denied a relationship with the bodies of their loves ones. The memorial provides a

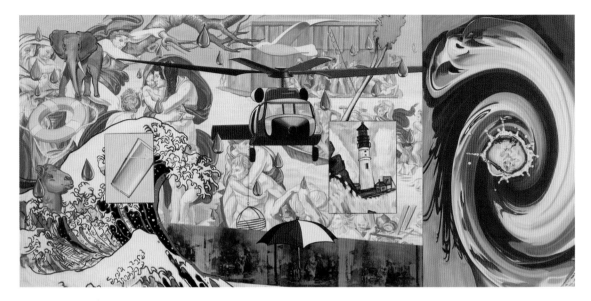

FIGURE 5.10. David Salle, *The Flood*. (Art © David Salle/Licensed by VAGA, New York. Courtesy of Mary Boone Gallery, New York.)

place marked by a material object that can be seen and touched, situated in an evocative environment. Built at the end of Stony Point Beach, Long Island, far from any residential area, the site capitalizes on the most significant local asset: the natural setting—a long stretch of sandy beach and the breaking waves of the Atlantic beyond. The area is empty of people in the winter, but on July 17 beachgoers mingle with family and friends of the crash victims, who gather for an annual memorial in what has become a place of both sun-seeking fun, and solace and remembrance.[55]

Its significance may pale by comparison with the more recent calamity that struck New York, but the creation of this memorial, no less than that for the victims of 9/11, raised thorny questions. How should the deaths of the hundreds of passengers and crew of widely different ethnic and religious backgrounds be commemorated? Who should decide? Who should be entrusted with the delicate

representational task of conjuring up lost bodies? Where should the memorial be located? These issues, compounded by the ten months required to recover the remains of all the bodies and the controversies surrounding the cause of the crash, meant that the memorial was not dedicated until July 14, 2004.

David Busch Associates, a firm in nearby Bay Harbor, was commissioned to create the memorial with funding from family members.[56] Reflecting on his involvement, Busch later noted in a professional publication, "It certainly was an emotional project. The family representatives had a list of elements for the memorial. And

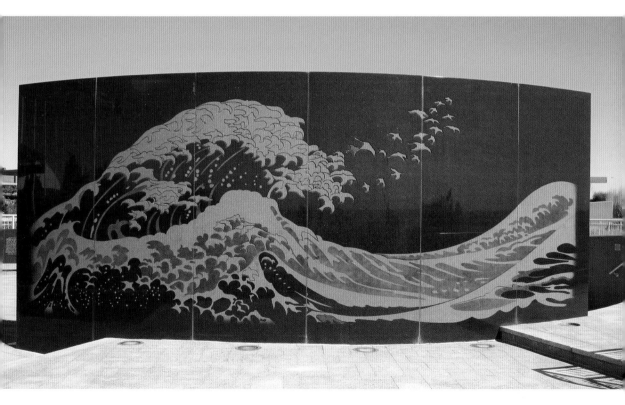

FIGURE 5.11. TWA 800 Memorial, Stony Point Beach, New York. (Author's photograph)

there were conditions at the proposed memorial site that shaped the opportunity of the project. I'd describe it as nestled and sculptured land with a seaside arboretum."[57] He did not, however, comment on the granite wall that forms the centerpiece of the memorial, nor did he respond to emails, letters, and telephone calls inquiring about its design. Whether this is owing to controversy surrounding it or other reasons remains unclear.

Whatever differences may have arisen in other parts of the project, there was unanimity in the choice of the shore at Smith Point County Park. The beach, close to John F. Kennedy Airport, where the 747 jet bound for Rome via Paris crashed into the sea twelve minutes after takeoff, was the location from which the search for bodies and belongings of the victims was conducted, and, in the aftermath of the crash, many friends and family had held a vigil there.[58] Memorials by definition are intended to last forever, and this one would not have had the same symbolic force farther inland, although the chosen location exposes it to the unwanted forces of nature, wind, erosion, and water.

Multiple languages of commemoration are adopted in the completed monument to address the often-conflicting needs that such emotionally fraught placemaking must fulfill. At the center of the site is a round platform suggesting a globe incised with the markings of longitude and latitude and fourteen flags representing the nations of the crash victims standing like sentries on one side. (On the 2009 anniversary of the crash, all the flags were at half-mast, a practice more commonly reserved for the deaths of revered public figures.)[59] Dominating the platform is a gently curved polished granite wall twelve feet high and twenty-eight feet long with the names of all the victims engraved on one side and, on the other, a giant cresting wave whose droplets morph into 230 gulls, one for each of the passengers and crew members. Naming, reinforced by the number of flags and birds, conveys the message that all are honored equally, a sense of commonality that may also mask any discordance that may have developed in the course of the realization of the memorial. Physical proximity to the Atlantic, where waves can be seen breaking, redoubles the effect of the motif on the

outside of the wall while also lending it an element of environmental authenticity.

With the possible exception of the wave and the gulls, the idiom adopted here is familiar from many other commemorative sites. "Memorials," David Simpson has written in his insightful *The Culture of Commemoration,* "subsist in a visual culture of conventionalized forms that allow for their identification as memorials in the first place."[60] Although the circumstances differed, the design of the TWA memorial is likely to have been informed by the same published guidelines as the 9/11 memorial. These included the mandate to "recognize each individual," to "be distinct from other memorial structures," to "convey historical authenticity," and to "reaffirm life itself," all of which are visibly incorporated into the final design.[61] When former New York mayor Rudolph Giuliani spoke at the memorial's unveiling, he praised its life-affirming quality.[62] It is this last mandate that the cresting wave with gulls helps to carry out by engendering a sense of transcendence that emerges from and interacts with site-specific referents. Thus the affective impact of the design follows from the convergence of its symbolic place, form, and content.

The relationship individuals have both to the crash and the memorial's siting are crucial to its interpretation. In the absence of information on the part of the memorial's designer or comments on any of the many websites about the memorial, it is difficult to know whether this opportunistic adaptation of a page of Hokusai's *One Hundred Views of Mount Fuji* came about through the designer's or collective decision making or if the relationship is even recognized by the TWA victims' family and friends. Repurposing requires working out what other meanings an image might interact with, because, once it is "out there," it is open to discursive readings that may be difficult to predict or control involving inchoate likes, dislikes, or prejudices that depend on the conditioning of the interpreter. Waves are widely understood to connote the precariousness of human existence, but this one has translated the consequences of human actions into the workings of nature. For some, the giant wave may summon up narratives of death and resurrection. Ascending birds suggest freedom, transcendence, or the

possibility of an afterlife in many religions in ways that, depending on the beholder, may either enrich or be detrimental to the wall's memorializing function.

The TWA memorial creates a visual and verbal narrative by a site-specific mapping that reflects the bereaved families' national backgrounds, perceptions of the event, its significance, and their own role as its guardians. The sea speaks to human experience in a way that transcends political boundaries, but the iconic wave may provoke more specific discursive meanings. Is its adaptive reuse appropriate for such a memorial? The affective power of the memorial depends on a generalized reading of it as an evocation of mortality and transcendence. This communicative purpose is undermined when the wave's specificity is acknowledged. Its repurposing in this emotionally fraught context highlights the potential tension that may arise between two local meanings, each with its own historical contingencies.

Adaptive reuse of "The Great Wave" to create local landmarks with transnational dimensions testifies that place matters more than ever in a globalized world. Whether intimate and shared, private or public, reinterpretations of this design are inextricably bound up with the negotiation of local, regional, and national identities in a world where these appear increasingly vulnerable to distant events and processes. Recoding spaces by filling them materially with tangible meaning and memory in ways that are dependent on context and location, placemaking serves a positive function of lessening anxiety and providing people a sense of agency in a world over which they have little control. Not surprisingly, mobilization of "The Great Wave" in this process of hybridization occurs primarily in regions where the convergence of old and new media have given the image a high degree of recognition. If there is an inherent contradiction in the use of a metaphor of distributive space to mark a particular place, these antithetical and mutually canceling propositions can coexist discursively, celebrating local identities both in opposition to and in concert with the external forces of globalization.

After the Tsunami

"Tsunami!" shrieked the people; and then all shrieks and all sounds and all power to hear sounds were annihilated by a nameless shock heavier than any thunder, as the colossal swell smote the shore with a weight that sent a shudder through the hills.

—LAFCADIO HEARN, "A Living God"

The sea is not ultimately the subject of art or poetry here. . . . Rather, both are reflections of something else, something which can only be apprehended indirectly, only intuitively imagined.

—NICHOLAS JENKINS, "Running on Waves"

IS CRITICAL CLOSURE POSSIBLE IN A STUDY THAT attempts to analyze a global phenomenon that figures so conspicuously in so many contexts and with so many meanings? Given the extraordinary range and ever-expanding scope of its iterations, this study has not sought to be comprehensive or to provide the last word on "The Great Wave." Its aim instead has been to bring new critical awareness to the complex process through which a woodblock print by a nineteenth-century Japanese artist has become a significant part of contemporary visual and material culture in many parts of the world. The motif is not popular primarily because it expresses some unique or intrinsically Japanese aesthetic sensibility, although it may be ascribed desirable qualities associated with that country. Hokusai's view of a giant white-capped cresting wave, with three small boats struggling to cut through it, and the perfectly conical form of Mount Fuji in the distance has undeniable dramatic power, but the visual qualities that make it so compelling can be

read in ways that, like the ocean itself, both unite and divide. In following its migrations, I have argued that "The Great Wave" is not a static entity but an image that has undergone dramatic changes through the very process of its relocation, replication, and reinterpretation by being invested with heterogeneous meanings bound up with many areas of human thought and activity. This process has occurred, paradoxically, through both the image's alignment with and its disalignment from its Japanese origins.

There is nothing inevitable about the trajectories that have seen "The Great Wave" circulate the globe from the coast of Kanagawa to Prague, Dubai, Stony Point Beach, and many places in between. As art historian Michael Baxandall suggested by analogy to the way the movement of the white ball reconfigures all the colored balls on a billiard table, so too every time the wave appears in a new place, it produces new relations among all the previous and future occurrences of the image.[1] Interpreting this complex multidirectional process *à la longue durée* has involved rethinking the disciplinary boundaries within which scholars conventionally operate when discussing "Under the Wave off Kanagawa." It has also required taking into account the mediation of technologies, old and new, and the cultural and commercial value accrued through repetition.

In closing this study, I want to reflect briefly on the "The Great Wave" with respect to the disparate ideas about nature and the environment that have coalesced around it. Revisiting and historicizing these helps to understand how the wave has come to be identified as a "tsunami," a term that specifically refers to a wave produced by earthquakes or volcanic eruptions with very different properties from one driven by high winds. This is a discursive reading that neither Hokusai nor his viewers is likely to have brought to the print and that most Japanese today resist as well, but one that nonetheless has gained currency in other parts of the world, especially since March 11, 2011.[2]

It is a measure of the celebrity of "Under the Wave off Kanagawa" that what kind of wave it represents is a question that has been taken up by geophysicists. In 1996 the prestigious science journal *Nature* reproduced a detail of the print on the cover of an issue featuring an

article about the discovery of geological evidence of an earthquake in the Cascadia region of Oregon and Washington on the West Coast of the United States that caused a tsunami in Japan in January of 1700. Many readers wrote letters objecting to this homology, pointing out that Hokusai's is a wind-driven not a tidal wave.[3] More recently, Julyan Cartwright and Hisami Nakamura have published two scholarly articles arguing that the print should be characterized as a "plunging breaker" or possibly even a "rogue wave."[4] They also point out that the word "tsunami," literally "harbor wave," in reference to the fact that it is not easily detected at sea, is a relatively late coinage in Japan, dating only to the seventeenth century. Until that time, *oshio,* "large tide," was more common.[5]

Despite scientific insistence that Hokusai represented a storm wave, the popular perception that it is a tsunami is widespread outside of Japan, fueled in large part by the popular media. Sensitivity to this issue was such that, in the aftermath of the tsunami that devastated northern Japan in 2011, preparations for a long-planned exhibition at the British Museum centering on a recently-acquired and especially fine impression of "Under the Wave off Kanagawa" included discussions with the Japanese Embassy and other parties in Japan to ensure that the show would not be construed as an inappropriate reminder of the recent disaster.[6] The official view that the exhibition was unproblematic reflected the significant gap in online references to the image between Japanese and English language sites between March and May 2011. Whereas English language sites saw a spike, this was not true of their Japanese counterparts.[7] Most of the former postings conjoined images of the wave with expressions of sympathy for the victims of the tsunami. One blog from the Philippines pointed out the likelihood of such a catastrophe occurring there, while expressing admiration for the "remarkable calm and discipline of the Japanese people."[8]

What is missing in the often literalist debate about what kind of wave Hokusai intended is that, despite its topographical specificity, the print is a work of the imagination open to interpretations that do not necessarily conform to artistic intentionality, much less historical or scientific accuracy. This prompts the more fundamental question of why

its identification as a tsunami first arose and has gained such widespread credence outside Japan. Why does the public want to see it as such, and what, if any, implications, does it have for the ongoing place of "The Great Wave" in the global imaginary.

As we have seen, the wave has from the start been a rich source of metaphors for expressing in compact visual form many positively and negatively charged social, cultural, and environmental phenomena. Our visual perception of the sea is oriented toward its movement, and this may take the form of many waves or may privilege a single one. Because the empirical experience of waves is so fleeting and so difficult to capture with the naked eye and Hokusai's silhouette of a cresting wave is so distinctive, it has shaped how many people imagine them. Just as the visual form created by Hokusai may at any point enter into dialogue with others, producing the effect that it has already been "half seen," so too does it have the potential to enter into dialogue with verbal representations that similarly expand its metaphoric range. The words *nami, la vague,* and "wave" each encodes different culturally and geographically specific experiences. The entry of the word "tsunami" into the international lexicon in the late nineteenth century further complicated existing visual and verbal understandings of local terms for waves by linking one particularly threatening type with Japan. The need to visualize this exotic and to many unfamiliar phenomenon has led to the term's identification with Hokusai's well-known image of a giant wave. An article about the March 11 catastrophe by Japanese reporter Yoichi Shimatsu (in English) testifies to the degree to which today a real tsunami can trigger a visualization of Hokusai's print: "The Wave, reminiscent of Hokusai's masterful woodblock print," he wrote, "blew past Japan's shoreline defenses of harbor breakwaters and gigantic four-legged blocks called tetrapods, lifting ships to ram through seawalls and crash onto downtown parking lots."[9]

This process of visual and verbal translation, mistranslation, and conflation is arguably both product and producer of the sometimes racist connotations of both the word "tsunami" and the ideological usages of Hokusai's wave outside of Japan. Such readings have led to a considerable interpretive gap between Japanese and Euro-American

appreciation of "Under the Wave off Kanagawa" since it became part of international discourse in the nineteenth century. When the print was first published as part of the *Thirty-Six Views of Mount Fuji*, the sacred mountain and the view of it from Kanagawa, a coastal town along the Tōkaidō Road, were likely the defining motifs for most of Hokusai's contemporaries. They also would have recognized the three boats depicted as *oshikuribune* traversing the notoriously rough seas off Kanagawa to supply fresh fish from the Bōsō Peninsula to the shogunal capital of Edo. This is not to say that Hokusai's contemporaries might not have found the image unsettling. Hokusai made this familiar scene of men going about their daily work in the shadow of Mount Fuji visually fresh and compelling by framing it within a dynamic and improbable dialogue between mountain and sea that confounds the viewer's expectations. Depicting a huge cresting wave threatening to engulf Mount Fuji provokes doubts about the real and representational worlds in a way that may arouse amusement but also reflection. It is an invitation to stand back and think about that which is presumed true. Visual wit of this kind was a permitted form of transgression that drew attention to social realities that could not be voiced and as such was a critical tool among many artists of Hokusai's day. Through this visual joke about spatial contradictions and conflicts, it might be argued that Hokusai engaged with larger discourses in which accepted hierarchical understandings of nature, society, and nation were being interrogated.

Hokusai's intent in "Under the Wave off Kanagawa" may have been little more than playfully subversive, but other artists, recognizing the implicit menace, adopted his giant wave and its variations for their own purposes. As discussed in Chapter 1, this included allusions to heroes facing seemingly insurmountable dangers, to natural disasters such as mudslides down the slopes of Mount Fuji, and to typhoons associated with the Mongol invasion. The anxieties associated with the growing number of environmental and geopolitical threats between the 1830s and 1850s—foreign ships seeking access to Japanese harbors, the crop failures and famines of the Tenpō era, and the 1854 earthquake and tsunami—fueled such imaginative

projections. Although no evidence has come to light that would suggest that Hokusai's wave was ever identified specifically as a tsunami, such a reading is not impossible.[10]

When Hokusai's woodblock prints were disseminated in Europe and America, however, the wave interacted with other preexisting images of waves and their connotations. Those unfamiliar with the Japanese locale and its historical particularities are likely to have interpreted the image in light of their own traditions of allegorical and historical paintings of ships foundering at sea, thus bringing to its reading a sense of impending disaster. The notion of divine terror or the sublime explicitly evoked by Goncourt, a key framework for its integration into the European canon, further inflected Hokusai's great wave with notions of environmental danger. To be sure, the visual authority of this image did not depend solely on the attraction of such negative readings: it also satisfied a deepening preoccupation with and nostalgia for lost connections with nature and the natural world.

If "The Great Wave" helped to make Japan imaginable, it also may have helped to imagine a tsunami, a phenomenon largely unfamiliar to those outside of East, South, and Southeast Asia. The introduction of the word to the Western lexicon in connection with a destructive tsunami that hit Japan in 1896, widely reported in the Western press, at the time when familiarity with Hokusai's woodcut was growing, may have contributed to this homology. To this already volatile mix one may add the "concatenation of disasters" around the turn of the century that included a volcanic eruption on the Caribbean island of Martinique in 1902, violent earthquakes in San Francisco and two Chilean cities in 1906, the Messina earthquake of 1908, and the flooding of Paris in 1910. As Lucien Boia observed of this period in *The Weather and the Imagination*, "as anxiety increased the dangers were more or less interchangeable. The 'other' assumed a more threatening aspect. European nations began to fear each other. Even worse was the 'yellow peril' arising in the Far East. The imminent conquest of Europe by a Sino-Japanese coalition was already being announced in some quarters; the Flood had acquired an equally frightening variant in the form of a 'human tide.'"[11] "The Great Wave," I would suggest,

offered the potential to express all of these inchoate fears, while leaving space for ambivalent, even contradictory positive readings.

The mobilization of the idea of a tsunami together with Hokusai's print has been particularly conspicuous at moments of geopolitical tension. The politicized discourse of the late nineteenth century was one such moment. The anxieties aroused by nuclear power and its threat of global annihilation in the aftermath of World War II was another, and the dramatic rise of Japanese economic power in the 1980s, still another such moment. The literary historian Nicholas Jenkins has shown that the advent of the nuclear age, the collapse of old colonial empires, and the geopolitics of the Cold War made expressions of fear in relation to the sea a particularly conspicuous feature of American visual and literary culture during the 1940s and 1950s. The American avant-garde was obsessed with the sea, in "historically specific ways" through which it "acquired a power and horror which is largely absent from writing and art of the earlier part of the century."[12] This new sense of menace lies behind works as disparate as the painter Jackson Pollock's *Full Fathom Five* (a title inspired by *The Tempest*) and poets Elizabeth Bishop's "At the Fishhouses," James Lowell's "The Quaker Graveyard in Nantucket," and Auden's "The Age of Anxiety," all published in 1947. One of its most influential expressions, however, was Rachel Carson's 1951 best seller *The Sea around Us,* which, more than any other publication at the time, aroused awareness of the consequences of ignoring the environment.[13]

Such concerns were also expressed in popular magazines such as the *Saturday Review,* whose editor, Norman Cousins, in 1945 published to a highly receptive audience an essay titled "Modern Man Is Obsolete." In it, he asserted that "the beginning of the Atomic Age has brought less hope than fear. It is a primitive fear, the fear of the unknown, the fear of forces man can neither channel nor comprehend. This fear is not new . . . but overnight it has become intensified, magnified."[14] The international success of the 1954 Japanese film about Gojira (retitled *Godzilla* in its American version), the lizard monster roused from the bottom of the sea by nuclear explosions, speaks to the way human-made disaster was both naturalized and transformed

into something terrifyingly primordial.[15] In Pearl Buck's allegorical tale *The Big Wave,* a tsunami fulfills a similar function. Both the Japanese film and the American children's story attest that, when the dangers of modern technology cannot be discussed directly, science fiction and the unpredictable forces of natural disaster offer convenient alternatives. Hokusai's print has been especially helpful in grappling with representations of disaster in an interconnected world because by aestheticizing and exoticizing it also fulfills the function of distancing it. This potential was clearly articulated in a blog following the publication of an article in the *New York Times* about how teachers should respond to the March 11 disaster in their science and health classes: "I would include Hokusai's print 'The Great Wave' with a mix of news photos and footage in order to provide some relief from the relentlessly distressing images while retaining relevance."[16]

Today, "tsunami" has evolved from its original Japanese denotation of "harbor wave" to become a powerful keyword comparable to and interchangeable with Hokusai's iconic wave. Their combined power and popularity derive not from their truth value but from the fact that they imaginatively map and condense the promise and dangers of global interconnectedness in an acceptable way. When it first entered the English lexicon in the context of reportage about the 1896 disaster in Japan, use of the word "tsunami" was relatively limited. Its circulation subsequently gained ground in literature on seismology, but recognition of this borrowed word both shaped and was shaped by Japan's economic rise, a development concomitant with growing global awareness of the particular geological features that make the Pacific region so unstable. Apocalyptic treatment of the subject in novels and films such as the 1973 Japanese hit *Nihon chinbotsu* based on the novel by Komatsu Sakyō (literally "Japan Sinks," but released in the United States as *Tidal Wave*) and the Australian director Peter Weir's 1977 *The Last Wave* no doubt fueled visions of such cataclysms in the Pacific.[17] Theatrical posters for the latter showed the hero, played by Richard Chamberlain, framed by a giant cresting wave resembling Hokusai's.[18] Added to this, since the 1990s many countries have adopted a cresting wave as the warning symbol for tsunami hazard zones.[19]

Growing figurative use of the term in political, economic, and cultural contexts, often in conjunction with an image like Hokusai's, further attests to this process of naturalization.[20] The wave/tsunami homology has evoked anxieties and suspicions about Japan as a global superpower and, since that country's economic collapse in 1991, implicit warnings that a similar fate might befall other countries.[21] The mass media have played a key role in institutionalizing this construct as part of a "journalistic disaster vocabulary." "Obscure no more," declared William Safire of the word in his weekly column "On Language" following the December 26, 2004, Indian Ocean tsunami. In that article Safire questioned whether "in light of the impact of a real rather than metaphoric disaster, political writers will hesitate to use the metaphor that causes so many shudders, reverting instead to less fearsome landslide, avalanche, surge, and firestorm." Like holocaust," he suggested, "the word tsunami must now be used with sensitivity."[22]

Will this be true of "The Great Wave as well?" Evidence suggests otherwise. As concern about the environment escalates, there is growing focus on the real world operations of nature—volcanic eruptions, typhoons, floods, and earthquakes—many of which have occurred in the Pacific region. Newspaper readers and television viewers around the world have become intimately familiar with the long-lasting damage to the environment and devastating loss of life that may follow from such catastrophes. The aestheticizing distance of Hokusai's cresting wave provides a welcome visual alternative to the horrifying realities of such events. At the same time, these global realities have destabilized modern certainties about progress and the ability to control nature. Hokusai's iconic wave has become an easily recognizable idiom for evoking both the means and meaning of cataclysmic change, one that also underscores our global interdependence.

Notes

INTRODUCTION

1. Stephen Greenblatt, "Resonance and Wonder," in Ivan Karp and Stephen D. Lavine, eds., *Exhibiting Cultures: The Poetics and Politics of Museum Display* (Washington and London: Smithsonian Institution Press, 1991), 42.

2. Timothy Clark, *Hokusai's Great Wave* (London: The British Museum, 2011), 23.

3. In 1981, for instance, Shindō Kaneto directed a bio-pic titled *Hokusai manga*, and in 1987 Ishinomori Shōtarō created an entire manga devoted to Hokusai.

4. Arjun Appadurai, "Disjunction and Difference in the Global Culture Economy," *Theory, Culture and Society* 7 (1990): 296–300.

5. The literature on this subject is vast. Useful overviews are: Arjun Appadurai, *Modernity at Large: Cultural Dimensions of Globalization* (Minneapolis and London: University of Minnesota Press, 1996, 2005); Jurgen Osterhammel and Niels P. Petersson, *Globalization: A Short History,* trans. Dona Geyer (Princeton and Oxford: Princeton University Press, 2003); and Jan Nederveen Pieterse, *Globalization and Culture: Global Melange* (Lanham: Rowman and Littlefield Publishers, 2009).

6. For broad-ranging discussions on hybridity, see Homi K. Bhabha, *The Location of Culture* (London and New York: Routledge Classics, 2004); Peter Burke, *Cultural Hybridity* (Cambridge: Polity Press, 2009); and John Huytnyk, "Hybridity," *Ethnic and Racial Studies* 28:1 (January 2005): 79–102.

7. Mikhael Bakhtin, *The Dialogic Imagination,* trans. C. Emerson and M. Holquist (Austin: University of Texas Press, 1981), 358, 304–305.

8. Martin Kemp, *From Christ to Coke: How Image Becomes Icon* (Oxford and New York: Oxford University Press, 2012), 3.

9. Ibid., 5.

10. A most dramatic instance of this is its use for the cover of Edward S. Miller, *Bankrupting the Enemy: The US Financial Siege of Japan before Pearl Harbor* (Naval Institute, 2007). See also the illustrations for "Japan's China Two-Step," *Worth*, January/February 2003, 57; and "Bravura Balancing Act," *Wall Street Journal,* August 21, 2003, Marketplace B, 1.

11. Kemp, *From Christ to Coke,* 8.

12. A fractal is any pattern that reveals greater complexity as it is enlarged. A cropped view of "The Great Wave" figures on the cover design of John Gribbin, *Deep Simplicity: Chaos, Complexity and the Emergence of Life* (Penguin Books, 2005), which includes extensive discussion of fractals. See also http://www.science.howstuffworks.com/fractals2.htm, accessed August 7, 2012.

13. Technically, Japan's closure extended from 1639, when the "Sakoku" edict was enacted, until the first Treaties of Amity and Commerce were signed in 1858–1859.

14. This is discussed more fully in my "Hokusai's Great Waves in Nineteenth-Century Japanese Visual Culture," *Art Bulletin* 93:4 (December 2011): 468–485.

15. Michael Baxandall, *Patterns of Intention: On the Historical Explanation of Pictures* (New Haven: Yale University Press, 1992), 58–59.

16 Thomas da Costa Kaufmann, *Toward a Geography of Art* (Chicago: University of Chicago Press, 2004).

17. Igor Kopytoff, "The Cultural Biography of Things: Commoditization as Process," in Arjun Appadurai, ed., *The Social Life of Things: Commodities in Cultural Perspective* (Cambridge: Cambridge University Press, 1992), 64–91.

18. Hergé, *Tintin: Les cigares du Pharaon* (1934); *Cigars of the Pharaoh* (London: Egmont, 2011), 12, frame with caption "We're finished Snowy"; Iris Murdoch, *The Sea, the Sea* (London: Chatto and Windus, 1978).

19. *Paint Your Wagon* (Paramount Pictures, 1969).

20. See http://www.jazjaz.net/2012/04/the-great-wave-painted-using-coke.html, accessed August 7, 2012.

21. I have deliberately cast a wide net, but in the process of research I gathered far more examples than I could reasonably discuss. In addition to the challenge of selection, because of its ephemeral nature some of the material found on the Internet has disappeared in the course of preparing the manuscript.

22. Especially useful was Bruno Latour, "Where Are the Missing Masses? The Sociology of a Few Mundane Artifacts," in Wiebe E. Bijker and John Law, eds., *Shaping Technology / Building Society* (Cambridge, MA: MIT Press, 1992), 225–258.

23. Henry Jenkins, *Convergence Culture: Where Old and New Media Collide* (New York and London: New York University Press, 2006).

24. Iijima Kyoshin, *Katsushika Hokusai den* (Tokyo: Hōsūkaku, 1893); Kano Hiroyuki, *Katsushika Hokusai Gaifū kaisei: Aka Fuji no fōkuroa* (Tokyo: Heibonsha 1994); Suzuki Jūzō, *Katsushika Hokusai hitsu Fugaku sanjūrokkei* (Tokyo: Shūeisha 1965); Kobayashi Tadashi, "Katsushika Hokusai no fugaku sanjūrokkei," in *Fugaku san-jūrokkei,* Ukiyo-e taikei, vol. 13 (Tokyo: Shūeisha, 1976). Other Japanese publications include Narazaki Muneshige, *Hokusai ron* (Tokyo Atoiesha, 1944; reprint 1998); Asano Shugio, *Hokusai*, vol. 4 in the Ukiyoe o yomu series (Tokyo: Asahi shinbunsha, 1997–1998); and Tsuji Nobuo, *Kisō no keifu—Matabei–Kuniyoshi* (Tokyo: Bijutsu shuppansha, 1970).

25. Fredrick Victor Dickins, *Fugaku hiyaku-kei, or, A Hundred Views of Fuji (Fusiyama)* (London: B. T. Batsford, 1880); Edmond de Goncourt, *Hokousai* (Paris: Bibliothèque Charpentier, 1896).

26. Jack Hillier's publications span nearly half a century. Beginning with a pioneering monograph, *Hokusai: Paintings, Drawings, and Woodcuts* (London: Phaidon, 1995; reprinted in 1985), he explored *Hokusai Drawings* (London: Phaidon, 1966)

and, most originally, *The Art of Hokusai in Book Illustration* (London: Sotheby Parke-Bernet, 1980).

27. Gian Carlo Calza, ed., *Hokusai*, (London and New York: Phaidon Press, 2003); Henry D. Smith, "Hokusai and the Blue Revolution in Edo Prints," in John Carpenter, ed., *Hokusai and His Age: Ukiyo-e Painting, Printmaking and Book Illustration in Late Edo Japan* (Leiden: Hotei Publishing, 2005), 235–269.

28. Timothy Clark, *One Hundred Views of Mount Fuji* (London: The British Museum Press, 2001); Matthi Forrer, *Hokusai with Texts by Edmond de Goncourt* (New York: Rizzoli, 1988); Roger S. Keyes, *Ehon: The Artist and the Book in Japan* (New York: New York Public Library, 2008); Richard Lane, *Hokusai: Life and Work* (New York: Dutton, 1989); Timon Screech, *The Lens within the Heart: The Western Scientific Gaze and Popular Imagery in Later Edo Japan* (Cambridge: Cambridge University Press, 1996).

29. Noteworthy among these are Inaga Shigemi, *Kaiga no tasogare: Eduardu Mane botsugo no tōsō* (Nagoya: Nagoya Daigaku shuppankai, 1997); *Kaiga no tōhō: Orientarizumu kara Japonizumu-e* (Nagoya: Nagoya Daigaku shuppankai, 1999); and "The Making of Hokusai's Reputation in the Context of Japonisme," *Japan Review* 15 (2003): 77–100.

30. Ministère de la Culture et de la Communication, ed., *Le Japonisme* (Paris: Éditions de la Réunion des Musées Nationaux, 1988); Siegfried Wichmann, *Japonisme: The Japanese Influence on Western Art since 1858* (London: Thames and Hudson, 2001).

31. Gabriel P. Weisberg, *Art Nouveau Bing: Paris Style 1900* (New York: Abrams, 1986); Gabriel P. Weisberg, Edwin Becker, and Evelyne Posseme, eds., *The Origins of l'Art Nouveau: The Bing Empire* (Amsterdam: Van Gogh Museum, 2004).

32. James A. Michener, "The Magic Hand of Hokusai," *Reader's Digest* 74 (June 1959): 240.

33. "The Great Wave" was aired on BBC television in 2004 as part of the series *The Private Life of a Masterpiece* and also issued as a DVD. The work was featured in 2010 as one of the objects in BBC Radio's series *A History of the World in One Hundred Objects*, downloadable from the BBC website as well as available in book form. A review of the radio series in *The Guardian*, October 15, 2010, features "Under the Wave off Kanagawa" (p. 7).

34. Nagata Seiji, ed., *Hokusai* (Tokyo: Nihon keizai shinbun, 2005).

35. Ann Yonemura, *Hokusai* (Washington, D.C.: Freer Gallery of Art and Arthur M. Sackler Museum, Smithsonian Institution, 2006).

36. See, for instance, the press release at http://www.asia.si.edu/press/past/prHokusai .htm, accessed June 19, 2011. The review of the show in the *New York Times* also featured the print (April 7, 2006, B27, B34).

37. For instance, the free brochure handed out to visitors to the Hokusai exhibition held at the Royal Academy of Arts in 1991–1992 featured it. See also http://www .euronews.com/2011/09/02/katsushika-hokusai-expo-opens-in-berlin/.

38. Roger Chartier, *The Order of Books* (Stanford: Stanford University Press, 1994), 14.

CHAPTER 1: "UNDER THE WAVE OFF KANAGAWA"

1. The translation of the advertisement is from Henry D. Smith, "Hokusai and the Blue Revolution," 254. I am indebted throughout this chapter to Smith's discussion of this advertisement as well as to his consideration of Berlin blue.

2. Suzuki Jūzō, *Ehon to ukiyo-e* (Tokyo: Bijutsu shuppansha, 1979), 296.

3. Kawamura Minsetsu had produced a series of four books featuring one hundred Fujis in 1767, but it had only limited circulation. Timothy Clark has suggested that Hokusai may have drawn inspiration from this book for some of his views. Clark, *One Hundred Views,* 20.

4. See Melinda Takeuchi, *Taiga's True Views: The Language of Landscape in Eighteenth-Century Japan* (Palo Alto: Stanford University Press, 1992).

5. On seriality in prints, see Allen Hockley, *The Prints of Isoda Koryūsai: Floating World Culture and Its Consumers in Eighteenth-Century Japan* (Seattle and London: University of Washington Press, 2003), 41–86.

6. For a chart of Chinese and Dutch imports of blue into Japan, see Henry D. Smith, "Hokusai and the Blue Revolution," 240.

7. Peter Kornicki, *The Book in Japan: A Cultural History from the Beginnings to the Nineteenth Century* (Honolulu: University of Hawai'i Press, 2001), 192.

8. There is no consensus on reasons for suspension of publication. For discussion of this issue, see Ewa Machokta, *Visual Genesis of Japanese National Identity: Hokusai's Hyakunin Isshū* (Brussels: Peter Lang, 2009), 73–78.

9. For reproduction and discussion of these prints, see Nicole Coolidge Rousmaniere, "The Accessioning of Japanese Art in Early Nineteenth-Century America: Ukiyo-e Prints in the Peabody Essex Museum, Salem," *Apollo*, March 1997, 23–29.

10. On print consumption see Tatsurō Akai, "The Common People and Painting," in Chie Nakane and Shinzaburō Oishi, eds., *Tokugawa Japan: The Social Antecedents of Modern Japan,* trans. Conrad Totman (Tokyo: University of Tokyo Press, 1990), 187–191.

11. On the role of commercial publishing in the development of aesthetic networks, see Eiko Ikegami, *Bonds of Civility: Aesthetic Networks and the Political Origins of Japanese Culture* (Cambridge University Press, 2005), 286–323.

12. For examples of this, see Julie Nelson Davis, *Utamaro and the Spectacle of Beauty* (London: Reaktion Books, 2007), chap. 5; and Melinda Takeuchi, "Kuniyoshi's *Minamoto Raikō and the Earth Spider*: Demons and Protest in Late Tokugawa Japan," *Ars Orientalis* 17 (1987): 5–38.

13. For discussion of the origins and technique, see Peter C. Marzio, *Chromolithography 1840–1900: The Democratic Art, Pictures for a 19th-Century America* (London: Scolar Press, 1979), 6–17.

14. For a discussion of the reasons for Japanese rejection of movable type, see Kornicki, *Book in Japan,* 131–135.

15. Davis, *Utamaro*, 25–61. See also Julie Nelson Davis, "Tsutaya Jūzaburō: Master Publisher," in Julia Meech and Jane Oliver, eds., *Designed for Pleasure: The World of Edo Japan in Prints and Paintings, 1680–1860* (New York: Asia Society and Japanese Art Society of America in association with University of Washington Press, 2008), 115–141.

16. See Lane, *Hokusai*, 110–119.

17. Peter Morse, ed., "Tokuno's Description of Japanese Printmaking," in Matthi Forrer, ed., *Essays on Japanese Art Dedicated to Jack Hillier* (London: Robert G. Sawers Publishing, 1982), 134.

18. Ibid., 131.

19. On copyright, see Kornicki, *Book in Japan*, 242–251.

20. Henry D. Smith, "Hokusai and the Blue Revolution," 256–259. There is no consensus on the order, but this issue is beyond the scope of this study.

21. Variations among surviving impressions are discussed in Matthi Forrer, *Hokusai Prints and Drawings* (Munich: Prestel Verlag and London: Royal Academy of Art, 1991), entries 11–32. For detailed discussion of the various impressions and states, see also Howard A. Link, "Thirty-Six Views of Mount Fuji: Impressions and States," in *Masterpieces of Landscape: Ukiyo-e Prints from the Honolulu Academy of Arts* (Honolulu: Honolulu Academy of Arts, 2003), 33–38.

22. Henry D. Smith, "Hokusai and the Blue Revolution," 244.

23. Kate Bailey, "A Note on Prussian Blue in Nineteenth-Century Canton," *Studies in Conservation* 57:2 (2012): 118–119.

24. It was first used in the *Kansas Times and Star*, April 25, 1889, according to the *Oxford English Dictionary*, electronic resource, accessed April 25, 2012.

25. A chapter of Kano Hiroyuki's study of the "Red Fuji" is titled "the birth of a best seller." See his *Katsushika Hokusai Gaifū kaisei*, 109. See also Matsunosuke Nishiyama, *Edo Culture: Daily Life and Diversions in Urban Japan, 1600–1868* (Honolulu: University of Hawai'i Press, 1997), 73–75; Eiko Ikegami, *Bonds of Civility: Aesthetic Networks and the Political Origins of Japanese Culture*, 305–306.

26. Davis, *Utamaro*, 16–17.

27. Chris Uhlenbeck, "Production Constraints in the World of Ukiyo-e: An Introduction to the Commercial Climate of Japanese Printmaking," in Amy Reigle Newland, ed., *The Commercial and Cultural Climate of Japanese Printmaking* (Amsterdam: Hotei Publishing, 2004), 12.

28. Ibid., citing Tatsurō Akai, "The Common People and Painting," 185.

29. Clark, *Hokusai's Great Wave*, 12; Forrer, *Hokusai Prints and Drawings*, entry 11.

30. See note 21 above for discussions of impressions and states.

31. For a summary of the reasons for the delay and views on the likely publication date, see Henry D. Smith, *Hokusai: One Hundred Views of Mt. Fuji* (New York: George Braziller, 1988), 17–18.

32. Ibid., 21.

33. It is discussed in Lane, *Hokusai*, 192. On other *kawaraban* of earthquakes and watery disasters, see Ono Hideo, *Kawaraban monogatari: Edo jidai no masu komi no rekishi* (Tokyo: Yūzankaku, 1960), 152–168; and Gennifer Weisenfeld, *Imaging Disaster: Tokyo and the Visual Culture of Japan's Great Earthquake of 1923* (Berkeley: University of California Press, 2012), 22–30.

34. See Forrer, *Hiroshige Prints and Drawings*, entry 89.

35. See Constantine Vaporis, *Travel and the State in Early Modern Japan: Breaking Barriers*, Harvard East Asian Monograph 163 (Cambridge, MA, and London: Harvard University Press, 1994). See also Jilly Traganou, *The Tōkaidō Road: Traveling and Representation in Edo and Meiji Japan* (New York and London: Routledge/Curzon, 2004).

36. Saitō Chōshū, comp., *Edo meisho zue,* in *Nihon zue zenshū* (Collection of early Japanese illustrated maps and guides to famous places), vols. 1–3 (Tokyo: Yoshikawa kōbunkan, 1928).

37. Suzuki, *Ehon to ukiyo-e,* 296.

38. Henry D. Smith, "World without Walls: Kuwagata Keisai's Panoramic Vision of Japan," in Gail Lee Bernstein and Haruhiro Fukui, eds., *Japan and the World: Essays on Japanese History and Politics in Honour of Ishii Takeshi* (Oxford: Macmillan Press, 1988), 16.

39. Ian Hideo Levy, *The Ten Thousand Leaves: A Translation of the Man'yōshū, Japan's Premier Anthology of Classical Poetry* (Princeton: Princeton Library of Asian Translations, 1981), 1:179.

40. Tsuji Nobuo, "The Impact of Western Book Illustration on the Designs of Hokusai—the Key to His Originality," in Carpenter, *Hokusai and His Age*, 343.

41. Henry D. Smith, *Hokusai: One Hundred Views*, 8–9. On the nativist (*kokugaku*) writings that played a key role in this development, see Susan L. Burns, *Before the Nation: Kokugaku and the Imagining of Community in Early Modern Japan* (Durham: Duke University Press, 2003).

42. Henry D. Smith, *Hokusai: One Hundred Views,* 8.

43. Engelbert Kaempfer, *Kaempfer's Japan: Tokugawa Culture Observed*, edited, translated, and annotated by Beatrice M. Bodart-Bailey (Honolulu: University of Hawai'i Press, 1999), 57.

44. See Henry D. Smith, *Hokusai: One Hundred Views,* 7–15.

45. On the cult of Fuji, see Martin Collcutt, "Mt. Fuji as the Realm of Miroku: The Transformation of Maitreya in the Cult of Mt. Fuji in Early Modern Japan," in Alan Sponberg and Helen Hardacre, eds., *Maitreya the Future Buddha* (Princeton: Princeton University Press, 1988), 248–269. For an overview of images related to the cult, see Naruse Fujio, *Fujisan no kaiga shi* (Tokyo: Chūō kōron bijutsu shuppan, 2005); and Timothy Clark, *One Hundred Views of Mount Fuji* (London: The British Museum Press, 2001).

46. Clark, *One Hundred Views*, 19; Kano, *Katsushika Hokusai Gaifū kaisei*, 81.

47. See, for instance, Ichitaro Kondo, *The Thirty-Six Views of Mount Fuji by Hokusai*, English adaptation by Charles S. Terry (Tokyo: Heibonsha 1966).

48. Translated in Clark, *One Hundred Views*, 21.

49. Kishi Fumikazu, *Edo no enkinhō: uki-e no shikaku* (Perspective systems of Edo: the viewpoints of *uki-e*) (Tokyo: Keisō shobō, 1994), 1–4. As Kishi points out, the introduction of perspective was also mediated by Chinese prints.

50. For excellent reproductions, see Kobayashi Tadashi, "Katsushika Hokusai no Fugaku sanjūrokkei."

51. On the introduction of the telescope and other European instruments of vision, see Screech, *Lens within the Heart*, 235–269. See also Henry D. Smith, "World without Walls," 16.

52. For discussion of Shiba Kōkan, an artist who painted in the Dutch style, see Calvin L. French, *Shiba Kōkan: Artist, Innovator, and Pioneer in the Westernization of Japan* (Tokyo and New York: Weatherhill, 1974).

53. On Hokusai's performance painting, see Lane, *Hokusai*, 110.

54. On this print, see Dean Schwaab, *Osaka Prints* (London: John Murray, 1989), 195.

55. For a range of images, see Naruse, *Fujisan no kaiga shi*; Clark, *One Hundred Views*.

56. Susan Stewart, *On Longing: Narratives of the Miniature, the Gigantic, the Souvenir, the Collection* (Durham and London: Duke University Press, 1998), 74, 95.

57. For an overview of the foreign threat, see *The Cambridge History of Japan*, volume 5: *The Nineteenth Century*, edited by John Hall, Marius B. Jansen, Madoka Kanai, and Denis Twitchett (Cambridge: Cambridge University Press, 1989), 259–307.

58. Line from a poem by the eighth-century poet Hitomaro translated in Levy, *Ten Thousand Leaves*, 1:173.

59. In the Heian period, this motif figured on screens in the Seiryōden Imperial Palace. See Sei Shonagon, *The Pillow Book of Sei Shonagon*, trans. Ivan Morris (New York: Columbia University Press, 1967), 1:15.

60. Marcia Yonemoto, "Maps and Metaphors of the 'Small Eastern Sea' in Tokugawa Japan (1603–1868)," *Geographical Review* 89:2 (April 1999): 170.

61. On this theme, see Ota Shōko, *Tawaraya Sōtatsu hitsu Matsushima-zu byōbu: Zashiki kara tsuzuku umi* (Tokyo: Heibonsha, 1995).

62. See Robert J. Maeda, "The Water Theme in Chinese Painting," *Artibus Asiae* 33:4 (1971): 247–290.

63. Howard Hibbett, *The Floating World in Japanese Fiction* (Freeport, NY: Books for Libraries Press, 1970), 11.

64. Translated in Haruo Shirane, *The Bridge of Dreams: A Poetics of the Tale of Genji* (Palo Alto: Stanford University Press, 1987), 21, as part of his discussion of the poetics of exile.

65. "Oto ni kiku takashi no hama no ada-nami ha kakeji ya sode no mo koso sure" and "Hito shirenu omohi ariso no ura-kaze ni namie no yoru koso ihamahoshikere," translated in Joshua S. Mostow, *Pictures of the Heart: The Hyakunin Isshu in Word and*

Image (Honolulu: University of Hawai'i Press, 1996), 354. The book illustrations are reproduced on pp. 355–356.

66. See Mostow, *Pictures of the Heart*, 256.

67. "Hakodate no seki no fusemori kokoro seyo nami nomi yosuru yoni shi araneba," translated in Timon Screech, *The Shogun's Painted Culture: Fear and Creativity in the Japanese States 1760–1829* (London: Reaktion Books, 2000), 221.

68. Ibid., 220.

69. On the tradition that a *kamikaze* destroyed the Mongol fleet, see Thomas D. Conlan, *In Little Need of Divine Intervention: Scrolls of the Mongol Invasions of Japan*, Cornell East Asian Series (Ithaca, NY: East Asian Program, Cornell University, 2001).

70. On this print see Timothy Clark, *Kuniyoshi: From the Arthur Miller Collection* (London: Royal Academy of Arts, 2009), 198. This biographical series also includes a view of Nichiren standing on a rocky promontory overlooking the ocean praying for rain in which the downpour has miraculously caused a small cresting wave. See Robert Schaap, *Heroes and Ghosts: Japanese Prints by Kuniyoshi 1797–1861* (Leiden: Hotei Publishing, 1998), 187.

71. The near total absence of waves in the votive paintings that sailors offered to shrines for safe passage is testimony of this. See Makino Ryōshin, *Nihon no fune ema-hokuzensen* (Japanese votive plaques of ships) (Tokyo: Kashiwa shōbo, 1977).

72. Katherine Plummer, *The Shogun's Reluctant Ambassadors: Japanese Sea Drifters in the North Pacific* (Tokyo: Lotus Press, 1985), 117–155.

73. Christopher Pinney, *"Photos of the Gods": The Printed Image and Political Struggle in India* (London: Reaktion Press, 2004), 206.

74. This is the premise of Kano Hiroyuki's study of the "Red Fuji." See his *Katsushika Hokusai Gaifū kaisei*. Timothy Clark concurs with this view. See his *Hokusai's Great Wave*, 23.

CHAPTER 2: INTERNATIONAL NATIONALISM

1. See Stephen Kern, *The Culture of Time and Place, 1880–1918* (Cambridge, MA: Harvard University Press, 1983, 2003).

2. "La mer est ton miroir, tu contemples ton âme dans le déroulement infini de sa lame," cited in Gloria Groom, "The Sea as Metaphor in 19th Century France," in Juliet Wilson-Bareau and David Degener, eds., *Monet and the Sea* (Philadelphia: Philadelphia Museum of Art, 2003), 51.

3. The term appears in Eliza Ruhamah Scidmore, "The Recent Earthquake Wave on the Coast of Japan," *National Geographic,* September 1896. See http://ngm .nationalgeographic.com/1896/09/japan-tsunamiscidmore-text, accessed July 21, 2011. The following year Lafcadio Hearn used it in his tale "A Living God," in *Gleanings in Buddha Fields: Studies of Hand and Soul in the Far East* (1897) (Vermont and Tokyo: Tuttle, 1971), 7.

4. Richard A. Proctor, "The Greatest Sea-Wave Ever Known," *Littells Living Age* 106:1365 (July 1870): 310–315.

5. Noteworthy studies include Gabriel Weisberg, Dennis Cate, et al., *Japonisme: Japanese Influence on French Art 1854–1910* (Cleveland: Cleveland Museum of Art, 1975); Ministère de la Culture, *Japonisme*; Toshio Watanabe, *High Victorian Japonisme,* Swiss Asian Studies Research Studies 10 (Bern, 1991); Klaus Berger, *Japonisme in Western Painting from Whistler to Matisse* (Cambridge and New York: Cambridge University Press, 1992); and Wichmann, *Japonisme.*

6. Modernity is used here to refer to the complex political, economic, and social processes associated with modernization, and modernism to the way these associated phenomena are manifested in art and culture.

7. The entire series is reproduced and discussed in the bilingual publication *The Sketchbooks of Hokusai: Hokusai Manga,* introduction by Kawakita Michiaki, 15 vols. (Tokyo: Unsōdō, 1993).

8. Among these are the waves created by the ghosts of the Taira warriors who attack Yoshitsune and Benkei in volume 4; the Straights of Awa in volume 6; the waves at the entrance to the "Cave of the Three Deities" in volume 9; and a Taoist conjuring waves from the palms of his hands in volume 10.

9. Charles Holmes*, Hokusai* (London: At the Sign of the Unicorn, 1899), 34.

10. For illustrations, see Ministère de la Culture, *Japonisme,* 62.

11. Quoted in Lane, *Hokusai,* 133.

12. Quoted in Colta Feller Ives, *The Great Wave: The Influence of Japanese Woodcuts on French Prints* (New York: The Metropolitan Museum of Art, 1974), 13.

13. Goncourt, *Hokousai,* 116 (emphasis in original).

14. Lane, *Hokusai,* 121. Lane uses the word "plates" here to refer to the images produced from a single block.

15. See, for instance, ibid., 121.

16. Cited in Shigemi Inaga, "The Making of Hokusai's Reputation in the Context of Japonisme," *Japan Review* 15 (2003): 85.

17. According to Henry D. Smith, there were reprintings of one or more volumes of the three-volume Fuji set in the 1840s, a new edition with additional gray and pink tones was introduced in the 1850s, and in the 1860s and 1870s the set was reissued with the original gray blocks. See his *Hokusai: One Hundred Views,* 21.

18. Christine W. Laidlaw, "The American Reaction to Japanese Art, 1853–1876" (Ph.D. dissertation, State University of New Jersey, 1996), 19.

19. Dickins, *Fugaku.*

20. Laidlaw, "American Reaction," 112. Laidlaw also suggests that Homer owned a copy of the *One Hundred Views of Mount Fuji.*

21. See H. Barbara Weinberg, *The Decorative Work of John La Farge* (New York: Garland Publishing, 1977), 57–60.

22. Henry Adams, "John La Farge's Discovery of Japanese Art: A New Perspective on

the Origins of *Japonisme,*" *Art Bulletin* 67 (September 1985): 449–485; Laidlaw, "American Reaction," 89–90.

23. Alfred, Lord Tennyson, *Selected Poems* (New York: Dover Publications, 1992), 56, 67.

24. John La Farge, *Great Masters* (Garden City, NY: Doubleday, Page and Co., 1903, 1915), viii.

25. Stacey Sloboda, "The Grammar of Ornament: Cosmopolitanism and Reform in British Design," *Journal of Design History* 21:3 (2008): 227–228.

26. Owen Jones, *Grammar of Ornament* (London: Day and Son, 1865).

27. Owen Jones, *Grammar of Chinese Ornament* (London: S. and T. Gilbert, 1867).

28. Thomas William Cutler, *Grammar of Japanese Ornament and Design* (London: B. T. Batsford, 1880; and Mineola, NY: Dover Editions, 2003).

29. Christopher Dresser, *Japan: Its Architecture, Art and Art Manufactures* (London: Longmans, Green and Co., 1882; New York: Scribner and Welford, 1882).

30. Ibid., 319.

31. Cutler, *Grammar of Japanese Ornament and Design,* 36.

32. The term "taxonomic" is adopted from Joe Earle, "The Taxonomic Obsession: British Collectors and Japanese Objects 1852–1986," *The Burlington Magazine* 128:1005 (December 1986): 862–873.

33. Louis Gonse, *L'art japonais* (Paris: A. Quantin, 1883), 2:358.

34. *Catalogue de l'Exposition Rétrospectif de l'Art Japonais aux Galeries Georges Petit* (Paris, 1883).

35. Dresser, *Japan,* 300.

36. On Krog and the revival of Royal Copenhagen, see H. V. F. Winstone, *Royal Copenhagen* (London: Stacey International, 1984), 86–95.

37. Ibid., 88. On the technical features of this pictorial underglaze, see Claire Pollard, *Master Potter of Meiji Japan: Makuzu Kōzan (1842–1916) and His Workshop* (Oxford: Oxford University Press, 2002), 64–65. The plate exhibited at the Nordic Exhibition of Industry, Agriculture, and Art in Copenhagen in 1888 is now in the Design Museum, Copenhagen.

38. Karl Madsen, *Japansk Malerkunst* (Copenhagen: P. G. Philipsens Forlag, 1885). On Danish Japonisme, see also Gunhild Borggren, "Kako no rinen: Denmaaku bijutsu ni okeru japonismu," *Bijutsu Forum* 21:5 (2001): 93–96. See also Elizabeth Oxfeldt, *Nordic Orientalism: Paris in the Cosmopolitan Imagination 1800–1900* (Copenhagen: Tusulanum Press, University of Copenhagen 2005).

39. Madsen, *Japansk Malerkunst,* 129. Translation courtesy of Malene Wagner.

40. Vibeke Woldbye, "Ceramic Interplay: Copenhagen and Japan during the 1880s and 1890s," in *Meiji no Takara: Treasures of Imperial Japan: Ceramics, Part One, Porcelain* (London: The Kibo Foundation, 1995), 65–68. Weisberg, *Art Nouveau Bing,* 29. For reproductions of Krog's and Chaplet's vases, see Wichmann, *Japonisme,* 130.

41. See Louis Lawrence, *Hirado: Prince of Porcelains* (Chicago, IL: Art Media Resources 1997).

42. Woldbye, "Ceramic Interplay," 64–77; Pollard, *Master Potter*, 51, 105.

43. Both Hirado dishes were owned by the London collector David Hyatt King.

44. Siegfried Bing, "Fu-gaku San'jiu-rok'kei, or The Thirty-Six Views of the Fuji-yama," *Transactions of the Japan Society* (London), 4 (1898), plate 14. Developed in the 1890s, half-tone photographic reproduction involves converting tones of a photograph into dots that are so closely spaced together that the eye sees them as a continuous tone.

45. Francis L. Hawks, *Narrative of the Expedition of an American Squadron to the China Seas and Japan in the Years 1852, 1853, and 1854* (Washington, D.C., 1856; Mineola, NY: Dover Publications, 2000), 460–461.

46. Cited in Ministère de la Culture, *Japonisme*, 86. The chromolithographic facsimilies were prepared by Felix Régamey, the artist who accompanied collector Emile Guimet to Japan.

47. It is reproduced in Weisberg, *Art Nouveau Bing*, 14.

48. Andrew Gosling, *Asian Treasures: Gems of the Written Word* (Sidney: National Library of Australia, 2011), 77.

49. From Phillip Dennis Cate, "Japanese Influence on French Prints 1883–1910," cited in Gabriel P. Weisberg et al., *Japonisme*, 56.

50. Brigitte Koyama-Richard, *Japon revé: Edmond de Goncourt et Hayashi Tadamasa* (Paris: Hermann, 2001), 165–166.

51. David Bromfield, "Japanese Art, Monet and the Formation of Impressionism: Cultural Exchange and Appropriation in Later Nineteenth Century European Art," in C. Andrew Gerstle and Anthony Crothers Milner, eds., *Recovering the Orient: Artists, Scholars, and Appropriations* (Chur, Switzerland, and Great Britain: Harwood Academic Publications, 1994), 8; see also Inaga, "Making of Hokusai's Reputation," 86–90.

52. Inaga, "Making of Hokusai's Reputation," 86–87.

53. Elisa Evett, *The Critical Reception of Japanese Art in Late Nineteenth Century Europe* (Ann Arbor, MI: UMI Research Press, 1982), 31–35; and Nicholas Mirzoeff, *An Introduction to Visual Culture* (London: Routledge, 1999), 51–58.

54. Cited in Pamela Warner, "Compare and Contrast: Rhetorical Strategies in Edmond de Goncourt's Japonisme," in *Nineteenth-Century Art Worldwide*, 8:1 (2009–2010), available at http://www.19thc-artworldwide.org.

55. My thanks to Helena Capkova for first bringing this image to my attention. See also Marketa Hanova, *Japonisme in the Fine Arts of the Czech Lands* (Prague: Norodni Galerie, 2010), 77–84.

56. "Japonisme! Attraction de l'époque, rage désorganisée dans notre art, nos modes, nos goûts, même notre raison." Adrien Dubouche, "La céramique contemporaine à l'Exposition universelle," *L'art,* October 1878, cited in Ministère de la Culture, *Japonisme,* 132.

57. Patricia Eckert Boyer and Dennis Cate, *Estampe originale: Artistic Printmaking in France 1893–1895* (Amsterdam: Van Gogh Museum, 1991), 62.

58. Phillip Dennis Cate, "Japanese Influence on French Prints 1883–1910," in Weisberg et al., eds., *Japonisme*, 56.

59. On their technical aspect, see McDonald, *Les trente-six vues de la Tour Eiffel par Henri Rivière* (Paris: Philippe Sers, 1989), 98–105. The seven prints are reproduced and discussed in Annette Haudiquet et al., *Vagues: Autour des paysages de mer de Gustave Courbet* (Paris: Somogy Éditions d'Art, 2004), 138–142.

60. Cited in McDonald, *Trente-six vues*, 92.

61. Iijima, *Katsushika Hokusaiden*.

62. On Hayashi's activities, see Brigitte Koyama-Richard, *Japon revé: Edmond de Goncourt et Hayashi Tadamasa* (Paris: Hermann, 2001).

63. Weisberg, *Art Nouveau Bing*, 37.

64. Sarah Burns, *Inventing the Modern Artist: Art and Culture in Gilded Age America* (New Haven: Yale University Press, 1996).

65. For a broader discussion of Goncourt's outlook toward Japanese art, see Warner, "Compare and Contrast."

66. The original French is as follows: "Dans les deux hemispheres, c'est donc la même injustice pour tout talent independent du passé. Voici le peintre qui a victorieusement enlevé la peinture de son pays aux influences persanes et chinoises, et qui, par une étude, pour ainsi dire, religieuse de la nature, l'a réjeunie, l'a renouvelée, l'a fait vraiment japonaise." Goncourt, *Hokousai*, 1; translation from Forrer, *Hokusai*, 10.

67. The original French is as follows: "L'interieur du flot en face de Kanagawa (à Tokaido). Planche, qui devrait s'appeler *la Vague,* et qui en est comme le dessin, un peu divinisé par un peintre, sous la terreur religieuse de la mer rédoutable entourant de toute part sa patrie; dessin qui vous donne le colereux de sa montée dans le ciel, l'azur profond de l'interieur transparent de sa courbe, le déchirement de sa crête, qui s'eparpille en une pluie de gouttelettes, ayant la forme de griffes d'animaux." Goncourt, *Hokousai*, 166; translation from Forrer, *Hokusai*, 266.

68. This association continues today, as evidenced in the inclusion of this print and four others from Hokusai's series in the recent catalogue of an exhibition held at Le Havre. See Haudiquet et al., *Vagues*.

69. Alain Corbin, *The Lure of the Sea: The Discovery of the Seaside in the Western World 1750–1840,* trans. Jocelyn Phelps (Cambridge: Polity Press, 1994), 74, 73.

70. Bing, "Fu-gaku San'jiu-rok'kei, or The Thirty-six Views of the Fuji-yama," 252.

71. Weisberg, *Art Nouveau Bing*, 8.

72. Bing, "Fu-gaku San'jiu-rok'kei," 249.

73. For background on this movement, see Rosalind P. Blakesley, "Russia," in Karen Livingstone and Linda Parry, eds., *International Arts and Crafts*, 256–265 (London: V and A Publications, 2005).

74. See Sergei Golynets, *Ivan Bilibin,* trans. Glenys Anne Kozlov (London: Pan Books; Leningrad: Aurora Art Publishers, 1981).

75. Johannes Fabian, *Time and Other: How Anthropology Makes Its Object* (New York: Columbia University Press, 1983).

76. John La Farge, "Bric-a-Brac," *Century* 46:24 (1893): 42.

77. Elena Diakonova, "*Japonisme* in Russia in the Late Nineteenth and Early Twentieth Centuries," in M. William Steele, ed., *Japan and Russia: Three Centuries of Mutual Images* (Folkstone: Global Oriental, 2007), 35–36.

78. Ibid., 34.

79. Ibid., 41.

80. Sergei Golynets, *Ivan Bilibin* (New York: Harry N. Abrams, Inc., 1981), 6.

81. Diakonova, "Japonisme," 40–43. See also Golynets, *Ivan Bilibin,* plates 22, 26, 161, 163, and 165.

82. Alexander Pushkin, *Collected Narrative and Lyrical Poetry,* translated in the prosodic forms of the original by Walter Arnt (Ann Arbor: Ardis Publishers, 1984), 376.

83. "J'aime les images presque autant que la musique." Cited in Richard Lanham Smith, "Debussy and the Art of Cinema," *Music and Letters* 54:1 (January 1973): 61.

84. Jean-Michel Nectoux, *Harmonie en bleu et or: Debussy, la musique et les arts* (Paris: Fayard, 2005), 191–192, citing Jacques Durand, *Quelques souvenirs d'un éditeur de musique* (Paris, 1925), 92–93. There does not appear to be any correspondence explicitly requesting this design, only an indirect reference in a letter to Durand of September 11, 1905. Earlier, however, in letters of August 21 and 27, 1903, Debussy gave Durant explicit directions about the typeface, ink, and colors to be used for his piano pieces titled "Estampes."

85. For an example of this uncritical and even erroneous perspective, see Calza, *Hokusai,* 506.

86. Simon Tresize, *Debussy: La Mer* (Cambridge: Cambridge University Press, 1994), 32–33.

87. The debates surrounding this composition are discussed in Leon Botstein, "Beyond the Illusions of Realism: Painting and Debussy's Break with Tradition," in Jane F. Fulcher, ed., *Debussy and His World* (Princeton, NJ, and Oxford: Princeton University Press, 2001), 141–179.

88. Ibid., 143–145.

89. Ibid., 150.

90. Cited in ibid.

91. Andreas Bluhm and Louise Lippincott, *Light! The Industrial Age 1750–1900: Art and Science, Technology and Society* (New York: Thames and Hudson, 2000), 174.

92. Bing, "Fu-gaku San'jiu-rok'kei," 250; Ernest Fenollosa, *The Masters of Ukioye: A Complete Historical Description of Japanese Paintings and Color Prints of the Genre School as Shown in an Exhibition at the Fine Arts Buildings, New York, January 1896* (New York: Knickerbocker Press, 1896), 106.

93. John Gage, *Colour and Culture* (London: Thames and Hudson, 1993), 243–244.

94. My thanks to David Robins for bringing these examples to my attention.

95. Richard Lanham Smith, "Debussy," 63.

96. On Mallarmé's "Salon japonais," see Jean-Michel Nectoux, *Harmonie,* 187.

97. Ibid., 193.

98. Cited in Tresize, *Debussy,* 38.

99. Nectoux, *Harmonie,* 186–196. It is worth noting, however, that *Estampes* consists of three pieces, "Pagodes," "La soirée dans Grenade," and "Jardins sous la pluie," that do not all refer to Japan.

100. Ibid., 189. According to Odile Ayral-Clause, Debussy and Claudel first met in Mallarmé's salon. *Camille Claudel, a Life* (New York: Harry N. Abrams, 2002), 107.

101. Claudel's wave is in sharp contrast to Courbet's erotic *Woman in the Waves* (1868; Metropolitan Museum) or Rodin's 1887 marble sculpture, also titled *The Wave,* with its entwined lovers rocking on the beach in syncopation with the wavelets that gently lap over their recumbent bodies.

102. See Anne Rivière et al., eds., *Camille Claudel: Catalogue raisonné* (Paris: Société nouvelle Adam Biro, 1996), 131–135. Claudel's special interest in the wave may have been further mediated by other works. In 1895 Claudel had to sell a painting she owned by Alexander Harrison called *The Wave* to raise money for materials. Ayral-Clause, *Camille Claudel,* 122, 131.

103. Quoted in Angelo Caranfa, *Camille Claudel: A Sculpture of Interior Solitude* (Lewisburg: Bucknell University Press, 1999), 90–91; emphasis in original.

104. See Akane Kawakami, *Travellers' Visions: French Literary Encounters with Japan 1881–2004* (Liverpool: Liverpool University Press, 2005), 90–127.

105. On its performance and recording history, see http://www.classicalnotes.net/classics/lamer.html, accessed July 21, 2011. The limited edition of one hundred is mentioned in the introductory notes to Marie Rolf, *La mer: Oeuvres complètes de Claude Debussy,* series 8, vol. 5 (Paris: Durand, 1997).

106. For this text and its intellectual background see Kuki Shūzō, *Reflections on Japanese Taste: The Structure of Iki,* trans. John Clark (Sidney: Power Publications, 1997).

107. Translated in Stephen Light, *Shuzo Kuki and Jean-Paul Sartre: Influence and Counter-Influence in the Early History of Existential Phenomenology* (Carbondale: Southern Illinois University Press, 1987), 61–62.

CHAPTER 3: AMERICA'S JAPAN

1. Christopher Benfey, *The Great Wave: Gilded Age Misfits and the Opening of Old Japan* (New York: Random House, 2003). The narrative revolves around wildly dissimilar figures including the shipwrecked Japanese sailor Manjirō, the art historian Ernest Fenollosa, the Boston philanthropist William Bigelow, the peripatetic Japanese scholar Okakura Kakuzō, and the collector Isabella Stewart Gardner.

2. *New York Times,* September 27, 2006, section A, p. 8.

3. Both "The Wave" and "The Great Wave" were used before World War II. See, for instance, "A Selection from the Holiday Books of the Year by W. G. Bowdoin," *Independent,* December 8, 1910, p. 1244; "Late Frederick W. Hunter's Collection of Japanese Prints on View," *New York Times,* March 10, 1919, p. 10; "Notes on Current Art," *New York Times,* June 1, 1919, 36; "$355 for Japanese print," *New York Times,* June 15, 1920, p. 32; "Japanese Prints to Go at Auction," *New York Times,* February 24, 1946, p. 42, accessed through Proquest Historical Newspapers, Stanford University Library, May 10, 2007.

4. "Critic's View," *New York Times,* Sunday, October 26, 1997, 39.

5. Julia Meech-Pekarik, "Early Collectors of Japanese Prints and the Metropolitan Museum of Art," *Metropolitan Museum Journal* 17 (1984): 116, citing Louis V. Ledoux, *The Art of Japan* (New York, 1927), 30.

6. Arthur Miller, "Japanese Prints Entrance: Specimens That Have influenced Western Art Now Being Shown in Pasadena Exhibition," *Los Angeles Times,* February 10, 1929, C 14, accessed through Proquest Historical Newspapers, Stanford University Library, May 10, 2007.

7. Quoted in Julia Meech, *Frank Lloyd Wright and the Art of Japan* (New York: Harry N. Abrams, 2001), 23.

8. Julia Meech, "The Early Years of Japanese Print Collecting in North America," *Impressions: The Journal of the Ukiyo-e Society of America, Inc.,* 25 (2003): 23.

9. Ibid., 49.

10. The museum accession numbers are 06.1153; 06.1283; 06.2548; 11.17652; 21.6764; 21.6765; 34.317.

11. Meech, "Early Years," 45. See also Julia Meech, "The Other Havemeyer Passion: Collecting Asian Art," in Alice Cooney Frelinghuysen et al., eds., *Splendid Legacy: The Havemeyer Collection* (New York: Metropolitan Museum of Art, 1993), 129–150. The accession numbers of the Met impressions are JP2972 (Phillips Collection); JP1936 (Mansfield Collection); JP1847 (Havemeyer Collection); J10 (Rogers Fund).

12. "Japanese Print Exhibit Opens," *Chicago Daily Tribune,* January 12, 1915, p. 3; accessed through Proquest Historical Newspapers, Stanford University Library, May 10, 2007.

13. Museum accession numbers are 1925.3245; 1952.343; 1928.1086.

14. See http://www.thinker.org/imagebase. The original print is accession number 1969.32.6. The "reproduction," listed simply as a gift of Clifton Hart in 1965, may be among the high-quality reproductions created under the auspices of Watanabe Shōzaburō. On his activities, see Hiromi Okamoto and Henry D. Smith II, "Ukiyo-e for Modern Japan: The Legacy," in Amy Reigle Stephens, ed., *The New Wave: Twentieth-Century Japanese Prints from the Robert O. Muller Collection* (London: Bamboo Publishing, 1993), 29–30.

15. Julia M. White, Introduction to *Masterpieces of Landscape: Ukiyo-e Prints from the Honolulu Academy of Arts* (Honolulu: Honolulu Academy of Arts, 2003), 17.

16. It was reprinted more than ten times before a revised edition was published. See James A. Michener, *The Floating World* (Honolulu: University of Hawai'i Press, 1983).

17. Gift of the Frederick R. Weisman Company (M.81.91.2).

18. Reproduced in Lafcadio Hearn, *Occidental Gleanings* (New York: Dodd, Mead, 1925), 209–240.

19. Cited in Hina Hirayama, "A True Japanese Taste: Construction of Knowledge about Japan in Boston 1880–1900" (Ph.D. dissertation, Boston University, 1999), 203, quoting from the *Boston Daily Evening Traveller,* supplement, October 13, 1883.

20. "Editorial Comment," *Atlanta Constitution,* January, 15, 1894, accessed through Proquest Historical Newspapers, Stanford University Library, May 10, 2007.

21. "Courage and Good Cheer in the Stricken City," *New York Times,* April 26, 1906, accessed through Proquest Historical Newspapers, Stanford University Library, May 10, 2007.

22. "The Selection of Christmas Gifts," *Harper's Bazaar,* December 1907, accessed through Proquest Historical Newspapers, Stanford University Library, May 10, 2007.

23. "Rare Album Disappears," *Washington Post,* February 14, 1908, accessed through Proquest Historical Newspapers, Stanford University Library, May 10, 2007.

24. Fenollosa, *Masters of Ukioye,* 106.

25. *Catalogue of the Valuable Collection of Japanese Coloured Prints Illustrated Books and a Few Kakemono the Property of John Stewart Happer Esq.* (London: Sotheby, Wilkinson and Hodge, 1909), 18, 21. My thanks to Tim Clark for bringing this catalogue to my attention. The currency conversion is based on calculations provided on http://www.nationalarchives.gov.uk.

26. Ibid., 21.

27. On Hayashi, see Koyama-Richard, *Japon revé*; on Matsuki, see Fred Scharf, *A Pleasing Novelty: Bunkio Matsuki and the Japan Craze in Victorian Salem* (Salem: Peabody Essex Museum, 1993); on Yamanaka, see Thomas Lawton, "Yamanaka Sadajirō: Advocate for Asian Art," *Orientations,* January 1995, 80–93.

28. "Hokusai in New York," *Independent,* March 27, 1916, online p. 465, accessed through Proquest Historical Newspapers, Stanford University Library, May 10, 2007.

29. See "$31,725 for Japanese Art," *New York Times* January 31, 1925, 9; accessed through Proquest Historical Newspapers, Stanford University Library, May 10, 2007.

30. Meech, *Frank Lloyd Wright,* 170 and note 79.

31. See Okamoto and Smith, "Ukiyo-e," 26–39.

32. Introduction to Hiroshi Yoshida, *The Complete Woodblock Prints of Yoshida Hiroshi* (Tokyo: Abe Publishing, 1996), 12.

33. Christina Klein, *Cold War Orientalism: Asia in the Middlebrow Imagination, 1951–1961* (Berkeley: University of California Press, 2003), 30.

34. Lucy Herndon Crockett, *Popcorn on the Ginza* (New York: William Sloane Associates, 1949), 35.

35. John Hersey, *Hiroshima* (1946; New York: Vintage Edition, 1989).

36. Their engagement figures throughout Klein, *Cold War Orientalism*.

37. Sheila Johnson, *The Japanese through American Eyes* (Stanford: Stanford University Press, 1988), 15.

38. Deborah Kogan Ray, *Hokusai: The Man Who Painted a Mountain* (New York: Farrar, Straus, and Giroux, 2001).

39. Veronique Massenot and Bruno Pilorget, *The Great Wave, a Children's Book Inspired by Hokusai* (Munich, London, New York: Prestel, 2010).

40. See Hearn, "A Living God."

41. Pearl S. Buck, *My Several Worlds: A Personal Record* (London: Methuen and Co., 1955), 4.

42. Pearl Buck, *The Big Wave, Illustrated with Prints by Hiroshige and Hokusai* (New York: John Day, 1948), introduction, 5.

43. Ibid., pp. 259–260.

44. Ibid., introduction, 5.

45. Ibid., introduction, 6.

46. See unit "Learning from Tragedy," PowerPoint guide for teachers at http://literature.ppst.com/ABC/pearl-buck.html, accessed May 6, 2010. The 1985 HarperTrophy paperback now in wide circulation has no illustrations at all.

47. "The 47 Rōnin," *Life,* November 1, 1943, 53.

48. Michener, "Magic," 237.

49. Ibid., 240.

50. Buck, *Big Wave*, introduction; "Learning from Tragedy," PowerPoint guide for teachers, http://literature.ppst.com/ABC/pearl-buck.html.

51. This question, with a line drawing detail of the print, appeared in a 2005 SAT test book. Personal communication, Allen Hockley.

52. Jonathan Rutherford, ed., "The Third Space: Interview with Homi Bhabha," in *Identity: Community, Culture, Difference* (London: Lawrence and Wishart, 1990), 208.

53. Okakura Tenshin, *Nihon bijutsu shi* (1900); (Tokyo: Heibonsha, 2001), 137.

54. An exhibition of the Matsukata Collection at Rutgers University may have been the first. The loan of a selection of prints from this collection, now in the Tokyo National Museum, commemorated industrialist Matsukata Kojirō's graduation from Rutgers. See Julia Meech, *The Matsukata Collection of Ukiyo-e Prints: Masterpieces from the Tokyo National Museum.* (New Brunswick, NJ: The Jane Voorhees Zimmerli Art Museum, 1988).

55. Douglas Frewer, "Japanese Postage Stamps as Social Agents: Some Anthropological Perspectives," *Japan Forum* 14:1 (2002): 2–3. My thanks to Radu Leca for drawing my attention to the importance of stamps in the dissemination of Japanese art.

56. Ibid., 9.

57. On the process, see Hugo Dobson, "Postage Stamps: Propaganda and Decision Making," *Japan Forum* 14:1 (2002): 25–26.

58. See http://www.iomoon.com/fujiilww.html, accessed June 20, 2012.

59. Hiroshi Onchi, "On Japanese Posters," *International Poster Annual* 1953/1954:9.

60. Richard Thornton mentions Landor's commission to redesign the trademark of Asahi beer, but in fact he redesigned that of Sapporo beer. Thornton, *Japanese Graphic Design* (London: Laurence King, 1991), 74; correspondence with Trevor Wade, Landor Associates, September 27, 2013.

61. Gian Carlo Calza, *Tanaka Ikko: Graphic Master* (London: Phaidon, 1997), 22.

62. Tanako Ikko, "Posters and Japanese Culture," in ibid., 243.

63. Arguably it was also the motif's familiarity and appeal to American audiences that led to its selection for display in an exhibition of Japanese design from 1950. See Felice Fischer, *Japanese Design since 1950* (Philadelphia Museum of Art in Association with Harry N. Abrams, New York, 1995), 80.

64. On the Nippon Design Center, see Richard S. Thornton, *Japanese Graphic Design,* 86–88.

65. Quoted in Minami Yusuke, ed., *Yokoo Tadanori Shinra Bansho* (*Tadanori Yokoo: All Things in the Universe*) (Tokyo: Tokyo Museum of Contemporary Art, 2002), 11.

66. The double cresting wave reappears in posters advertising the *Ballad to the Severed Little Finger,* a book on gangster films, with Takakura Ken, a frequent star in such films in the 1960s, at its center; in the poster for Hara Jūrō's 1966 play *Koshimaki Osen bokyaku hen* (Petticoat Osen); and in an ad for Mishima's book *Owari no bigaku* (Aesthetics of the end), whose dystopian theme is suggested by a train cutting through waves in a headlong crash with the viewer.

67. Koichi Tanikawa, *100 Posters of Yokoo Tadanori* (New York: Images Graphiques, 1978), 6.

68. John Nathan, *Mishima: A Biography* (London: Hamish Hamilton, 1975), 254.

69. Ibid., 254–255.

70. For a good discussion of this, see Dong-Yeon Koh, "Murakami's 'Little Boy' Syndrome: Victim or Aggressor in Contemporary Japanese and American Arts?" *Inter-Asia Cultural Studies* 11:3 (2010): 393–412; http://www.gwern.net/docs/2010-koh.pdf, accessed August 22, 2012.

71. See Judith H. Dobrynski, "Art Museum Attendance Keeps Rising in the U.S.," *New York Times,* February 1, 1999, accessed through Proquest Historical Newspapers, Stanford University Library, May 10, 2007.

72. Thomas Hoving, *Making the Mummies Dance* (New York: Simon and Schuster, 1993). The first quote is from p. 429, the second from p. 33.

73. Gary Tinterow, *Impressionism: A Centenary Exhibition* (New York: Metropolitan Museum of Art, 1974), 427. It is unlikely that Monet was familiar with "Under the Wave off Kanagawa" in 1867, though he may well have seen other prints derived from it.

74. Colta Feller Ives, *The Great Wave: The Influence of Japanese Woodcuts on French Prints* (New York: Metropolitan Museum of Art, 1974).

75. Ibid., 102–103.

76. Brian Moeran, Introduction, in Eyal Ben-ari, Brian Moeran, and James Valentine, eds., *Unwrapping Japan: Society and Culture in Anthropological Perspective* (Manchester: Manchester University Press, 1990), 2.

77. For an excellent account of Japanese involvement in the Impressionist art market, see Cynthia Saltzman, *The Portrait of Dr. Gachet* (New York: Viking, 1998), 305–330.

78. Letter from September 8, 1888, reproduced in *The Complete Letters of Vincent van Gogh* (London: Thames and Hudson, 1958), 3:29.

79. John Nathan, *Japan Unbound: A Volatile Nation's Quest for Pride and Purpose* (Boston: Houghton Mifflin, 2004), 18.

80. Adrian Favell, "Tokyo to LA Story: How Southern California Became the Gateway for a Japanese Global Pop Phenomenon," *Kontour: Culture, History, Politics* 20:12 (2010): 55.

81. See http://www.janm.org, accessed September 21, 2013.

82. Yone Noguchi, *The Letters of a Japanese Parlour-Maid by Miss Morning Glory* (Tokyo: Fuzanbo, 1905).

83. Yone Noguchi, *Hokusai* (London: Elkin Mathews, 1925), 25–26.

84. Emily Stamey, *The Prints of Roger Shimomura: A Catalogue Raisonné, 1968–2005* (Lawrence and Seattle: Spencer Museum of Art in association with the University of Washington Press, 2007), 17.

85. Ibid., 21.

86. See James T. Ulak, Alexandra Monroe, Masami Teraoka, with Lynda Hess, *Paintings by Masami Teraoka* (Washington, D.C.: Arthur M. Sackler Gallery, Smithsonian Institution; New York and Tokyo: Weatherhill, 1996), 42.

87. For reproductions see Howard S. Link, *Waves and Plagues: The Art of Masami Teraoka* (San Francisco: Chronicle Books, 1988), figs. 9 and 11.

88. Ibid., 26

89. See ibid., plates 6–16.

90. His first solo exhibition in Japan was not held until 1997 in Obuse, a city closely associated with Hokusai, on the occasion of the 1998 Nagano Olympics. John Stevenson, *Masami Teraoka: From Tradition to Technology, the Floating World Comes of Age* (Seattle and London: University of Washington Press, 1997), 8.

91. http://en.wikipedia.org/wiki/Giant_Robot_(magazine), accessed September 21, 2013.

92. http://web.mit.edu/chosetec/www/, accessed August 22, 2013.

93. Email exchange, August 22, 2013.
94. http://www.etsy.com/listing/43983647/a-great-eva-off-kanagawa-digital-print, accessed September 21, 2013.
95. Henry Jenkins, *Convergence Culture: Where Old and New Media Collide* (New York and London: New York University Press, 2006), 2.

CHAPTER 4: LIFESTYLE BRANDING

1. Undated advertising flyer accompanying Sunday edition of the *San Francisco Chronicle* in the autumn of 2007.
2. B. Joseph Pine II and James H. Gilmore, *The Experience Economy: Work Is Theater and Every Business a Stage* (Boston: Harvard Business School Press, 1999), 74.
3. Ibid., 29–31.
4. Terry Smith, *The Architecture of Aftermath* (Chicago: University of Chicago Press, 2006), 22.
5. Robert Goldman and Stephen Papson, *Nike Culture* (London: Sage, 2000), 1.
6. Ibid.
7. The watch was advertised in the magazine accompanying the weekend edition of the *Financial Times,* May 2–3, 2009. Background information from press release, courtesy of Girard-Perregaux, July 24, 2013.
8. Kopytoff, "Cultural Biography of Things," 80–83.
9. See http://www.artfund.org/artwork/10242/under-the-wave-of-kanagawa-(the -great-wave), accessed May 31, 2011. The British Art Fund subsidized £25,000 of the £130,000 purchase price.
10. Kopytoff, "Cultural Biography of Things," 76.
11. See http://www.amazon.co.uk/Inspired-Argentium-SilverThe-Great-Necklace/ dp/B002SXN1US, accessed May 31, 2011.
12. *New York Times,* February 24, 2009.
13. The T-shirt designed by Peggy Lindt discussed below, for instance, was available in 2004 at the Denver Art Museum, which does not even own an impression of Hokusai's print.
14. For examples see Nagata Seiji, *Hokusai* (Berlin), 134–137.
15. On Tezuka Osamu see Frederick L. Schodt, *Dreamland Japan: Writings on Modern Manga* (Berkeley: Stone Bridge Press, 1996), 233–277.
16. Katarzyna J. Cwierrtka, *Modern Japanese Cuisine: Food, Power and National Identity* (London: Reaktion Books, 2006), 182.
17. Ibid., 183.
18. See http://adsoftheworld.com/media/print/kikkoman_the_great_wave_of _kikkoman?size=_original, accessed September 21, 2013.
19. Ronald E. Yates, *The Kikkoman Chronicles: A Global Company with a Japanese Soul* (New York: McGraw-Hill, 1998), chap. 1.

20. For a review by a Trader Joe's fan, see http://www.facebook.com/note.php?note_id=414711605669, accessed June 3, 2011.

21. http://en.gigazine.net/index.php?/news/comments/20090710_hokusai_cream_puff/, accessed May 31, 2011.

22. http://8tokyo.com/2009/11/06/fauchon-eclair-la-vague/ and http://blog.oggi.tv/present/2010/05/fauchon.html, accessed May 31, 2011.

23. Thorstein Veblen, *The Theory of the Leisure Class* (London: Unwin, 1970); Pierre Bourdieu, *Distinction: A Social Critique of the Judgment of Taste*, trans. Richard Nice (Cambridge, MA: Harvard University Press, 1984).

24. http://Fliptomania.com/category/2.html, accessed May 31, 2011.

25. For a good discussion of this phenomenon, see Christine R. Yano, "Wink on Pink: Interpreting Japanese Cute," *Journal of Asian Studies* 68:3 (August 2009): 681–688.

26. Koichi Iwabuchi, *Recentering Globalization: Popular Culture and Japanese Transnationalism* (Durham, NC: Duke University Press, 2002), 28.

27. Although "Kasumi for RIC" appears below the image, I have not been able to determine the identity of its creator.

28. It is possible that the clothing was inspired by Sally Swain's *Great Housewives of Art* (London: Grafton Books, 1988), a publication that similarly spoofed famous works of art. My thanks to Anna Jackson and Julia Hutt for drawing my attention to this book.

29. Other examples include pens, where the wave suggests the flow of ink, and watches and clocks whose hands echo the circular sweep of the wave.

30. Introduction to Daniel Miller and Sophie Woodward, eds., *Global Denim* (London: Berg, 2010), 1–21.

31. Ami Kealoha, "Denim Hokusai," http://www.coolhunting.com/archives/2005/10/14, accessed June 3, 2011. For another example of promotional use of Levi's jeans, see http://www.designer-daily.com/hokusais-great-wave-is-everywhere-4697, accessed October 27, 2009. The locale is not identified.

32. Viviana Narotsky, "Selling the Nation: Identity and Design in 1980s Catalonia," *Design Issues* 25:3 (Summer 2009): 71 and 68.

33. Gennifer Weisenfeld, "From Baby's First Bath: Modern Soap and Modern Japanese Commercial Design," *Art Bulletin* 86:3 (September 2004): 577.

34. Email exchange, May 13, 2011.

35. See http://www.houzz.com/photos/bathroom/Great-Wave, http://www.paintamural.pipalo.com/step-1–5-ideas-part-ii-painting-a-mural-in-a-bedroom-living-room-dining-room-kitchen-or-bathroom/, accessed August 7, 2012.

36. Quoted in Eric Nakamura, "Rabbits and Robots," *Giant Robot* 28 (Summer 2003): 67.

37. For an excellent discussion of Murakami and Yoshitomo and their entrepreneurial activities, see Adrian Favell, *Before and after Superflat: A Short History of Japanese*

Contemporary Art 1990–2011 (Hong Kong: Blue Kingfisher Limited, 2011), especially 15–56.

38. http://www.zazzle.co.uk/zazzle+great+wave+shoes, accessed May 31, 2011.
39. Benedict Anderson, *Imagined Communities: Reflections on the Origins and Spread of Nationalism* (London: Verso, 1991).
40. See http://www.filf.co.uk/skate/carver-skateboards/carver-skateboard-37-great-wave.html, accessed June 3, 2011. Quiksilver is another company with a cresting wave logo that markets to surfing fans.
41. http://www.hyattsvillewire.com/2012/06/11/the-great-wave-off-anacostia/, accessed August 12, 2012.
42. http://www.apple.com/downloads/dashboard/information/maree_bobbyhugges.html, accessed April 28, 2011.
43. Marjorie Kelly, "Projecting an Image and Expressing Identity: T-shirts in Hawaii," *Fashion Theory* 7:2 (2003): 205.
44. This ad was part of its 2006 "Invest Japan" campaign. The exact date of its appearance is unknown.
45. For a good discussion of skateboarding, see Iain Borden, *Skateboarding, Space, and the City: Architecture and the Body* (London: Berg, 2001).
46. Dick Hebdige, *Sub-culture: The Meaning of Style* (London: Routledge, 1987), 102–106.
47. *Sneakers: The Complete Collectors' Guide*, written and designed by Unorthodox Styles (London: Thames and Hudson, 2005), 7.
48. http://www.patagonia.com/us/patagonia.go?assetid=3351, accessed June 2, 2011.
49. See GPIWŌ Sign Logo T-shirt Style 51844 at http://www.patagonia.com, accessed June 1, 2011.
50. On Chouinard's engagement with Japan, see Yvon Chouinard, *Let My People Go Surfing: The Education of a Reluctant Businessman* (New York: Penguin Press, 2005), 74–75, 127–128.
51. The magazine ceased publication in 2009.
52. Douglas McGray, "Japan's Gross National Cool," *Foreign Policy* 130 (May–June 2002), 51, 47.
53. Sarah Thornton, *Seven Days in the Art World* (London: Granta Books, 2008), 189.
54. Margrit Brehm, ed., *The Japanese Experience-Inevitable* (Kraichtal: Ursula Blickle Foundation, 2002), 17.
55. Sotheby's sales catalogue, May 14, 2008; *The Art Newspaper,* June 2008. My thanks to Glenn Adamson for the latter reference.
56. McGray, "Japan's Gross National Cool," 53.
57. "Cover Story: 'Cool Japan' Goes Global," *Japan Echo* 2009:21.
58. http://www.japantravelinfo.com/puffyamiyumi. The poster was removed from the website between 2007, when this information was first accessed, and September 21, 2013. Requests to reproduce it were denied.

CHAPTER 5: PLACEMAKING

1. There are many definitions of site-specific art, but here I follow that of Nick Kaye: "A site specific work might articulate and define itself through properties, qualities or meanings produced in specific relationships between an 'object' or 'event' and a position it occupies." Nick Kaye, *Site Specific Art: Performance, Place and Documentation* (London and New York: Routledge, 2000), 1. In thinking through the issues in this chapter, I have also benefited from Suzanne Lacy, ed., *Mapping the Terrain: New Genre Public Art* (Seattle: Bay Press, 1995); and Alex Coles, ed., *Site Specificity: The Ethnographic Turn* (London: Black Dog Publishing Limited, n.d.).

2. Notable among them are Lynda H. Schneekloth and Robert G. Shibley, *Placemaking: The Art and Practice of Building Communities* (New York: Wiley, 1995); Timothy Beatley and Kristy Manning, *The Ecology of Place* (Washington, D.C.: Island Press, 1997); and Laurie Olin, *OLIN: Placemaking* (New York: Monacelli Press, 2008).

3. Ronald Lee Fleming, *The Art of Placemaking: Interpreting Community through Public Art and Urban Design* (London and New York: Merrell, 2007), 14.

4. For humorous Paris Golo postcards, see http://www.parisgolo.fr/ou.html, accessed August 26, 2012.

5. For publicity on the Dubai version, see http://www.islamicartsmagazine.com/magazine/view/mohamed_kanoo_at_meem_gallery. It gained further exposure through its reproduction in *Timeout Dubai,* along with a pastiche of Barack Obama in a headdress. See http://www.timeoutdubai.com/gallery/33424-barack-obama-in-a-headdress?image=2, accessed August 15, 2012.

6. For one such misreading, see Brian F. Atwater et al., *The Orphan Tsunami of 1700* (U.S. Geological Service and Seattle: University of Washington Press, 2005), 80.

7. Pico Iyer, *The Global Soul* (New York: Knopf, 2000), 43.

8. Marc Augé, *Non-places: An Introduction to Supermodernity* (London and New York: Verso, 1995), 76.

9. This feature was first instituted in 1928 at London's Croydon Aerodrome and marked the emergence of what Alistair Gordon has called the "airport vernacular." Alastair Gordon, *Naked Airport: A Cultural History of the World's Most Revolutionary Structures* (New York: Metropolitan Books-Henry Holt and Co., 2004), 15.

10. Fleming, *Art of Placemaking,* 150.

11. Ibid., 150–153.

12. http://www.yvr.ca/en/about/facts-stats.aspx, accessed August 2, 2012.

13. http://www.yvr.ca/guide/todo/art/wavewall.asp, accessed August 2, 2012.

14. Email communication with Lutz Haufschild, July 27, 2012.

15. An informal survey among a small number of colleagues in Japanese studies, who one might expect to make the connection, revealed that none had paid any attention to the glass wall, much less thought about its connection to Hokusai's wave.

16. For more detailed background on this work and its creator, see http://

www.yvr.ca/en/about/art-architecture/Art-Haida-Gwaii.aspx and http://www
.billreidfoundation.org/bill_reid.htm, accessed August 2, 2012.

17. http://www.en.wikipedia.org/Haida_Gwaii, accessed August 2, 2012.

18. See http://www.yvr.ca/en/about/art-architecture/Art-Haida-Gwaii.aspx, accessed August 2, 2012.

19. On this subject, see Jeffrey Deitch, *Art in the Streets* (New York: Skira/Rizzoli, 2011).

20. See http://www.flickr.com/photos/wayneo42/2774671289/in/set-72157606727278627, accessed September 15, 2012.

21. Titled *Die Woge*, this work by Tobias Stengel commemorates the flooding of the Elbe River in 2002. See http://www.flickr.com/photos/qatsi/3055223099/, accessed September 15, 2012.

22. See, for instance, Neil Shea, "Under Paris," *National Geographic,* February 2011, 104–125; and Joshua Levine, "Paris from Below," *Wall Street Journal (WSJ Magazine)*, May 26, 2011; for Newtown, see http://www.en.wikipedia.org/wiki/Newtown_area_graffiti_and_street_art, accessed August 1, 2012.

23. Andy Leon Harney, "Home Graphics: All Some houses Need Is a Good Paint Job," *Washington Post,* January 16, 1983, accessed through Proquest Historical Newspapers, Stanford University Library, May 10, 2007. The first record of the mural by J. MacConnell at 3510 O St. NW is in a photograph from 1977 by Ernest A. Long, who documented street art around the United States. See http://archives.getty.edu/R/?func=dbin-jump-full&object_id=5486613&local_base=GEN01, accessed August 5, 2012.

24. As quoted in Harney, "Home Graphics."

25. On the real estate valuation of the house, see http://www.frenchtwistdc.com/2012/05/great-wave-of-georgetown.html, accessed August 5, 2012. A well-publicized exhibition of Hokusai's *Thirty-Six Views of Mount Fuji* at the Freer/Sackler Gallery of the Smithsonian Institution in 2011 led to a resurgence of interest in the local landmark and to its inclusion in this tour. See http://guaa.tumblr.com/post/21231745571/exclusive-private-curator-led-tour-at-the-freer and http://www.thegeorgetowndish.com/the-latest/update-great-wave-georgetown-added-fresco-tour, accessed August 5, 2012.

26. http://www.flickr.com/photos/14725326@N00/5689921375/lightbox/.

27. Tony Fry, "A Geography of Power: Design History and Marginality," in Victor Margolin and Richard Buchanan, eds., *The Idea of Design: A Design Issues Reader* (Cambridge and London: MIT Press, 1995), 214.

28. http://www.carriereichardt.co.uk/content/all-about-treatment-rooms and http://www.carriereichardt.co.uk/content/abort-mag, accessed September 30, 2012.

29. Email correspondence, September 9, 2012.

30. https://www.youtube.com/watch?feature=player_embedded&v=FMG3MJsD2fU, accessed October 5, 2013.

31. Eilert Ekwall, *Oxford English Dictionary of English Place Names*, 4th edition (Oxford: Oxford University Press, 1960), 116.

32. Telephone interview, September 25, 2012.

33. http://www.camberwellarts.org.uk, accessed August 2, 2012.

34. Telephone interview, September 25, 2012.

35. http://londonmuralpreservationsociety.com/murals/hokusai-wave-mural/, accessed August 2, 1012.

36. The exhibition, in a gallery off the main entrance to the museum, was held from November 3, 2011, through January 8, 2012. Both it and the accompanying catalogue included photographs of the Camberwell mural. See Clark, *Hokusai's Great Wave*.

37. On the history of Inakadate's rice paddy art, see http://www.vill.inakadate.lg.jp/bunya/dentogyoji/kikakukankouka/, accessed August 26, 2013. See also Yoko Hani, "Homegrown Art," *Japan Times* (online), August 26, 2007, http://www.japantimes.co.jp/text/fl20070826x1.html, accessed August 6, 2012.

38. The site was discovered in 1981, but it was not until March 9, 1999, that Inakadate applied to the Ministry of Cultural Affairs to designate Tareyanagi (Hanging Willow Tree) as National Historic Ruins. Anthony S. Rausch, *A Year with the Local Newspaper: Understanding the Times in Aomori Japan, 1999* (Lanham, MD: University Press of America, 2001), 178–179.

39. Ibid., 103.

40. http://pinktentacle.com/2008/07/jal-logo-uprooted-from-rice-paddy-art/, accessed August 3, 2012.

41. The *Telegraph,* August 3, 2009, http://www.telegraph.co.uk/news/worldnews/asia/japan/5965073/Farmers-create-coloured-rice-murals-in-Japan.html, accessed August 3, 2012.

42. For a provocative and broad-ranging discussion see, Marilyn Ivy, *Discourses of the Vanishing: Modernity, Phantasm, Japan* (Chicago and London: University of Chicago Press, 1995). For a more focused study, see Anthony S. Rausch, *Cultural Commodities in Japanese Rural Revitalization: Tsugaru Nuri Lacquerware and Tsugaru Shamisen* (Leiden: Brill, 2010).

43. On this subject see Emiko Ohnuki-Tierney, *Rice as Self: Japanese Identities through Time* (Princeton: Princeton University Press, 1993).

44. Full consideration of the ties between Inakadate and global manifestations of site-specific art is beyond the scope of this book. For a good discussion of the issues, see Miwon Kwon, "One After Another: Notes on Site Specificity," *October* 80 (Spring 1997): 83–110.

45. Stan Herd, *Crop Art* (New York: Abrams, 1994), 10, 28.

46. This and other works are reproduced at http://www.millermeiers.com/stanherd/examples.html, accessed August 10, 2012.

47. Herd, *Crop Art*, 28.

48. http://webecoist.momtastic.com/2010/05/20/amazing-living-art-18-giant-rice-murals-pics/, accessed August 3, 2012.

49. Fleming, *Art of Placemaking,* 28.

50. View expressed in the film "The Great Wave," in the BBC television series *The Private Life of a Masterpiece.*

51. Interview in ibid.

52. Anthony Lane, "This Is Not a Movie," *New Yorker,* September 24, 2011, http://www.newyorker.com/archive/2001/09/24/010924crci_cinema?currentPage=all, accessed August 15, 2012.

53. Interview in the BBC film "The Great Wave."

54. For background on this work, see http://www.apollo-magazine.com/june-2006/73676/interview-with-carlo-bilotti.thtml, accessed August 5, 2012. See also http://en.museocarlobilotti.it/mostre_ed_eventi/mostre/damien_hirst_david_salle_jenny_saville_the_bilotti_chapel, accessed August 15, 2012.

55. For photographs of the mourners, their annual gatherings, and the memorial, see http://www.newsday.com/long-island/suffolk/a-beachfront-tribute-to-flight-800-victims-1.2107012#1, accessed August 4, 2012.

56. The *New York Times,* July 17, 2004, covered the dedication of the memorial.

57. Quoted in "Inspirational Architect," article in *New York Institute of Technology Magazine* 1:2 (Fall 2002): 42.

58. For information on the crash and the memorial, see http://en.wikipedia.org/wiki/TWA_Flight_800, accessed August 2, 2012.

59. See http://www.apollo-magazine.com/june-2006/73676/interview-with-carlo-bilotti.thtml, accessed August 5, 2012.

60. David Simpson, *9/11: The Culture of Commemoration* (Chicago and London: University of Chicago Press, 2006), 75.

61. Ibid., 75.

62. Quoted in "Inspirational Architect," article in *New York Institute of Technology Magazine* 1:2 (Fall 2002): 42.

EPILOGUE: AFTER THE TSUNAMI

1. Baxandall, *Patterns of Intention,* 60.

2. A discussion of the difference between Japanese and European readings of this print opens Banyan's editorial on how Japan views the sea and itself in the *Economist,* June 4, 2011, 78.

3 Hiroo Kanamori and Thomas H. Heaton, "The Wake of a Legendary Earthquake," *Nature* 379:6562 (January 18, 1996): 203–204.

4. See Julyan H. E. Cartwright and Hisami Nakamura, "Tsunami: A History of the Term and of Scientific Understanding of the Phenomenon in Japanese and Western Culture," *Notes of the Royal Society* 62:2 (June 2008): 151–166, and "What

Kind of Wave Is Hokusai's *Great Wave off Kanagawa?*" *Notes and Records of the Royal Society* 63 (2009): 119–135.

5. Cartwright and Nakamura, "Tsunami," 153.
6. Personal communication, Tim Clark.
7. Research carried out by Zoya Street using google.co.uk and google.co.jp between March and May 2011 revealed a spike in the former but not in the latter.
8. http://www.icp.pinoy.com, accessed March 15, 2011.
9. http://newamericamedia.org/2011/03/japans-tsunami-human-failings-not -natures-power-are-the-real-calamity.php, accessed March 12, 2011.
10. Pictorializations of tsunamis are rare, but one example uses a conventionalized profile like Hokusai's. See the wave painted by Furuta Eisho, an eyewitness to the tsunami that struck Hiro village in southwest Honshu on December 24, 1854, following an 8.5 magnitude earthquake, in Atwater, *Orphan Tsunami,* 47.
11. Lucien Boia, *The Weather in the Imagination* (London: Reaktion Books, 2005), 145–146.
12. Nicholas Jenkins, "Running on the Waves: Pollock, Lowell, Bishop and the American Ocean," *Yale Review*, April 2007, 56 and 58.
13. Ibid., 62.
14. Cited in Giles Slade, *Made to Break: Technology and Obsolescence in America* (Cambridge, MA: Harvard University Press, 2006), 144.
15. For a discussion of this film in the context of disaster, see Susan J. Napier, "Panic Sites: The Japanese Imagination of Disaster from Godzilla to Akira," *Journal of Japanese Studies* 19:2 (Summer 1993): 327–351.
16. http://learning.blogs.nytimes.com/2011/03/18/teachers-respond-to-the-crisis -in-japan/, accessed March 18, 2011.
17 On *Nihon chinbotsu,* see Napier, "Panic Sites," 331–336.
18. See http://en.wikipedia.org/wiki/The_Last_Wave, accessed September 6, 2012.
19. For the road sign adopted in Oregon, for instance, see Atwater, *Orphan Tsunami,* 46. For the version used in Japan, see http://en.wikipedia.org/wiki/Tsunami _warning_system, accessed September 6, 2012.
20. For a history of the term's usage, see "tsunami," *Oxford English Dictionary*, 2nd edition, 1989; online version, June 2012, http://www.oed.com/view/Entry/207116, accessed September 7, 2012.
21. This is the implication of "Japanese insurers: Ready for the Next Tsunami?" an article accompanied by a reproduction of the print in the *Economist,* August 2, 2003, 64.
22. "On Language," *New York Times,* Sunday Magazine, January 16, 2005.

Bibliography

Adams, Henry. "John La Farge's Discovery of Japanese Art: A New Perspective on the Origins of *Japonisme.*" *Art Bulletin* 67 (September 1985): 449–485.

Akai, Tatsurō. "The Common People and Painting." In Chie Nakane and Shinzaburō Oishi, eds., *Tokugawa Japan: The Social Antecedents of Modern Japan,* trans. Conrad Totman, 187–191. Tokyo: University of Tokyo Press, 1990.

Anderson, Benedict. *Imagined Communities: Reflections on the Origins and Spread of Nationalism.* London: Verso, 1991.

Appadurai, Arjun. "Disjunction and Difference in the Global Culture Economy." *Theory, Culture and Society* 7 (1990): 295–310.

———. *Modernity at Large: Cultural Dimensions of Globalization.* Minneapolis and London: University of Minnesota Press, 1996, 2005.

———, ed. *The Social Life of Things: Commodities in Cultural Perspective,* Cambridge: Cambridge University Press, 1992.

Asano Shugio. *Hokusai.* Ukiyo o yomu, vol. 4. Tokyo: Asahi shinbunsha, 1997–1998.

Atwater, Brian F., et al. *The Orphan Tsunami of 1700.* U.S. Geological Service and Seattle: University of Washington Press, 2005.

Augé, Marc. *Non-places: An Introduction to Supermodernity.* London and New York: Verso, 1995.

Ayral-Clause, Odile. *Camille Claudel, a Life.* New York: Harry N. Abrams, 2002.

Bahktin, Mikhael. *The Dialogic Imagination.* Trans. C. Emerson and M. Holquist. Austin: University of Texas Press, 1981.

Bailey, Kate. "A Note on Prussian Blue in Nineteenth-Century Canton." *Studies in Conservation* 57:2 (2012): 116–121.

Baxandall, Michael. *Patterns of Intention: On the Historical Explanation of Pictures.* New Haven: Yale University Press, 1992.

Beatley, Timothy, and Kristy Manning. *The Ecology of Place.* Washington, D.C.: Island Press, 1997.

Benfey, Christopher. *The Great Wave: Gilded Age Misfits and the Opening of Old Japan.* New York: Random House, 2003.

Berger, Klaus. *Japonisme in Western Painting from Whistler to Matisse.* Cambridge and New York: Cambridge University Press, 1992.

Bhabha, Homi K. *The Location of Culture.* London and New York: Routledge Classics, 2004.

Bing, Siegfried. "Fu-gaku San'jiu-rok'kei, or The Thirty-Six Views of the Fuji-yama." *Transactions of the Japan Society* (London), 4 (1898): 242–254.

Bluhm, Andreas, and Louise Lippincott. *Light! The Industrial Age 1750–1900: Art and Science, Technology and Society.* New York: Thames and Hudson, 2000.

Boia, Lucien. *The Weather in the Imagination.* London: Reaktion Books, 2005.

Borden, Iain. *Skateboarding, Space, and the City: Architecture and the Body.* London: Berg, 2001.

Borggren, Gunhild. "Kako no rinen: Denmaaku bijutsu ni okeru japonismu" (Ideals of the past: Japonisme in Denmark). *Bijutsu Forum* 21:5 (2001): 93–96.

Botstein, Leon. "Beyond the Illusions of Realism: Painting and Debussy's Break with Tradition." In Jane F. Fulcher, ed., *Debussy and His World,* 141–179. Princeton, NJ, and Oxford: Princeton University Press, 2001.

Boyer, Patricia Eckert, and Dennis Cate. *Estampe originale: Artistic Printmaking in France 1893–1895.* Amsterdam: Van Gogh Museum, 1991.

Brehm, Margrit, ed. *The Japanese Experience-Inevitable.* Kraichtal: Ursula Blickle Foundation, 2002.

Bromfield, David. "Japanese Art, Monet and the Formation of Impressionism: Cultural Exchange and Appropriation in Later Nineteenth Century European Art." In C. Andrew Gerstle and Anthony Crothers Milner, eds., *Recovering the Orient: Artists, Scholars, Appropriations,* 7–43. Chur, Switzerland, and Great Britain: Harwood Academic Publishers, 1994.

Buck, Pearl S. *The Big Wave, Illustrated with Prints by Hiroshige and Hokusai.* New York: John Day, 1948.

———. *My Several Worlds: A Personal Record.* London: Methuen and Co., 1955.

Burke, Peter. *Cultural Hybridity.* Cambridge: Polity Press, 2009.

Burns, Sarah. *Inventing the Modern Artist: Art and Culture in Gilded Age America.* New Haven: Yale University Press, 1996.

Burns, Susan L. *Before the Nation: Kokugaku and the Imagining of Community in Early Modern Japan.* Durham: Duke University Press, 2003.

Calza, Gian Carlo, ed. *Hokusai.* London and New York: Phaidon Press, 2003.

———. *Tanaka Ikko: Graphic Master.* London: Phaidon, 1997.

Carpenter, John, ed. *Hokusai and His Age: Ukiyo-e Painting, Printmaking and Book Illustration in late Edo Japan.* Leiden: Hotei Publishing, Amsterdam, 2005.

Cartwright, Julyan H. E., and Hisami Nakamura. "Tsunami: A History of the Term and of Scientific Understanding of the Phenomenon in Japanese and Western Culture." *Notes of the Royal Society* 62:2 (June 2008): 151–166.

———. "What Kind of Wave Is Hokusai's *Great Wave off Kanagawa?*" *Notes and Records of the Royal Society* 63 (2009): 119–135.

Chartier, Roger. *The Order of Books.* Stanford: Stanford University Press, 1994.

Chouinard, Yvon. *Let My People Go Surfing: The Education of a Reluctant Businessman.* New York: Penguin Press, 2005.

Clark, Timothy. *Hokusai's Great Wave.* London: The British Museum, 2011.

———. *Kuniyoshi: From the Arthur Miller Collection* (London: Royal Academy of Arts, 2009.

———. *One Hundred Views of Mount Fuji.* London: The British Museum Press, 2001.

Coles, Alex, ed. *Site Specificity: The Ethnographic Turn*. London: Black Dog Publishing Limited, n.d.

Collcutt, Martin. "Mt. Fuji as the Realm of Miroku: The Transformation of Maitreya in the Cult of Mt. Fuji in Early Modern Japan." In Alan Sponberg and Helen Hardacre, eds., *Maitreya the Future Buddha*, 248–269. Princeton: Princeton University Press, 1988.

Condry, Ian. *The Soul of Anime: Collaborative Creativity and Japan's Media Success Story*. Durham and London: Duke University Press, 2013.

Conlan, Thomas D. *In Little Need of Divine Intervention: Scrolls of the Mongol Invasions of Japan*. Cornell East Asian Series. Ithaca, NY: East Asian Program, Cornell University, 2001.

" 'Cool Japan' Goes Global." *Japan Echo* 2009: 21–23.

Corbin, Alain. *The Lure of the Sea: The Discovery of the Seaside in the Western World 1750–1840*. Trans. Jocelyn Phelps. Cambridge: Polity Press, 1994.

Cutler, Thomas William. *Grammar of Japanese Ornament and Design*. London: B. T. Batsford, 1880; reprint Mineola, NY: Dover Editions, 2003.

Cwierrtka, Katarzyna J. *Modern Japanese Cuisine: Food, Power and National Identity*. London: Reaktion Books, 2006.

Davis, Julie Nelson. "Tsutaya Jūzaburō: Master Publisher." In Julia Meech and Jane Oliver, eds., *Designed for Pleasure: The World of Edo Japan in Prints and Paintings, 1680–1860*, 115–141. New York: Asia Society and Japanese Art Society of America in association with University of Washington Press, 2008.

———. *Utamaro and the Spectacle of Beauty*. London; Reaktion Books, 2007.

Diakonova, Elena. "*Japonisme* in Russia in the Late Nineteenth and Early Twentieth Centuries." In M. William Steele, ed., *Japan and Russia: Three Centuries of Mutual Images,* 32–46. Folkstone: Global Oriental, 2007.

Dickins, Fredrick Victor. *Fugaku hiyaku-kei, or, A Hundred Views of Fuji (Fusiyama)*. London: B. T. Batsford, 1880.

Dobson, Hugo. "Postage Stamps: Propaganda and Decision Making," *Japan Forum* 14:1 (2002): 21–39.

Dresser, Christopher. *Japan: Its Architecture, Art and Art Manufactures*. London: Longmans, Green and Co.; New York: Scribner and Welford, 1882.

Earle, Joe. "The Taxonomic Obsession: British Collectors and Japanese Objects 1852–1986." *The Burlington Magazine* 128:1005 (December 1986): 862–873.

Evett, Elisa. *The Critical Reception of Japanese Art in Late Nineteenth Century Europe*. Ann Arbor, MI: UMI Research Press, 1982.

Fabian, Johannes. *Time and Other: How Anthropology Makes Its Object*. New York: Columbia University Press, 1983.

Favell, Adrian. *Before and after Superflat: A Short History of Japanese Contemporary Art 1990–2011*. Hong Kong: Blue Kingfisher Limited, 2011.

———. "Tokyo to LA Story: How Southern California Became the Gateway for a

Japanese Global Pop Phenomenon." *Kontour: Culture, History, Politics* 20:12 (2010): 54–68.

Fenollosa, Ernest. *The Masters of Ukioye* [sic]*: A Complete Historical Description of Japanese Paintings and Color Prints of the Genre School as Shown in an Exhibition at the Fine Arts Buildings, New York, January 1896.* New York: Knickerbocker Press, 1896.

Fleming, Ronald Lee. *The Art of Placemaking: Interpreting Community through Public Art and Urban Design.* London and New York: Merrell, 2007.

Forrer, Matthi. *Hiroshige Prints and Drawings.* Munich: Prestel, 1997.

———. *Hokusai Prints and Drawings.* Munich: Prestel Verlag and London: Royal Academy of Art, 1991.

———. *Hokusai, with Texts by Edmond de Goncourt.* New York: Rizzoli, 1988.

Frelinghuysen, Alice Cooney, et al., eds. *Splendid Legacy: The Havemeyer Collection.* New York: Metropolitan Museum of Art, 1993.

French, Calvin L. *Shiba Kōkan: Artist, Innovator, and Pioneer in the Westernization of Japan.* Tokyo and New York: Weatherhill, 1974.

Frewer, Douglas. "Japanese Postage Stamps as Social Agents: Some Anthropological Perspectives." *Japan Forum* 14:1 (2002): 1–19.

Fry, Tony. "A Geography of Power: Design History and Marginality." In Victor Margolin and Richard Buchanan, eds., *The Idea of Design: A Design Issues Reader,* 204–214. Cambridge and London: MIT Press, 1995.

Gage, John. *Colour and Culture.* London: Thames and Hudson, 1993.

Goldman, Robert, and Stephen Papson. *Nike Culture.* London: Sage, 2000.

Golynets, Sergei. *Ivan Bilibin.* Trans. Glenys Anne Kozlov. London: Pan Books; Leningrad: Aurora Art Publishers, 1981.

Goncourt, Edmond de. *Hokousai.* Paris: Bibliothèque Charpentier, 1896.

Gonse, Louis. *L'art japonais.* 2 vols. Paris: A. Quantin, 1883.

Gordon, Alastair. *Naked Airport: A Cultural History of the World's Most Revolutionary Structures.* New York: Metropolitan Books–Henry Holt and Co., 2004.

Gramsci, Antonio. *Selections from the Prison Notebooks of Antonio Gramsci.* Ed. and trans. Quintin Hoare and Geoffrey Nowell Smith. London: Lawrence and Wishart, 1971.

Greenblatt, Stephen. "Resonance and Wonder." In Ivan Karp and Stephen D. Lavine, eds., *Exhibiting Cultures: The Poetics and Politics of Museum Display,* 42–56. Washington and London: Smithsonian Institution Press, 1991.

Guth, Christine M. E. "Hokusai's Great Wave in Nineteenth-Century Japanese Visual Culture." *Art Bulletin* 93:4 (December 2011): 468–485.

———. "The Local and the Global: Hokusai's Great Wave in Contemporary Product Design." *Design Issues* 2:2 (Spring 2012): 16–29.

Hanova, Marketa. *Japonisme in the Fine Arts of the Czech Lands.* Prague: Norodni Galerie, 2010.

Haudiquet, Annette, et al. *Vagues: Autour des paysages de mer de Gustave Courbet.* Paris: Somogy Éditions d'Art, 2004.

Hawks, Francis L. *Narrative of the Expedition of an American Squadron to the China Seas and Japan in the Years 1852, 1853, and 1854.* Washington, D.C., 1856; Mineola, NY: Dover Publications, 2000.

Hearn, Lafcadio. "A Living God." In *Gleanings in Buddha Fields: Studies of Hand and Soul in the Far East* (1897). Vermont and Tokyo: Tuttle, 1971.

————. *Occidental Gleanings.* New York: Dodd, Mead, 1925.

Hebdige, Dick. *Sub-culture: The Meaning of Style.* London: Routledge, 1987.

Herd, Stan. *Crop Art.* New York: Abrams, 1994.

Hersey, John. *Hiroshima.* 1946. New York: Vintage, 1989.

Hibbett, Howard. *The Floating World in Japanese Fiction.* Freeport, NY: Books for Libraries Press, 1970.

Hillier, Jack. *The Art of Hokusai in Book Illustration.* 2 vols. London: Sotheby Parke-Bernet, 1980.

————. *Hokusai: Paintings, Drawings, and Woodcuts.* London: Phaidon, 1955.

————. *Hokusai Drawings.* London: Phaidon, 1966.

Hirayama, Hina. "A True Japanese Taste: Construction of Knowledge about Japan in Boston 1880–1900." Ph.D. dissertation, Boston University, 1999.

Hockley, Allen. *The Prints of Isoda Koryūsai: Floating World Culture and Its Consumers in Eighteenth-Century Japan.* Seattle and London: University of Washington Press, 2003.

Holmes, Charles. *Hokusai.* London: At the Sign of the Unicorn, 1899.

House, John, Virginia Spate, and David Bromfield. *Monet and Japan.* Canberra: National Gallery of Australia, 2001.

Hoving, Thomas. *Making the Mummies Dance.* New York: Simon and Schuster, 1993.

Huytnyk, John. "Hybridity." *Ethnic and Racial Studies* 28:1 (January 2005): 79–102.

Iijima Kyoshin. *Katsushika Hokusai den.* Tokyo: Hōsūkaku, 1893; reprint Tokyo: Iwanami bunko, 1999.

Ikegami, Eiko. *Bonds of Civility: Aesthetic Networks and the Political Origins of Japanese Culture.* Cambridge: Cambridge University Press, 2005.

Inaga Shigemi. *Kaiga no tasogare: Eduarudu Mane botsugo no tōsō* (The beginnings of modern painting: Eduard Manet's posthumous battle). Nagoya: Nagoya Daigaku shuppankai, 1997.

————. *Kaiga no tōhō: Orientarizumu kara Japonizumu-e* (The Orient of painting: Orientalism to Japonisme). Nagoya: Nagoya Daigaku shuppankai, 1999.

————. "The Making of Hokusai's Reputation in the Context of Japonisme." *Japan Review* 15 (2003): 77–100.

Ives, Colta Feller. *The Great Wave: The Influence of Japanese Woodcuts on French Prints.* New York: Metropolitan Museum of Art, 1974.

Ivy, Marilyn. *Discourses of the Vanishing: Modernity, Phantasm, Japan.* Chicago and London: University of Chicago Press, 1995.

Iwabuchi, Koichi. *Recentering Globalization: Popular Culture and Japanese Transnationalism.* Durham, NC: Duke University Press, 2002.

Iyer, Pico. *The Global Soul.* New York: Knopf, 2000.

Jenkins, Henry. *Convergence Culture: Where Old and New Media Collide.* New York and London: New York University Press, 2006.

Jenkins, Nicholas. "Running on the Waves: Pollock, Lowell, Bishop and the American Ocean." *Yale Review,* April 2007, 46–82.

Johnson, Sheila. *The Japanese through American Eyes.* Stanford: Stanford University Press, 1988.

Jones, Owen. *Grammar of Chinese Ornament.* London: S. and T. Gilbert, 1867.

———. *Grammar of Ornament.* London: Day and Son, 1865.

Kaempfer, Engelbert. *Kaempfer's Japan: Tokugawa Culture Observed.* Edited, translated, and annotated by Beatrice M. Bodart-Bailey. Honolulu: University of Hawai'i Press, 1999.

Kanamori, Hiroo, and Thomas H. Heaton. "The Wake of a Legendary Earthquake." *Nature* 379 (January 18, 1996): 203–204.

Kano Hiroyuki. *Katsushika Hokusai Gaifū kaisei: Aka Fuji no fōkuroa* (Katsushika Hokusai's "South Wind, Clear Dawn": the folklore of the Red Fuji). Tokyo: Heibonsha 1994.

Kaufmann, Thomas da Costa. *Toward a Geography of Art.* Chicago: University of Chicago Press, 2004.

Kawakami, Akane. *Travellers' Visions: French Literary Encounters with Japan 1881–2004.* Liverpool: Liverpool University Press, 2005.

Kaye, Nick. *Site Specific Art: Performance, Place and Documentation.* London and New York: Routledge, 2000.

Kelly, Marjorie. "Projecting an Image and Expressing Identity: T-Shirts in Hawaii." *Fashion Theory* 7:2 (2003): 191–212.

Kemp, Martin. *From Christ to Coke: How Image Becomes Icon.* Oxford and New York: Oxford University Press, 2012.

Kern, Stephen. *The Culture of Time and Place, 1880–1918.* Cambridge, MA: Harvard University Press, 1983, 2003.

Keyes, Roger S. *Ehon: The Artist and the Book in Japan.* New York: New York Public Library, 2008.

Kishi Fumikazu. *Edo no enkinhō: Uki-e no shikaku* (Perspective systems of Edo: the viewpoints of *uki-e*). Tokyo: Keisō shobō, 1994.

Klein, Christina. *Cold War Orientalism: Asia in the Middlebrow Imagination, 1951–1961.* Berkeley: University of California Press, 2003.

Kobayashi Tadashi. "Katsushika Hokusai no Fugaku sanjūrokkei" (Katsushika Hokusai's *Thirty-Six Views of Mount Fuji*). In *Fugaku sanjūrokkei,* Ukiyo-e taikei, vol. 13. Tokyo: Shūeisha, 1976.

Koh, Dong-Yeon. "Murakami's 'Little Boy' Syndrome: Victim or Aggressor in Contemporary Japanese and American Arts?" *Inter-Asia Cultural Studies* 11:3 (2010): 393–412.

Kondo, Ichitaro. *The Thirty-Six Views of Mount Fuji by Hokusai*. English adaptation by Charles S. Terry. Tokyo: Heibonsha 1966.

Kopytoff, Igor. "The Cultural Biography of Things: Commoditization as Process." In Arjun Appadurai, ed., *The Social Life of Things: Commodities in Cultural Perspective*, 64–91. Cambridge: Cambridge University Press, 1992.

Kornicki, Peter. *The Book in Japan: A Cultural History from the Beginnings to the Nineteenth Century*. Honolulu: University of Hawai'i Press, 2001.

Koyama-Richard, Brigitte. *Japon revé: Edmond de Goncourt et Hayashi Tadamasa*. Paris: Hermann, 2001.

Kuki Shūzō. *Reflections on Japanese Taste: The Structure of Iki*. Trans. John Clark. Sidney: Power Publications, 1997.

La Farge, John. "Bric-a-Brac." *Century* 46:24 (1893): 419–428.

———. *Great Masters*. Garden City, NY: Doubleday, Page and Co., 1903, 1915.

Laidlaw, Christine W. "The American Reaction to Japanese Art, 1853–1876." Ph.D. dissertation, Rutgers: State University of New Jersey, 1996.

Lane, Richard. *Hokusai: Life and Work*. New York: Dutton, 1989.

Latour, Bruno. "Where Are the Missing Masses? The Sociology of a Few Mundane Artifacts." In Wiebe E. Bijker and John Law, eds., *Shaping Technology / Building Society*. Cambridge, MA: MIT Press, 1992.

Lawrence, Louis. *Hirado: Prince of Porcelains*. Chicago, IL: Art Media Resources, 1997.

Lawton, Thomas. "Yamanaka Sadajirō: Advocate for Asian Art." *Orientations,* January 1995, 80–93.

Levy, Ian Hideo. *The Ten Thousand Leaves: A Translation of the Man'yōshū, Japan's Premier Anthology of Classical Poetry*. 2 vols. Princeton: Princeton Library of Asian Translations, 1981.

Light, Stephen. *Shuzo Kuki and Jean-Paul Sartre: Influence and Counter-Influence in the Early History of Existential Phenomenology*. Carbondale: Southern Illinois University Press, 1987.

Link, Howard A. "Thirty-Six Views of Mount Fuji: Impressions and States." In *Masterpieces of Landscape: Ukiyo-e Prints from the Honolulu Academy of Arts*, 33–38. Honolulu: Honolulu Academy of Arts, 2003.

———. *Waves and Plagues: The Art of Masami Teraoka*. San Francisco: Chronicle Books, 1988.

Livingstone, Karen, and Linda Parry. *International Arts and Crafts*. London: V and A Publications, 2005.

Machokta, Ewa. *Visual Genesis of Japanese National Identity: Hokusai's Hyakunin Isshū*. Brussels: Peter Lang, 2009.

Madsen, Karl. *Japansk Malerkunst*. Copenhagen: P. G. Philipsens Forlag, 1885.

Maeda, Robert J. "The Water Theme in Chinese Painting." *Artibus Asiae* 33:4 (1971): 247–290.

McDonald, Louisa Aya. *Les trente-six vues de la Tour Eiffel par Henri Rivière*. Paris: Philippe Sers, 1989.

McGray, Douglas. "Japan's Gross National Cool." *Foreign Policy* 130 (May–June 2002): 44–54.

Meech, Julia. "The Early Years of Japanese Print Collecting in North America." *Impressions: The Journal of the Ukiyo-e Society of America, Inc.*, 25 (2003).

————. *Frank Lloyd Wright and the Art of Japan*. New York: Harry N. Abrams, 2001.

Meech-Pekarik, Julia. "Early Collectors of Japanese Prints and the Metropolitan Museum of Art." *Metropolitan Museum Journal* 17 (1984): 93–118.

Michener, James A. *The Floating World*. Honolulu: University of Hawai'i Press, 1983.

————. "The Magic Hand of Hokusai." *Reader's Digest* 74 (June 1959): 236–240.

Miller, Daniel, and Sophie Woodward, eds. *Global Denim*. London: Berg, 2010.

Minami Yusuke, ed. *Yokoo Tadanori shinra bansho* (*Tadanori Yokoo: All Things in the Universe*). Tokyo: Tokyo Museum of Contemporary Art, 2002.

Ministère de la Culture et de la Communication, ed. *Le Japonisme*. Paris: Éditions de la Réunion des Musées Nationaux, 1988.

Mirzoeff, Nicholas. *An Introduction to Visual Culture*. London: Routledge, 1999.

Moeran, Brian. Introduction. In Eyal Ben-ari, Brian Moeran, and James Valentine, eds., *Unwrapping Japan: Society and Culture in Anthropological Perspective*. Manchester: Manchester University Press, 1990.

Morse, Peter, ed. "Tokuno's Description of Japanese Printmaking." In Matthi Forrer, ed., *Essays on Japanese Art Dedicated to Jack Hillier*, 125–134. London: Robert G. Sawers Publishing 1982.

Mostow, Joshua S. *Pictures of the Heart: The Hyakunin Isshu in Word and Image*. Honolulu: University of Hawai'i Press, 1996.

Nagata Seiji. *Hokusai*. Berlin: Nicolai, 2011.

————, ed. *Hokusai*. Tokyo: Nihon keizai shinbun, 2005.

Nakamura, Eric. "Rabbits and Robots." *Giant Robot* 28 (Summer 2003): 64–67.

Napier, Susan J. "Panic Sites: The Japanese Imagination of Disaster from Godzilla to Akira." *Journal of Japanese Studies* 19:2 (Summer 1993): 327–351.

Narazaki Muneshige. *Hokusai ron* (Hokusai discourse). Tokyo: Atoiesha, 1944.

Narotsky, Viviana. "Selling the Nation: Identity and Design in 1980s Catalonia." *Design Issues* 25:3 (Summer 2009): 62–75.

Naruse Fujio. *Fujisan no kaiga shi* (The history of paintings of Mount Fuji). Tokyo: Chūō kōron bijutsu shuppan, 2005.

Nathan, John. *Japan Unbound: A Volatile Nation's Quest for Pride and Purpose*. Boston: Houghton Mifflin, 2004.

————. *Mishima: A Biography*. London: Hamish Hamilton, 1975.

Nectoux, Jean-Michel. *Harmonie en bleu et or: Debussy, la musique et les arts*. Paris: Fayard, 2005.

Nishiyama, Matsunosuke. *Edo Culture: Daily Life and Diversions in Urban Japan, 1600–1868.* Honolulu: University of Hawai'i Press, 1997.

Ohnuki-Tierney, Emiko. *Rice as Self: Japanese Identities through Time.* Princeton: Princeton University Press, 1993.

Okakura Tenshin. *Nihon bijutsu shi* (History of Japanese art). 1900. Tokyo: Heibonsha, 2001.

Okamoto, Hiromi, and Henry D. Smith II. "Ukiyo-e for Modern Japan: The Legacy." In Amy Reigle Stephens, ed., *The New Wave: Twentieth-Century Japanese Prints from the Robert O. Muller Collection,* 26–39. London: Bamboo Publishing, 1993.

Olin, Laurie. *OLIN: Placemaking.* New York: Monacelli Press, 2008.

Ono Hideo. *Kawaraban monogatari: Edo jidai no masu komi no rekishi* (Kawaraban tales: History of mass communication in the Edo period). Tokyo: Yūzankaku, 1960.

Osterhammel, Jurgen, and Niels P. Petersson. *Globalization: A Short History.* Trans. Dona Geyer. Princeton and Oxford: Princeton University Press, 2003.

Ota Shōko. *Tawaraya Sōtatsu hitsu Matsushima-zu byōbu: Zashiki kara tsuzuku umi* (Tawaraya Sōtatsu's Matsushima screens: the sea depicted from the reception room). Tokyo: Heibonsha, 1995.

Oxfeldt, Elizabeth. *Nordic Orientalism: Paris in the Cosmopolitan Imagination 1800–1900.* Copenhagen: Tusulanum Press, University of Copenhagen, 2005.

Pieterse, Jan Nederveen. *Globalization and Culture: Global Melange.* Lanham, MD: Rowman and Littlefield Publishers, 2009.

Pine, B. Joseph II, and James H. Gilmore. *The Experience Economy: Work Is Theater and Every Business a Stage.* Boston: Harvard Business School Press, 1999.

Pinney, Christopher. *"Photos of the Gods": The Printed Image and Political Struggle in India.* London: Reaktion Press, 2004.

Plummer, Katherine. *The Shogun's Reluctant Ambassadors: Japanese Sea Drifters in the North Pacific.* Tokyo: Lotus Press, 1985.

Pollard, Claire. *Master Potter of Meiji Japan: Makuzu Kōzan (1842–1916) and His Workshop.* Oxford: Oxford University Press, 2002.

Proctor, Richard A. "The Greatest Sea-Wave Ever Known." *Littell's Living Age* 106:1365 (July 1870): 310–315.

Rausch, Anthony S. *Cultural Commodities in Japanese Rural Revitalization: Tsugaru Nuri Lacquerware and Tsugaru Shamisen.* Leiden: Brill, 2010.

———. *A Year with the Local Newspaper: Understanding the Times in Aomori Japan, 1999.* Lanham, MD: University Press of America, 2001.

Rousmaniere, Nicole Coolidge. "The Accessioning of Japanese Art in Early Nineteenth-Century America: Ukiyo-e Prints in the Peabody Essex Museum, Salem." *Apollo,* March 1997: 23–29.

Rutherford, Jonathan. "The Third Space: Interview with Homi Bhabha." In Jonathan Rutherford, ed., *Identity: Community, Culture, Difference,* 207–221. London: Lawrence and Wishart, 1990.

Schaap, Robert. *Heroes and Ghosts: Japanese Prints by Kuniyoshi 1797–1861.* Leiden: Hotei Publishing, 1998.

Scharf, Fred. *A Pleasing Novelty: Bunkio Matsuki and the Japan Craze in Victorian Salem.* Salem: Peabody Essex Museum, 1993.

Schneekloth, Lynda H., and Robert G. Shibley. *Placemaking: The Art and Practice of Building Communities.* New York: Wiley, 1995.

Schodt, Frederick L. *Dreamland Japan: Writings on Modern Manga.* Berkeley: Stone Bridge Press, 1996.

Schwaab, Dean. *Osaka Prints.* London: John Murray, 1989.

Scidmore, Eliza Ruhamah. "The Recent Earthquake Wave on the Coast of Japan." *National Geographic,* September 1896, available at http://ngm.nationalgeographic.com/1896/09/japan-tsunami/scidmore-text.

Screech, Timon. *The Lens within the Heart: The Western Scientific Gaze and Popular Imagery in Later Edo Japan.* Cambridge: Cambridge University Press, 1996.

———. *The Shogun's Painted Culture: Fear and Creativity in the Japanese States 1760–1829.* London: Reaktion Books, 2000.

Shirane, Haruo. *The Bridge of Dreams: A Poetics of the Tale of Genji.* Palo Alto: Stanford University Press, 1987.

Simpson, David Simpson. *9/11: The Culture of Commemoration.* Chicago and London: University of Chicago Press, 2006.

The Sketchbooks of Hokusai: Hokusai Manga. Introduction by Kawakita Michiaki. 15 vols. Tokyo: Unsōdō, 1993.

Slade, Giles. *Made to Break: Technology and Obsolescence in America.* Cambridge, MA: Harvard University Press, 2006.

Sloboda, Stacey. "The Grammar of Ornament: Cosmopolitanism and Reform in British Design." *Journal of Design History* 21:3 (2008): 223–236.

Smith, Henry D. II. *Hokusai: One Hundred Views of Mount Fuji.* New York: George Braziller, 1988.

———. "Hokusai and the Blue Revolution in Edo Prints." In John Carpenter, ed., *Hokusai and His Age: Ukiyo-e Painting, Printmaking and Book Illustration in Late Edo Japan,* 235–269. Leiden: Hotei Publishing, 2005.

———. "World without Walls: Kuwagata Keisai's Panoramic Vision of Japan." In Gail Lee Bernstein and Haruhiro Fukui, eds., *Japan and the World: Essays on Japanese History and Politics in Honour of Ishii Takeshi,* 3–19. Oxford: Macmillan Press, 1988.

Smith, Richard Lanham. "Debussy and the Art of Cinema." *Music and Letters* 54:1 (January 1973): 61–70.

Smith, Terry. *The Architecture of Aftermath.* Chicago: University of Chicago Press, 2006.

Sneakers: The Complete Collectors' Guide. Written and designed by Unorthodox Styles. London: Thames and Hudson, 2005.

Stamey, Emily. *The Prints of Roger Shimomura: A Catalogue Raisonné, 1968–2005.* Lawrence and Seattle: Spencer Museum of Art in association with the University of Washington Press, 2007.

Stevenson, John. *Masami Teraoka: From Tradition to Technology, the Floating World Comes of Age.* Seattle and London: University of Washington Press, 1997.

Stewart, Susan. *On Longing: Narratives of the Miniature, the Gigantic, the Souvenir, the Collection.* Durham and London: Duke University Press, 1998.

Suzuki Jūzō. *Ehon to ukiyo-e* (Picture books and ukiyo-e). Tokyo: Bijutsu shuppansha, 1979.

———. *Katsushika Hokusai hitsu Fugaku sanjūrokkei* (Hokusai's *Thirty-Six Views of Mount Fuji*). Tokyo: Shūeisha, 1965.

Takeuchi, Melinda. *Taiga's True Views: The Language of Landscape in Eighteenth-Century Japan.* Palo Alto: Stanford University Press, 1992.

Tanikawa, Koichi. *100 Posters of Yokoo Tadanori.* New York: Images Graphiques, 1978.

Thornton, Richard S. *Japanese Graphic Design.* London: Laurence King. 1991.

Thornton, Sarah. *Seven Days in the Art World.* London: Granta Books, 2008.

Tinterow, Gary. *Impressionism: A Centenary Exhibition.* New York: Metropolitan Museum of Art, 1974.

Traganou, Jilly. *The Tōkaidō Road: Traveling and Representation in Edo and Meiji Japan.* New York and London: Routledge/Curzon, 2004.

Tresize, Simon. *Debussy: La Mer.* Cambridge: Cambridge University Press, 1994.

Tsuji Nobuo. *Kisō no keifu—Matabei–Kuniyoshi* (The lineage of eccentricity from Matabei to Kuniyoshi). Tokyo: Bijutsu shuppansha, 1970.

Uhlenbeck, Chris. "Production Constraints in the World of Ukiyo-e: An Introduction to the Commercial Climate of Japanese Printmaking." In Amy Reigle Newland, ed., *The Commercial and Cultural Climate of Japanese Printmaking*, 11–22. Amsterdam: Hotei Publishing, 2004.

Ulak, James T., Alexandra Monroe, Masami Teraoka, with Lynda Hess. *Paintings by Masami Teraoka.* Washington, D.C.: Arthur M. Sackler Gallery, Smithsonian Institution; New York and Tokyo: Weatherhill, 1996.

Van Gogh, Vincent. *The Complete Letters of Vincent van Gogh.* London: Thames and Hudson, 1958.

Vaporis, Constantine. *Travel and the State in Early Modern Japan: Breaking Barriers.* Harvard East Asian Monograph 163. Cambridge, MA, and London: Harvard University Press, 1994.

Warner, Pamela. "Compare and Contrast: Rhetorical Strategies in Edmond de Goncourt's Japonisme." In *Nineteenth-Century Art Worldwide* 8:1 (2009–2010), available at http://www.19thc-artworldwide.org.

Watanabe, Toshio. *High Victorian Japonisme.* Swiss Asian Studies Research Studies 10. Bern, 1991.

Weisberg, Gabriel P. *Art Nouveau Bing: Paris Style 1900.* New York: Abrams, 1986.

Weisberg, Gabriel P., Edwin Becker, and Evelyne Posseme, eds. *The Origins of l'Art Nouveau: The Bing Empire*. Amsterdam: Van Gogh Museum, 2004.

Weisberg, Gabriel, Dennis Cate, et al. *Japonisme: Japanese Influence on French Art 1854–1910*. Cleveland: Cleveland Museum of Art, 1975.

Weisenfeld, Gennifer. "From Baby's First Bath: Modern Soap and Modern Japanese Commercial Design." *Art Bulletin* 86:3 (September 2004): 573–598.

———. *Imaging Disaster: Tokyo and the Visual Culture of Japan's Great Earthquake of 1923*. Berkeley: University of California Press, 2012.

White, Julia M. *Masterpieces of Landscape: Ukiyo-e Prints from the Honolulu Academy of Arts*. Honolulu: Honolulu Academy of Arts, 2003.

Wichmann, Siegfried. *Japonisme: The Japanese Influence on Western Art since 1858*. London: Thames and Hudson, 2001.

Wilson-Bareau, Juliet, and David Degener, eds. *Monet and the Sea*. Philadelphia: Philadelphia Museum of Art, 2003.

Winstone, H. V. F. *Royal Copenhagen*. London: Stacey International, 1984.

Woldbye, Vibeke. "Ceramic Interplay: Copenhagen and Japan during the 1880s and 1890s." In *Meiji no Takara: Treasures of Imperial Japan: Ceramics, Part One, Porcelain*, 64–77. London: The Kibo Foundation, 1995.

Yano, Christine R. "Wink on Pink: Interpreting Japanese Cute." *Journal of Asian Studies* 68:3 (August 2009): 681–688.

Yates, Ronald E. *The Kikkoman Chronicles: A Global Company with a Japanese Soul*. New York: McGraw-Hill, 1998.

Yonemoto, Marcia. "Maps and Metaphors of the 'Small Eastern Sea' in Tokugawa Japan (1603–1868)." *Geographical Review* 89:2 (April 1999): 169–187.

Yonemura, Ann. *Hokusai*. Washington, D.C.: Freer Gallery of Art and Arthur M. Sackler Museum, Smithsonian Institution, 2006.

Index

United States: Asian Americans, 126–134, 146; crop art, 190–191; illustrated book collectors, 60–63, 101; Japanese American internment, 108, 127, 128; Japonisme, 12, 121, 123–124; Pop art, 115–116, 129–130; prisons, 182; SAT exams, 111; stamps, 99, **99**; woodblock print collectors, 13, 101–107, 121, 123. *See also* New York City

United States, relations with Japan: alliance, 98, 115; Hokusai references, 104; iconic role of "Great Wave," 97–100, 109, 110–111, 136; immigration, 104, 127; occupation, 106–107, 109, 112, 113, 115; Perry's opening of Japan, 97, 99

Unmitigated Audacity Productions (UAP), 180

urban spaces: bricolage, 182; modernization, 59–60; placemaking, 169–170; street art, 177–187

Utagawa Hiroshige: *Fifty-Three Stages of the Tōkaidō Road*, 29, 34, 112; *One Hundred Pictures of Fuji*, 32–34, 38; reproductions of prints, 109; "The Embankment at Koganei in Musashi Province," 32; "The Sea at Satta in Suruga Province," 32, **33**, 67, 69, 70; *Thirty-Six Views of Mount Fuji*, 32; "View of Uraga Bay in Sagami Province," 28, **28**; Western reproductions, 72–73; Wright on, 102

Utagawa Kuniteru, 24–25

Utagawa Kuniyoshi, 29, 34; "On the Waves at Kakuda on the Way to Sado Island," 50, **51**

Utagawa Sadahide, *The Seaweed Gatherer*, 123, **124**

Vancouver International Airport, "The Great Wave" (Haufschild), 174–177, **175**

Van Gogh, Vincent, 91; study of Hokusai, 125; *Sunflowers*, 125, 137, 191

vase with encircling waves, 68, **68**

Victoria and Albert (V&A) Museum, 68, 140–141, 142, 157

von Lenkiewitcz, Wolfe, *Creation*, 7

Wagner, Richard, 90, 92

Warm Planet Bicycles, 156–157, **156**

"Wa" socks with great wave motif, 150, **150**

Watanabe Shōzaburō, 106

wave images: in architecture, 173; Chinese, 47–48; in Courbet's works, 82–83, 222n101; face-to-face, 97, 116, 127; in Hokusai's works, 44, 57, 65, 117–118, 119; in Japanese art, 46–47, 52–53; metaphoric meanings, 44, 48–50, 54–55, 119–120, 160–161, 168, 197, 202; in music, 90; on porcelain, 47–48, 65–67, 69–72; sports and, 155; travel and, 143; in West, 54–55, 61, 65–69, 70

waves: creativity and, 94–95; meanings, 6–7, 99; sound and light, 55, 91. *See also* tsunamis

Weir, Peter, 206

Weisberg, Gabriel P., 12, 84–85

Weisenfeld, Gennifer, 156

Whistler, James McNeill, 91–92

Wichmann, Siegfried, 12

wine, 148

Wong, Martin, 133–134

woodblock prints: best sellers, 29–30; collectors, 13, 74, 101–107, 121–122, 123; color printing technology, 23, 24–25, 72; edition sizes, 30; exhibitions, 101–102, 103, 225n54; influence on Western art, 73–79, 91–92, 95, 121–125; landscapes, 22, 24, 103, 106, 107, 111; mass reproduction in West, 72–73; *nishiki-e*, 22, 29–30; pigments, 20, 26–29; as popular art form, 4, 22, 29–30, 96, 101, 102; prices, 25, 29–30, 104, 105–106, 141; publishers, 22, 23–26; purchasers, 22–23; recent impressions, 106; repetition and reworking, 25–26; stamps reproducing, 111–112; *uki-e* (floating pictures), 39–40, 48, 144; use of perspective, 38–40. *See also* ukiyo-e

World of Art, 85–86

World War II, 107, 108, 109–110, 127, 128

Wright, Frank Lloyd, 102

Yamanaka Sadajirō, 105

Yamashiro Ryūichi, poster for Museum of Modern Art, Tokyo, 113–114, **114**

Yasuda Fire and Marine Insurance Company, 125

Yokoo Tadanori, 114–117; poster for Kyōto Ro-on, 115, **116**; poster for *The Moon like a Drawn Bow*, 117–120, **117**

Yōkoso Japan (Welcome to Japan) campaign, 166–168, **167**

Yomiuri Shimbun advertisement, 97, **98**

Yonemoto, Marcia, 45

Zazzle, 158, 159